Hope you enjoy!.
Regards Saul & Paul.

ANDREW MARTIN

Interior Design Review Volume 13

'I'll have them fly to India for gold, ransack the ocean for orient pearl'. So wrote Christopher Marlowe in 1592 and thus it has been for interior designers ever since. Scouring the globe for treasures is an integral element of the decorator's metier. Goods for the home have inexorably driven forward the development of trade and the history of humanity. The lust for luxury made silk the most coveted product in the ancient world. The Roman Emperor Elagabalus (who was top dog for just four years 218-222 AD) is not just remembered for shocking his contemporaries with his fondness for young boys and surprising them with white make up and removal of all his body hair, he also turbo powered the fashion for silk. He pioneered the blend of silk and linen, still a super sophisticated look 2000 years later. Seneca the Stoic philosopher may have despised extravagance but it didn't stop him owning 500 ivory tables.

The Silk Route has played a pivotal role throughout time. Buddhism was transported along with the merchants and centuries later designers still pillage its iconography. These images containing the essential contradiction of austerity and compassion have become a cliche in the home. The pre eminence of Muslim traders either side of the start of the 2nd Millennium equally allowed Islam to be brought to the world. Today we still cherish the fables of Sinbad and the remarkable tales of Ibn Battuta, who travelled 74,000 miles in the 13th century. Around the time the Vikings were marauding, a Persian sea captain called Ibn Shahryar wrote of 'a ship laden with a million dinars of musk, as well as silks and porcelain of equal value, and quite as much again in jewellery and stones, not counting a whole heap of marvellous objects of Chinese workmanship'. Plus ça change.

Today the world is littered with emporia of every kind. However there is none that quite resonates with interior designers like the castle near Antwerp of Axel Vervoordt, this year's Designer of the Year. For as long as I can remember it has been a kind of Camelot for collectors, somewhere to go on a quest for the Holy Grail. His 50 room home is the proverbial cornucopia of art, antiques and pre requisites for both his own schemes and the design world's cognoscenti. Axel's own philosophy is deceptively simple; 'make them feel at home and love their house'.

Martin Waller

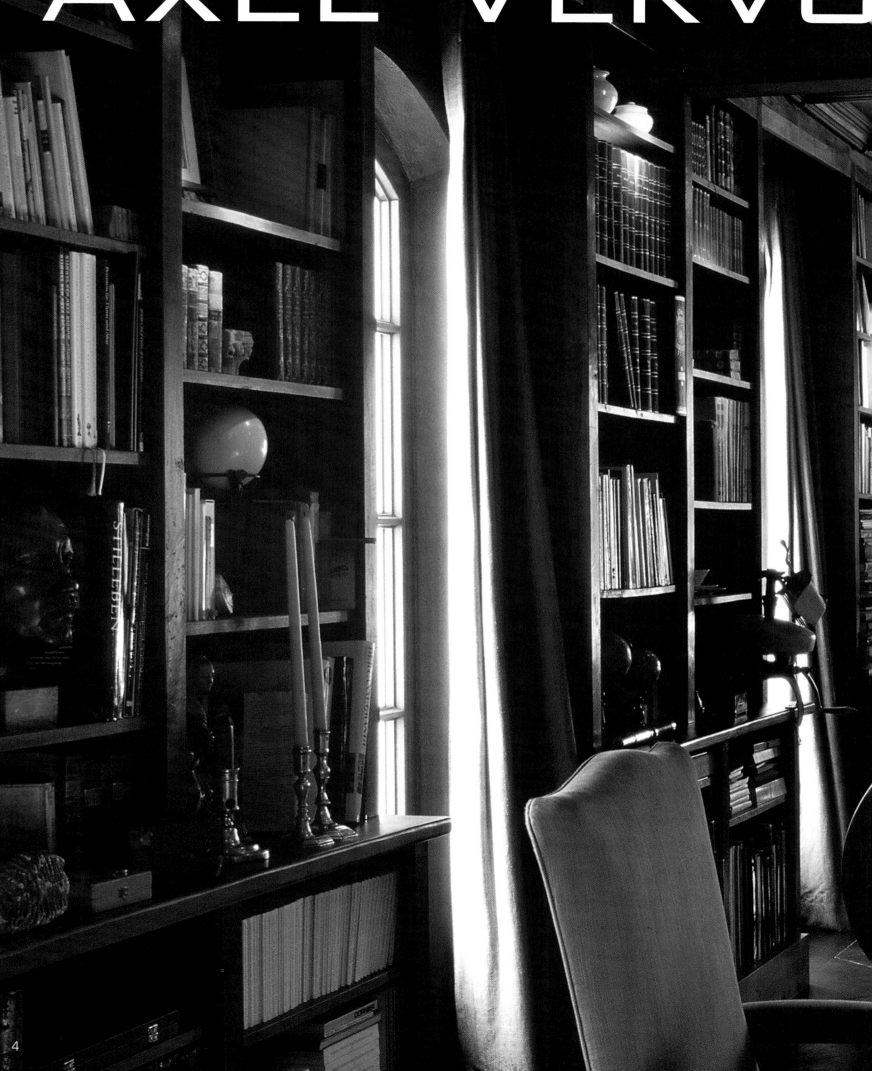

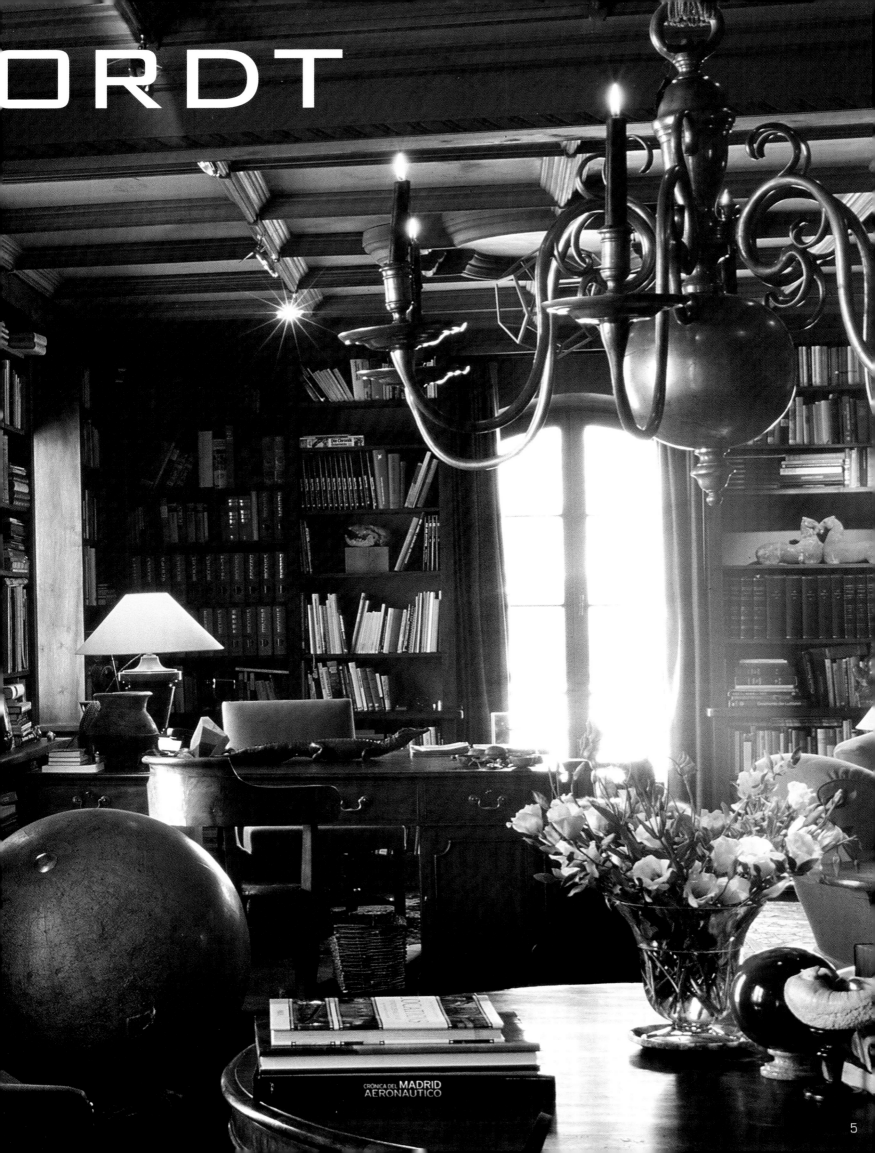

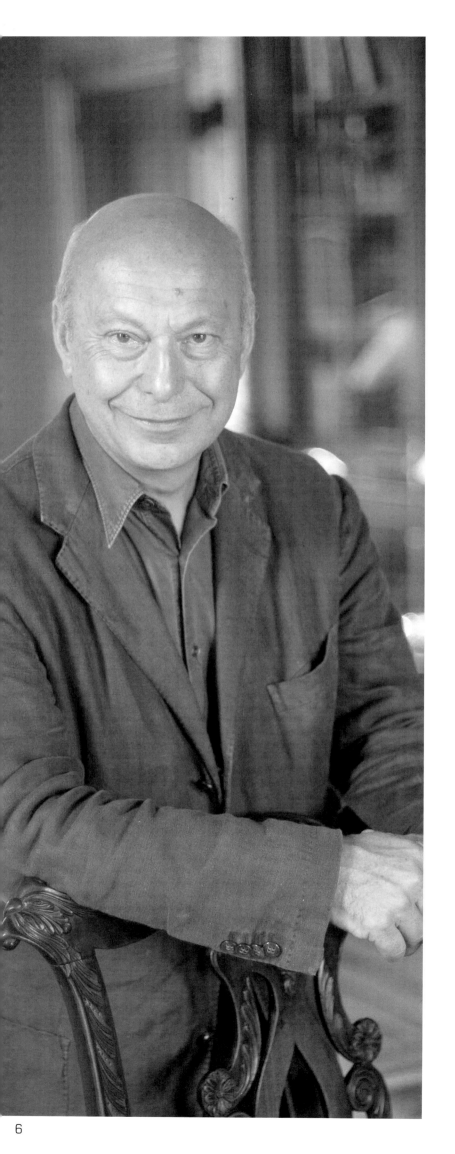

Designer: Axel Vervoordt.
Company: Axel Vervoordt NV, Belgium.
Profile: Family run firm with a team of almost a hundred specialist art historians, architects, designers, restorers and supporting staff. Active in the international world of art and antiques they cater to an elite global clientele including royalty, museums and established collectors.

Axel and May Vervoordt are a Zen-like couple for whom peace is priority, the Dalai Lama a hero and interior decorating their destiny. Good friends are musicians and designers. Axel dresses mostly in Dries van Noten, favourite fragrance Terre d'Hermes. A hard working team they like nothing better than Sunday afternoon on the sofa by the fireplace. Unafraid of growing old, Axel's happiest in the garden or in his jeep in the country, May with her grandchildren. She believes that life is evolution. Favourite shopping, artistic areas of Paris, favourite architects Palladio and Le Corbusier. Most memorable meal Japan (3 guests, 8 cooks.)

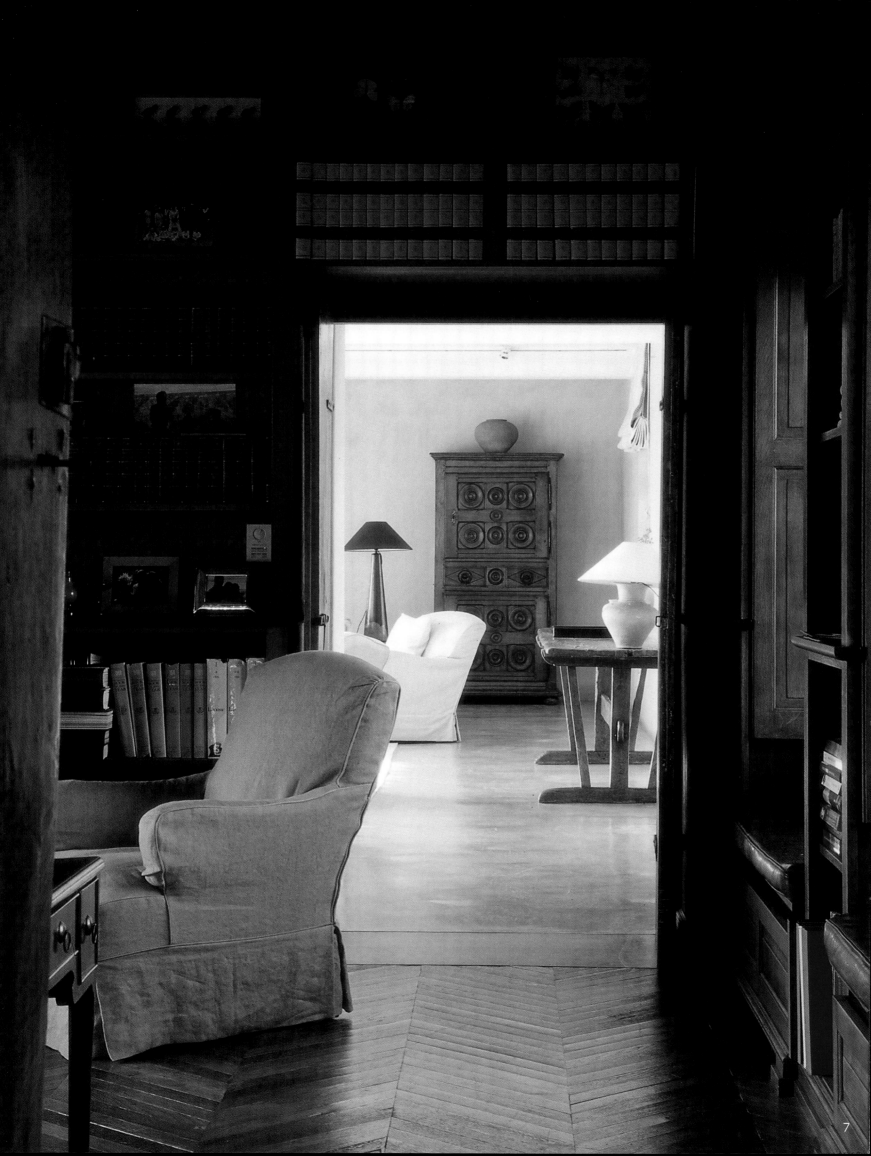

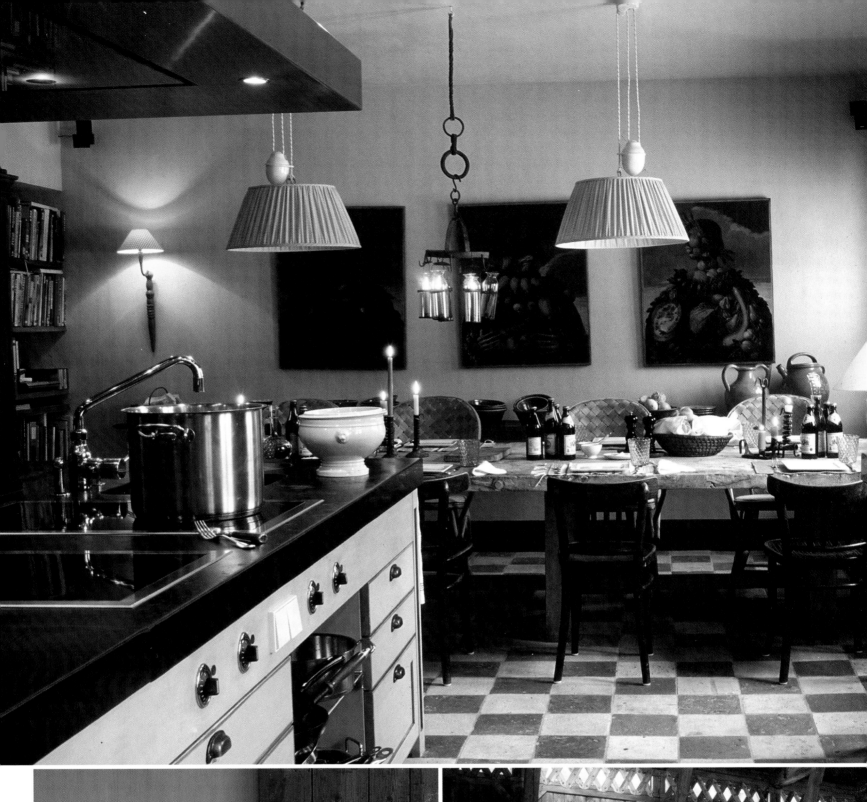

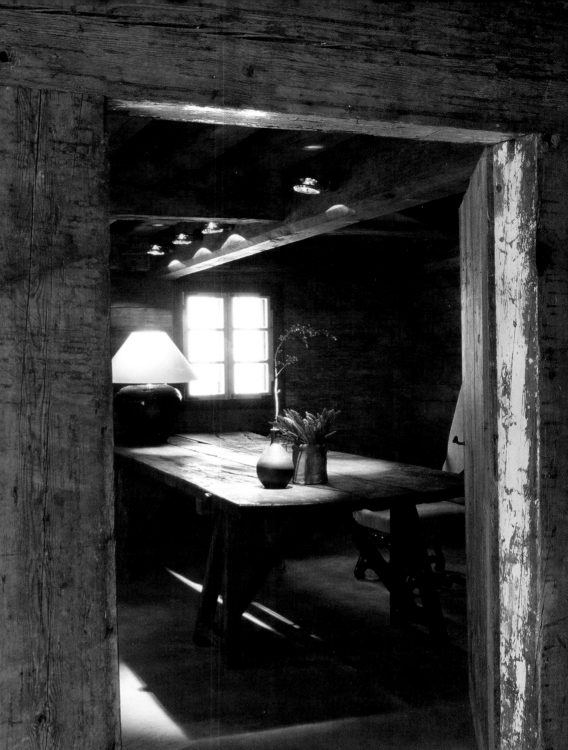

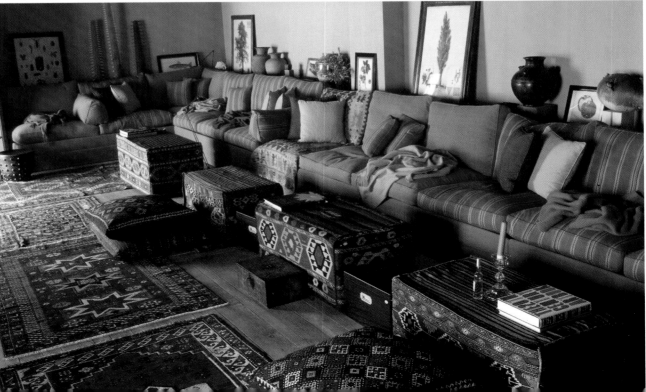

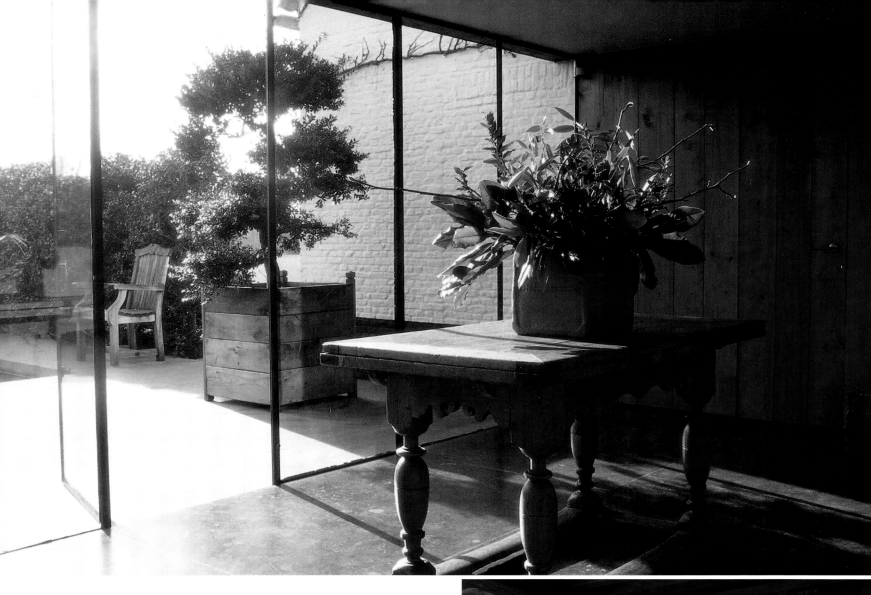

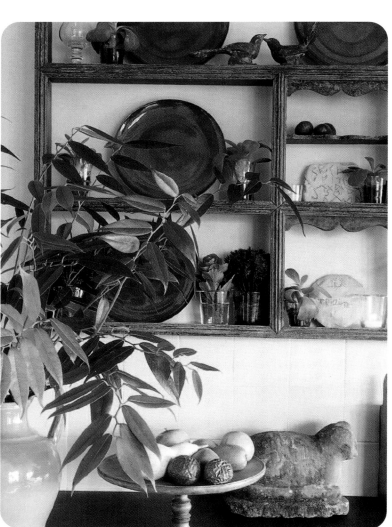

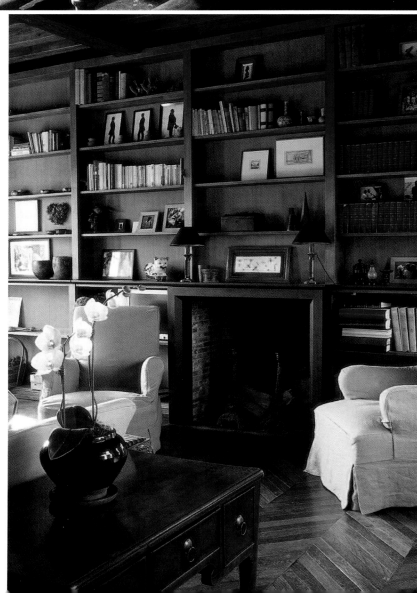

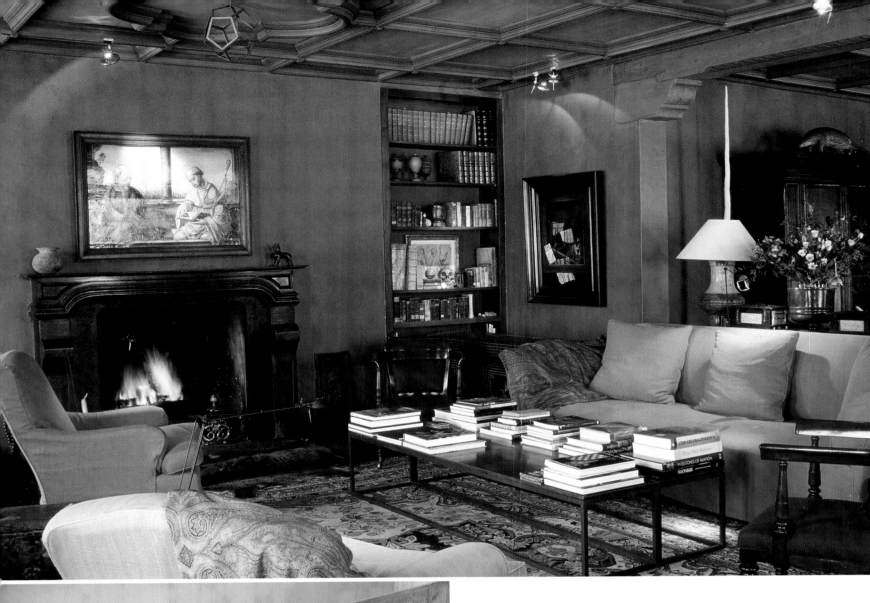

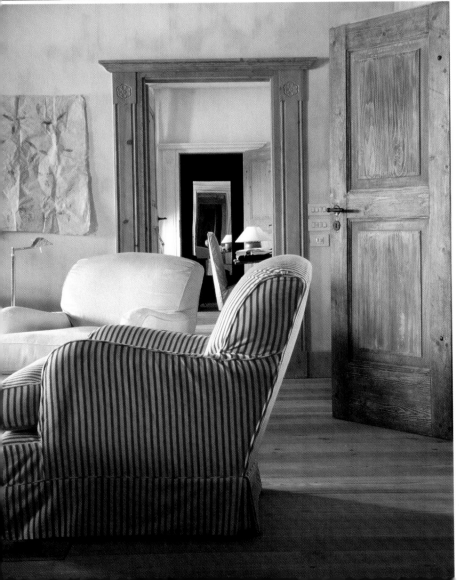

ITERBO

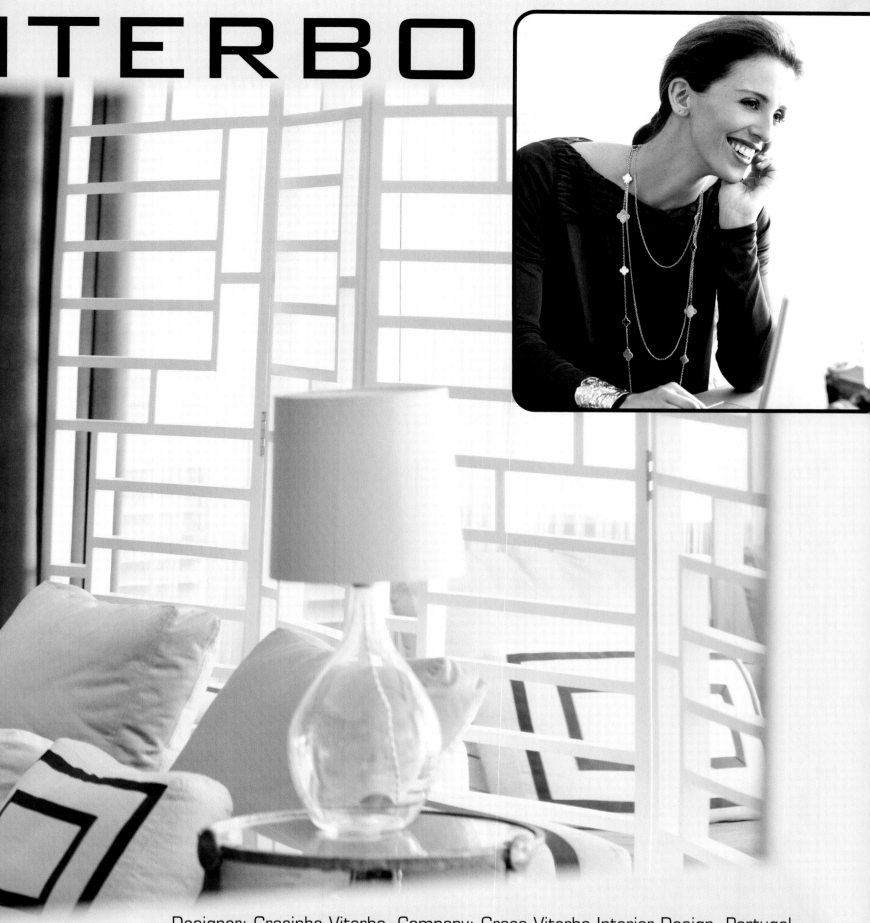

Designer: Gracinha Viterbo. Company: Graça Viterbo Interior Design, Portugal.
Profile: A mother and daughter partnership with over forty years experience.
Viterbo is one of Portugal's leading Interior Design firms with international
offices taking them to Europe, Africa and Asia. Work includes private and
commercial projects with numerous luxury and boutique hotels. Recent work
includes an exclusive hotel in Lugano, Switzerland and Hotel Grande Real Villa
Italia Hotel & Spa, Cascais, Portugal. They are currently working on various
private homes, a chain of business hotels throughout Angola and a boutique
hotel in the Algarve.

A greener world would be Gracinha's first priority if she were Prime Minister for the day. Her favourite architect Frank Gehry, best car Mercedes 300 SL, most overrated book 'The Da Vinci Code'. At heart she's a citizen of the world, living in both Lisbon where she's inspired by the history and craftsmanship and London for its energy and mix of cultures. As a child Gracinha's ambition was to go around the world in 80 days. Now she'd visit the moon.

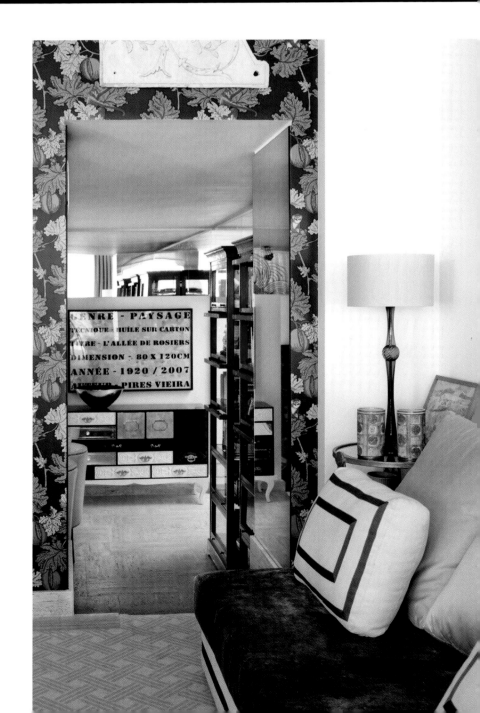

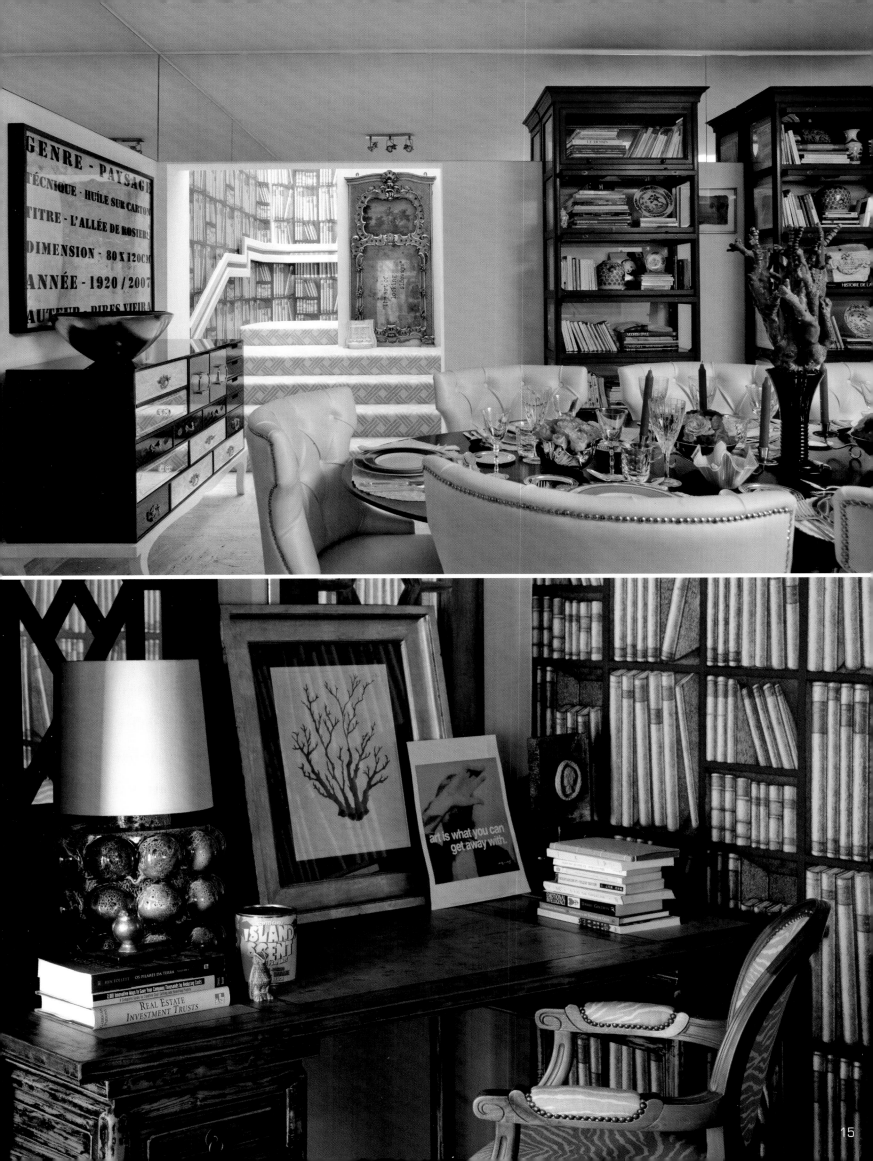

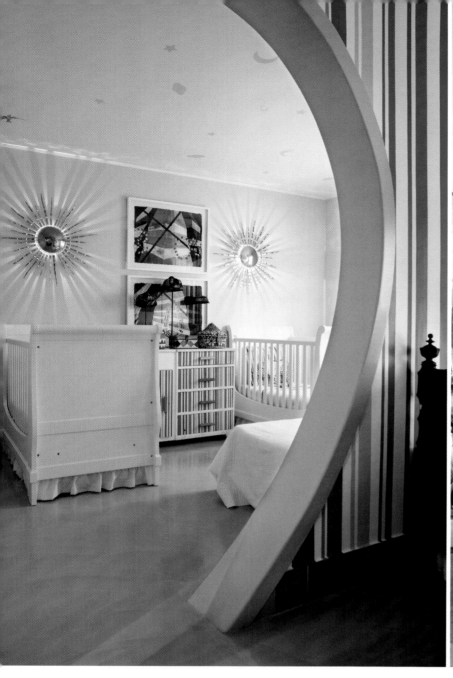
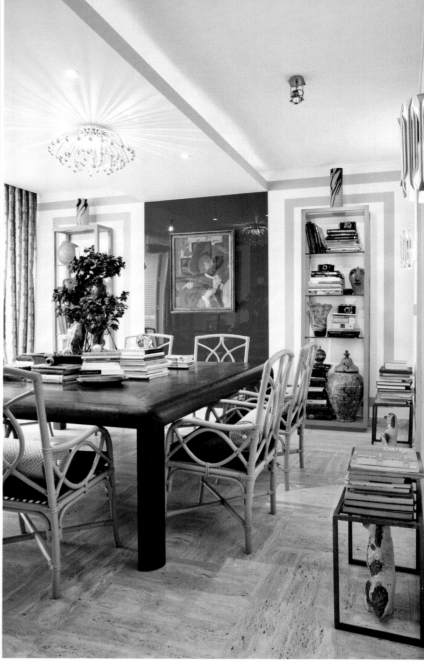

everything will be okay
in the end.

if it's not okay,
it's not the end.

(unknown)

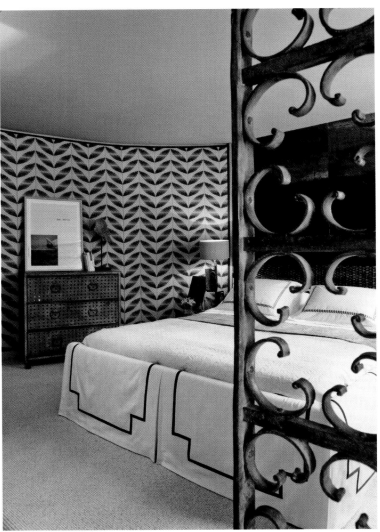

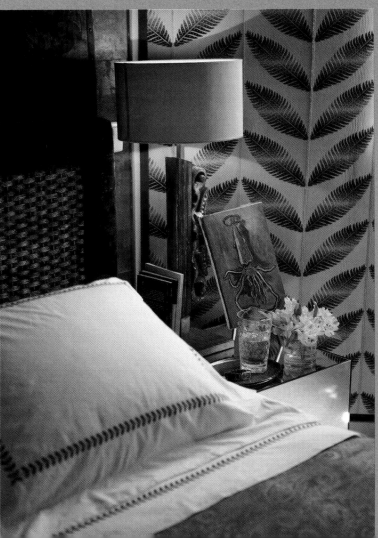

Her first job was at Kelly Hoppen's office in London where she learned that in design we have to take risks.

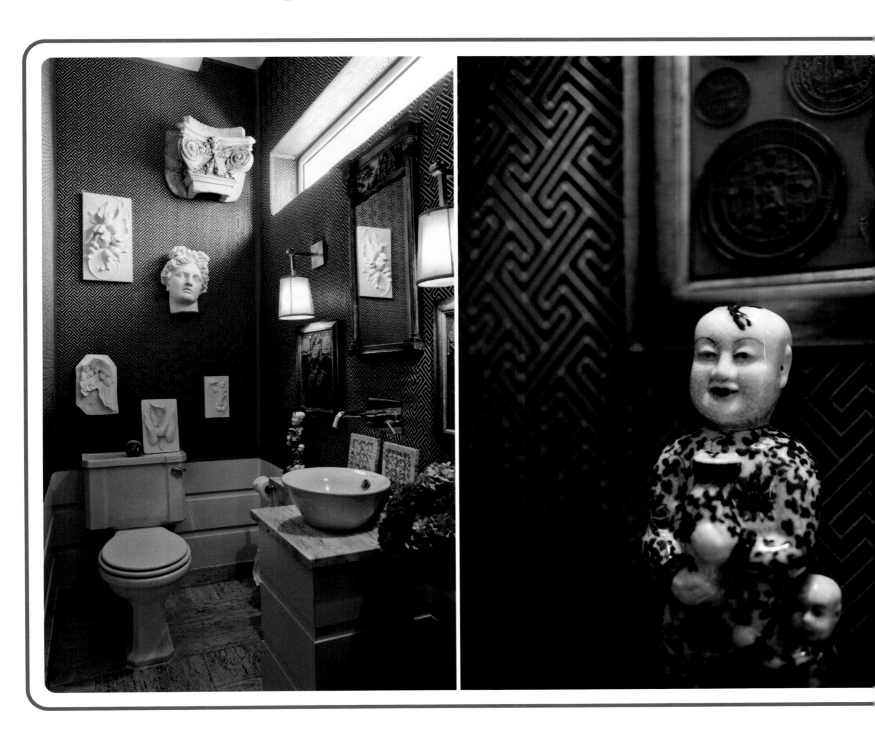

The most important thing in business for her today is 'innovating'. Would like to be in Cirque du Soleil for a day.

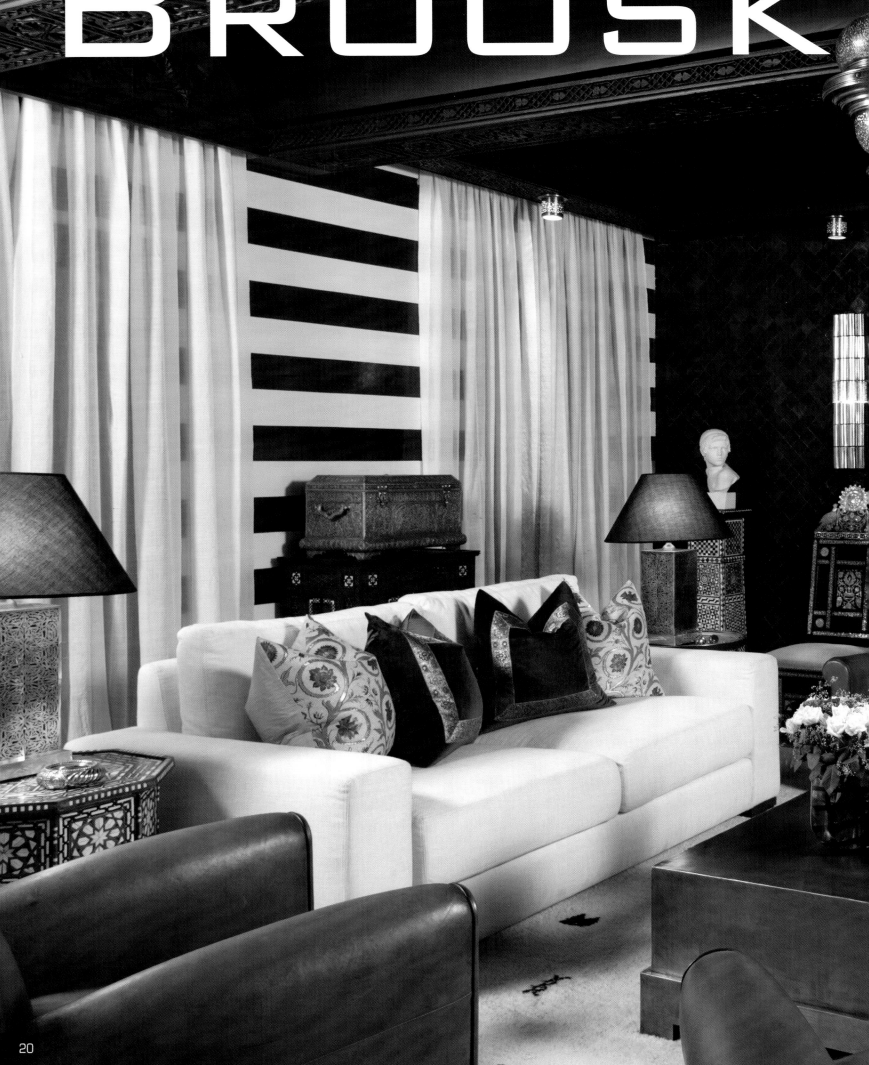

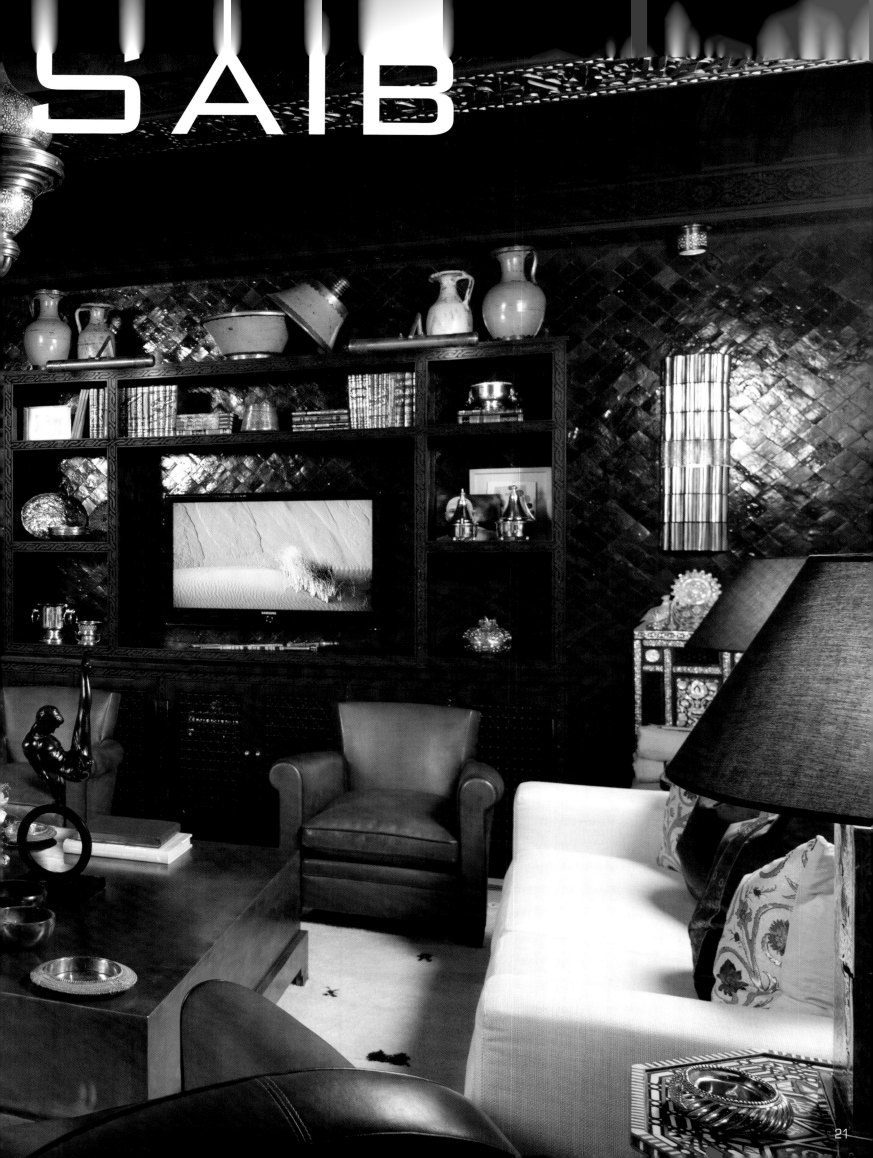

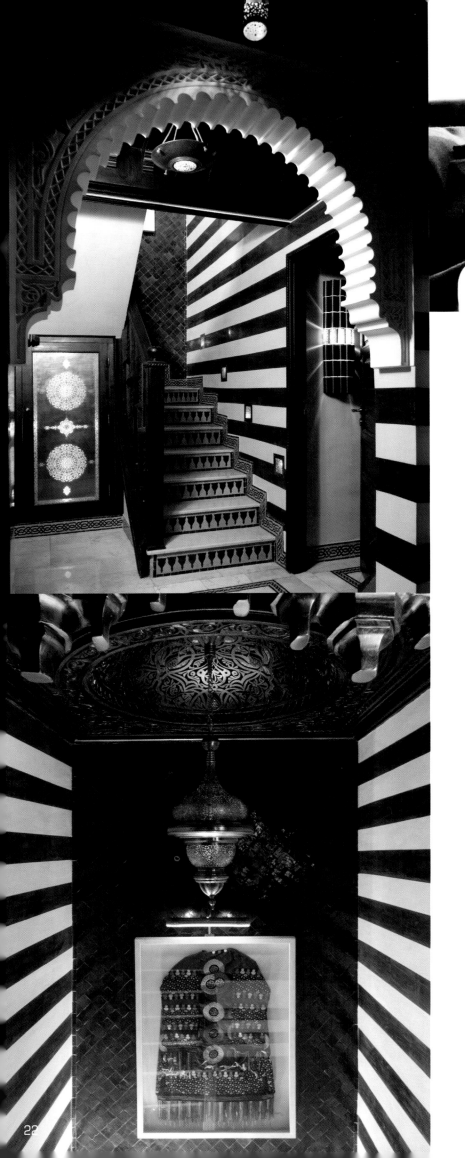

Designer: Broosk Saib.
Company: Broosk Saib, London.
Profile: Specialising in private work internationally. Recent projects include a family home in Notting Hill, a bachelor pad in Chelsea and a holiday apartment in Marrakech. Current work includes a large family home in Chelsea, a beach house in Cyprus and a country house in Sweden.

For this patriarch of good taste Broosk's ideas of holiday hell are The Canary Islands, The Satanic Verses and Simon Cowell. This Ralph Lauren dressed, Piscean dandy wears Czech & Speake Aromatics No 88 and has lots of secret crushes. He's an opera lover with a passion for politics, his hero Margaret Thatcher and his favourite shoes Converse. For Broosk, sun, sleep and plenty of mangoes are the secret to long life although KFC his guilty pleasure. The best advice ever received, 'try everything in life.'

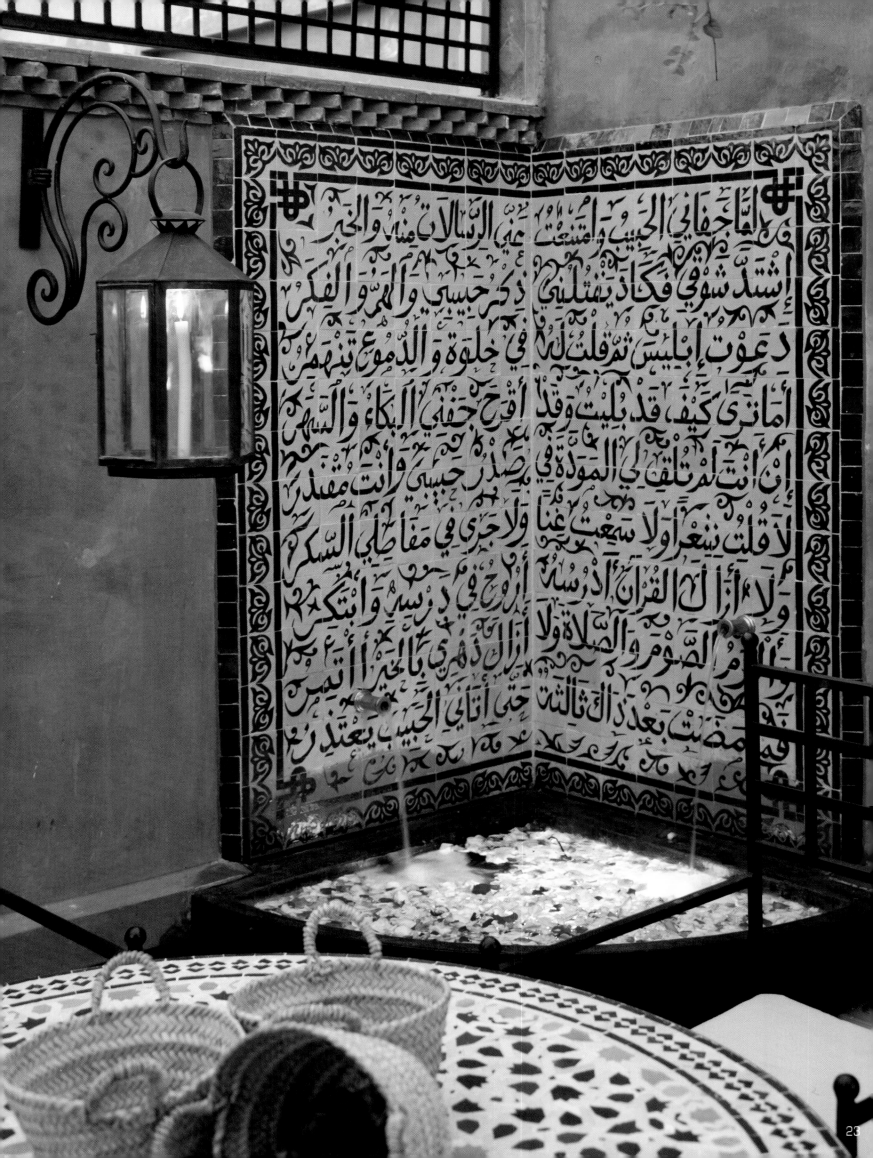

23

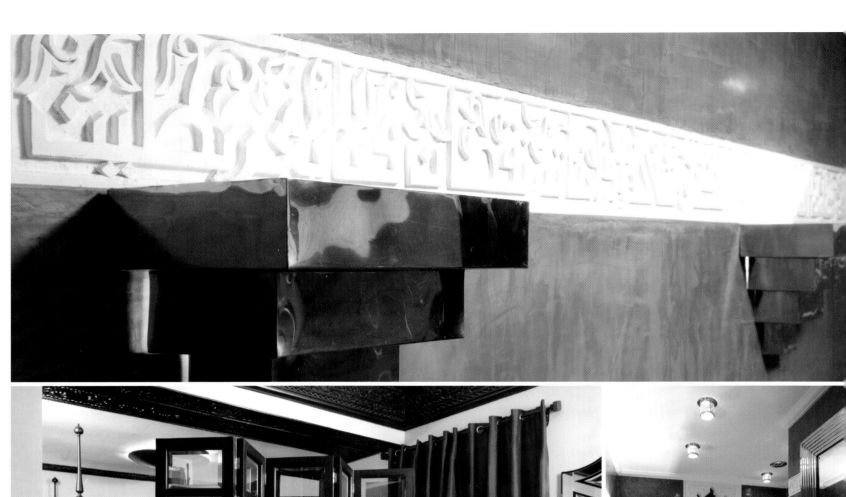

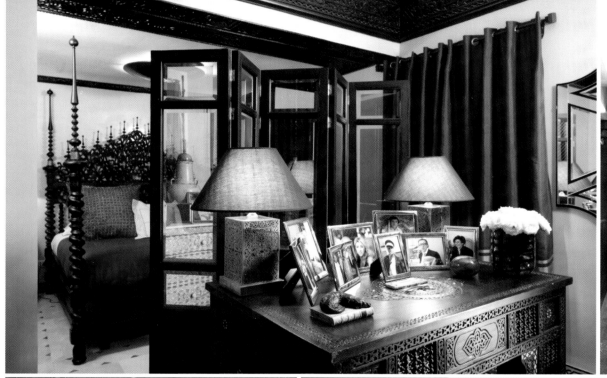

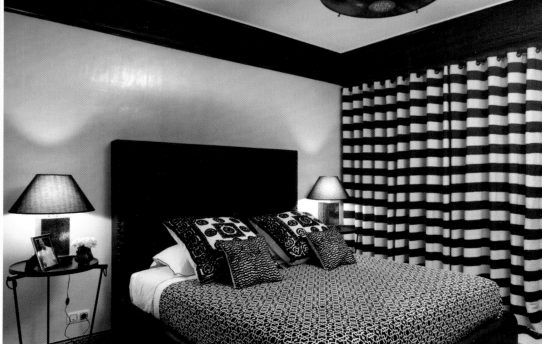

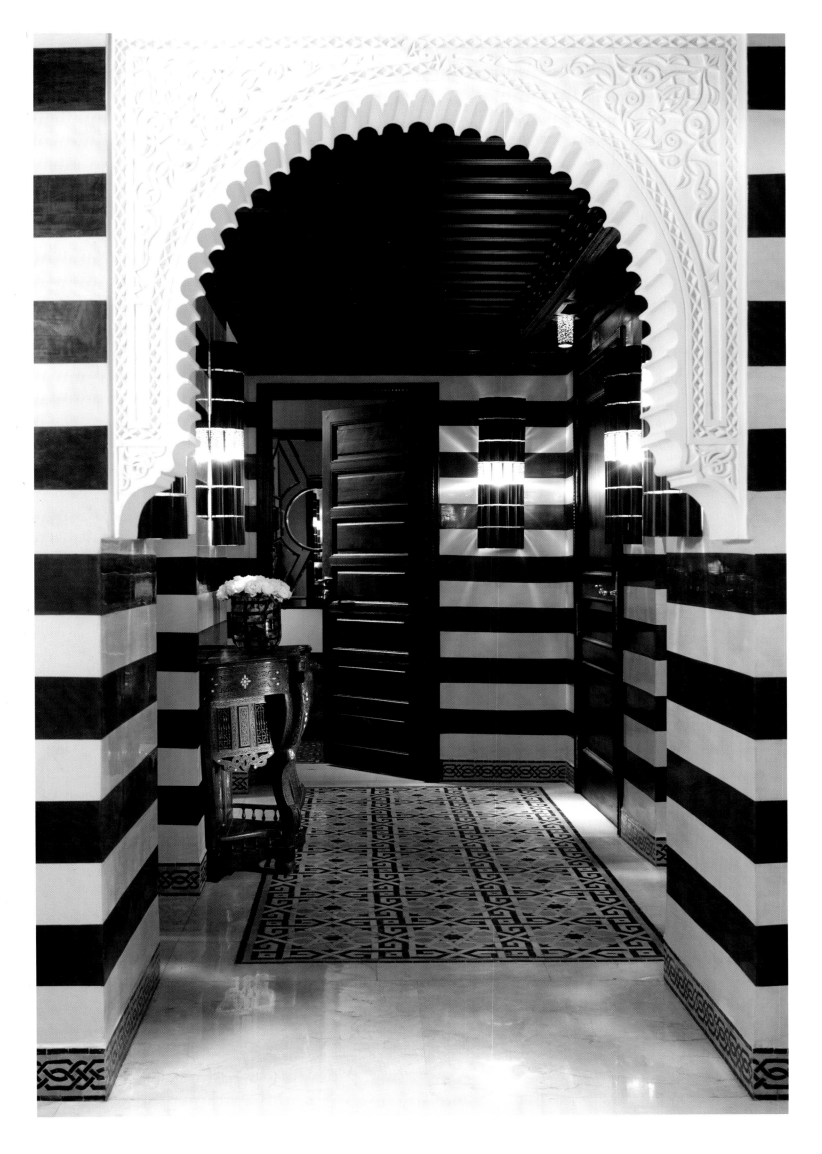

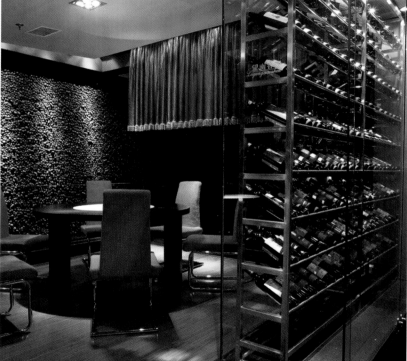

Designer: Joseph Sy.
Company: Joseph Sy
& Associates, Hong Kong.
Profile: Retail, corporate,
commercial and residential
predominantly in Hong
Kong, mainland China, The
Philippines, Indonesia and
Singapore.

JOSEPH SY

Jazz drummer manqué, Joseph would wear his technicolour jeancoat.

A collector, of cd's, his favourite home comfort listening to music; Stan Getz, Antonio Carlos Jobim, Oscar Peterson.

He's a player, favourite sport squash, favourite food chicken and rice.

Nervous of deadlines, happiest with project completion, favourite architect Tadao Ando, best skill space planning.

His epitaph 'help'.

FERNANDO HIPÓLITO

Designer: Fernando Hipólito.
Company: Fernando Hipólito Arquitectura, Interiores e Decoraçäo, Portugal.
Profile: Recent projects include a health and fitness shop in Portugal, a private apartment in Munich and a house in Sintra, Portugal. Current work includes a house in Lisbon and a penthouse and boutique hotel in Luanda, Angola.

A competent chef, his most memorable meal fois gras at 'le Cirque' in Las Vegas, favourite takeaway Japanese. Earliest memory, Shanghai, his childhood dream to be a pilot. First job modelling, taught him self belief. Favourite home comfort reading by the fireplace. Favourite holiday Praslin Island, Seychelles. Political hero's Marquês de Pombal, favourite designer Prada, secret crush Ava Gardner. Happiest with his wife and children, favourite saying 'I love you'.

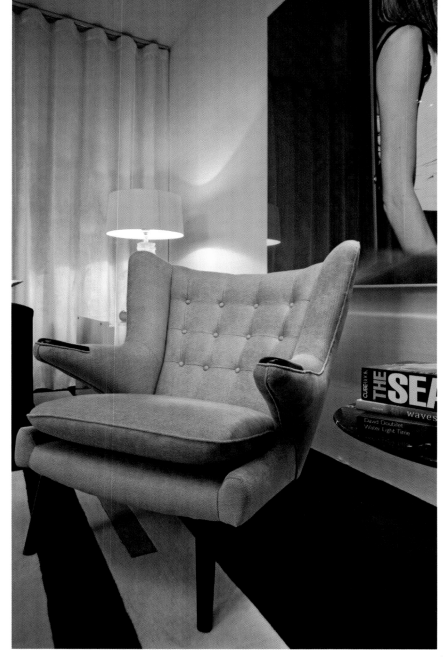

Wunder woman loves to tango but Jayne's childhood ambition was to become a prima ballerina. She lives out her fantasy job daily and believes integrity to be the most important part of business as long as she goes home to her cashmere slippers. John Pawson is her favourite architect, Monaco the best holiday. The truth makes her happy and her secret for long life is laughter. Favourite saying 'go for it'.

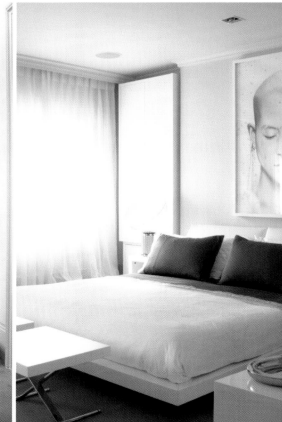

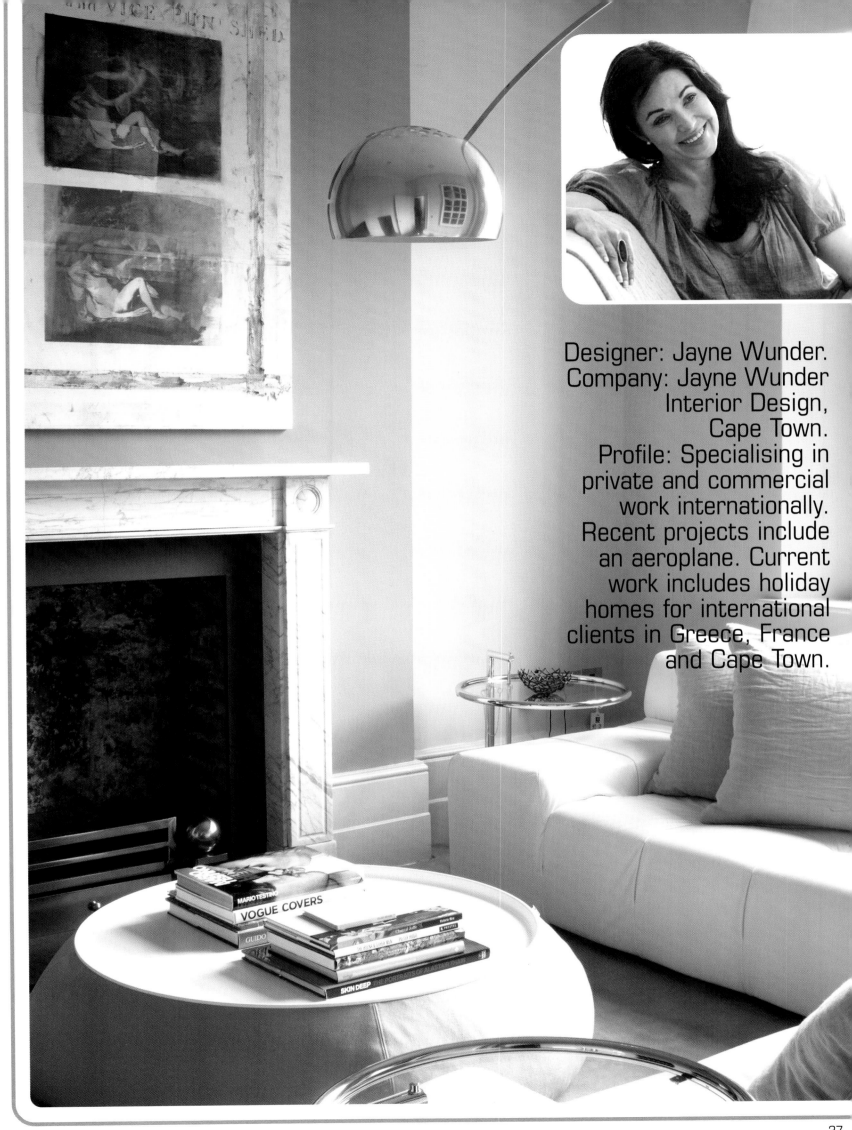

Designer: Jayne Wunder.
Company: Jayne Wunder
Interior Design,
Cape Town.
Profile: Specialising in
private and commercial
work internationally.
Recent projects include
an aeroplane. Current
work includes holiday
homes for international
clients in Greece, France
and Cape Town.

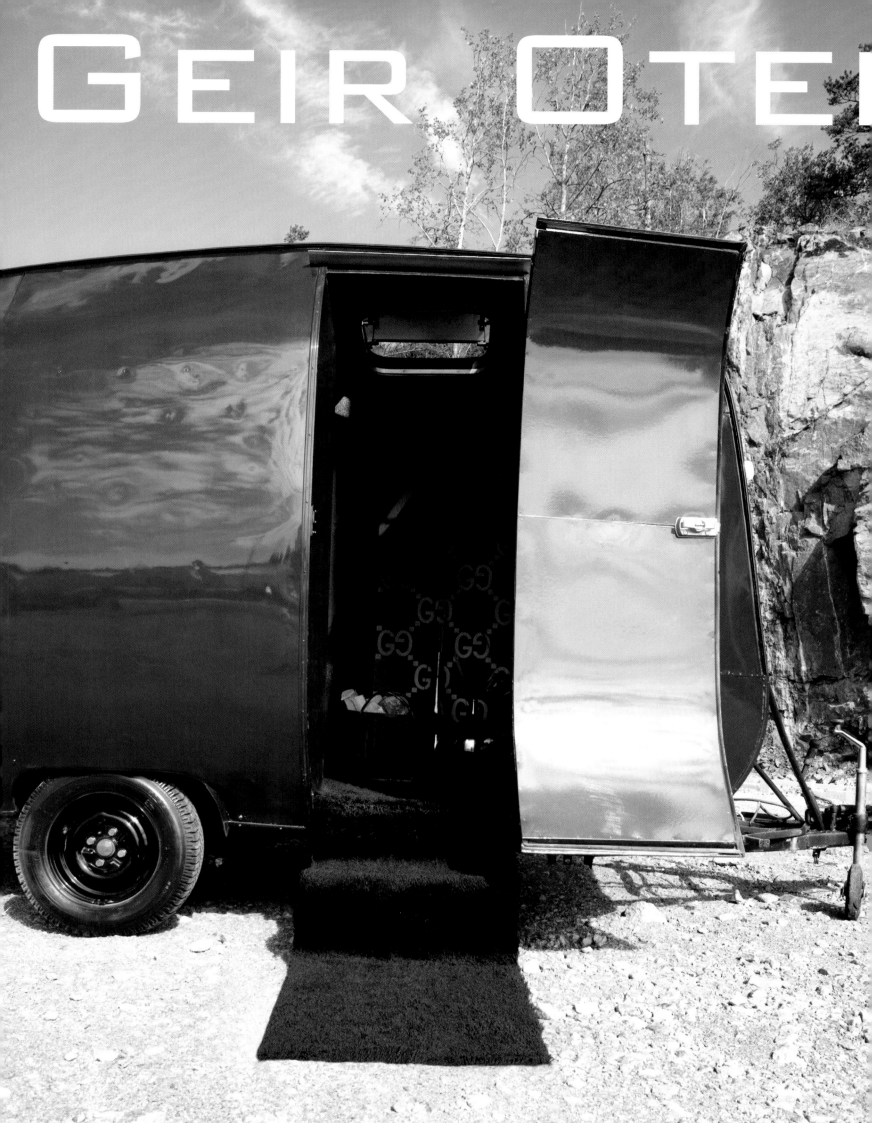

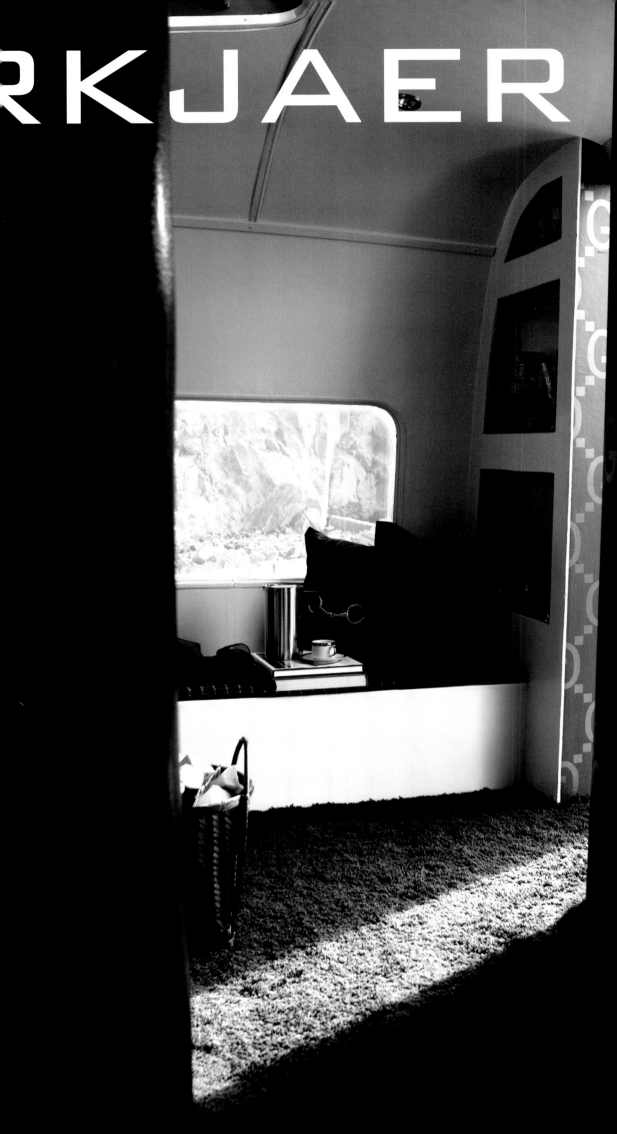

RKJAER

Designer: Geir Oterkjaer featuring Tico.
Company: At Home, Sweden.
Profile: Work is predominantly residential in Sweden with some international work including apartments, restaurants and boutiques with an emphasis on compact living spaces. Completed projects include Da Wagon, a luxury chrome caravan, a city apartment in Stockholm and a Japanese restaurant.

Wannabe superhero who's unimpressed by Superman. He'd like to meet Annie Lennox. Favourite saying 'life is a party and I'm invited'. Worst advice ever was to die his hair blue (1984). Favourite car a Karmann Ghia.

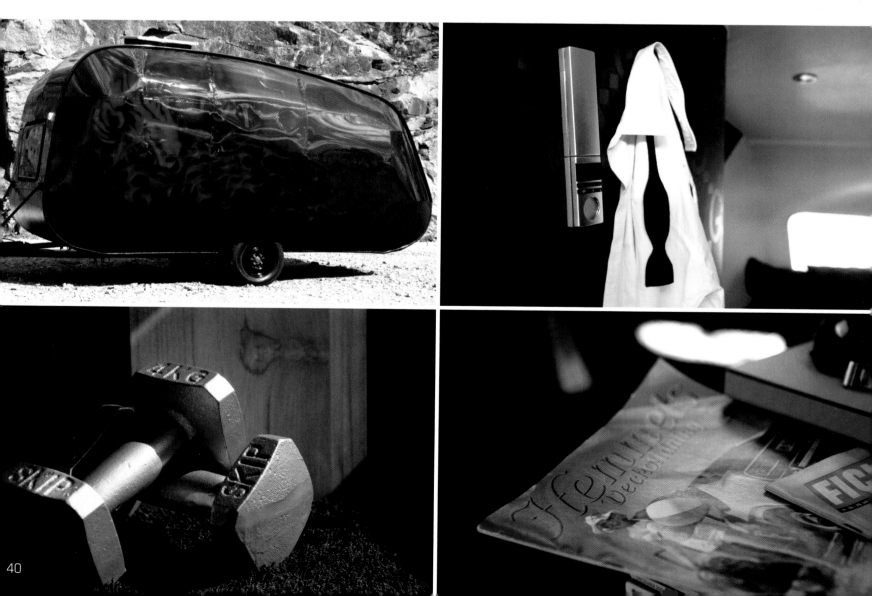

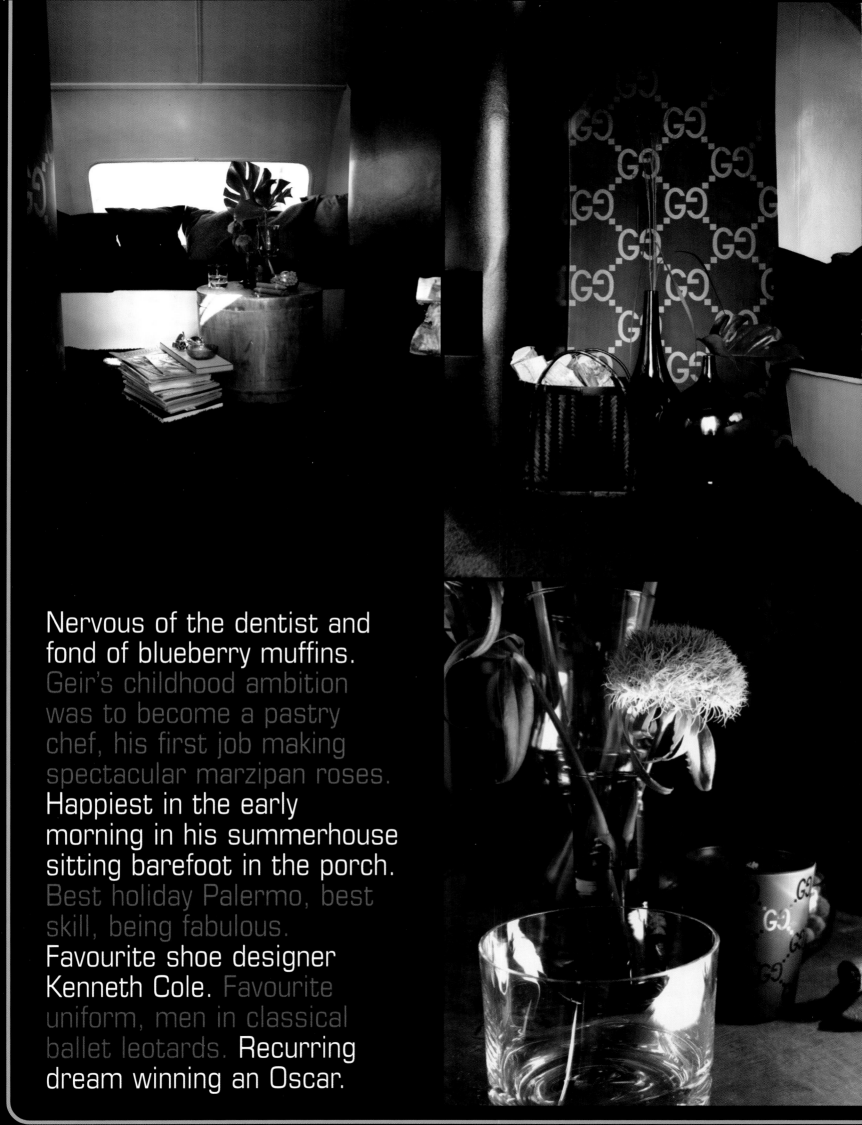

Nervous of the dentist and fond of blueberry muffins. Geir's childhood ambition was to become a pastry chef, his first job making spectacular marzipan roses. Happiest in the early morning in his summerhouse sitting barefoot in the porch. Best holiday Palermo, best skill, being fabulous. Favourite shoe designer Kenneth Cole. Favourite uniform, men in classical ballet leotards. Recurring dream winning an Oscar.

Designer: Nicola Fontanella. Company: Argent Design, London. Profile: Specialising in high end commercial and residential projects internationally. Recent work includes a 63 metre super yacht in Monaco, a large private townhouse in Mayfair, a beach villa in Miami and a Gulf Stream private jet. Current projects include a period house in Belgravia, opulent twin penthouses in Monaco, a villa in St Tropez and a luxury penthouse in Dubai.

Fantasy pole dancer and professional poker player, for whom Botox is the secret of long life, she'll forever be cool. Her favourite TV show Nip / Tuck. Even her toothbrush is covered in diamonds. She'd visit the Arctic for the polar bears. Happy in credit, nervous in debt. Nicola's everyday outfit 'whatever, with Louboutins'. She collects men and will make their temperature rise, last fancy dress outfit a nurse. Ideal date, Sylvester. For Nicola, tenacity is the most important thing in business, proudest achievement her new yacht.

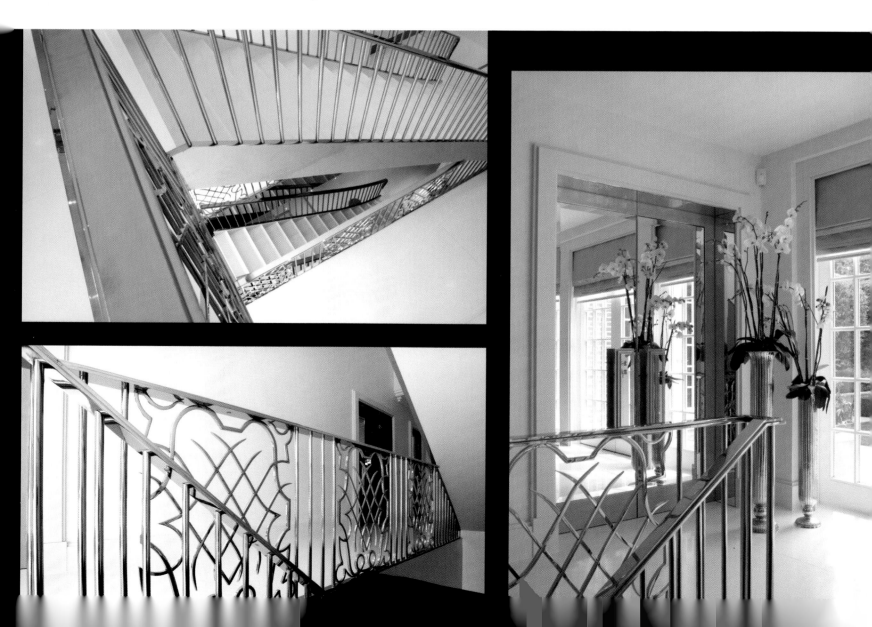

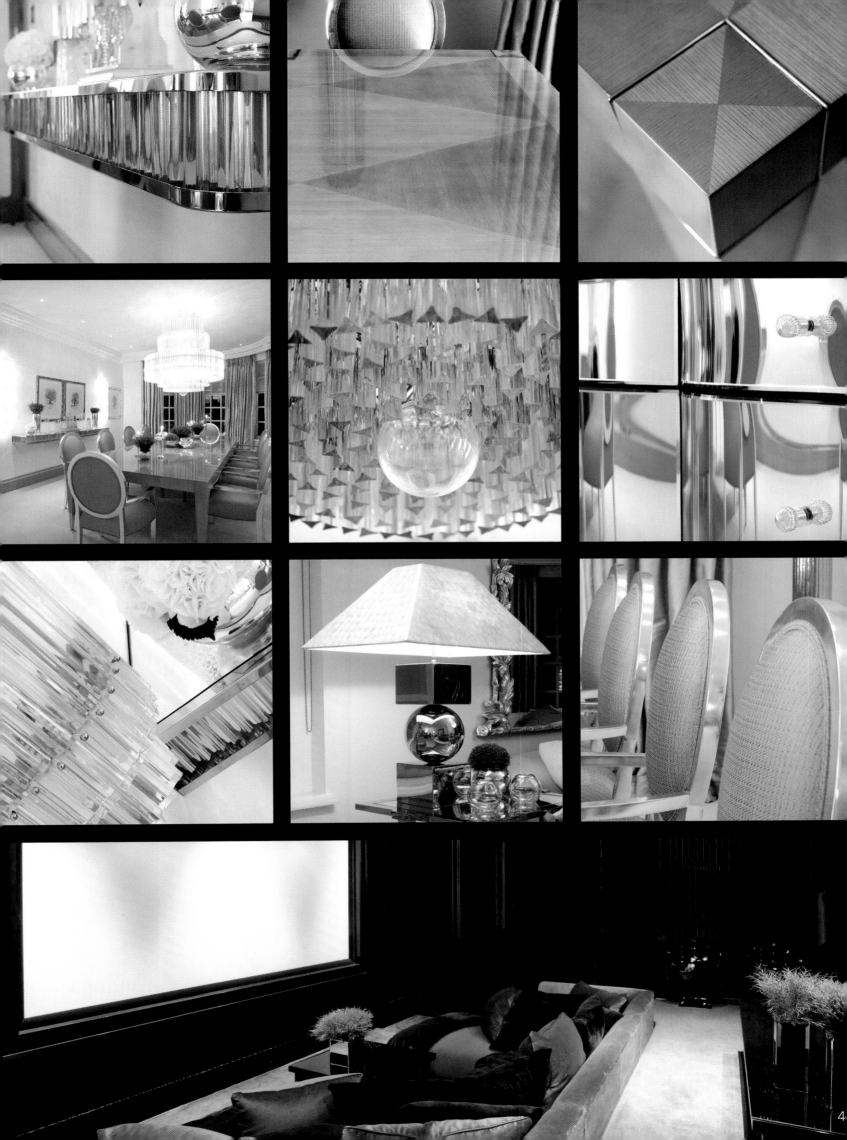

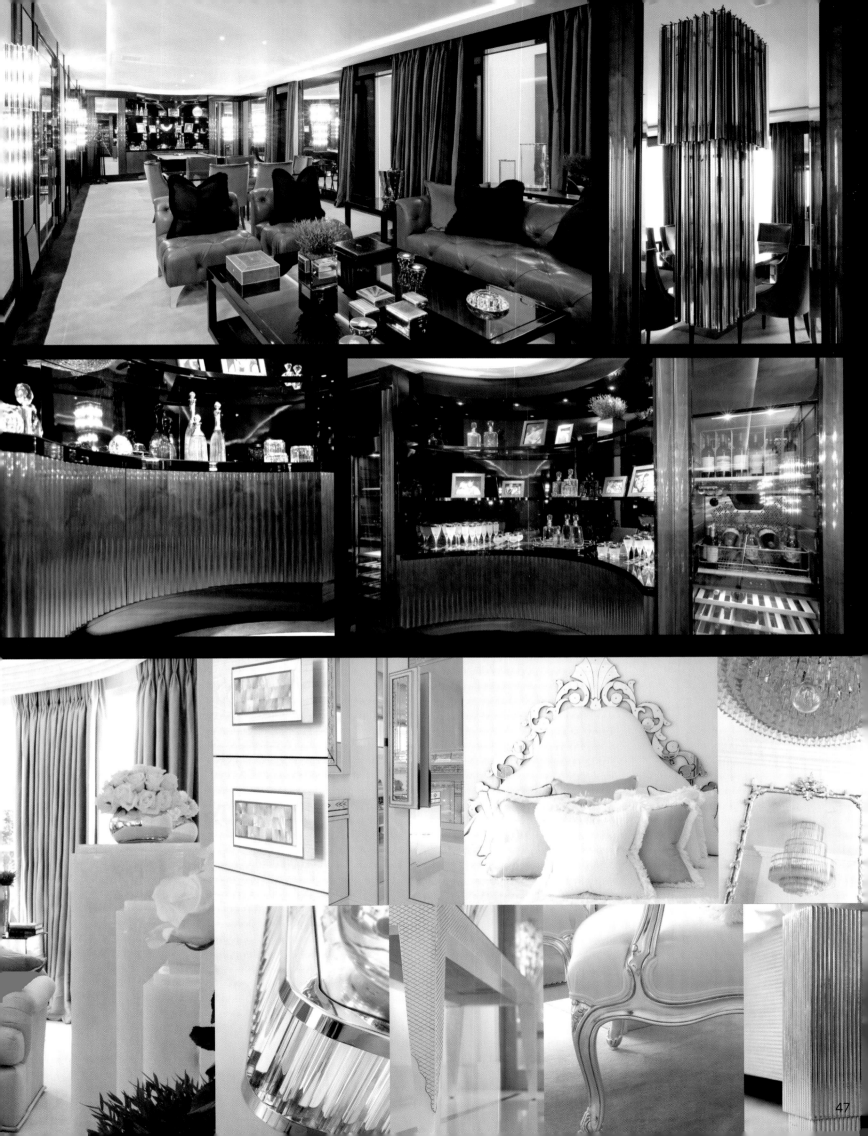

Designer: Ileana Dimopoulou-Cadena.
Company: Cadena Design Group, Athens.
Profile: A small company specialising in
residential and commercial work, including
yacht interiors, hotels, shops and
restaurants predominantly in Greece.
Current work includes a complex of four
villas on Mykonos island, a villa at
Parnassus mountain and an ultra modern
24 metre yacht.

ILEANA DIMOPO

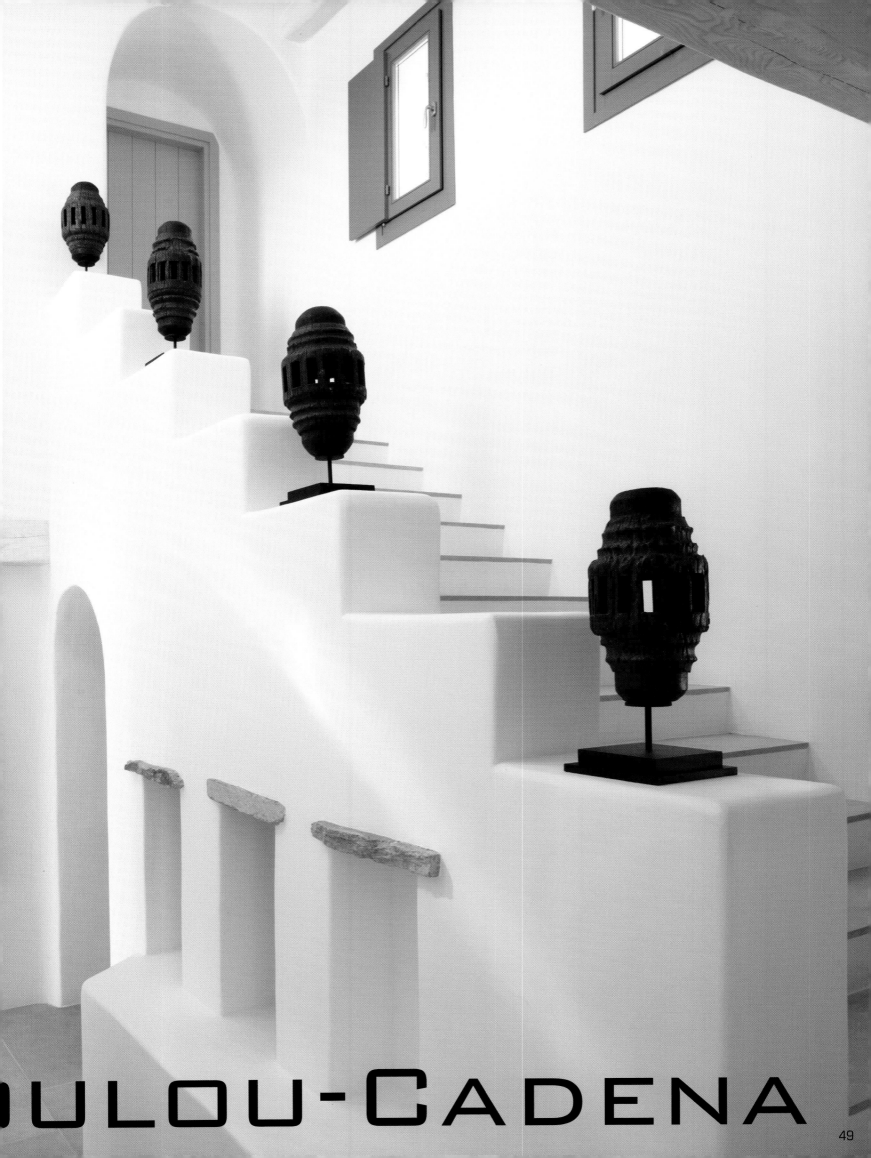

OULOU-CADENA

Independent, straight talking Greek Goddess who relies on nobody, the best advice she ever received. At 12 she was banished to her bedroom by her parents so tied her bed sheets together and escaped through the 2nd storey window. Her childhood ambition was to become famous, her adulthood hobby collecting obelisks and shoes, she bought 50 pairs in one season. Angered by ingratitude and bad manners, watch out for her Manolos. Happiest at home on her mattress, the secret of long life 'insouciance'. Her epitaph 'real death only comes when people you love forget you'.

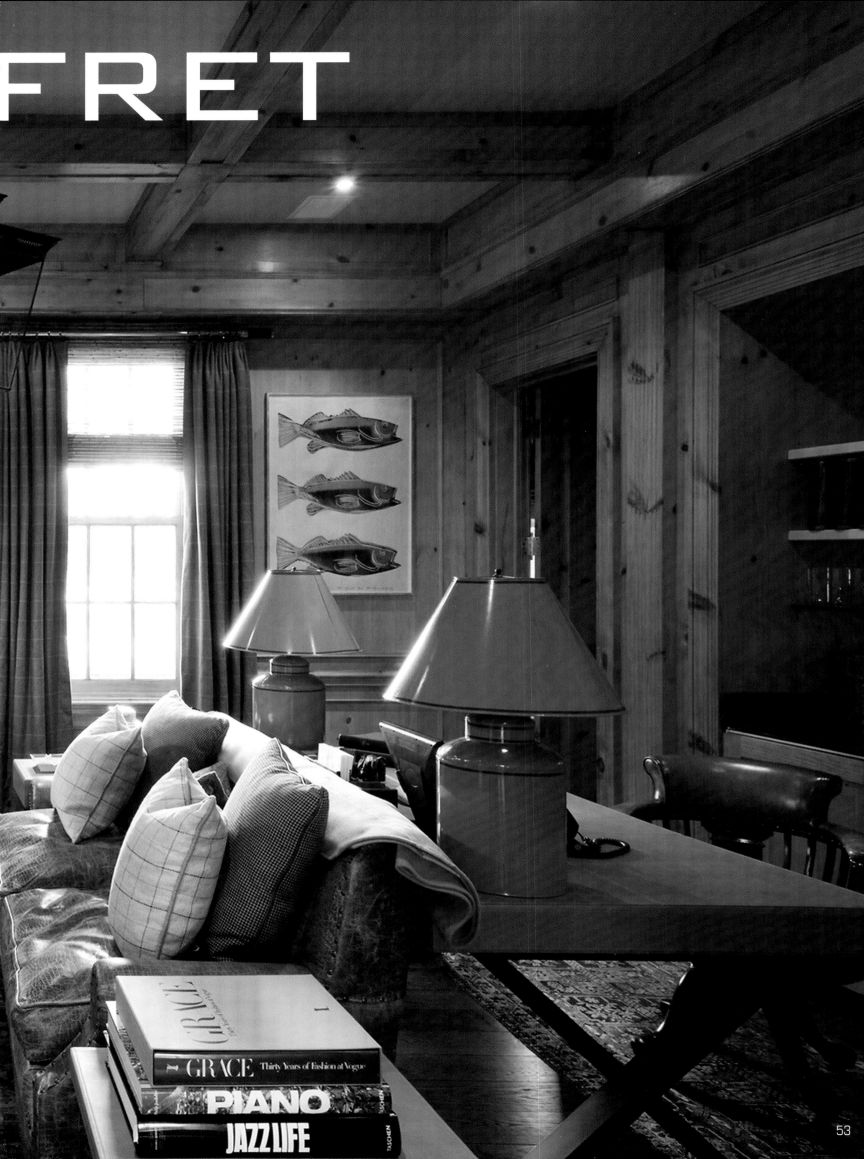

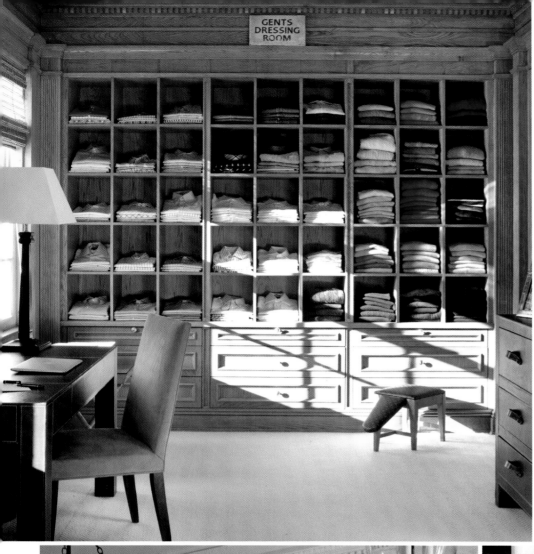

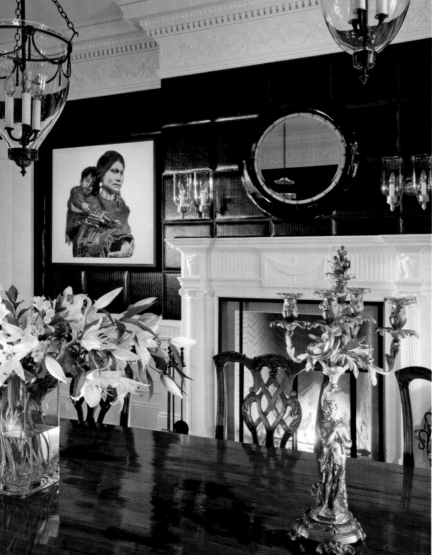

Designer: Cindy Rinfret. Company: Rinfret Ltd, Greenwich, Connecticut.
Profile: A team of 10 plus a home and garden store. Work is primarily residential. Rinfret specialise in timeless, classic, luxurious and comfortable design. Current projects include a grand country estate and manor house in Greenwich plus Tommy Hilfiger's penthouse apartment in Manhattan. More recently they have completed a ranch in Wyoming, a contemporary ski house in Colorado and a bachelor pad in Greenwich.

Valentino clad and Tiffany scented, Cindy would take a private jet to Portofino to relive her most memorable meal of langoustines in cognac. Her massage therapist would be on speed dial whilst she lies back, champagne in hand, alligator pumps on feet, listening to Pavarotti. Love and maintenance are the secrets of long life. Cindy's childhood ambition was to be a spy. Like her mother, who has great genes and great elegance, she believes she will age just as well, or so her plastic surgeon says. The worst advice she ever received was 'just marry him'. Best advice 'don't mistake charm for character,' words of wisdom from her mother. Her epitaph will read 'been there, done that'.

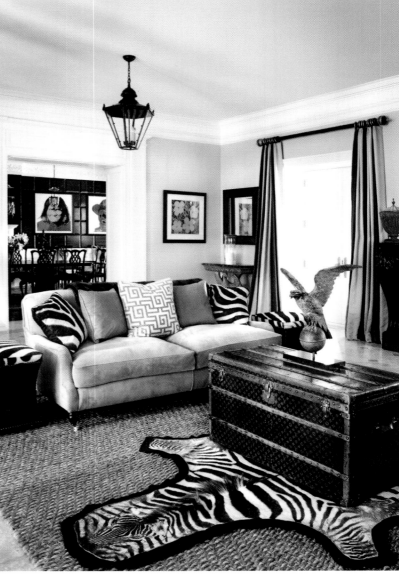

Designer: Zeynep Fadillioğlu. Company: ZF Design, Istanbul. Profile: Specialising in private work internationally. Recent projects include a contemporary mosque in Istanbul's oldest cemetery, a fully refurbished Ottoman yalis and a family house and garden in India. Current work includes a restaurant in Qatar and a hotel in Antalya.

Wannabe scientist who doesn't age, Zeynep likes to dress up and is reborn everyday. Her greatest extravagance is wishful thinking, timeless favourites Andrea Palladio and Sean Connery, Istanbul her inspiration. Her proudest achievement being asked to design a mosque, favourite saying 'life is what happens to you whilst you're making other plans.'

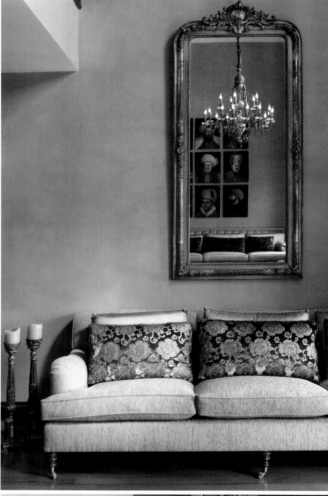

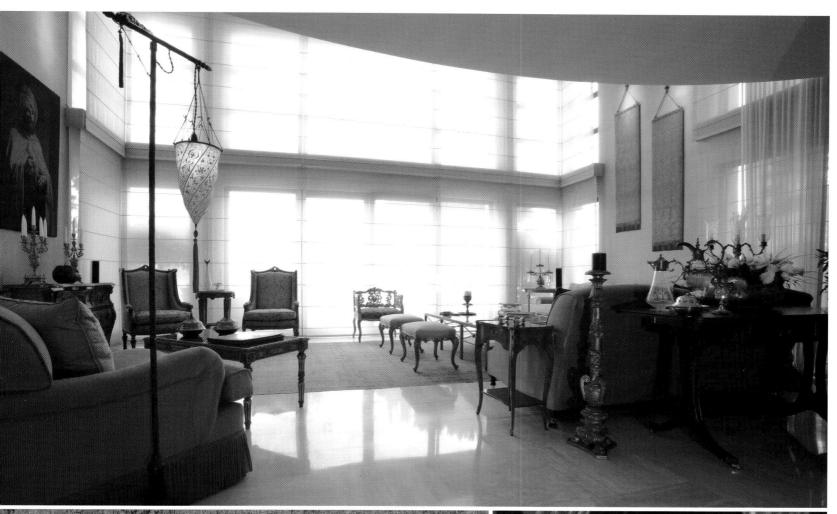

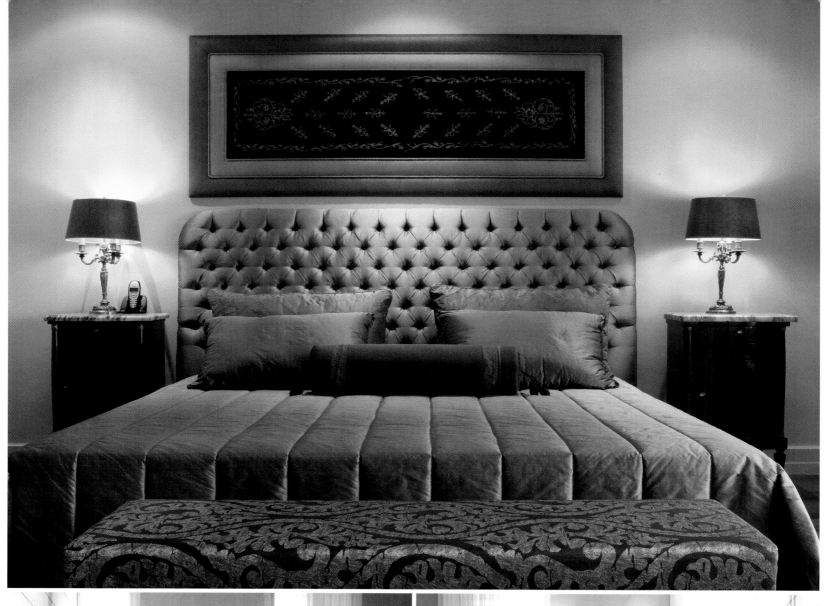

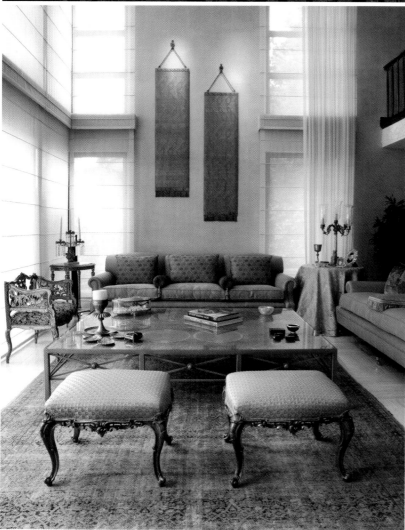

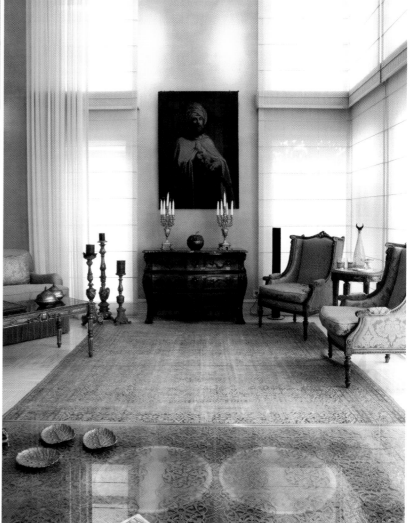

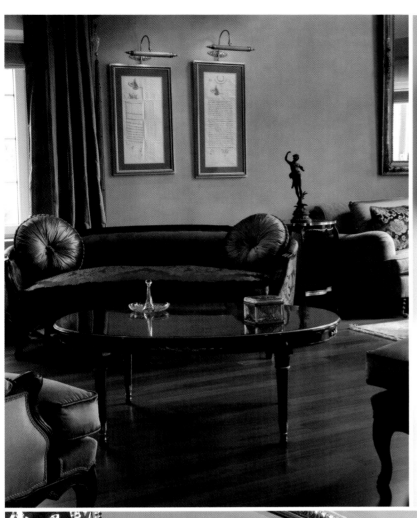

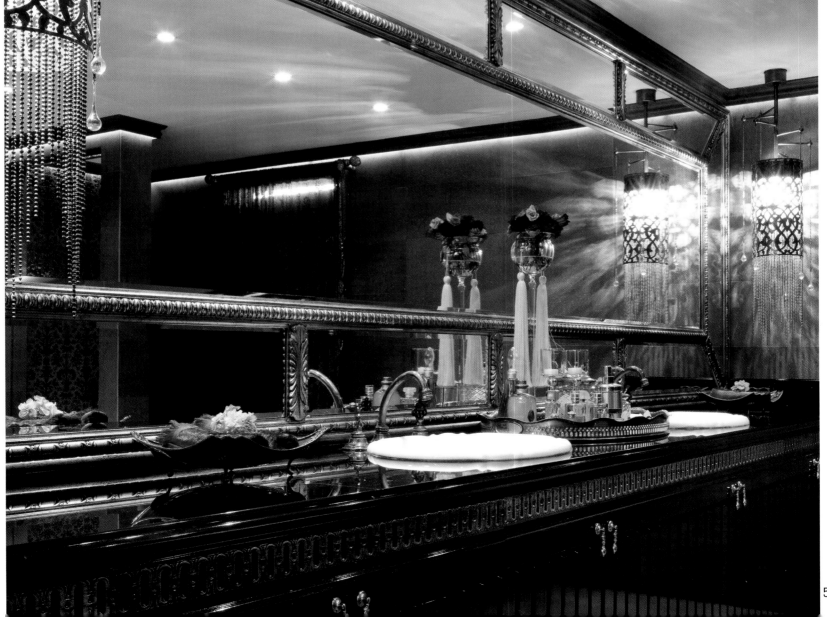

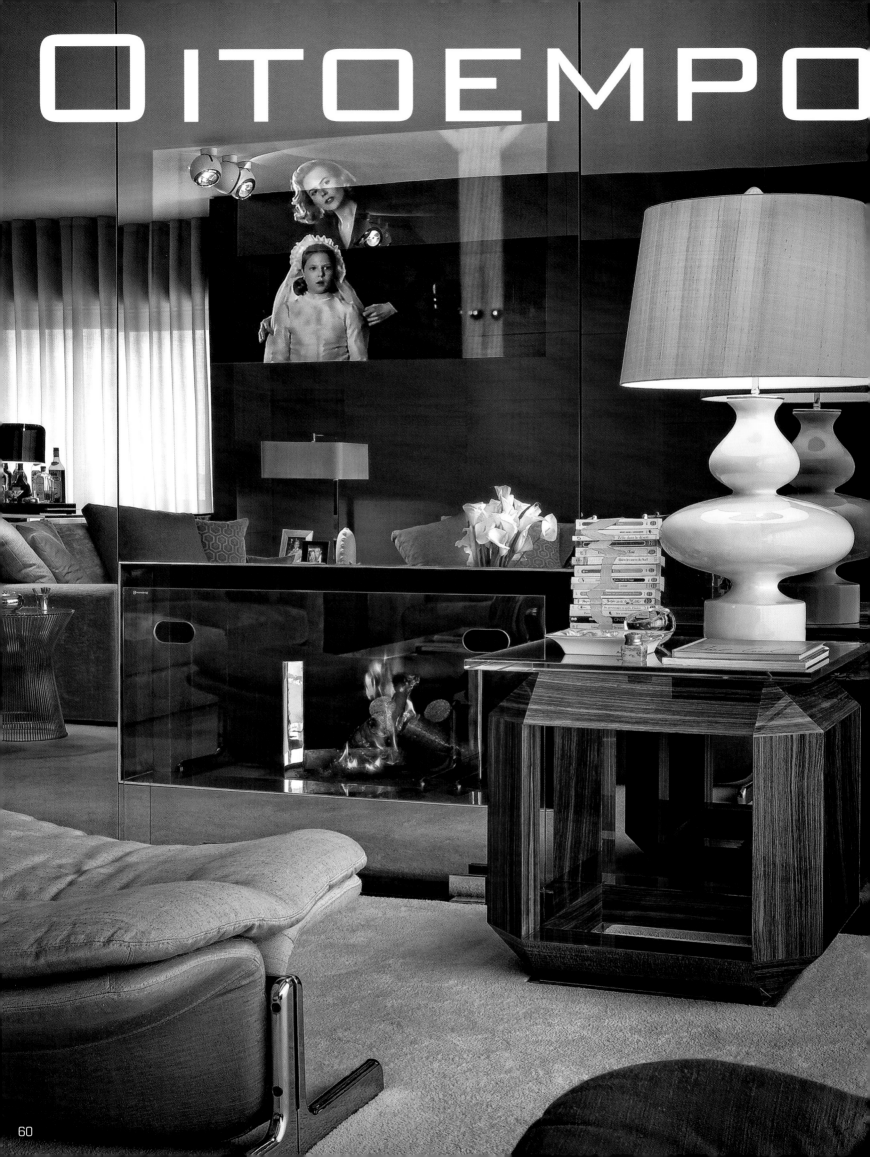

Designers: Artur Miranda & Jacques Bec. Company: Oitoemponto, Portugal. Profile: After many years in fashion in Portugal and Sweden Artur diversified into interior design in 1993 and set up Oitoemponto two years later with Jacques, from Paris. Work is predominantly private with some commercial. From a large showroom in Porto they showcase their own furniture, carpet and lighting design alongside a collection of vintage and contemporary objects bought from travels abroad. Current work includes a 40's style, 1200 sqm 'all Travertine' house near Oporto, a duplex penthouse beside the sea and an 'all linen and marble' villa in Luanda, Angola. Recent projects include an 1800 sq metre house with interior and exterior pool in Northern Portugal, a six storey house in Belgravia, London and a 2000 sq metre restaurant in Luanda, Angola.

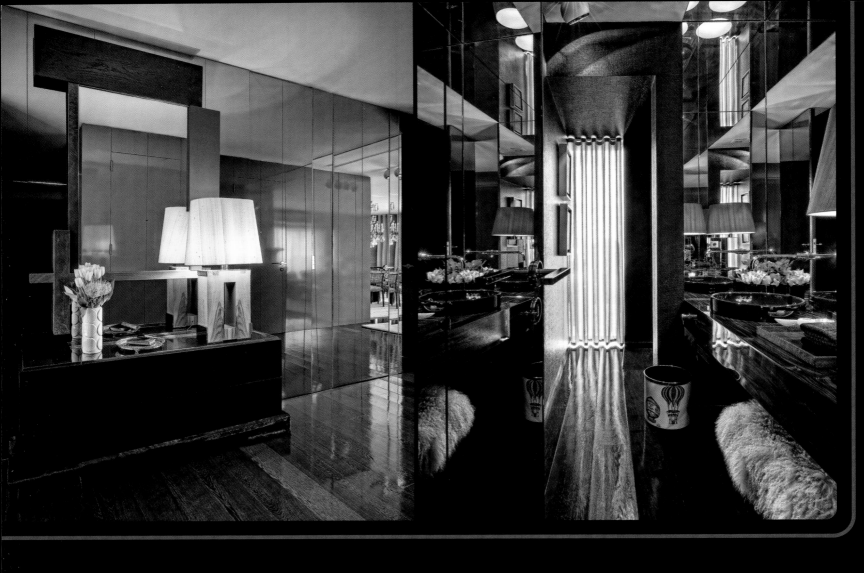

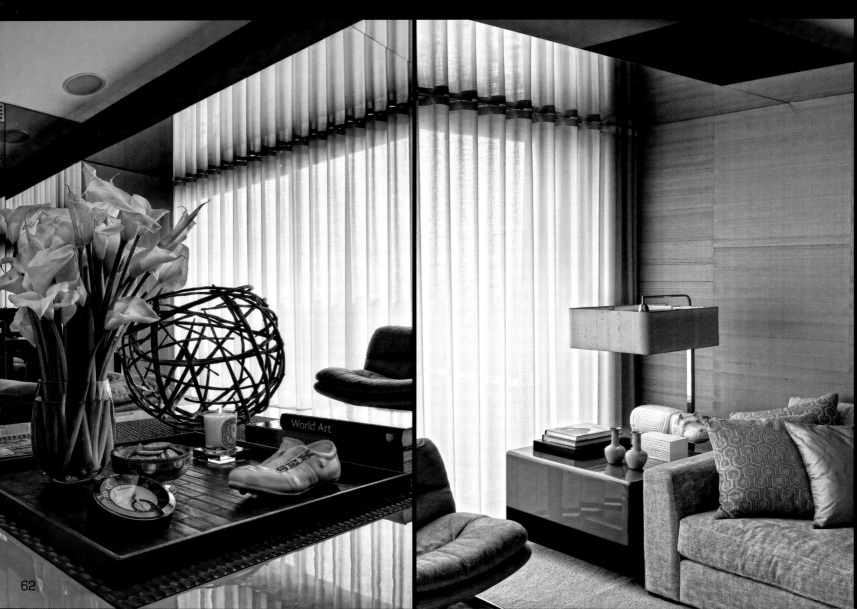

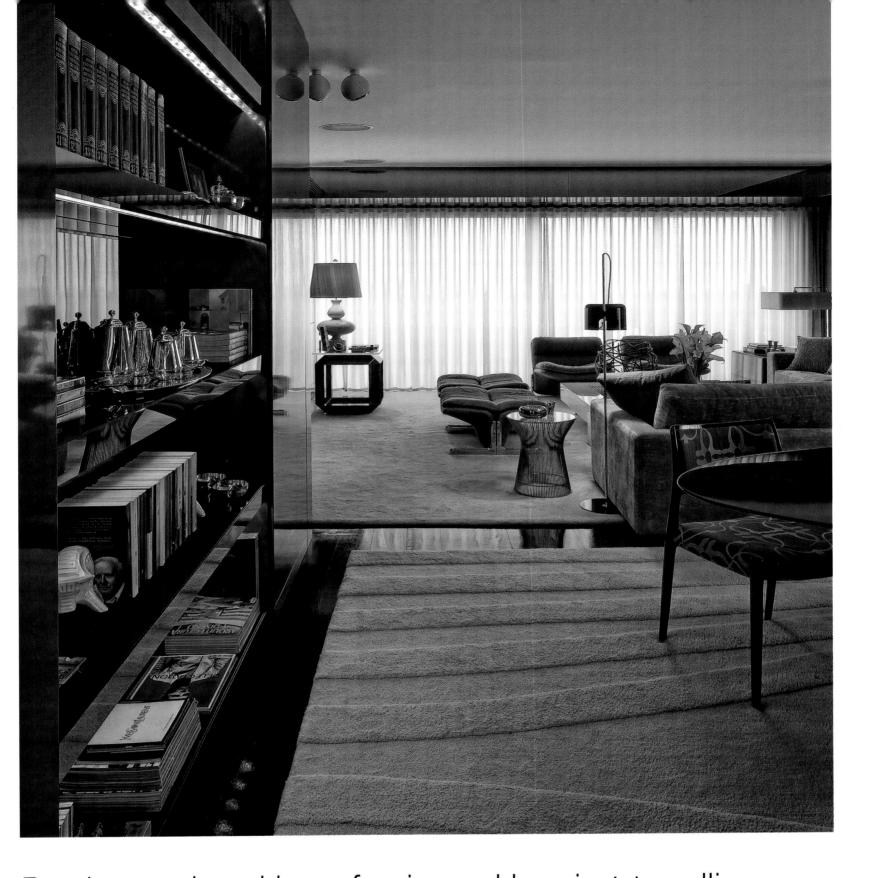

Passionate about his profession and happiest travelling. Artur is a collector of watches and match boxes. Favourite home comfort jazz and a glass of champagne, best takeaway blinis and caviar. Best holiday Capri, favourite musician Bill Evans. Heroes, Baron Haussmann, Oscar Wilde and Amy Winehouse. His ideal date 'a threesome, with Tilda Swinton and Andrés Velencoso'. His epitaph 'who cares about the day after? I just care about the night before'.

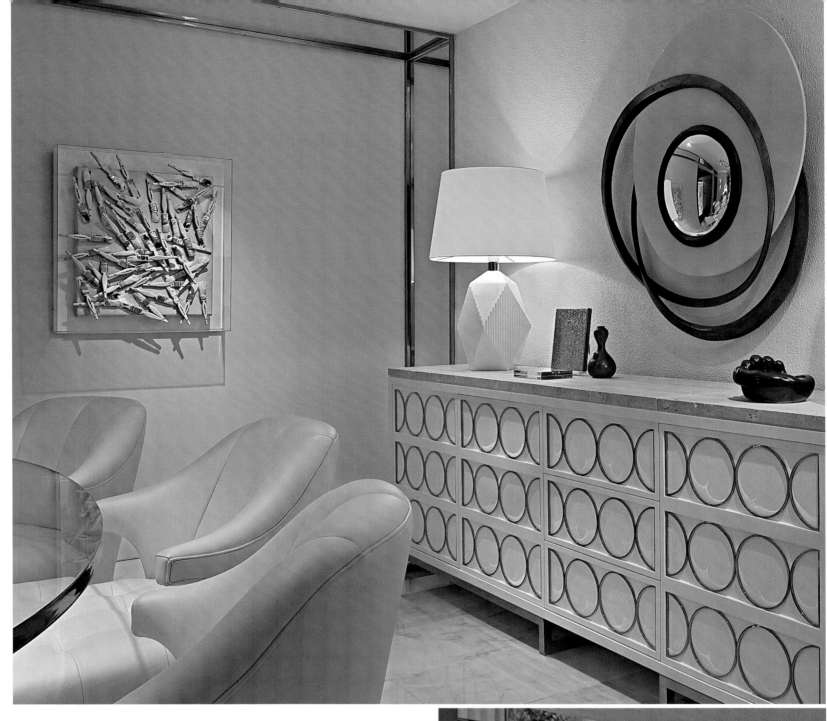

French fencing champion (in his youth) Jacques dreams of being a Jedi Knight. His greatest extravagance was being the first client at Tom Ford, Milan. Hero Victor Hugo, favourite musician Debussy, best friend Artur, greatest skill making him laugh. Jacques's favourite saying 'since the Greeks, so little has been invented'.

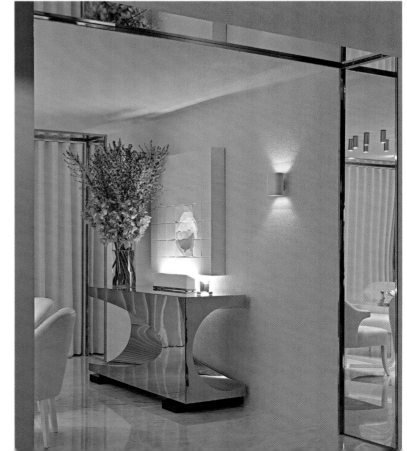

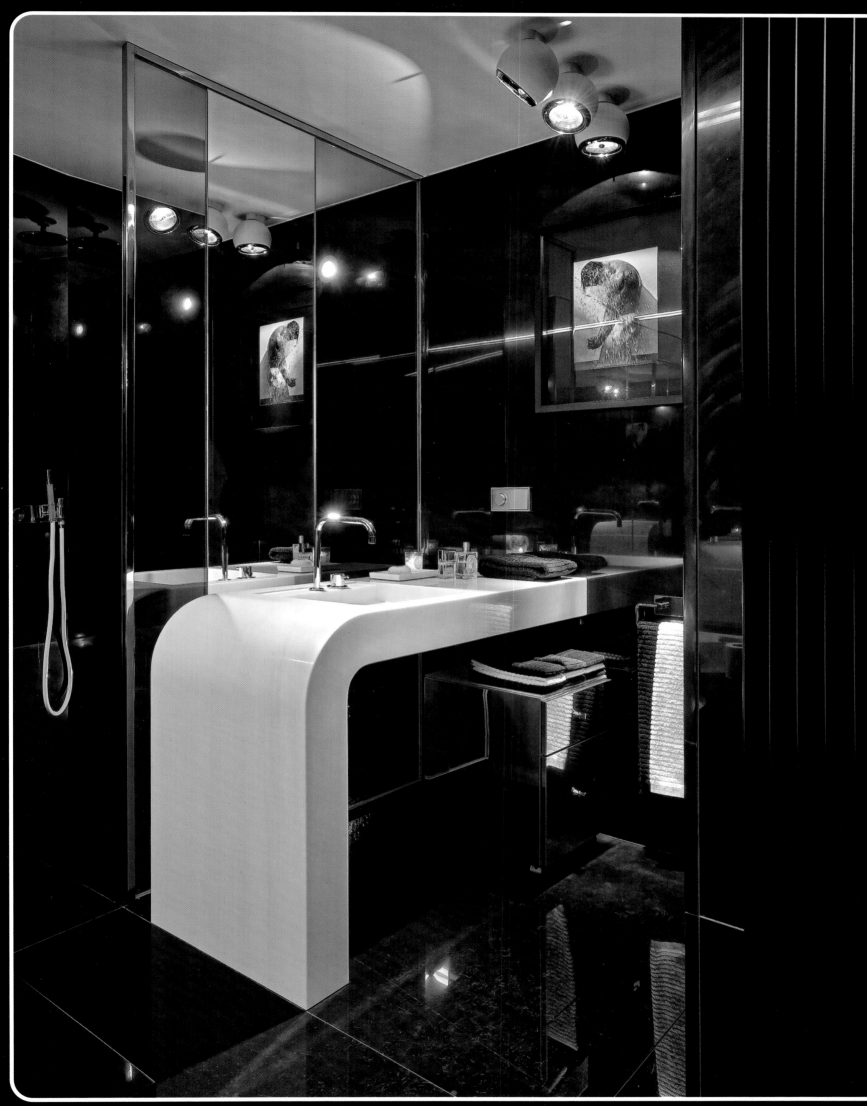

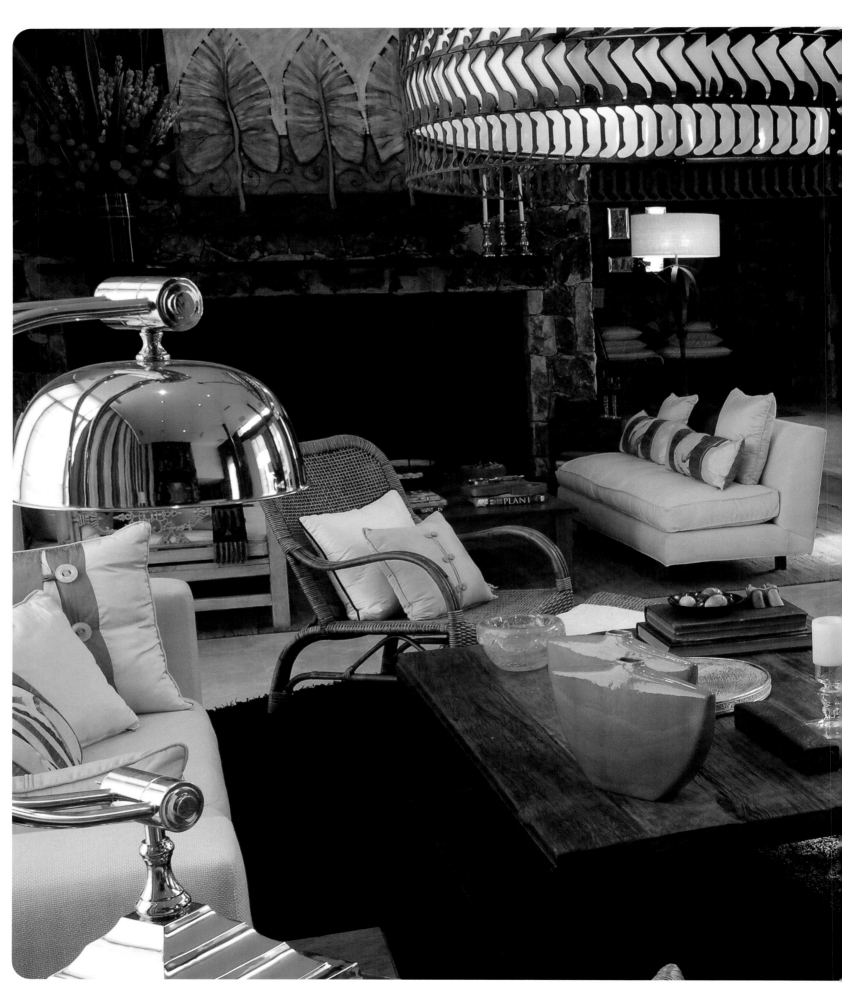

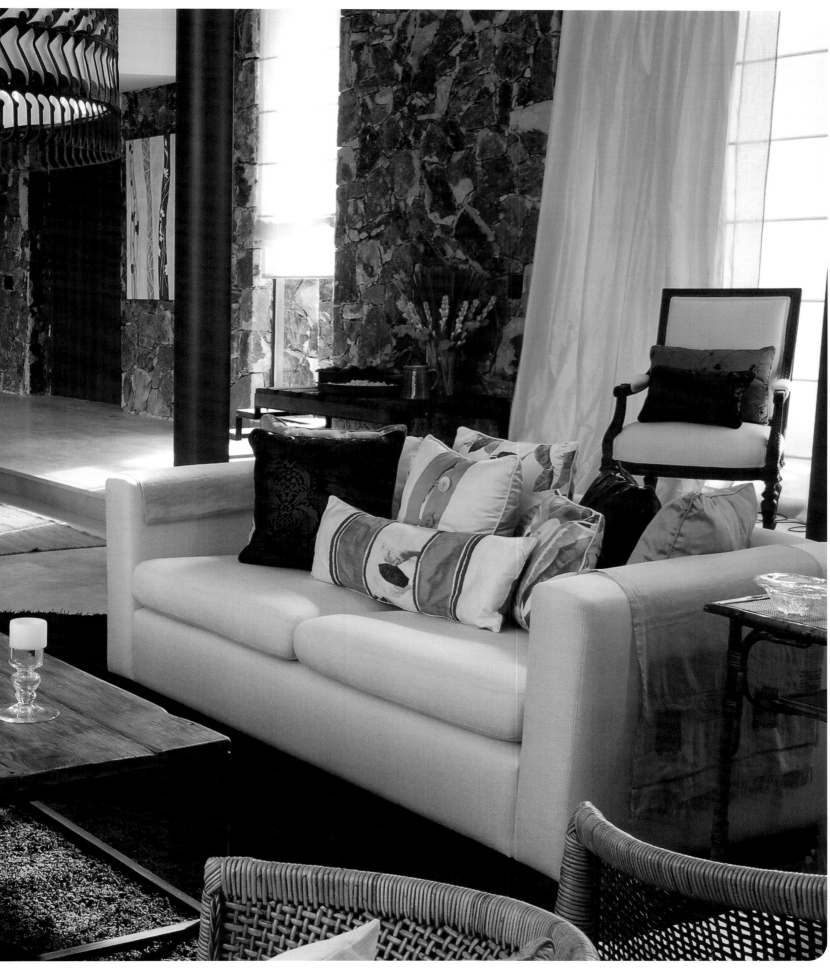

Designer: Sandy Cairncross. Company: Ornamenta Interiors, Buenos Aires. Profile: A small company working predominantly with private clients, offices and commercial spaces internationally. Recent work includes a laboratory, HLB Pharma, an apartment in São Paulo and a boutique in Punta del Este, Uruguay. Current projects include a private flat in Buenos Aires, a small hotel in San Antonio de Areco and a flat in an ancient building in the heart of Buenos Aires.

Wannabe actor who loves to persevere but hates routine. As a child he would tire of seeing furniture or objects in the same place and would move them constantly. His great skill is realising potential. He finds it hard to believe how when he was younger he spent 8 hours a day working in the same place. Sandy's hometown is Buenos Aires, the architectural variety his inspiration. He likes Mozart, Prada, the 1980's and Obama. For him, the secret of long life is feeling happy in your own company. His favourite saying 'the best is yet to come'.

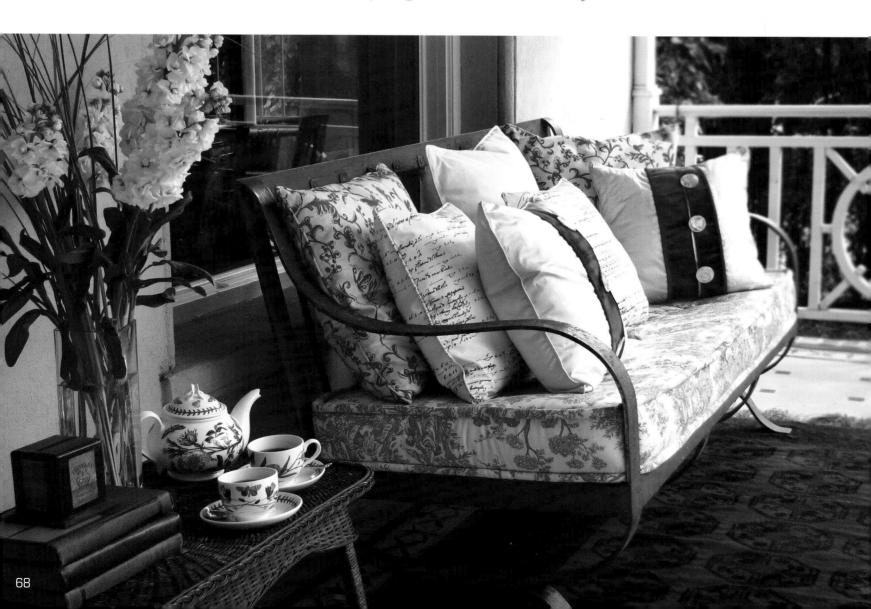

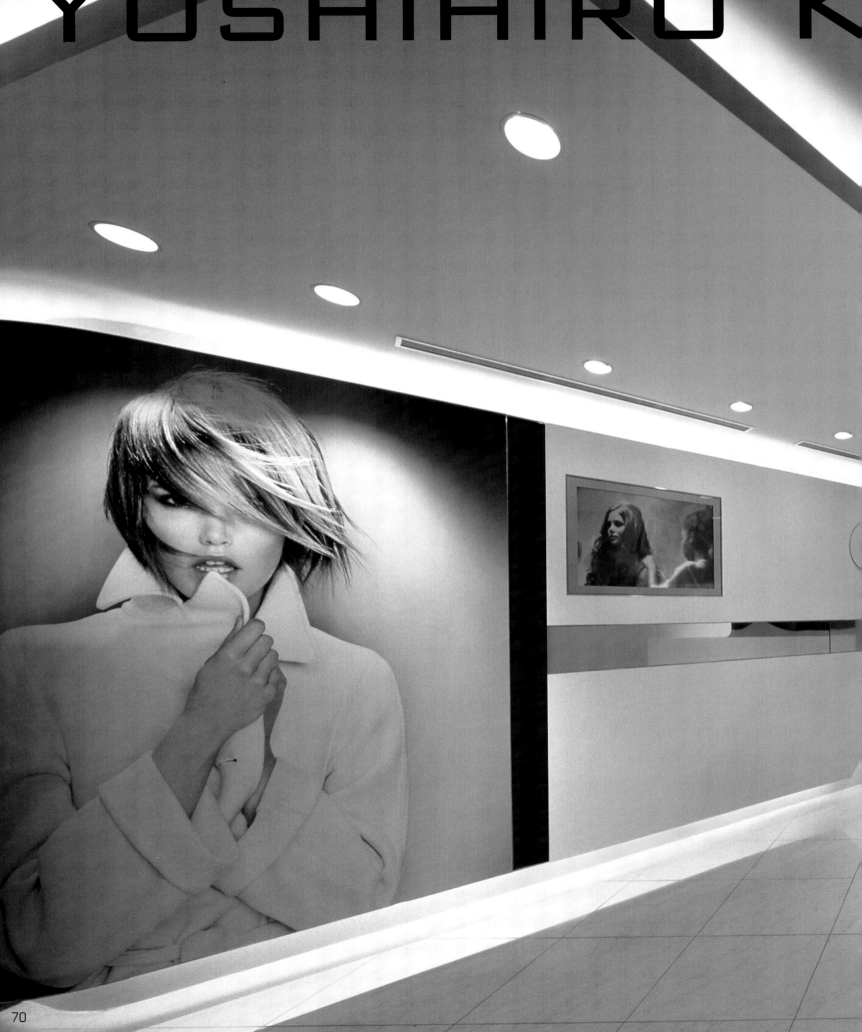

AWASAKI

Designer: Yoshihiro Kawasaki. Company: Propeller Design, Japan. Profile: Specialising in commercial design including offices, beauty salons and boutiques. Major projects include the Schwarzkopf showroom, and the award winning V.I.P. room for Toyota Motor Corporation.

City boy who dreams of escaping barking dogs and traffic jams to restore historical buildings. Thinks speed and accuracy are the most important things in business. Favourite architect Tadao Ando, fashion model Devon Aoki, designer Marc Jacobs. Home town Hokkaido his inspiration the grand landscape. He likes to ski. Best holiday Florida, most memorable meal Mexican, best takeaway pizza. He listens to Daft punk, favourite car Citroën DS, shopping Harajuku, Tokyo. Favourite saying 'when one door closes, another one opens'.

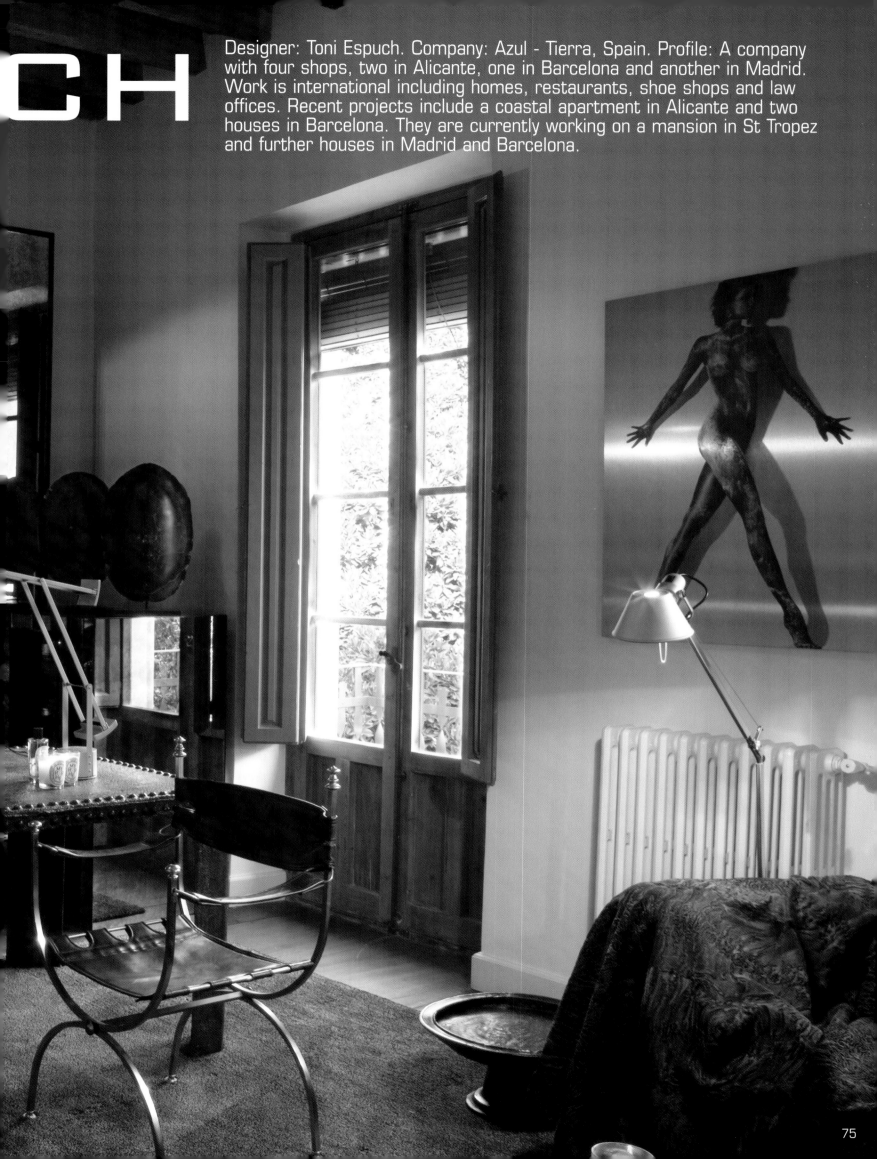

CH

Designer: Toni Espuch. Company: Azul - Tierra, Spain. Profile: A company with four shops, two in Alicante, one in Barcelona and another in Madrid. Work is international including homes, restaurants, shoe shops and law offices. Recent projects include a coastal apartment in Alicante and two houses in Barcelona. They are currently working on a mansion in St Tropez and further houses in Madrid and Barcelona.

Life's a beach for Toni. Spanish sunshine, sea and light are his inspiration. An opera lover and passionate decorator for whom happiness is the secret of long life and a photographic memory his great skill.

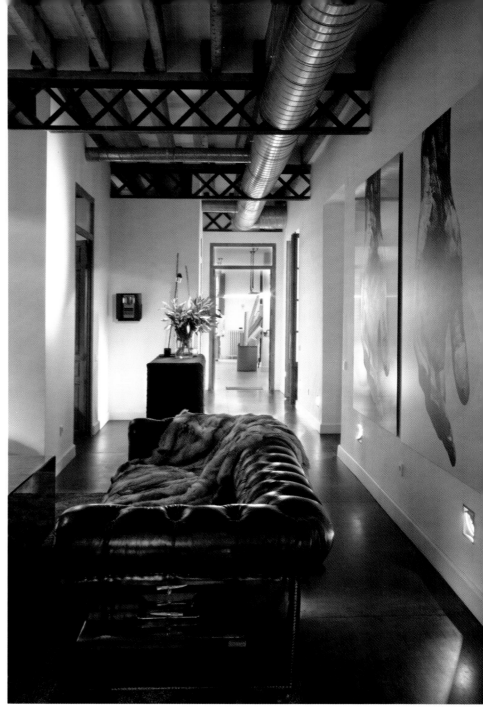

Bathed in his favourite fragrance Hotel Costes body perfume he would rather be in Paris than the Arctic. If he were to accompany anyone in the whole of history on a long haul flight he'd choose his favourite decorator, Axel Vervoordt.

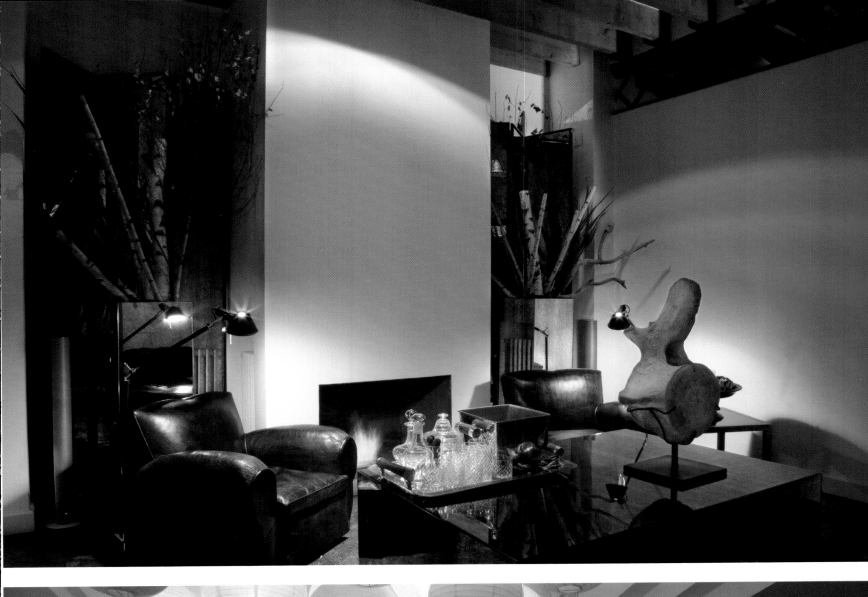

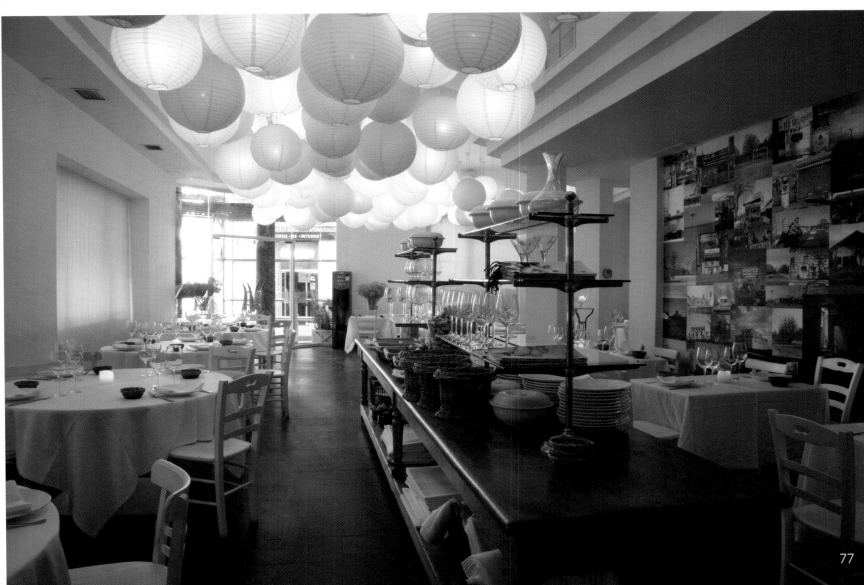

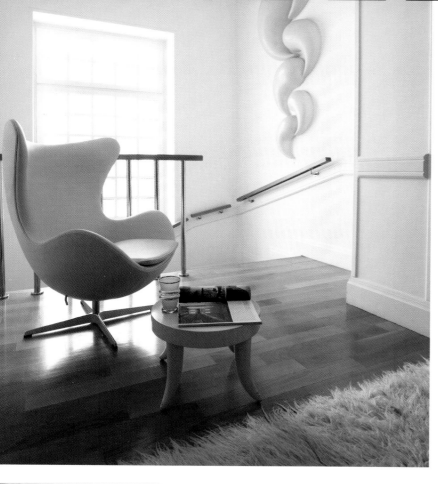

Designer: Angelos Angelopoulos.
Company: Angelos Angelopoulos,
Athens, Greece.
Profile: Established in 1990,
Angelos began his career
designing a hotel in Athens. Since
then he has completed over 30
hotels, 10 of which are boutique.
Projects include residences,
apartments, restaurants, clubs
and showrooms in Greece,
Cyprus, Istanbul and New York.

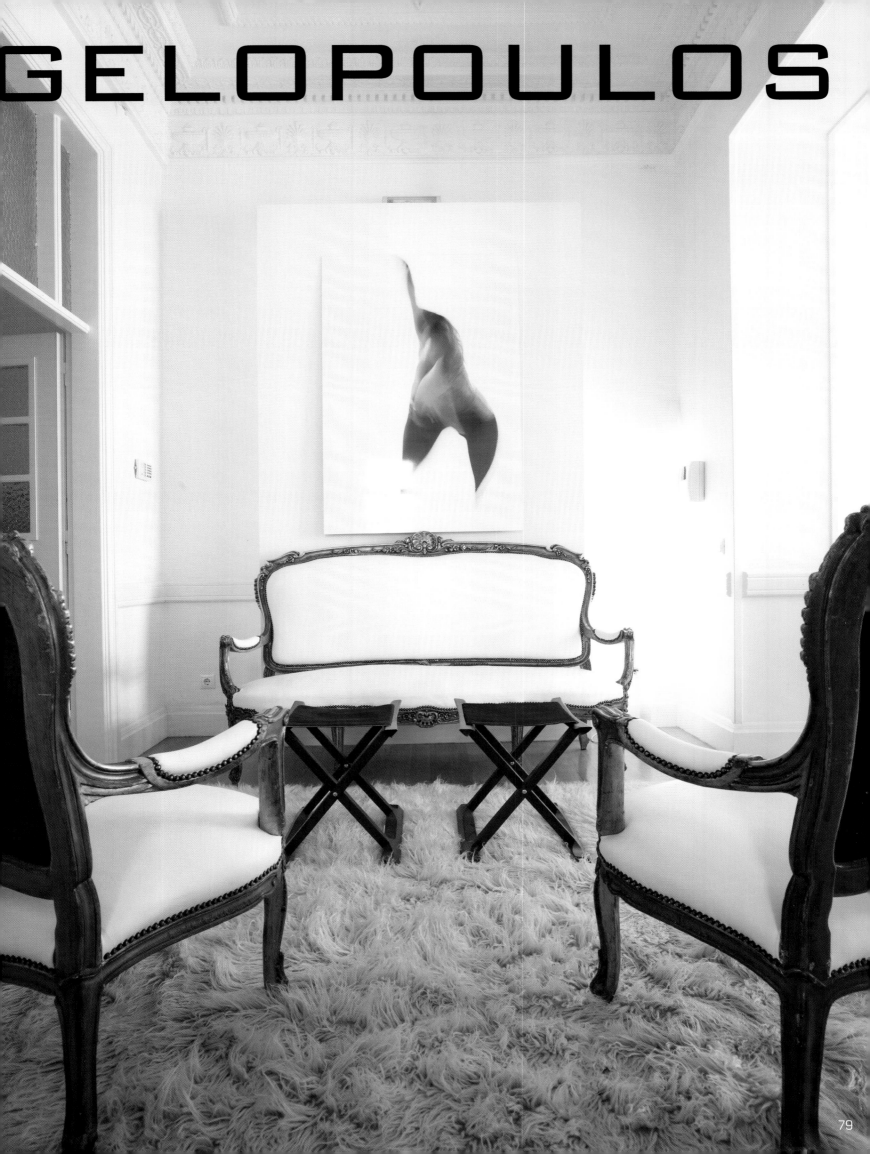

Cool, calm and collecting: art, watches, bags and perfume - he has his own brand. Angelos's home comforts; hammam, aromatherapy and meditation. Has recurring dreams of flying through the heavens.

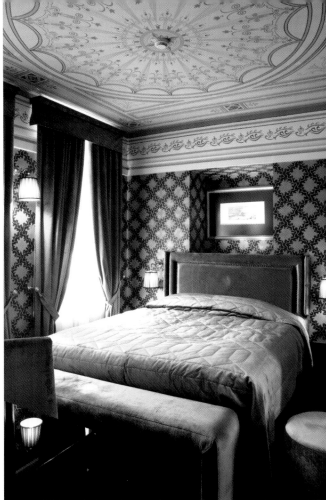

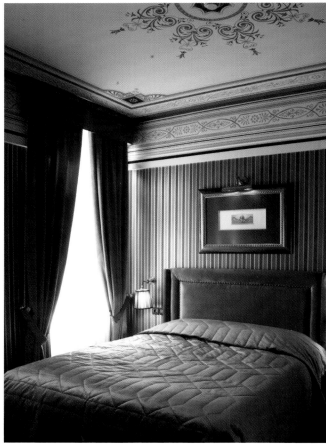

Fantasy job, therapist, he'd sit between Socrates and Buddha. Best skill 'healing through spatial design'. Favourite holiday Burma, musician Miles Davis, architect Oscar Niemeyer. His inspiration Athens, for the order in chaos.

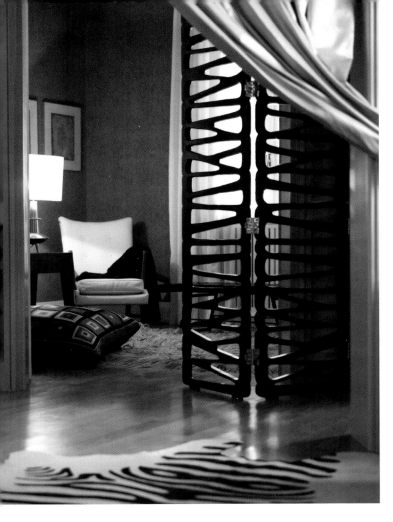

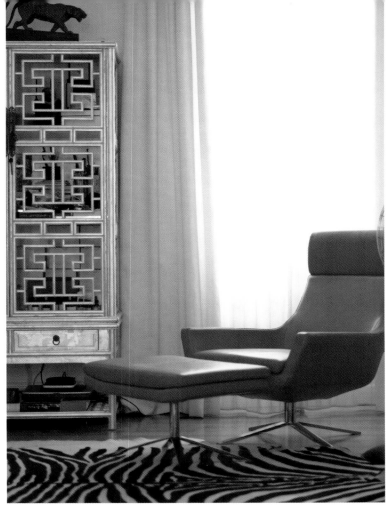

Designer: Thomas Stiefel. Company: Retailpartners, Zürich.
Profile: A team of 18 people formed in 1996. In 2006 they joined
the Andreas Messerli group providing specialist insight in the fields
of retail, branding and interiors. Recent completed projects include
the Jelmoli Group multi media factories, Starbucks Switzerland and
Esprit Distribution. Current projects include Geberit
International, Victorinox flagship stores Europe, U.S. and Asia.

Unfulfilled rock star and wannabe Lifeguard, Thomas's craziest moment was barefoot water skiing on Lake Zürich. He takes his inspiration from sunny days in the mountain scenery driving his dream Ferrari 250 GT dressed like Tom Cruise in Top Gun. He began his career as a banking assistant but was bored to death, his new career came by accident. Thomas's attitude to decorating is 'less is more' and he strongly believes in the importance of client bonding, his proudest moments are when they are happy.

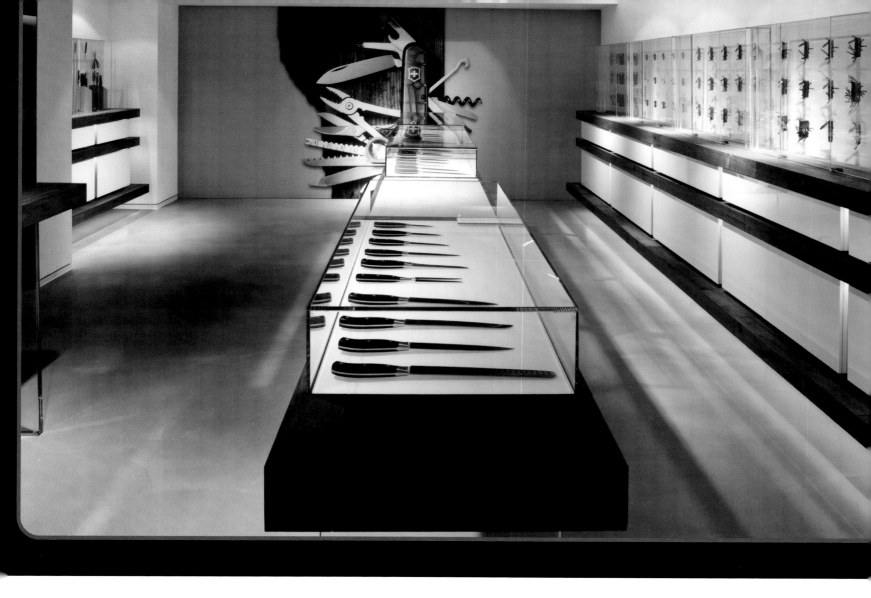

JORGE

Designer: Jorge Cañete.
Company: Jorge Cañete Interior Design, Geneva, Switzerland.
Profile: Specialising in private and commercial work in Europe. Recent projects include interior design boutique guidelines for the luxury brand Backes & Strauss, a large private event for Pictet & Cie Bankers and an 18th Century private house and vineyard in Neuchâtel. Current work includes a private apartment in Geneva, a house in France and a chalet in Haute Nendaz.

Nature loving Catalan with Swiss citizenship, Jorge would take flight with French artist Isa Barbier to discuss her marvellous feathered creations.

Fantasy job, assistant to Sophie Calle.

He'd like to meet the Lilac Fairy from the movie Peau d'Âne by Jacques Demy. He describes his way of decorating as elaborating a concept, mixing memories, modernity and poetry. Favourite shopping, St-Sulpice, Paris for Pierre Hermé's exquisite pâtisserie. Happiest with Swiss cheese and Spanish wine. Best holiday a road tour in Iran stopping at the gardens of Isfahan. Favourite music Purcell's Dido & Aeneas and the delicate songs of Icelandic group Sigur Rós.

[ART IS A PHILOSOPHY]

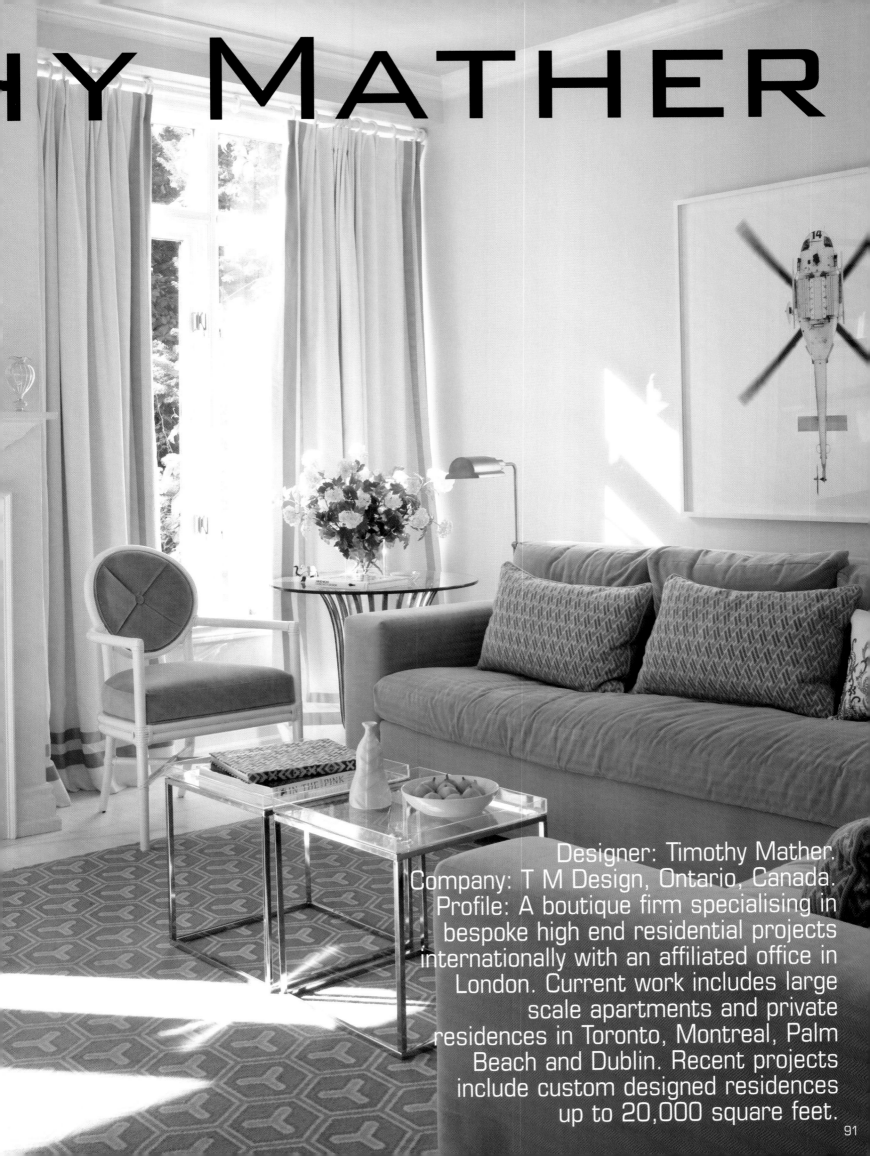

Designer: Timothy Mather.
Company: T M Design, Ontario, Canada.
Profile: A boutique firm specialising in bespoke high end residential projects internationally with an affiliated office in London. Current work includes large scale apartments and private residences in Toronto, Montreal, Palm Beach and Dublin. Recent projects include custom designed residences up to 20,000 square feet.

His body is a temple and his partner a saint. Favourite sport tennis, favourite dance ballet. Most memorable meal lobster pasta in South Beach, Miami. Earliest memory 1960, in an incubator, three months premature. Late 1970's a regular at Studio 54. Nervous of big crowds, happiest shopping and

driving a convertible in the sunshine. Best holiday Harbour Island, Bahamas. Favourite perfume Versace, greatest extravagance Hermès. Rates Robert Adam, David Hicks, Gucci, Abba and British Airways. Would most like to date Tom Ford. Best advice, 'trust your gut instinct'. Worst advice, 'invest in the stock market'.

STEV

Designer: Steve Leung.
Company: Steve Leung Designers Ltd, Hong Kong. Profile: A large design company with over 270 staff including architects and designers who have expanded into product design creating unique furniture lines plus fur and textile accessories for the home. Work is predominantly commercial including hotels, apartments, restaurants, show flats, club houses and retail shops in Hong Kong, mainland China, Dubai, Macau and Singapore. Recent projects include Mango Tree, Dubai, Fairwood Café Generation II, Hong Kong and Hyatt Regency Sha Tin, Hong Kong. Current projects have been Jiu Jiu Yuan Resort hotel, Huangshan, China, a Chinese restaurant at W Hotel Guangzhou, China and a speciality restaurant at Four Seasons Hotel, Guangzhou, China.

A typical Gemini and passionate collector of contemporary art, Steve has immense adoration for Le Corbusier and would nominate him for sainthood. Steve's inspiration is Hong Kong and its maximisation of space.

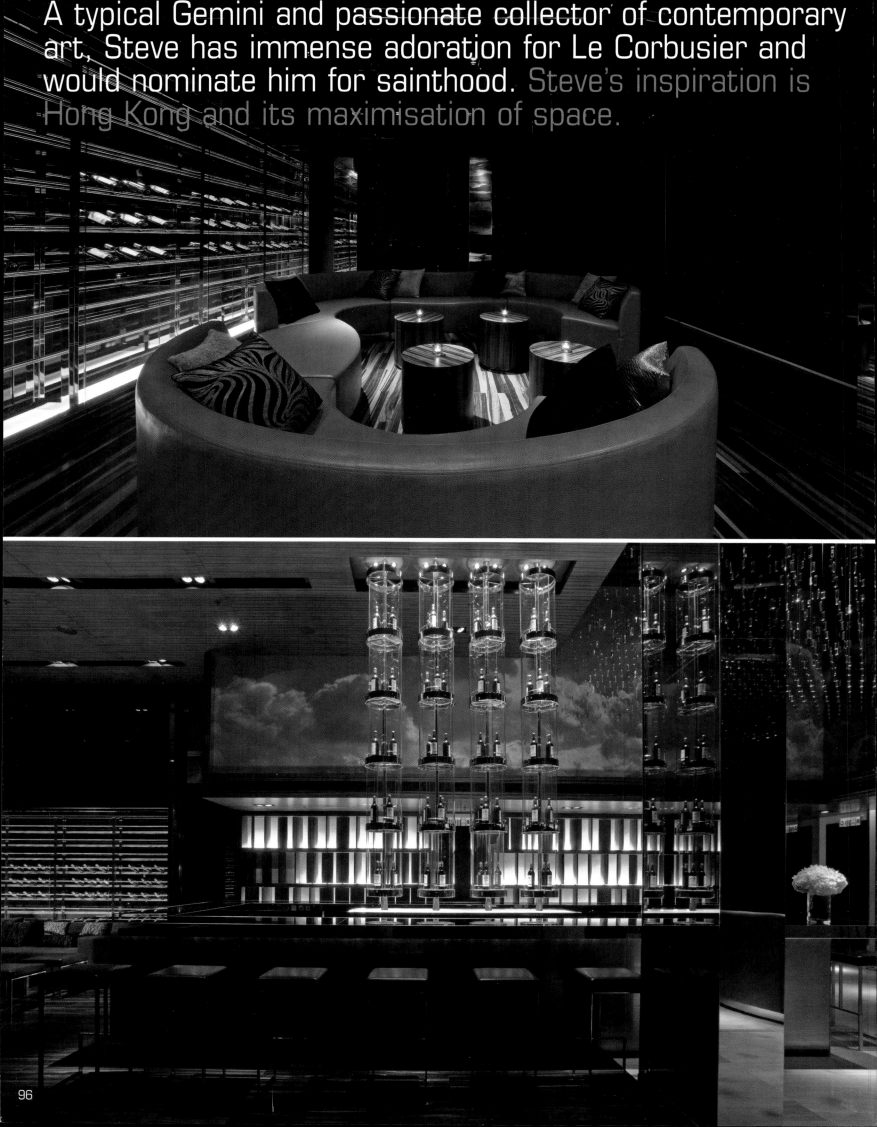

In business, he believes the most important thing is people, at home he's happiest spending time with his beloved wife and children and relaxing on his yacht. Aside from his fantasy of becoming a movie director, Steve's unfulfilled ambition is to own a boutique hotel in which everything inside is designed by him. His motto is 'enjoy life, enjoy design'.

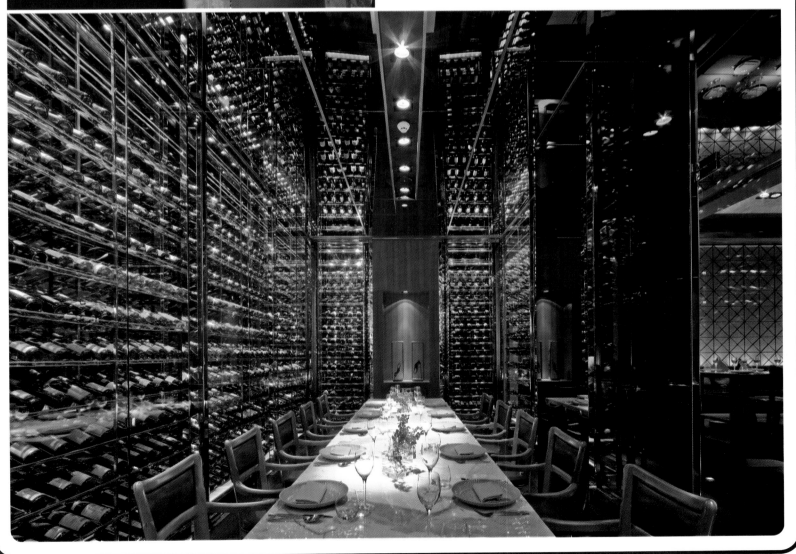

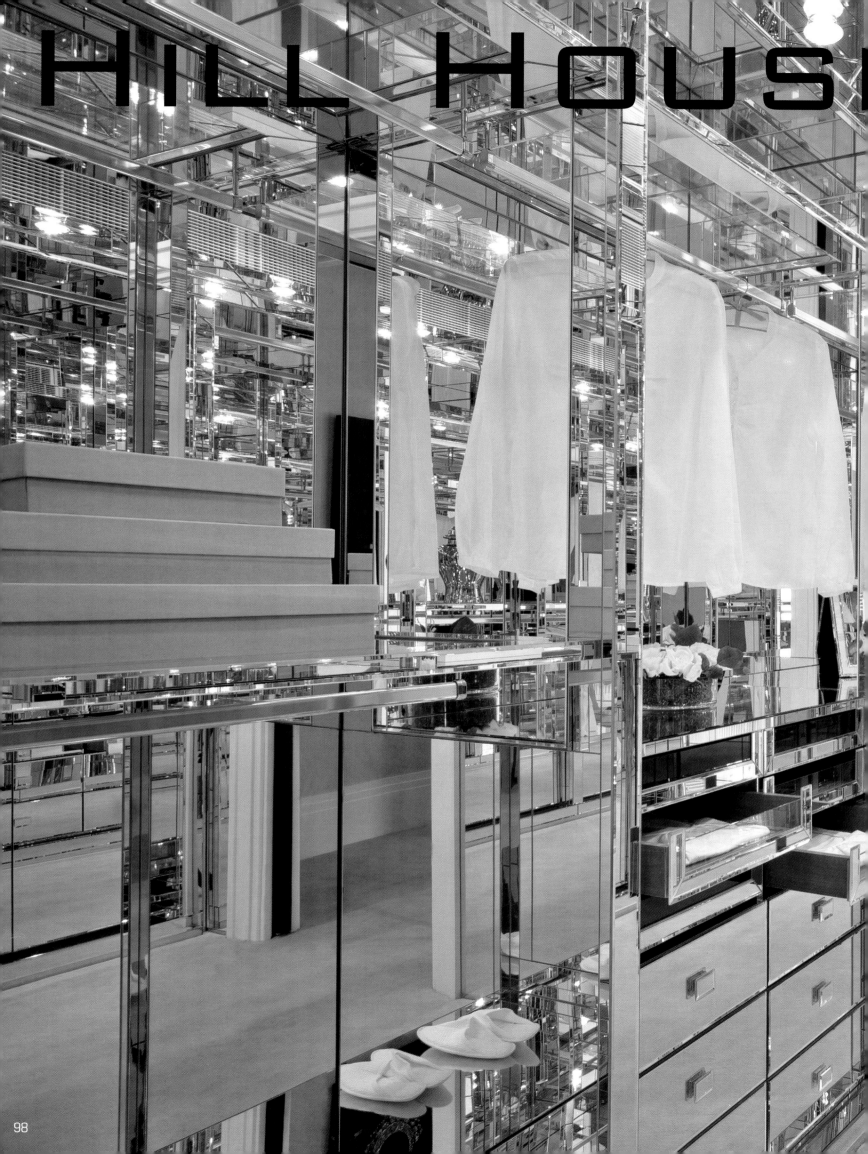

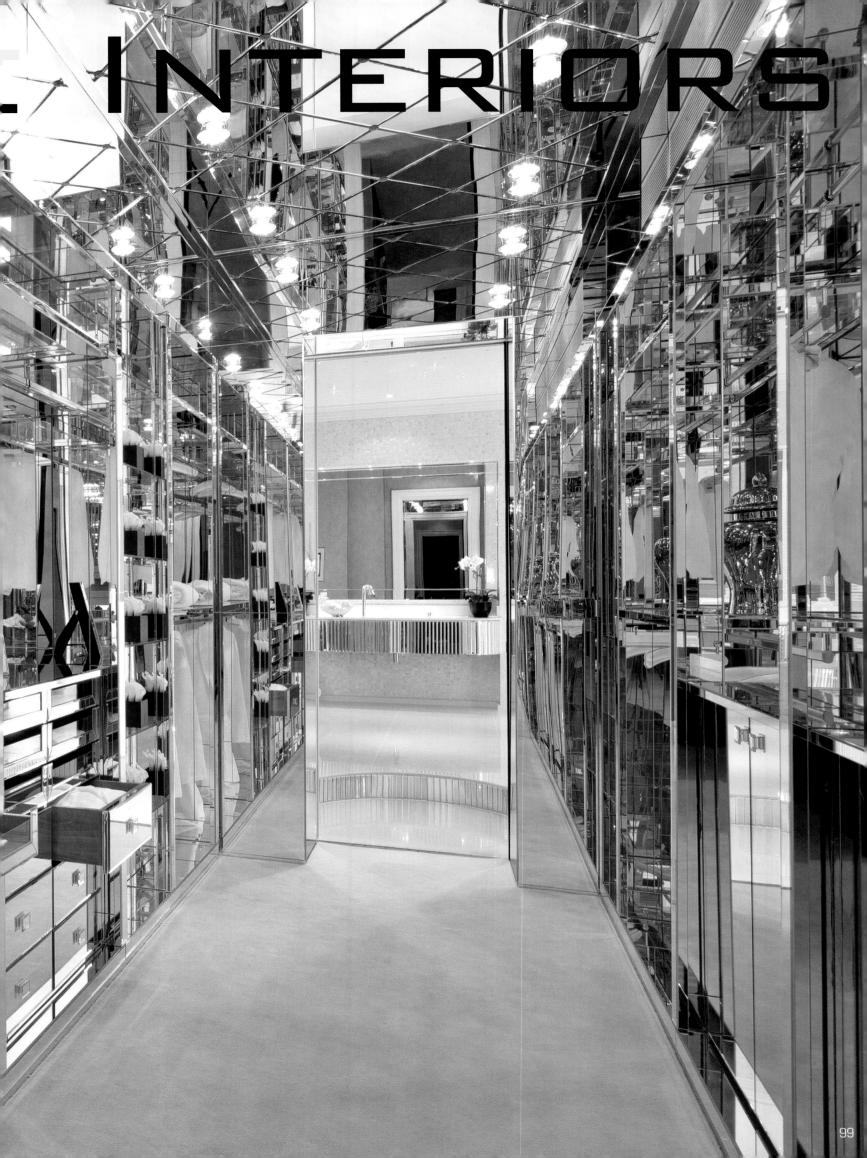

Her boots are made for walking. Jenny will shop till she drops her map, admitting to no sense of direction. Best skill patience and calmness. Greatest extravagance her wardrobe, best shopping Melrose Avenue, Los Angeles.

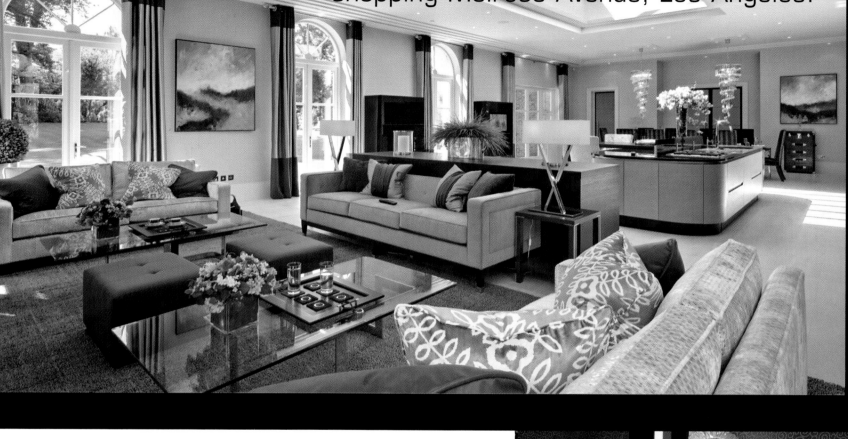

Designers:
Jenny Weiss &
Helen Bygraves.
Company: Hill House
Interiors, Surrey, U.K.
Profile: Specialising
in luxury private
residences
internationally. Recent
projects include
penthouses in Mayfair
and Poole Harbour.
Current work
includes a villa in
Antibes, large family
residences in
Hertfordshire and
Kent and a restaurant
and bar in Surrey.

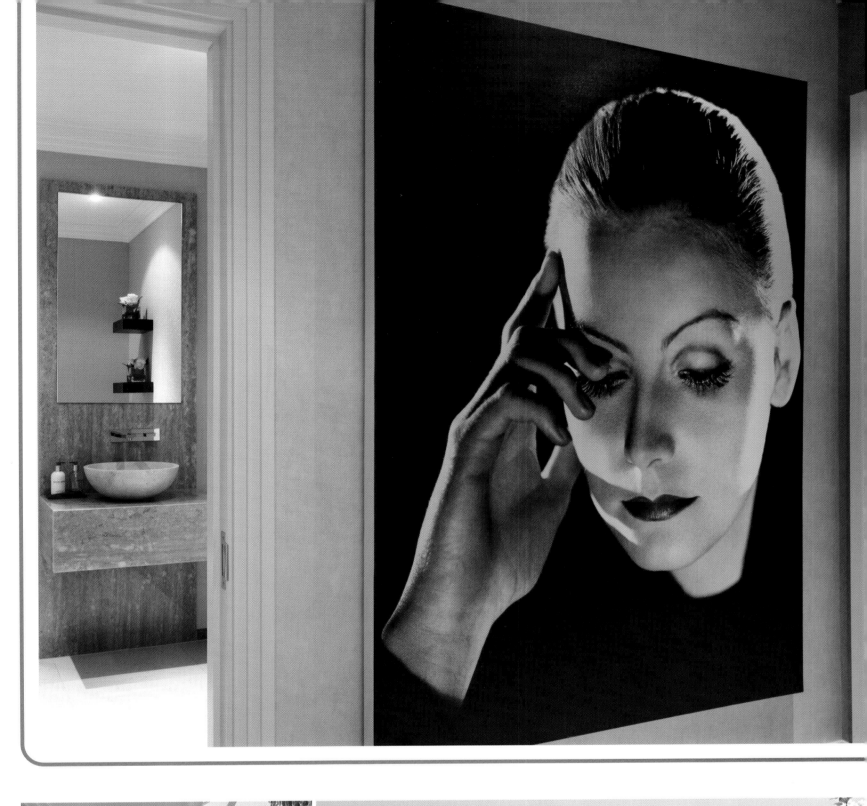

Best advice received 'what's meant for you will find you'. Fantasy job in musical theatre. Favourites: Mathew Bourne, Audrey Hepburn, Barbra Streisand, von Fürstenberg & Valentino. Favourite book: 60 years of Dior. Earliest memory sitting on a flagstone floor in Ireland, sharing an ice cream with her grandmother's cat. Her epitaph will be 'overture and beginners please....' Happiest collecting shoes. Helen's a trained dancer. Last fancy dress Flamenco. Fantasy job travel writer. Favourite shopping Via Montenapoleone, Milan, everyday outfit Diane von Fürstenberg, fragrance Eau d'Hadrien by Annick Goutal. Best holiday The Maldives, worst camping. Crush Clive Owen, car Ferrari 599. Secret of long life; good food, good wine, good exercise. Best advice 'live for today'.

ART

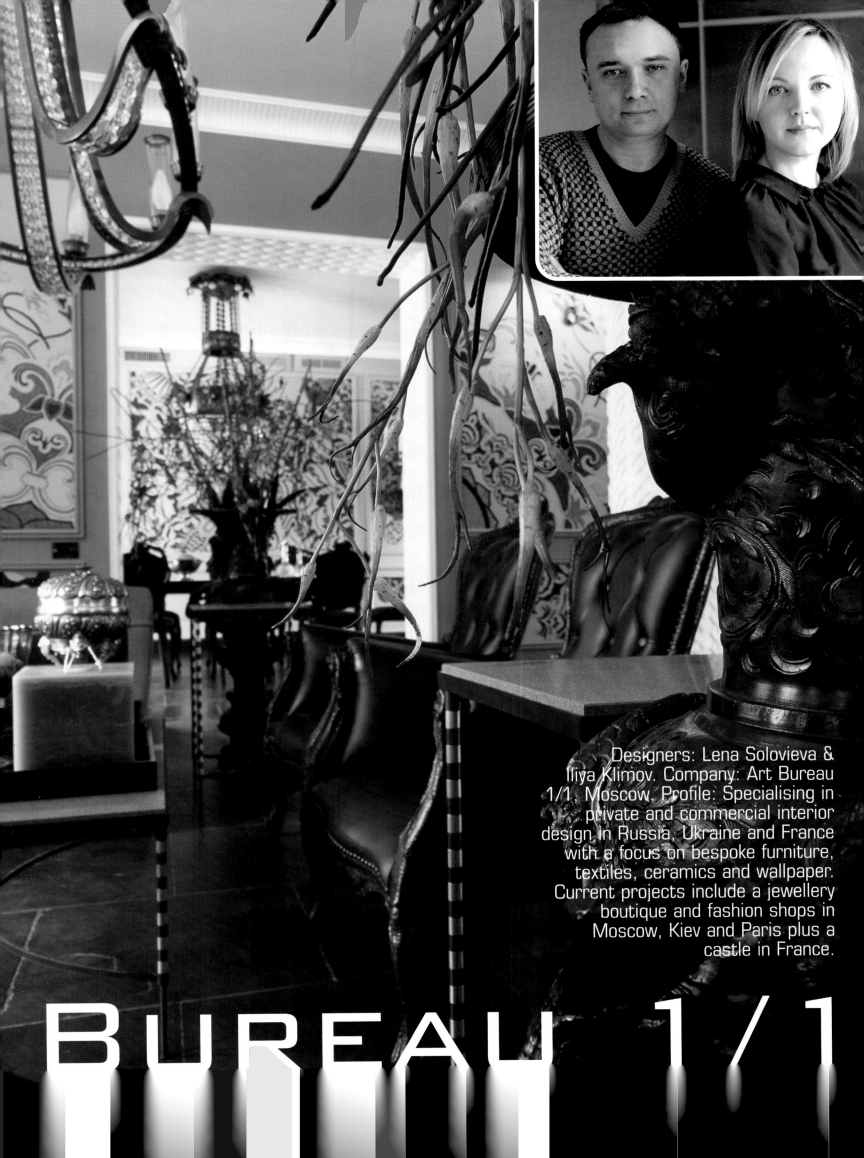

Designers: Lena Solovieva & Iliya Klimov. Company: Art Bureau 1/1, Moscow. Profile: Specialising in private and commercial interior design in Russia, Ukraine and France with a focus on bespoke furniture, textiles, ceramics and wallpaper. Current projects include a jewellery boutique and fashion shops in Moscow, Kiev and Paris plus a castle in France.

BUREAU 1/1

Romantic Russian night owls, for whom happiness is being in love, harmony and optimism the secret of long life. Inspired by Moscow's architecture, Lena's skills are in mixing styles and colours, Iliya in furniture design. He's a dare devil ice hockey champion whose craziest moment was riding on the top of a lift (without his boots), for Lena it was hitchhiking across Russia. Lena's fantasy job is to design for Dita Von Teese, Iliya to decorate a Greek island hotel. Best holiday Tokyo, anywhere except Egypt.

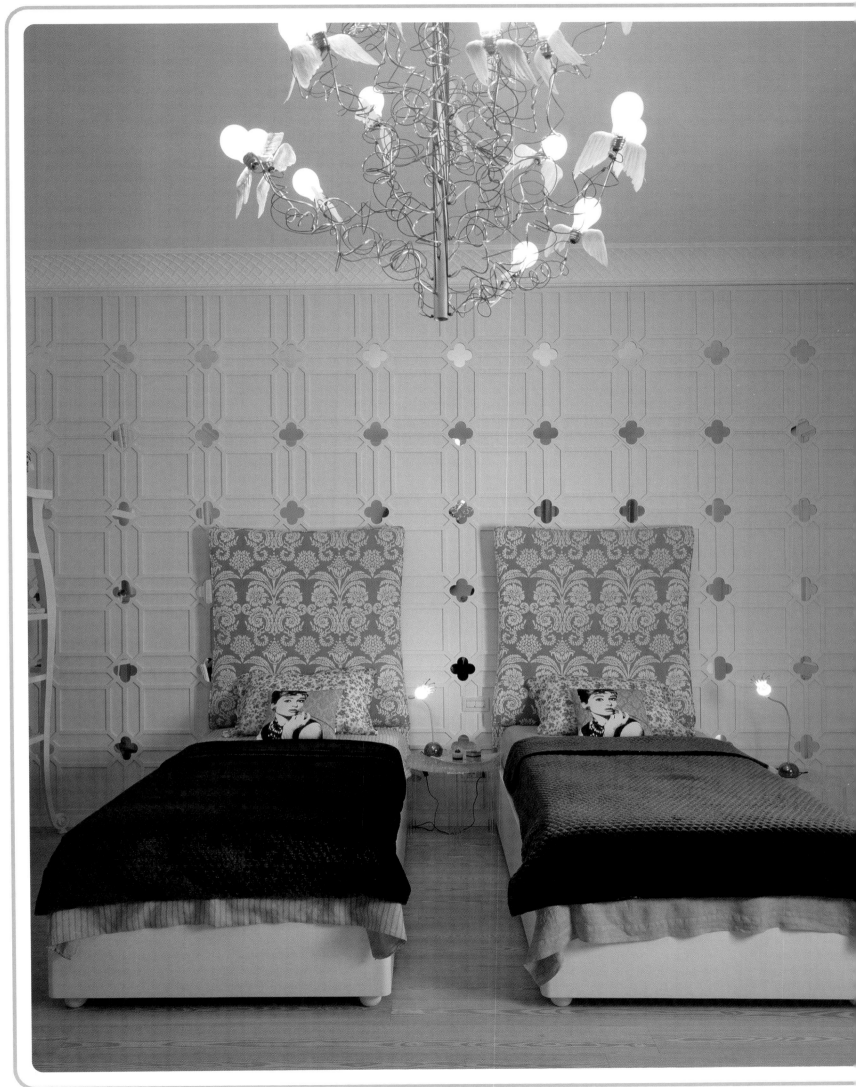

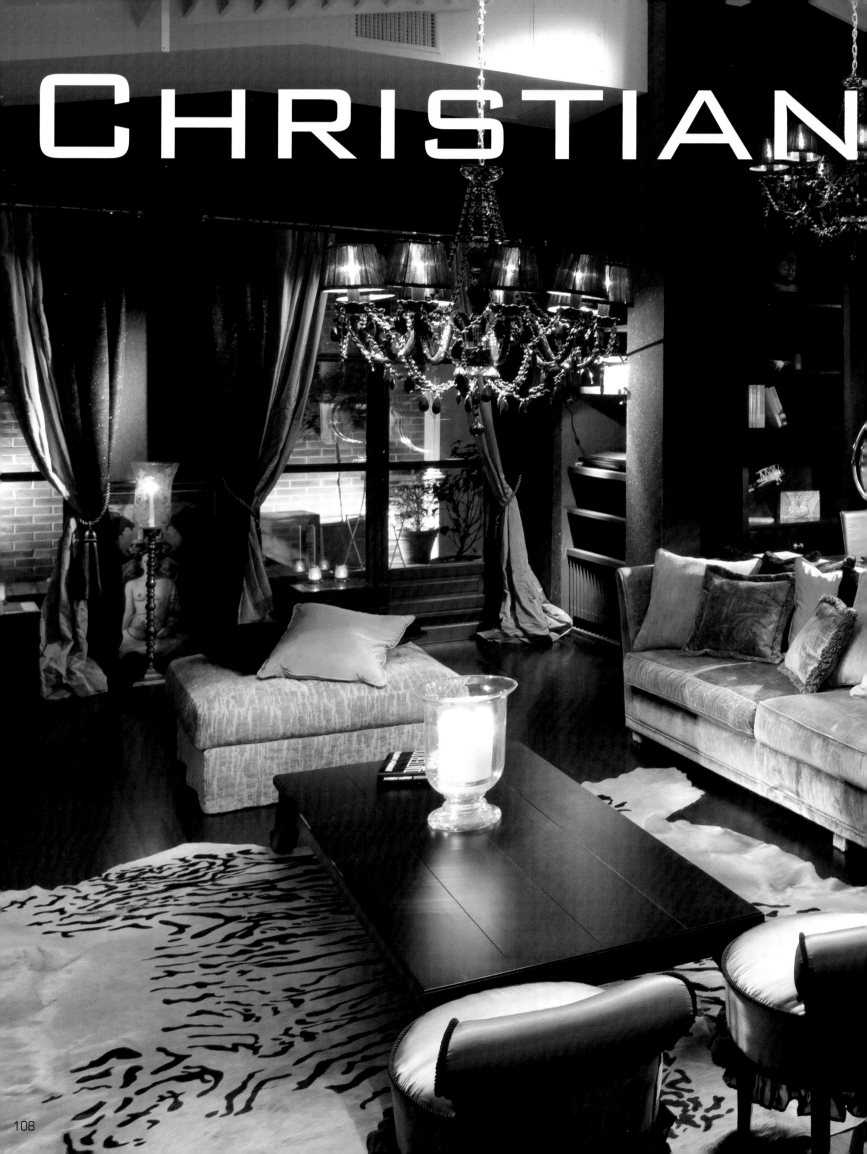

CHRISTIAN

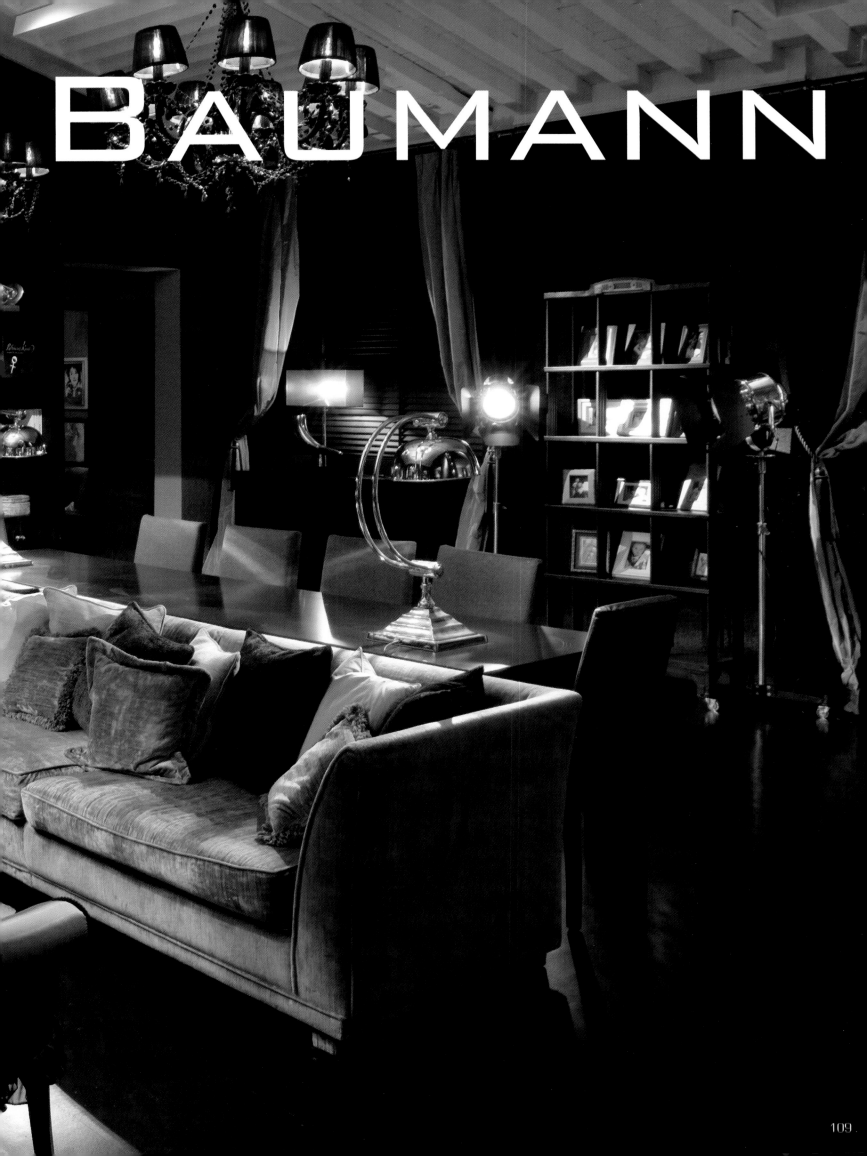

BAUMANN

Designer: Christian Baumann.
Company: Abraxas Intérieur, Zürich.
Profile: Predominantly private work internationally. Recent projects include an exclusive pied à terre in Paris, a shoe boutique in Stockholm and a chalet in the Swiss mountains. Current work includes two villas on Zürich's Goldküste, a flamboyantly designed office in Provence and an owner's villa at a stables in München.

Fencing champion with a love of boxing and an indulgence for silver biker's arm jewellery. His childhood ambition was to become a surgeon but now it is to compete as a driver in the Mille Miglia.

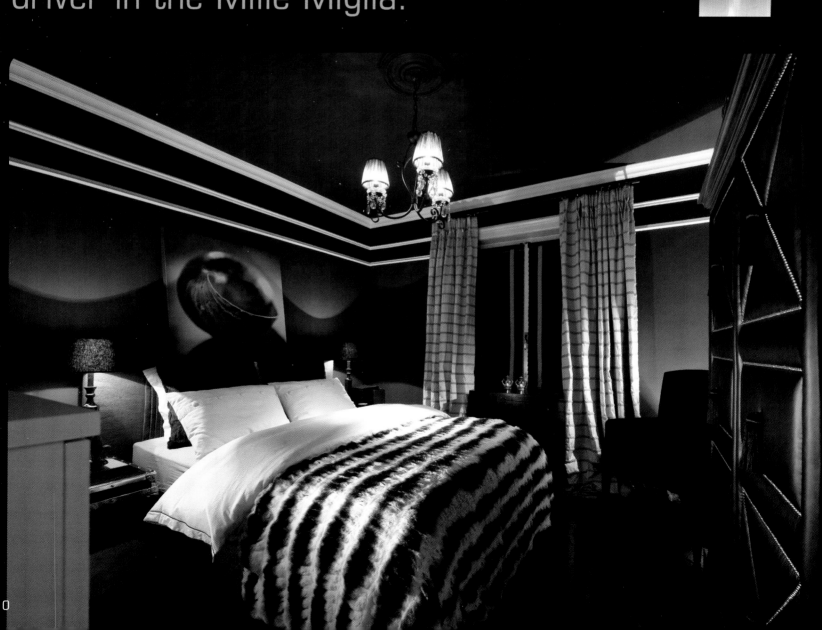

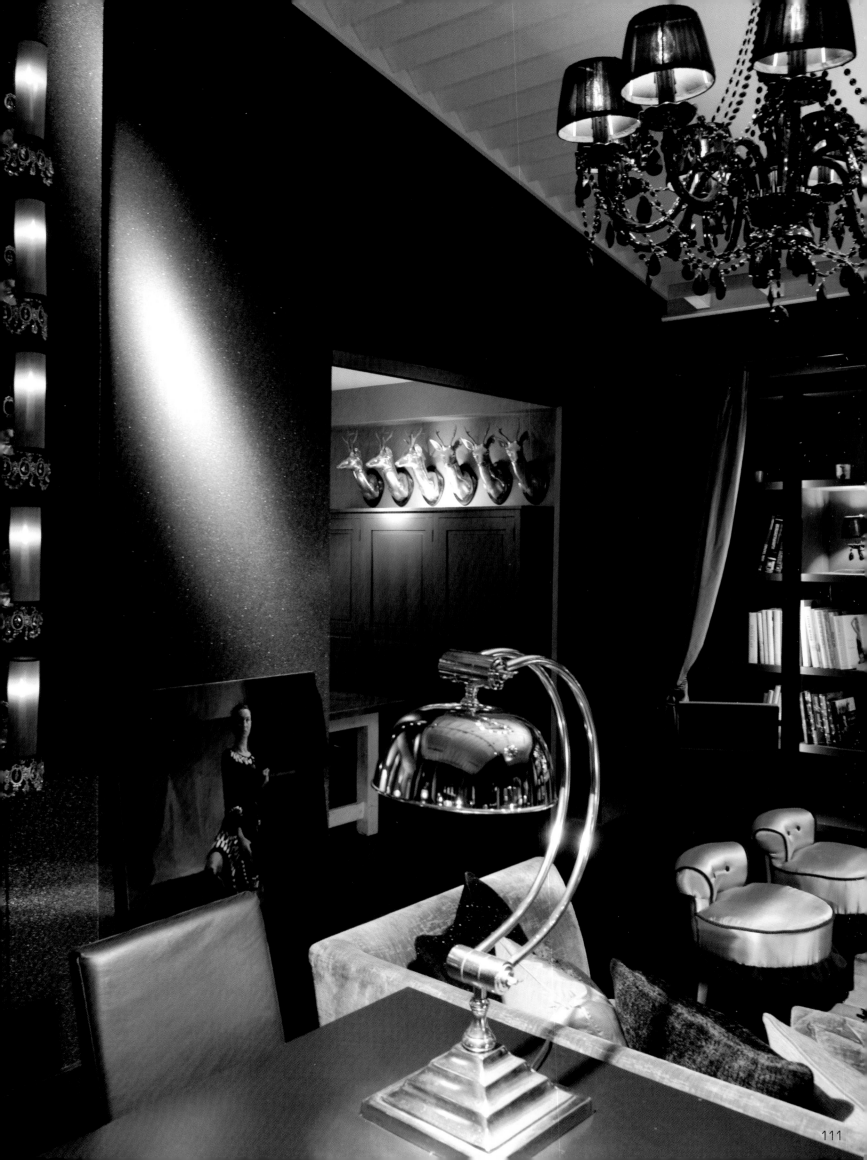

Christian's first job was for IBM, it taught him that IT wasn't his vocation. He now has his dream job and describes his work as beautiful, breathtaking and bespoke. Proudest having clients who don't want to know what he's doing as they're 100% confident he'll do it right. The most important thing in business, trust and honesty. The most important thing at home, his wife.

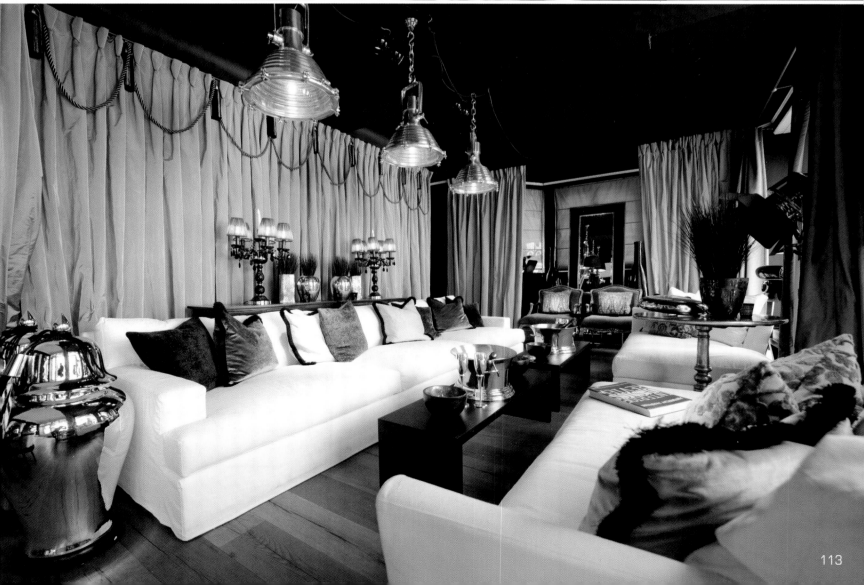

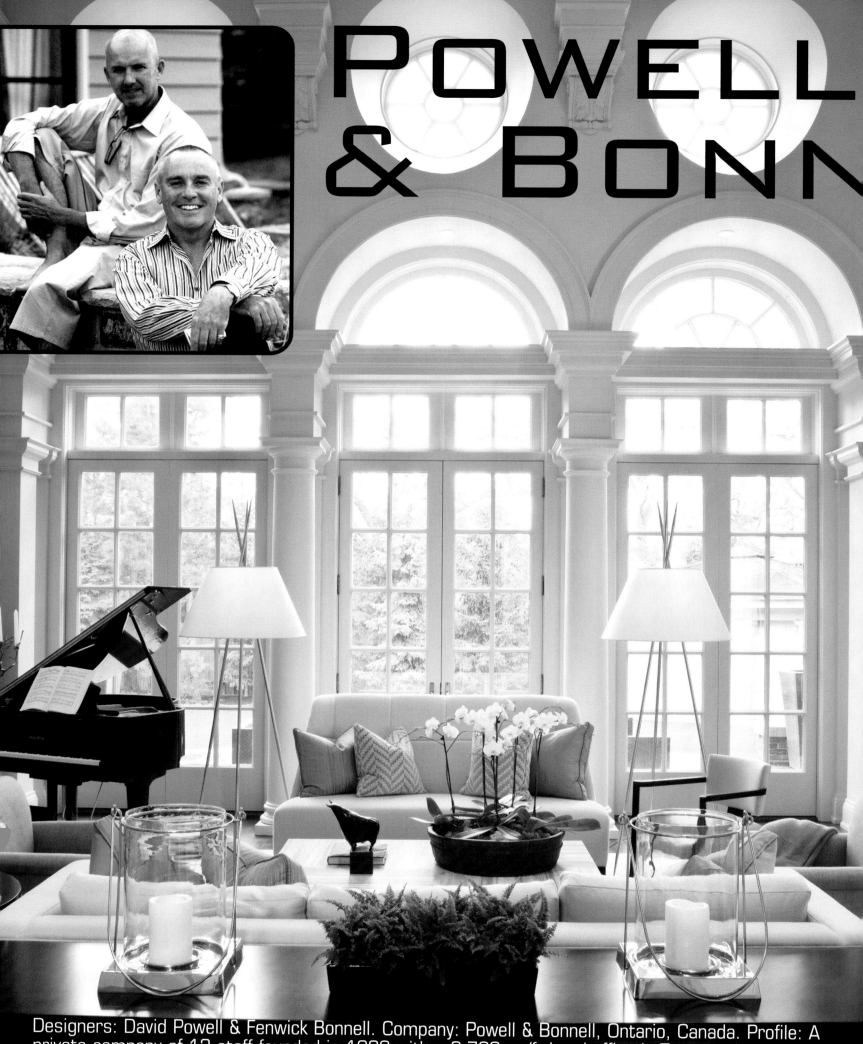

POWELL & BONN

Designers: David Powell & Fenwick Bonnell. Company: Powell & Bonnell, Ontario, Canada. Profile: A private company of 13 staff founded in 1990 with a 3,700 sq/ft head office in Toronto showcasing the firm's 'laboratory' style. They specialise in interior and product design including furniture, lighting and textiles. Recent work includes a historic mill in Ontario, a condominium in Toronto and an award

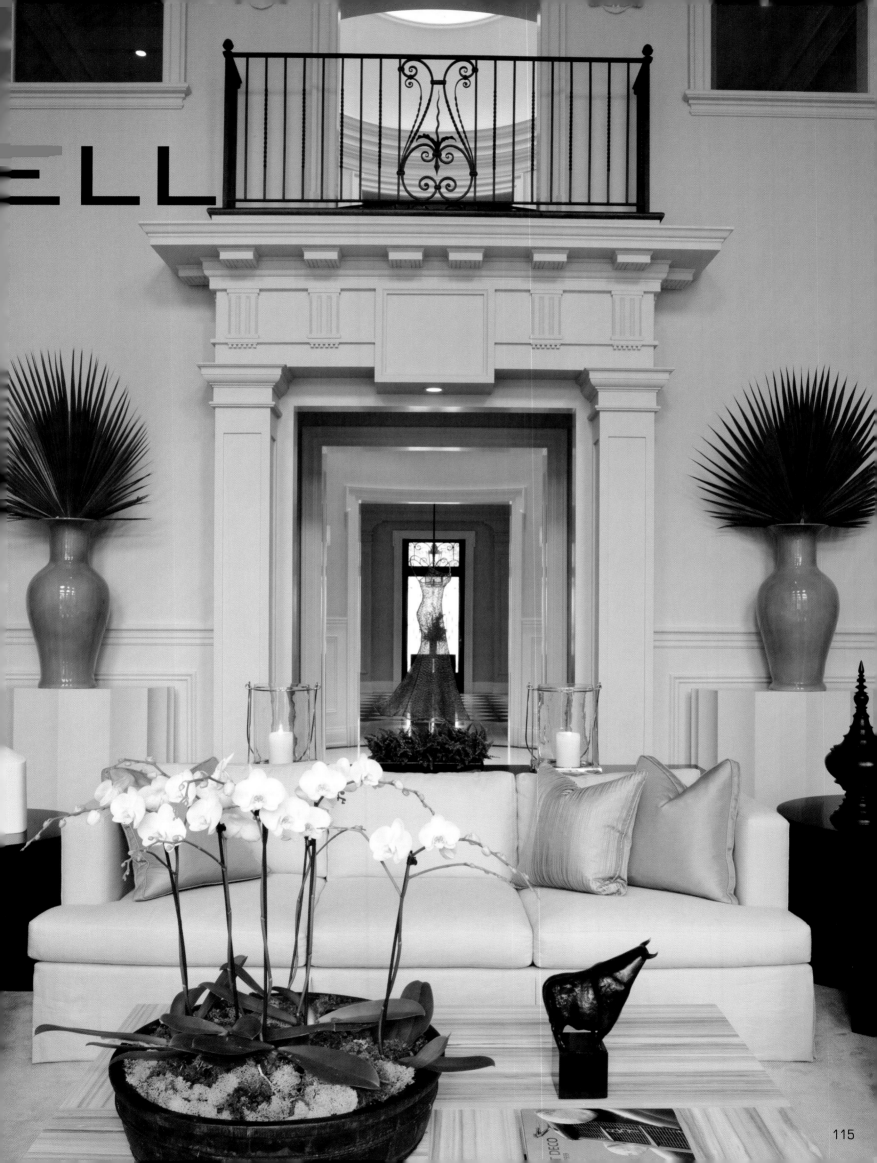

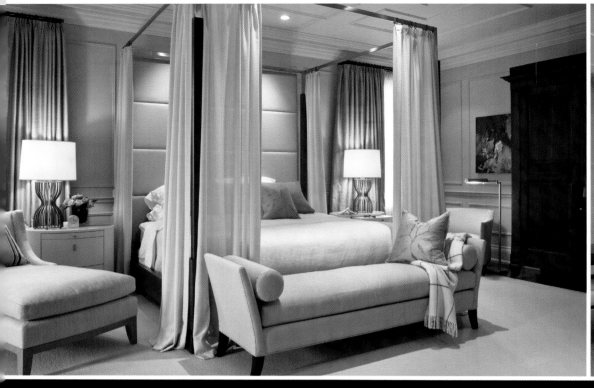
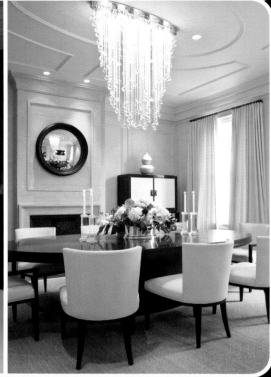

Cooler now than as a teenager, sporty Fenwick is true to his water sign Aquarius. If not out rowing or climbing an active volcano, he's happiest relaxing beside a calm lake listening to others. His home is the Canadian Maritimes, his inspiration its people and their generosity. The best advice he ever received, from his father 'be who you want to be, just be damn good at it'.

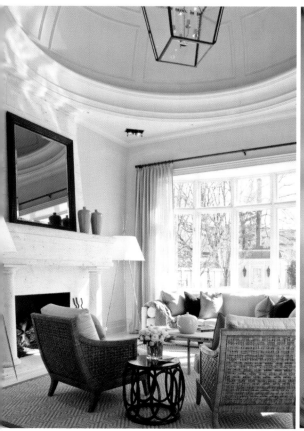
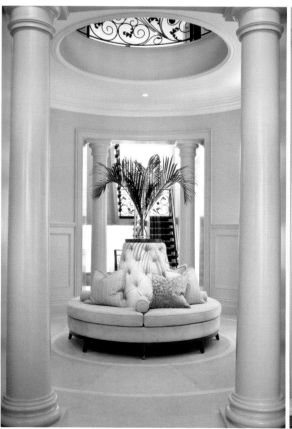
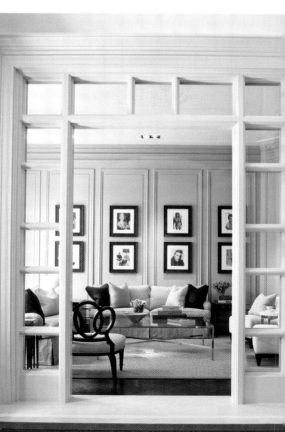

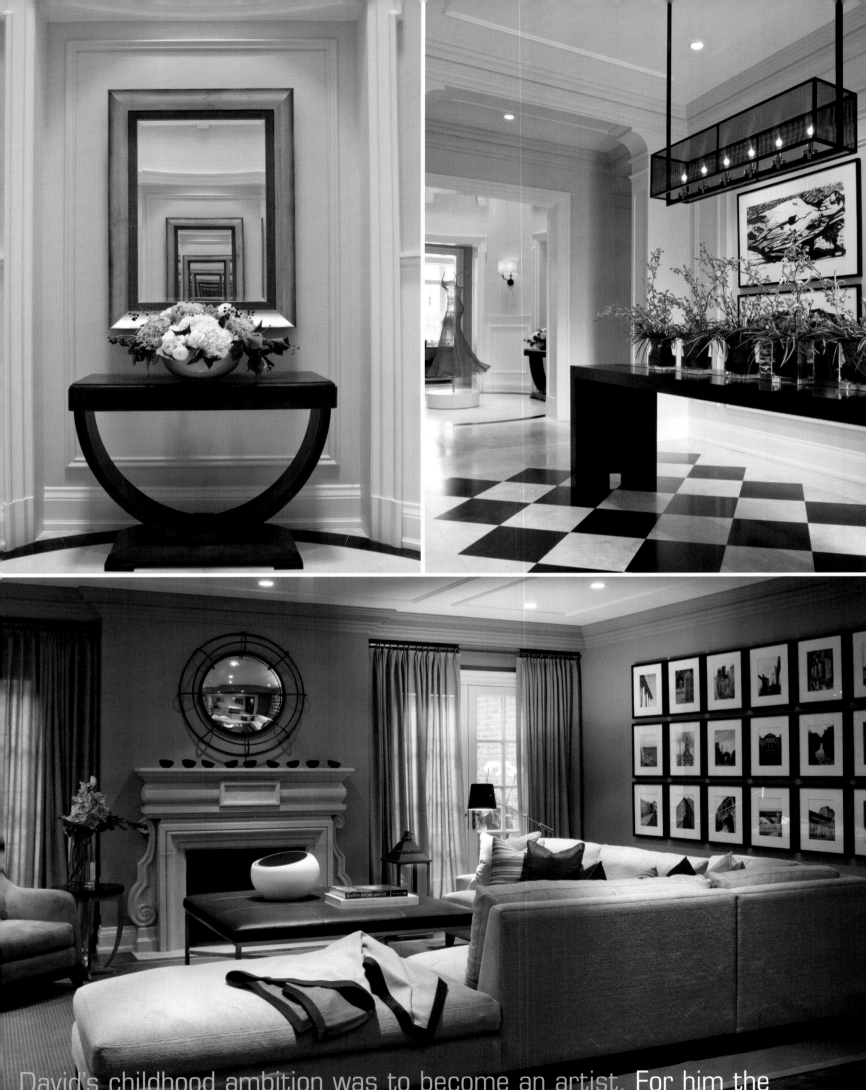

David's childhood ambition was to become an artist. For him the
70's were recovery from the 60's and now he's often happiest alone.

117

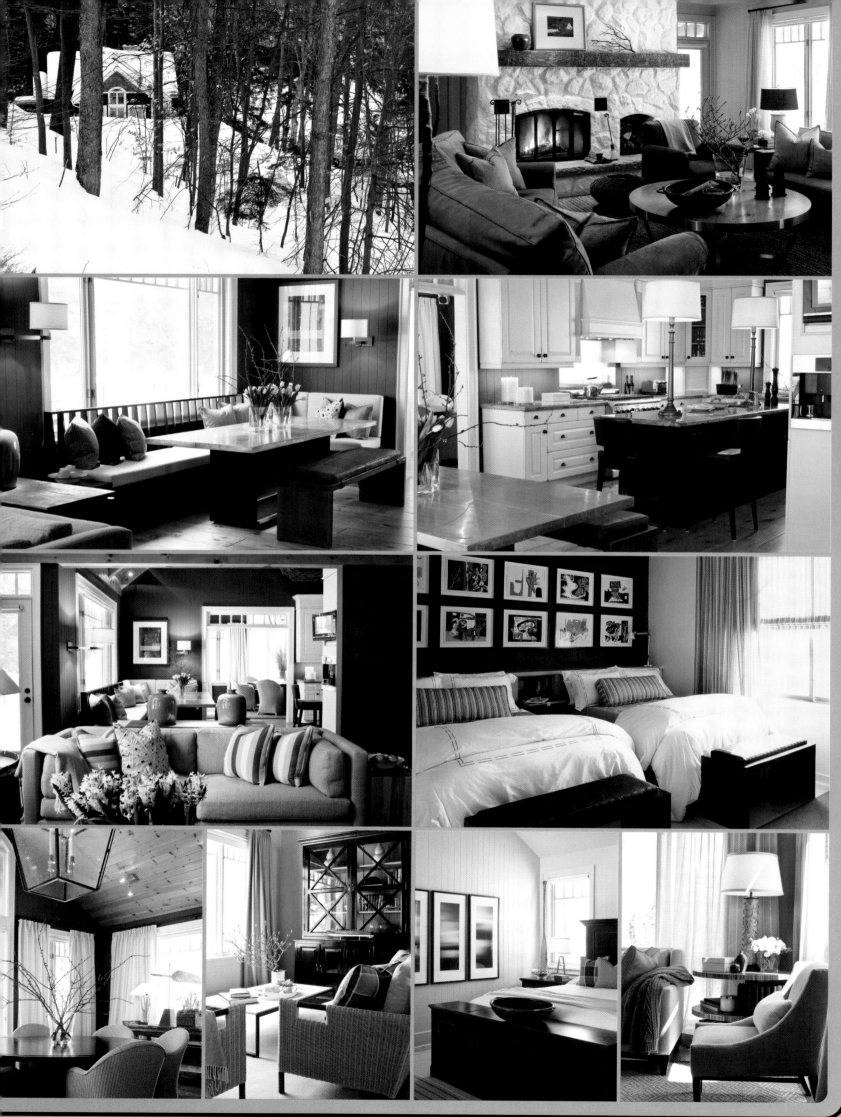

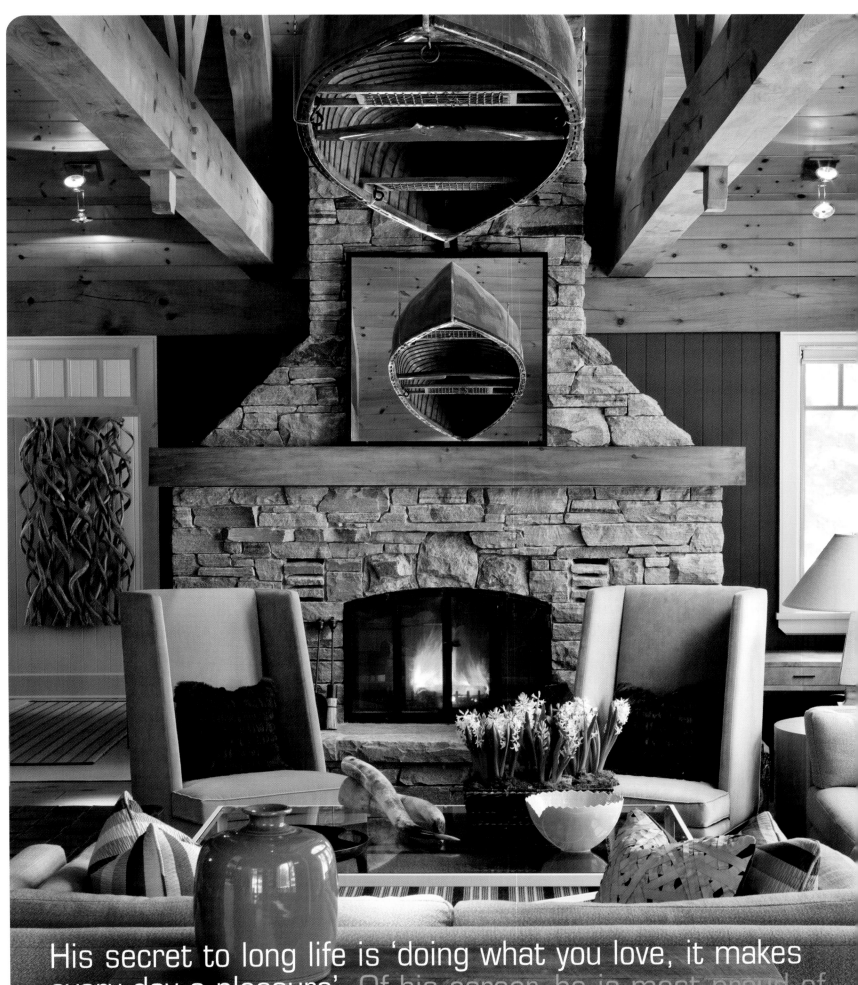

His secret to long life is 'doing what you love, it makes every day a pleasure'. Of his career, he is most proud of the integrity he and his partner have brought to the business. Given the choice he'd visit Paris rather than the Arctic, apparently the croissants just don't compare.

GLAMOROUS

Designer: Yasumichi Morita
Company: Glamorous Co Ltd, Hyogo, Japan.
Profile: Private and commercial interior design. Recent work includes the W. Hotel Hong Kong, BALS Corporation head office Tokyo and French Brasserie Paul Bocuse La Maison, Nagoya, Japan. Current projects are a Japanese restaurant in Santa Monica, a Chinese fine dining restaurant at Doha, Qatar and a commercial duplex at Osaka, Japan.

Yasumichi is a happy night owl, proud of his career achievements and whose great extravagance would be to spend seven days doing absolutely nothing in The Maldives. Inspiration comes from his hometown Osaka where he masters the cooking of Takoyaki. Most memorable meal, his first experience at Joël Robuchon. Best and worst advice he received 'don't get carried away.'

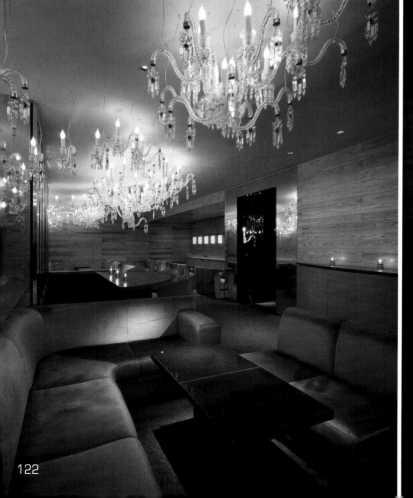

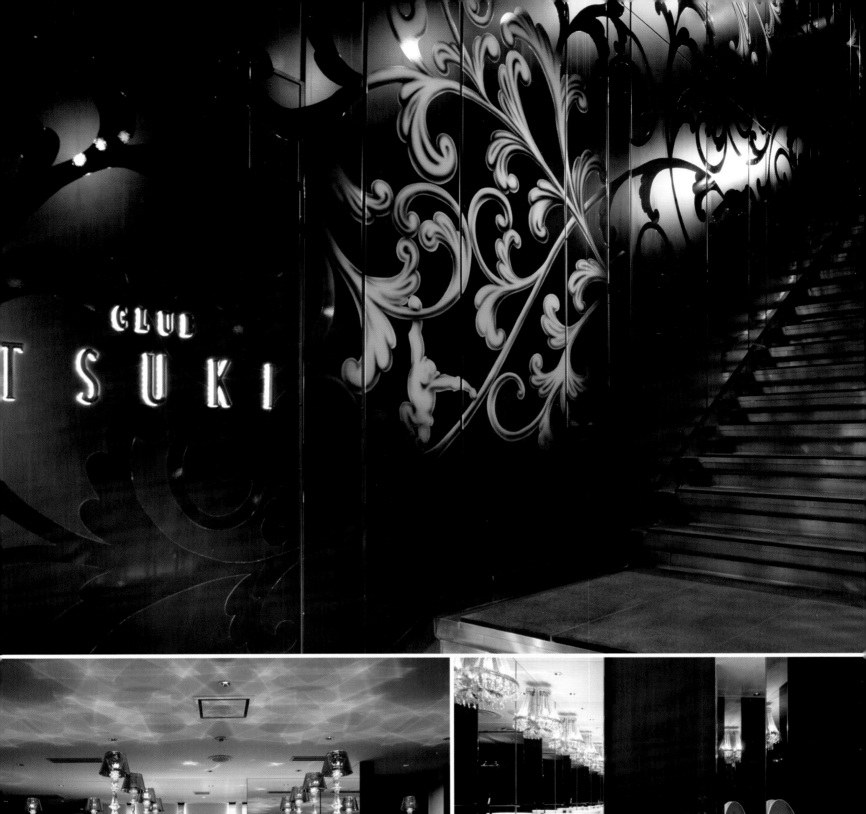

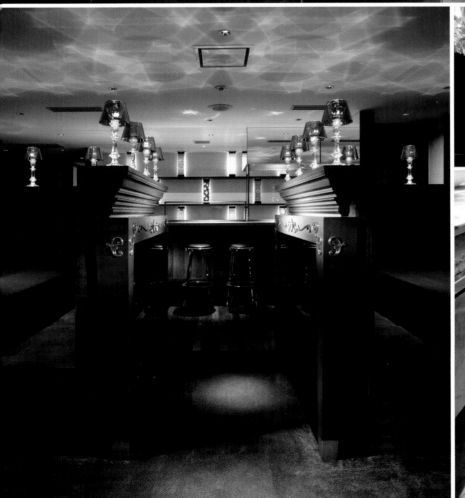

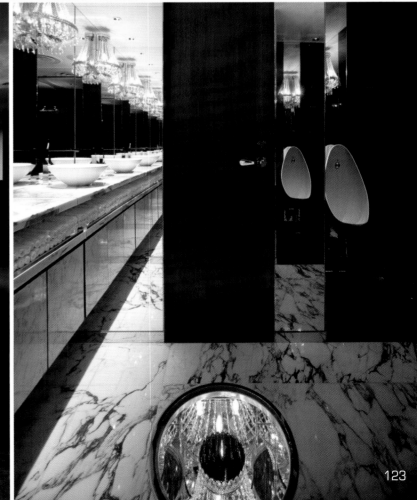

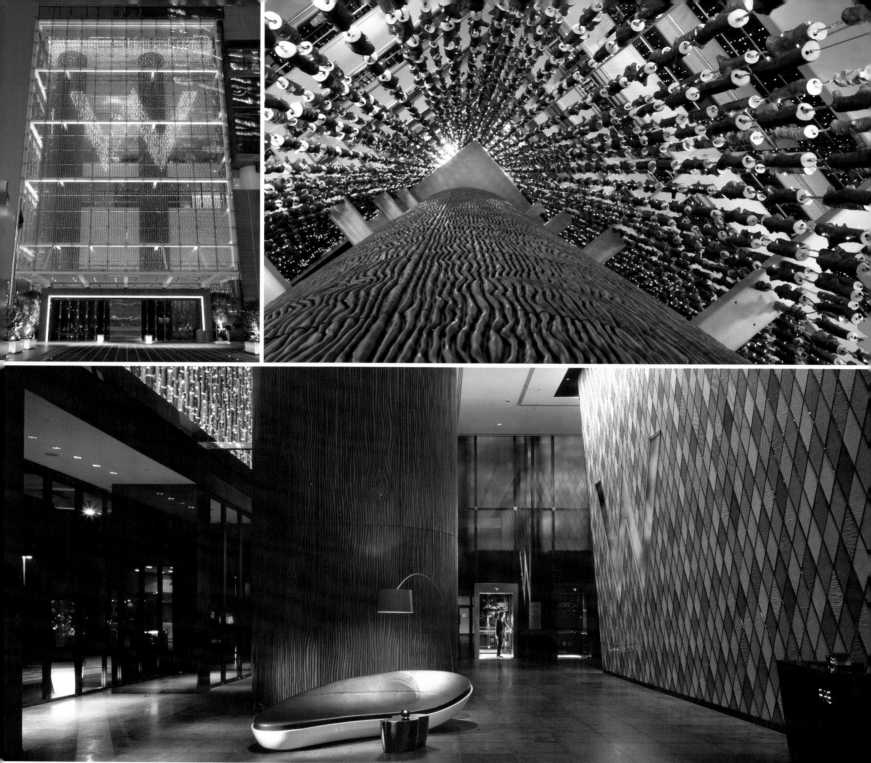
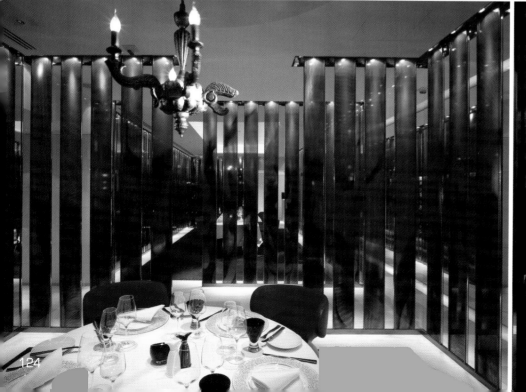

124

STEFAN

Designer: Stefano Dorata.
Company: Stefano Dorata Architetto, Rome.
Profile: Specialising in private work including houses and villas internationally. Recent projects include apartments in Rome and Tel Aviv plus a villa in Florence. Current work includes a house in London and villas in Portofino and Mykonos.

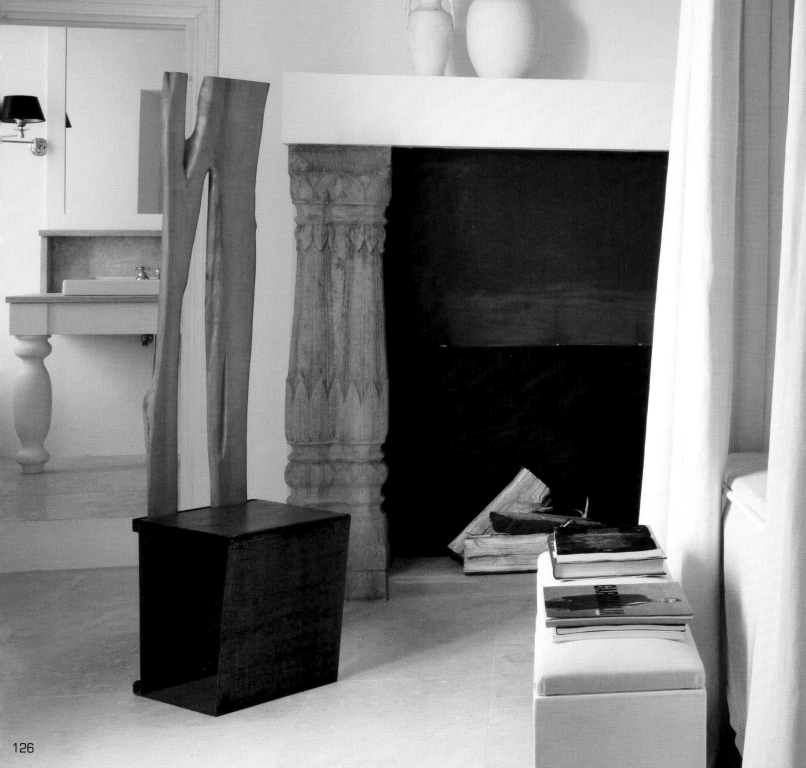

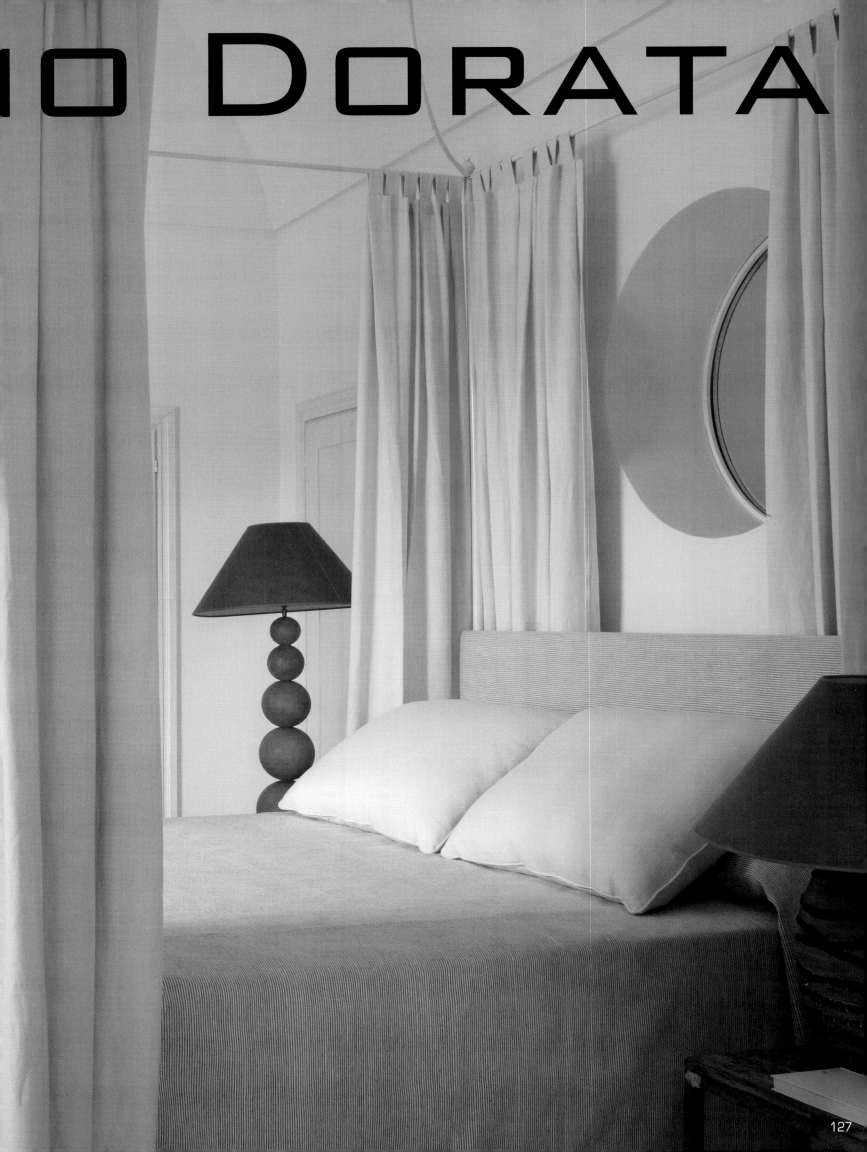

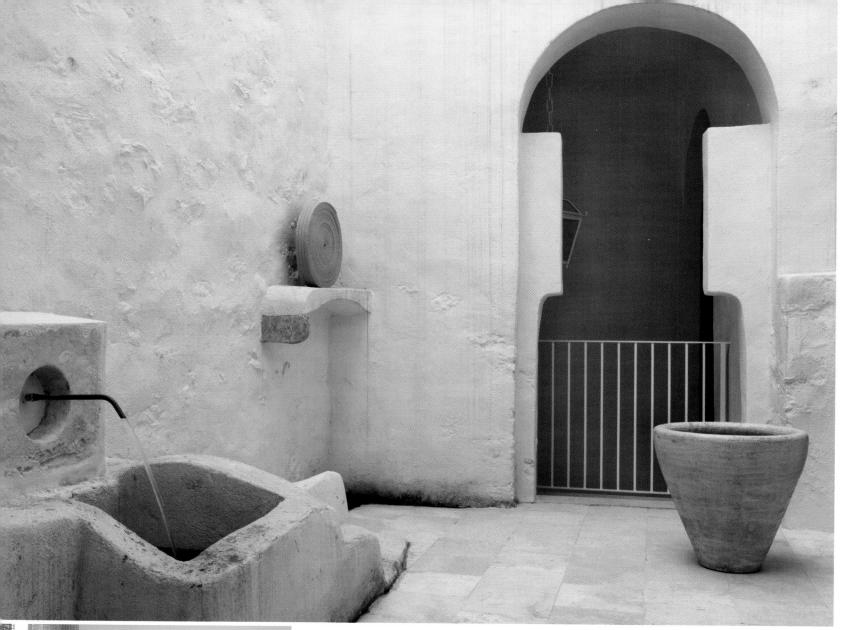

Happiest in his career and proudest of his next project. Stefano's inspiration is the classical architecture of Rome. His defining attribute, passion. Stefano loves water sports, his favourite home comfort the shower, favourite holiday windsurfing in Sardinia, favourite takeaway, ice cream. Favourite car ever made, Ferrari 430. Craziest thing he ever did, a helicopter bungee jump.

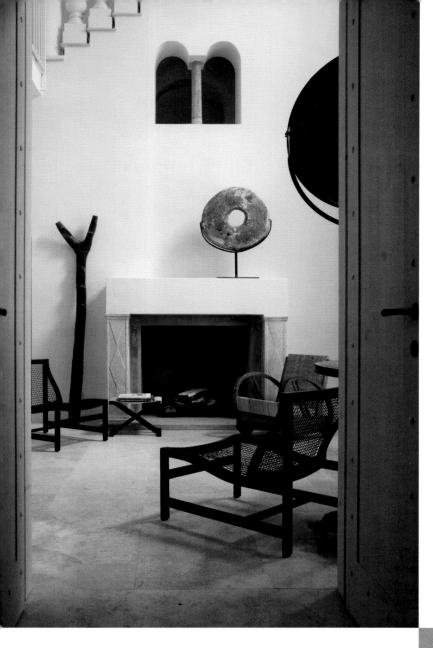
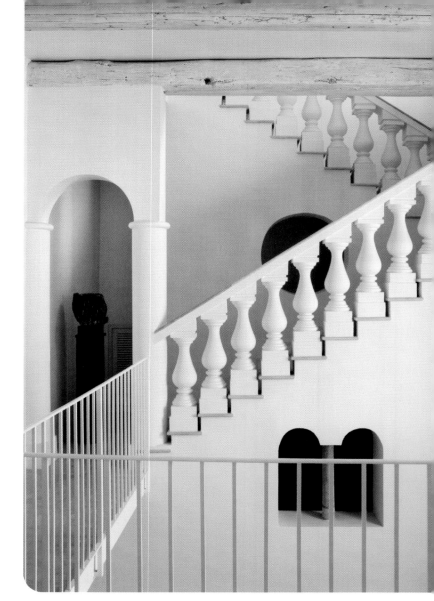
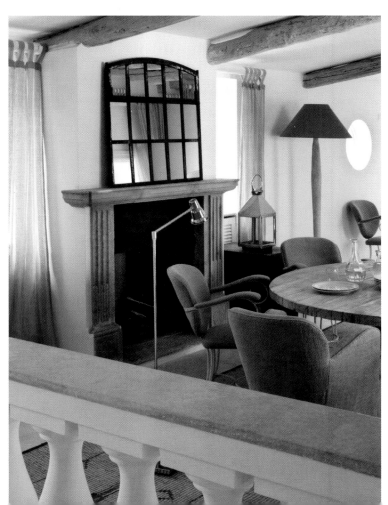

ETCETERA LIVING

Designers: Lesley Zaal & Marie-Inez Botha.
Company: Etcetera Living, Dubai.
Profile: Specialising in high end residential projects in the
U.A.E. Recent work includes boutique hotels and villas on the
Palm Jumeirah and Al Barari in Dubai.

Skilled gossip and organiser, Lesley loves a great handbag and shopping on the Boulevard St Germain, Paris. Most memorable meal at L'Oustau de Baumanière, Provence. Lesley wears Donna Karan, fancies Clive Owen, admires Bill Clinton, listens to Stevie Wonder. The Al Barari show villas are her proudest work, best advice 'grab the bull by the horns'. Lesley learnt to scuba dive at 40 and believes the secret of long life is 'going with the flow and lots of vitamins'. An 80's baby from Johannesburg, Marie's a fitness fanatic whose fantasy job is being a barmaid in Ireland. She loves Lindt chocolate, Tom Ford, Nina Simone and a bargain. Her favourite shopping is Antique Street in Saigon, her earliest memory, eating ice cream in a park in Japan aged 2. She has a secret crush on the 'mosque-man' and loves to hear his voice at 4am.

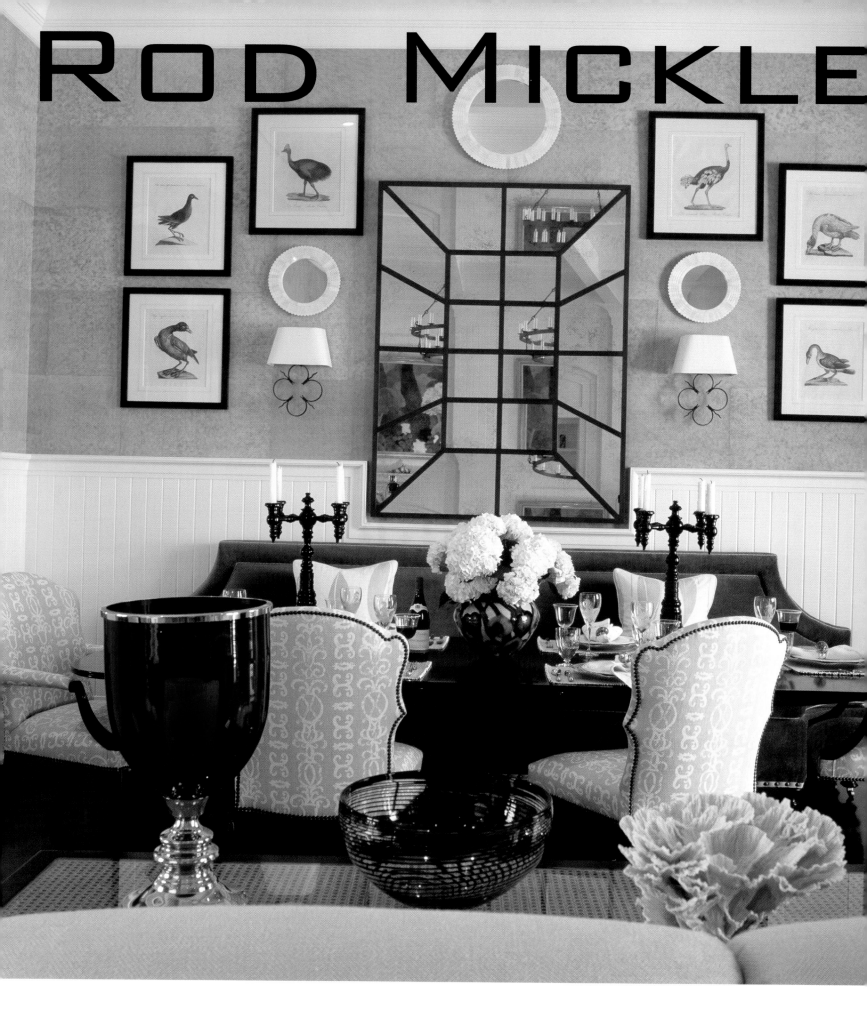

Designer: Rod Mickley. Company: Rod Mickley Interiors, Florida, U.S.A. Profile: Predominantly residential work in the U.S. Recent projects are in Florida and include the Swarovski residence. Current work includes projects in Connecticut and Florida.

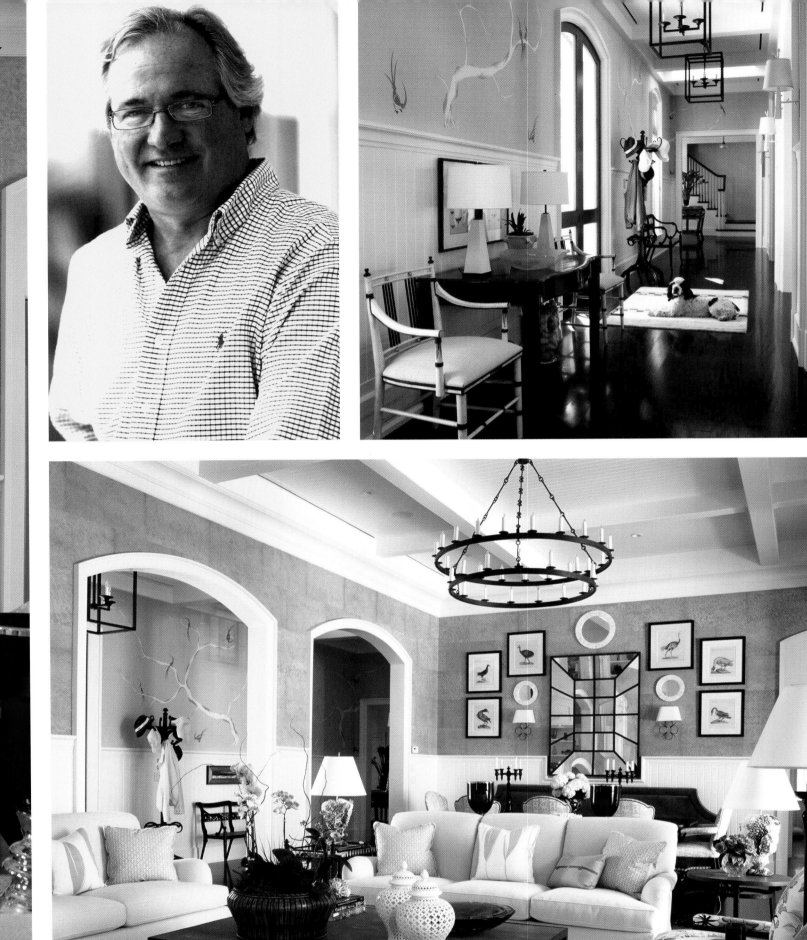

Art collecting golfer who loves to cruise the Med. He's inspired by the humility of his hometown Louisville, Ohio. Rod's earliest memory is hiding his four knuckle boots in the shrubs on the way to school. His first job was washing dishes, and his first car is still his favourite – a Dodge Dart. The craziest thing he ever did was putting his finger on a map and moving there. The best advice 'keep employees to a minimum'.

ANDREW

WINCH

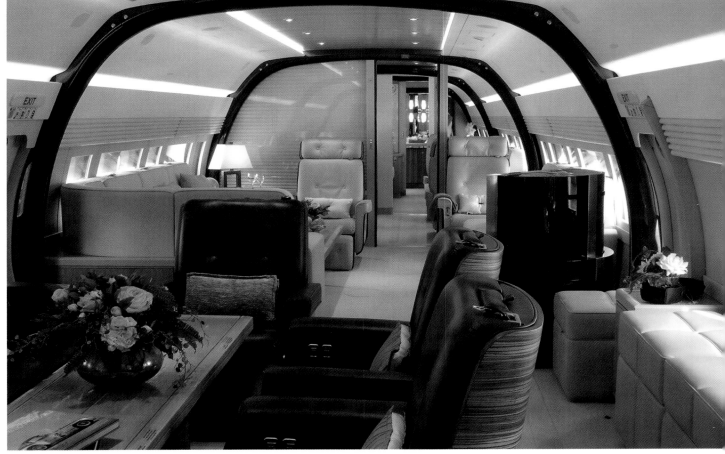

Designer: Andrew Winch.
Company: Andrew Winch Designs, London.
Profile: Work is international specialising in the interior and exterior design of luxury yachts, jets and residences. Recent work includes a property in Kiev, three motor yachts and a Boeing business Jet.

As a child Andrew dreamt of being a sailor, his earliest memory is sitting by the water in Bosham, his first job running a sailing yacht. Passionate about yacht design, the craziest thing he ever did was sail the Atlantic. His most memorable meal was fresh lobster with mayonnaise and a bottle of chilled Chablis, on the back of a sailing boat in Yarmouth Bay, Isle of Wight.

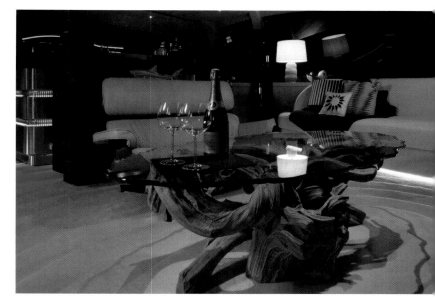

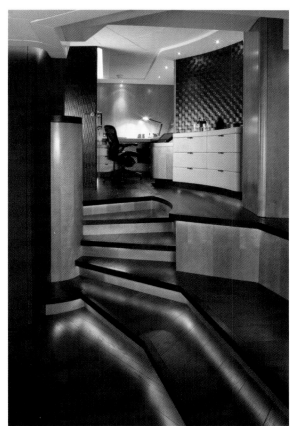

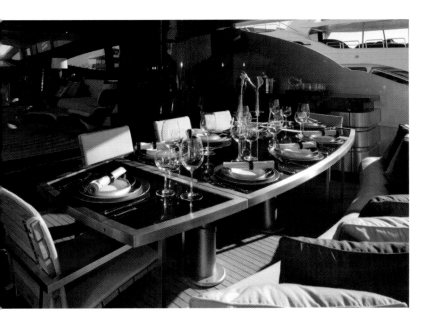
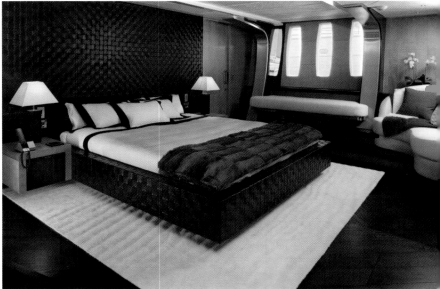

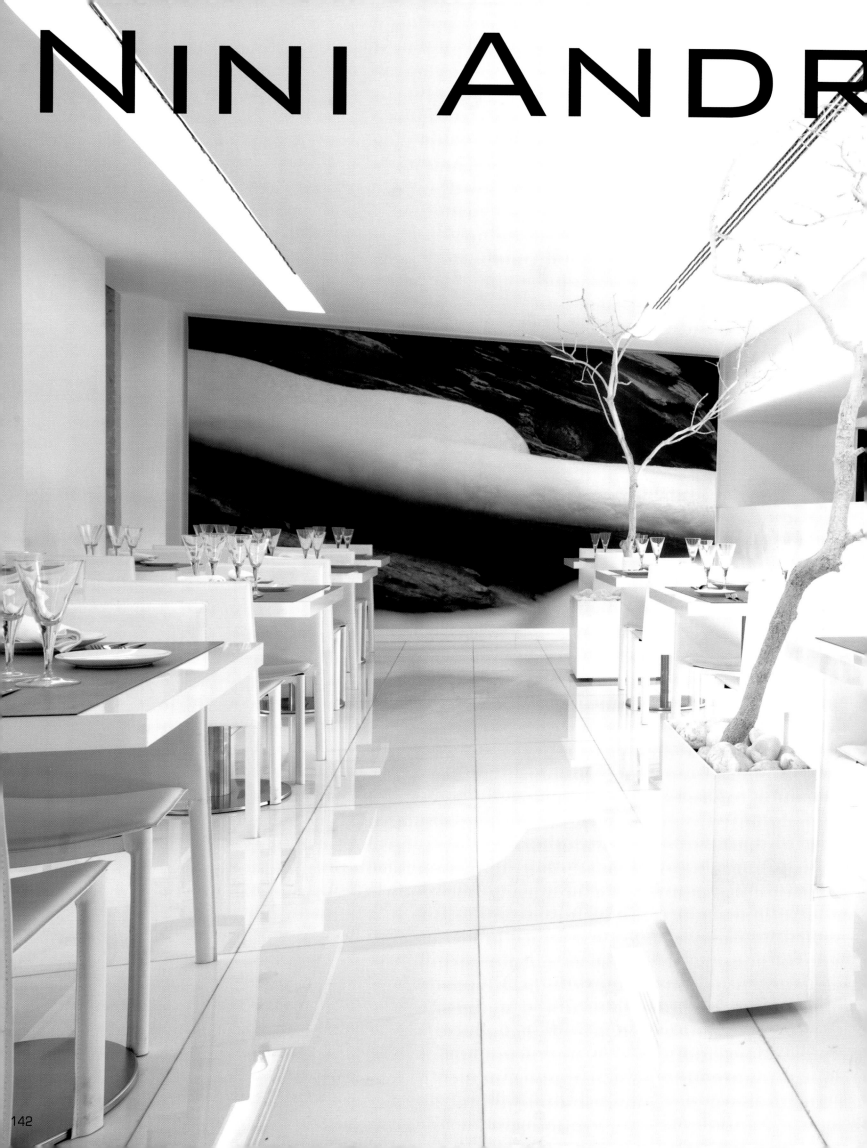

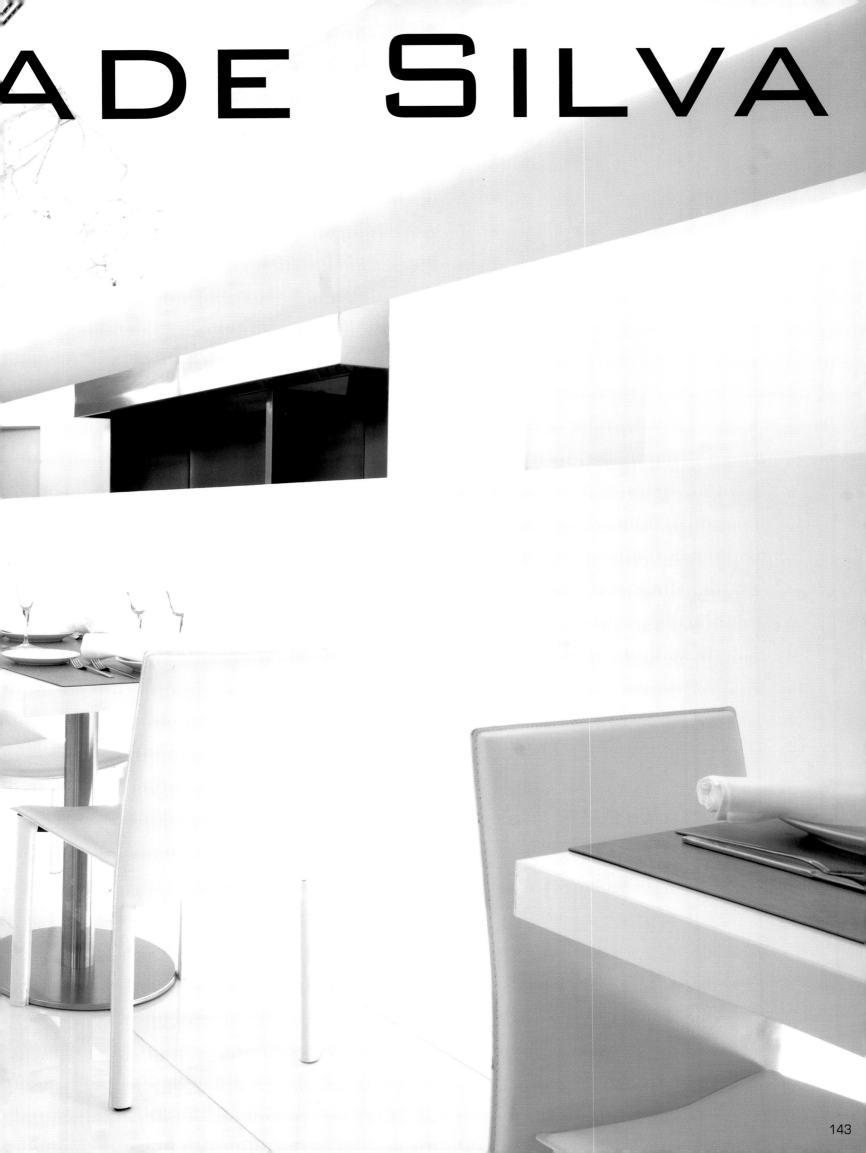

Nini's most memorable meal was a candlelit picnic in the mountains. Her favourite home comfort is looking at a rainy sky onto the ocean from her sitting room with a cup of tea. Her inspiration is Funchal.

Designer: Nini Andrade Silva. Company: Atelier Nini Andrade Silva, Madeira, Portugal. Profile: Projects are international with an ever growing team based in two offices in Portugal. Work includes award winning hotels, private houses, commercial spaces, offices and events. Recent projects include Aquapura Douro Valley, Fontana Park Hotel, Lisbon and The Vine Hotel, Madeira Island. Current work includes Hotel Teatro, Oporto, Hotel Do Sal, Green Cape Islands and Hotel Golf, Pinheiros Altos, Algarve.

Dignity, originality and hard work are for her the most important thing in business.

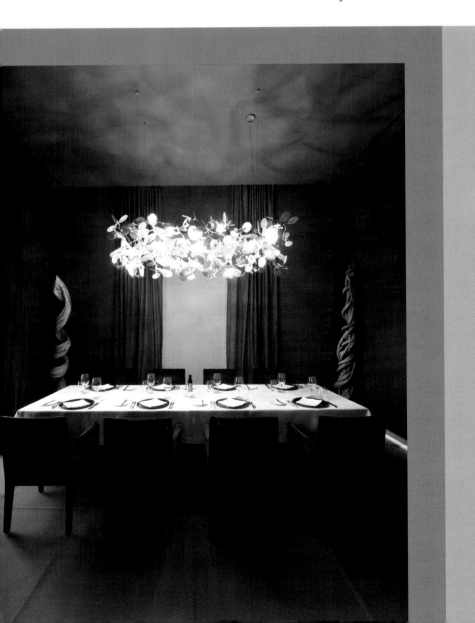

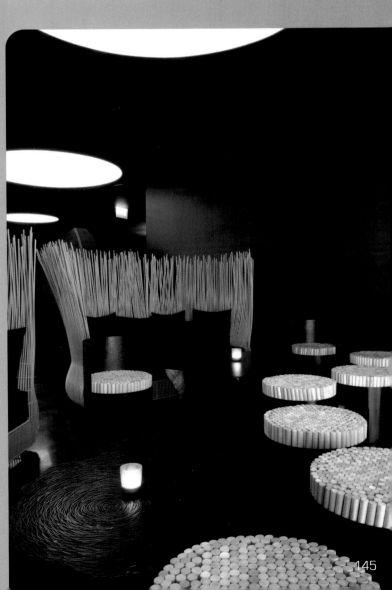

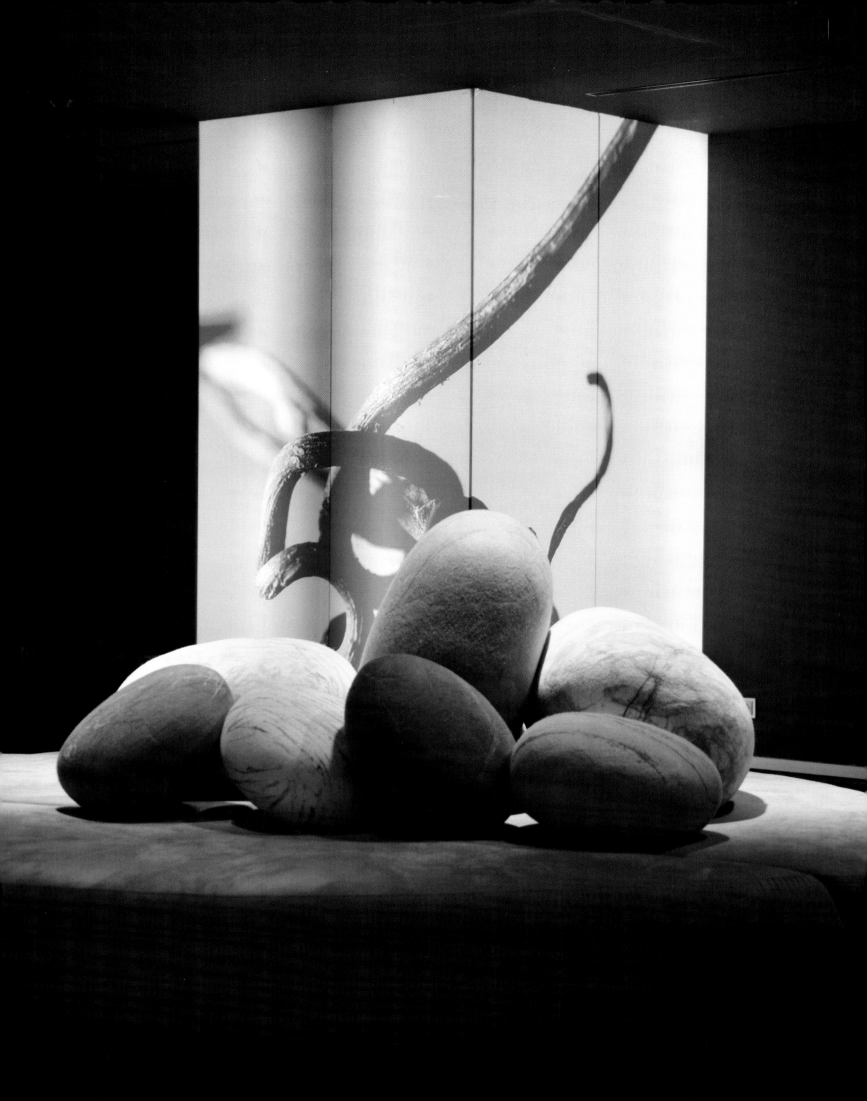

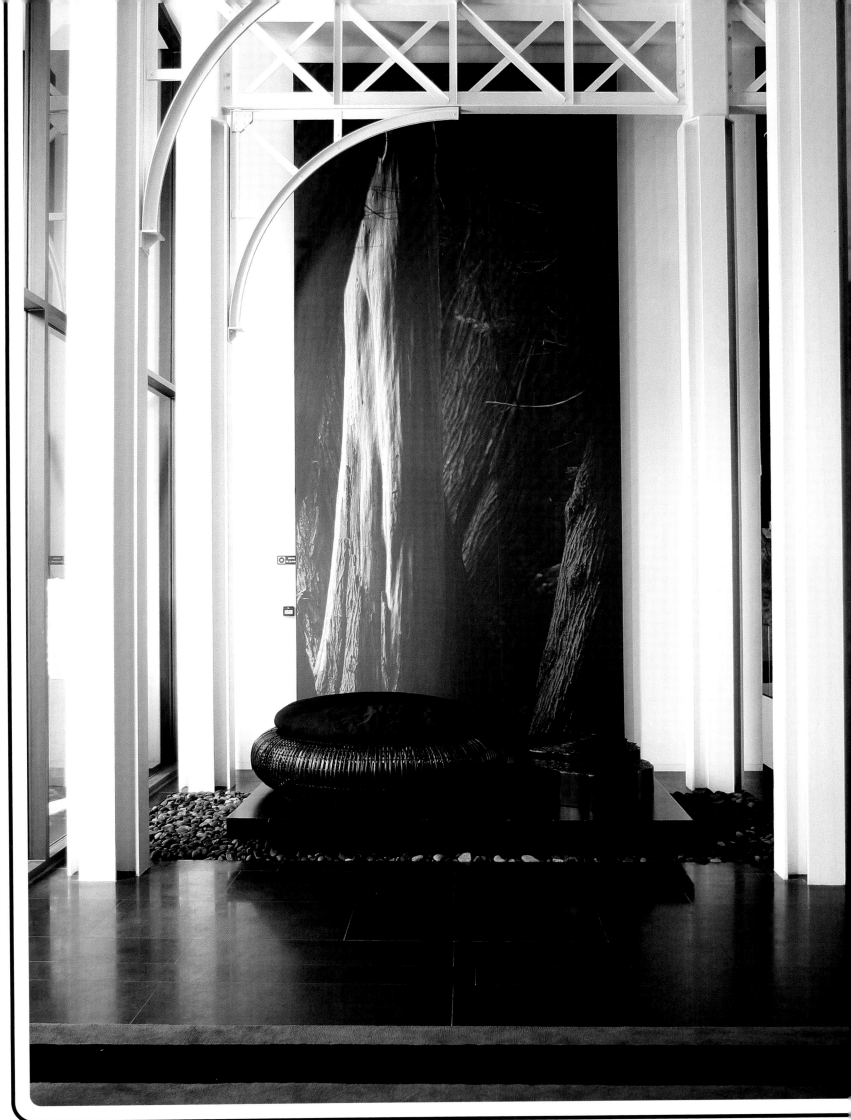

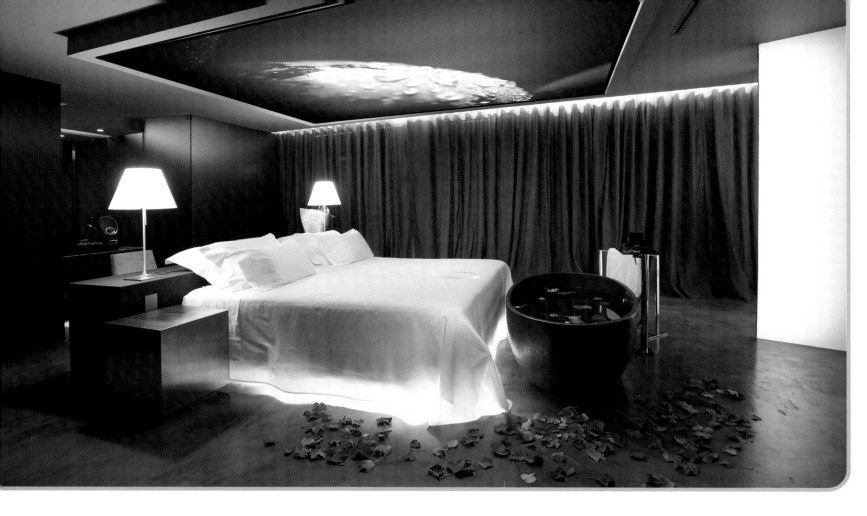

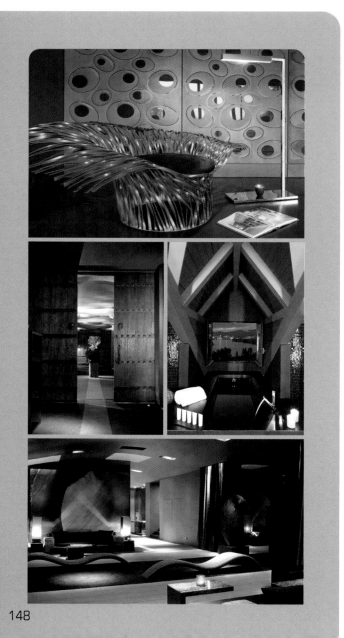

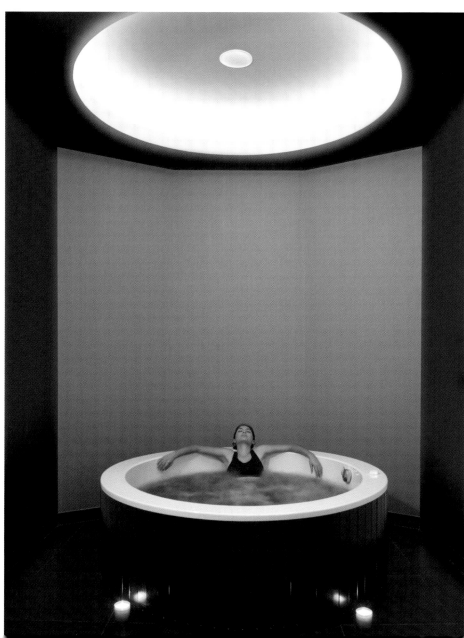

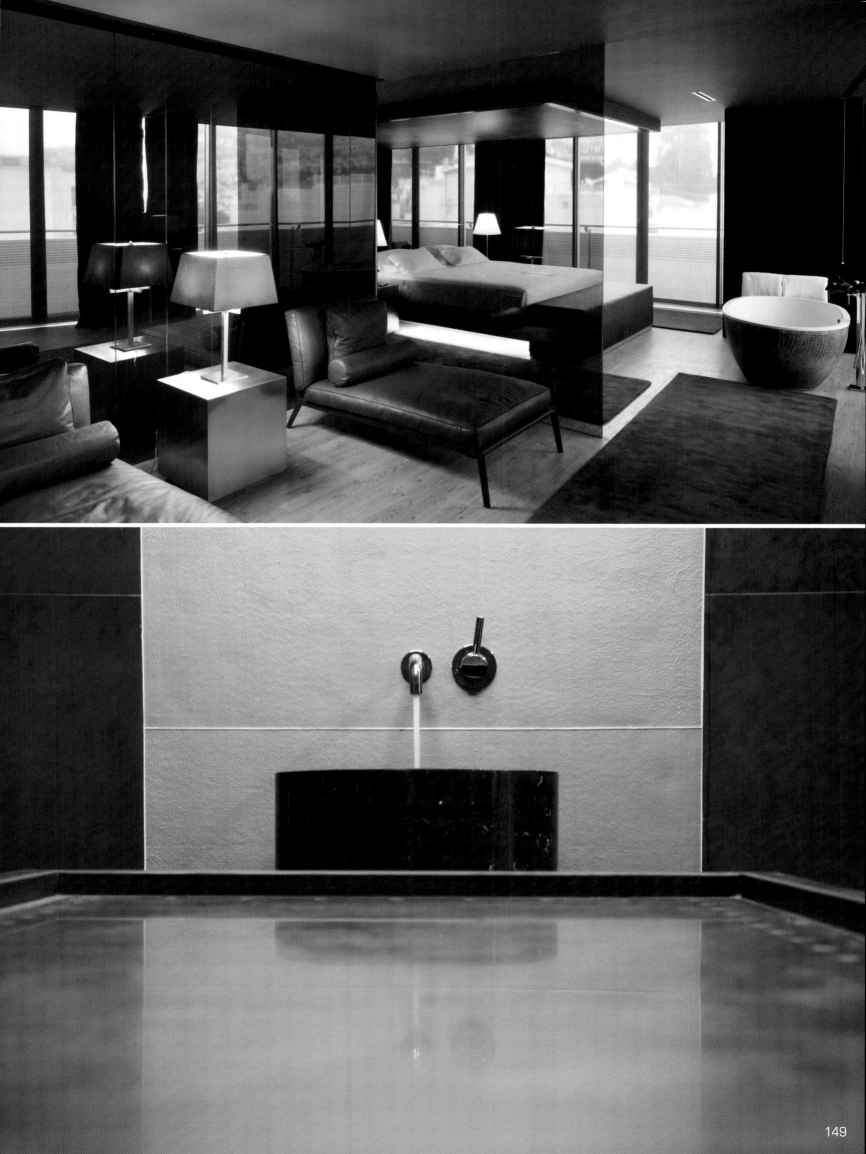

TOCAR

Susan blames America's obsession with 'Brangelina' for the financial crisis. Star sign Capricorn, confident and hard working, best skill an eye for detail. Attitude to decorating, keep it classic, comfortable and clutter free. First job selling handmade Christmas tree ornaments, taught her entrepreneurship and self belief. Cries in movies, even when King Kong died. Childhood ambition to date Burt Reynolds, favourite saying 'want to meet for a drink?' Christina is still a cool kid, still has a crush on David Gilmour, Big Macs, Aston Martins and Christian Dior.

Designers: Christina Sullivan & Susan Bednar Long. Company: Tocar Design, N.Y. U.S.A. Profile: High end residential and commercial interiors predominantly in the U.S. Recent projects include a family house and loft apartment in Manhattan, a townhouse in Chester Square, London and a family house in Connecticut. Current work includes a mountain residence in Utah, a flat in Southampton and a penthouse in Lower N.Y.C.

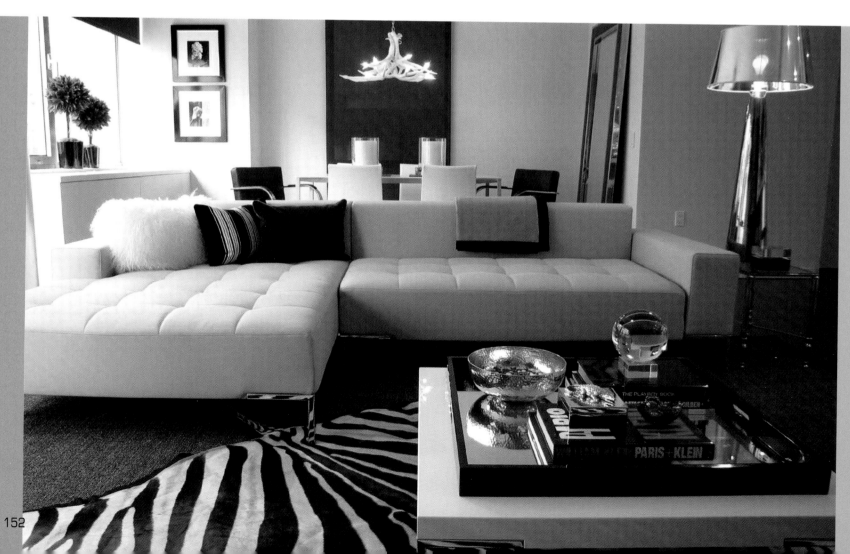

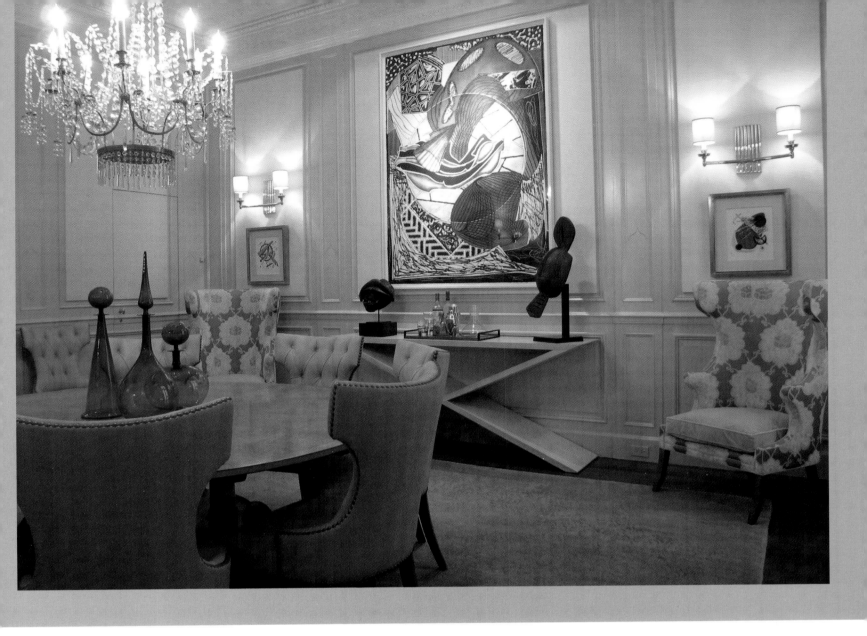

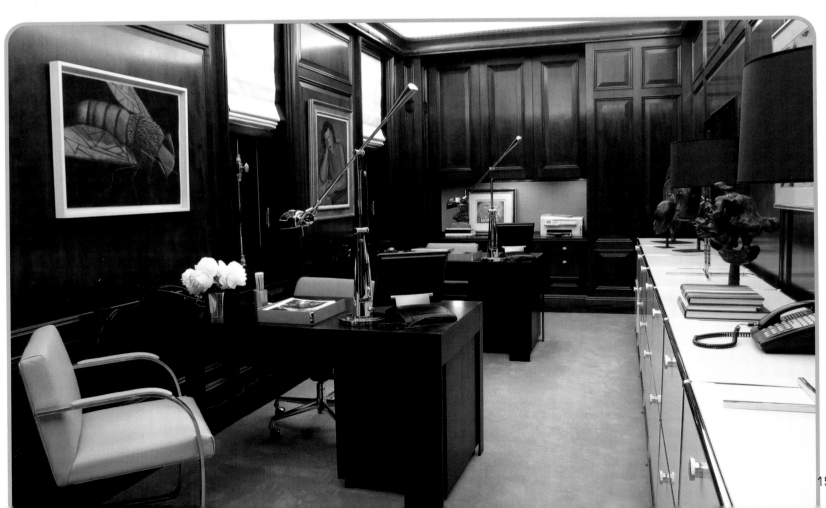

153

PATRICK LEUNG

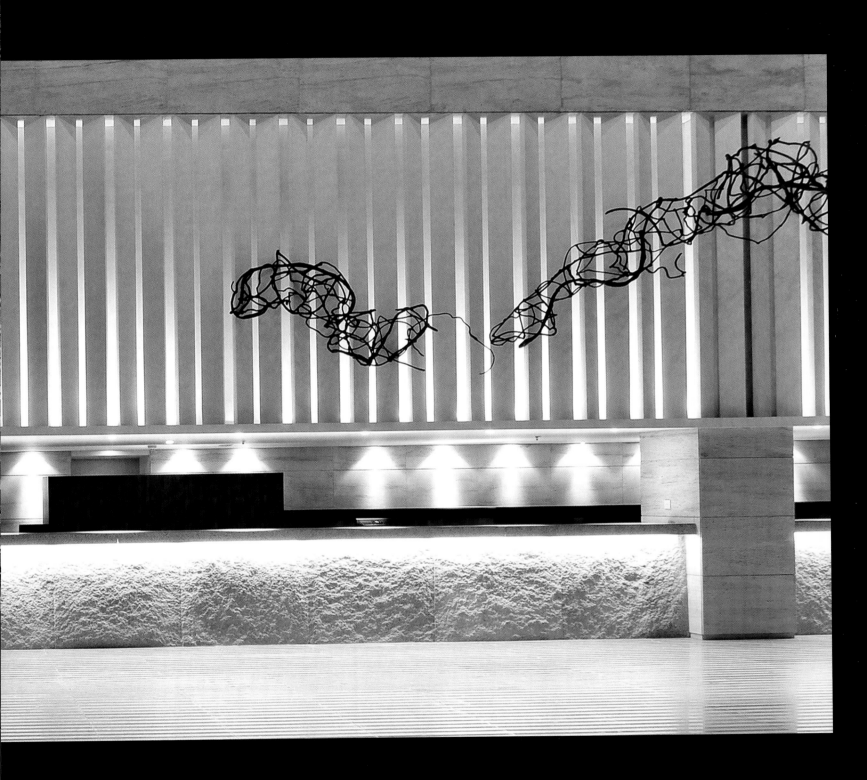

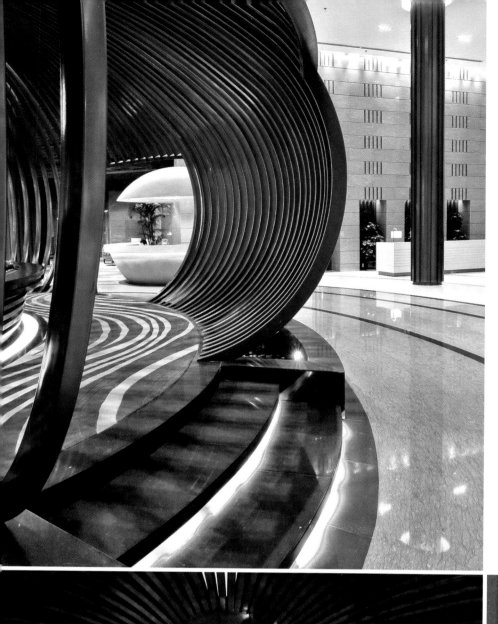

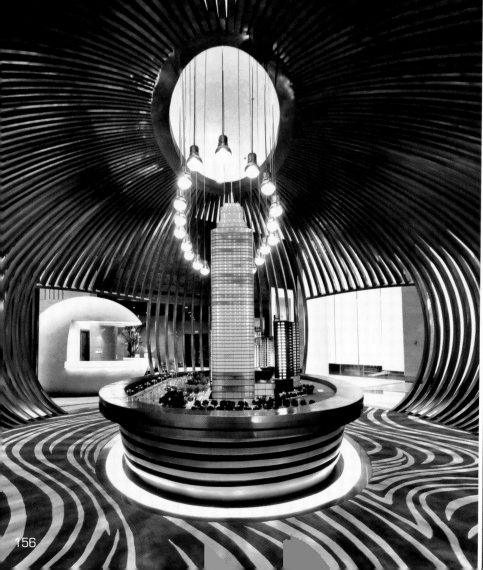
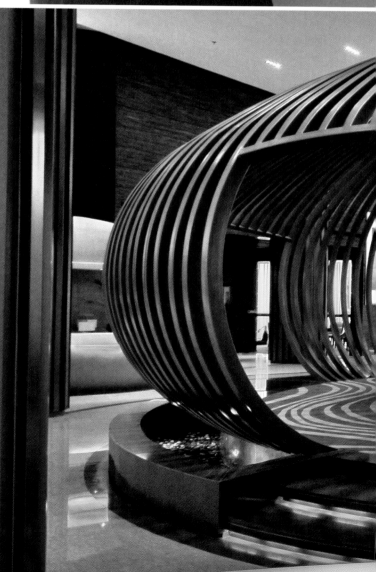

Designer: Patrick Leung.
Company: PAL Design Consultants, Hong Kong.
Profile: Award winning company founded in 1994 specialising in hotels, restaurants, clubs, showflats and large corporate interiors internationally. Recent work in China includes Hilton Hotel, Beijing, Mission Hills Golf Club and Resort Hotel at Tianjin. Current projects include Hilton Hotel, Huangshan, Harbin View Hotel, Beijing and Kempinski Hotel, Xian.

Patrick's childhood ambition was to be a great man. His earliest memory is his mother not allowing him to go to the school picnic, aged 3. He was a cool teenager but is even cooler now. Describing his attitude to decorating as subtle, balanced and thoughtful. He says the secret of long life is to smile and be happy. Inspired by Hong Kong, likes Armani, hamburgers and the countryside.

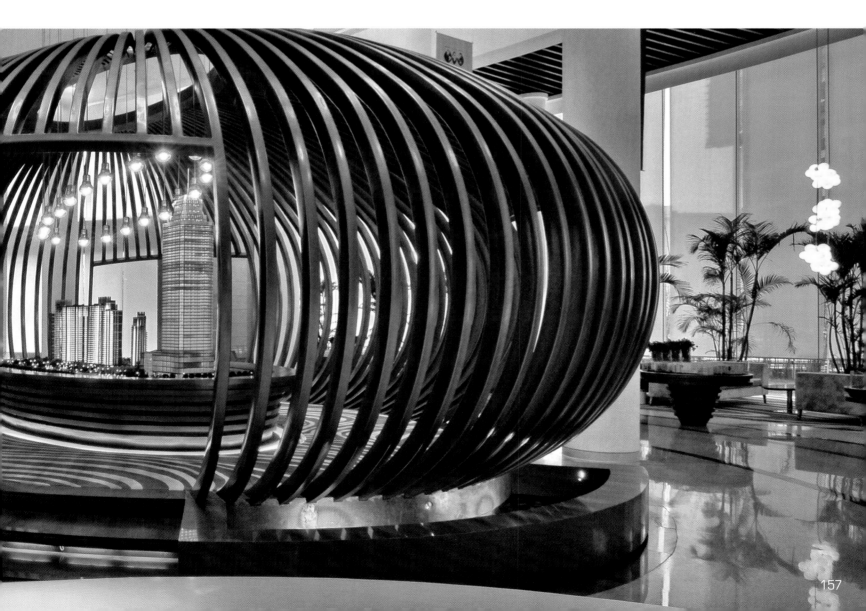

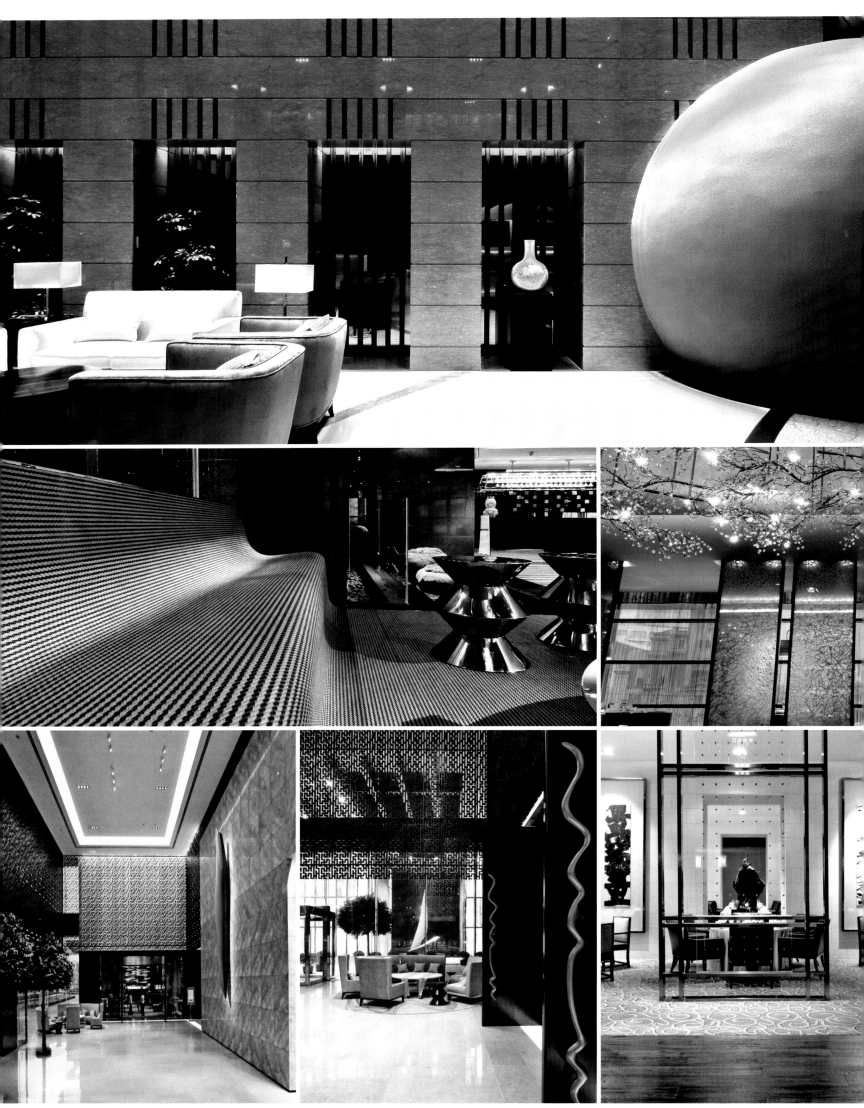

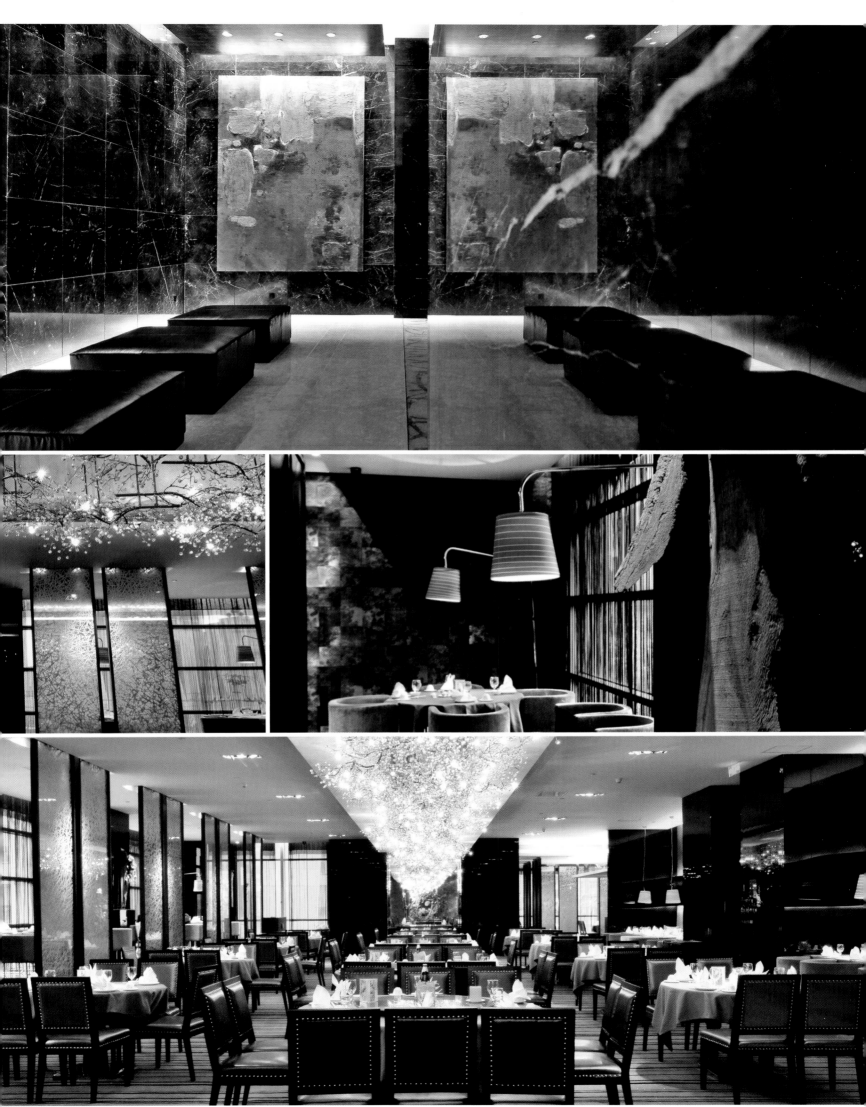

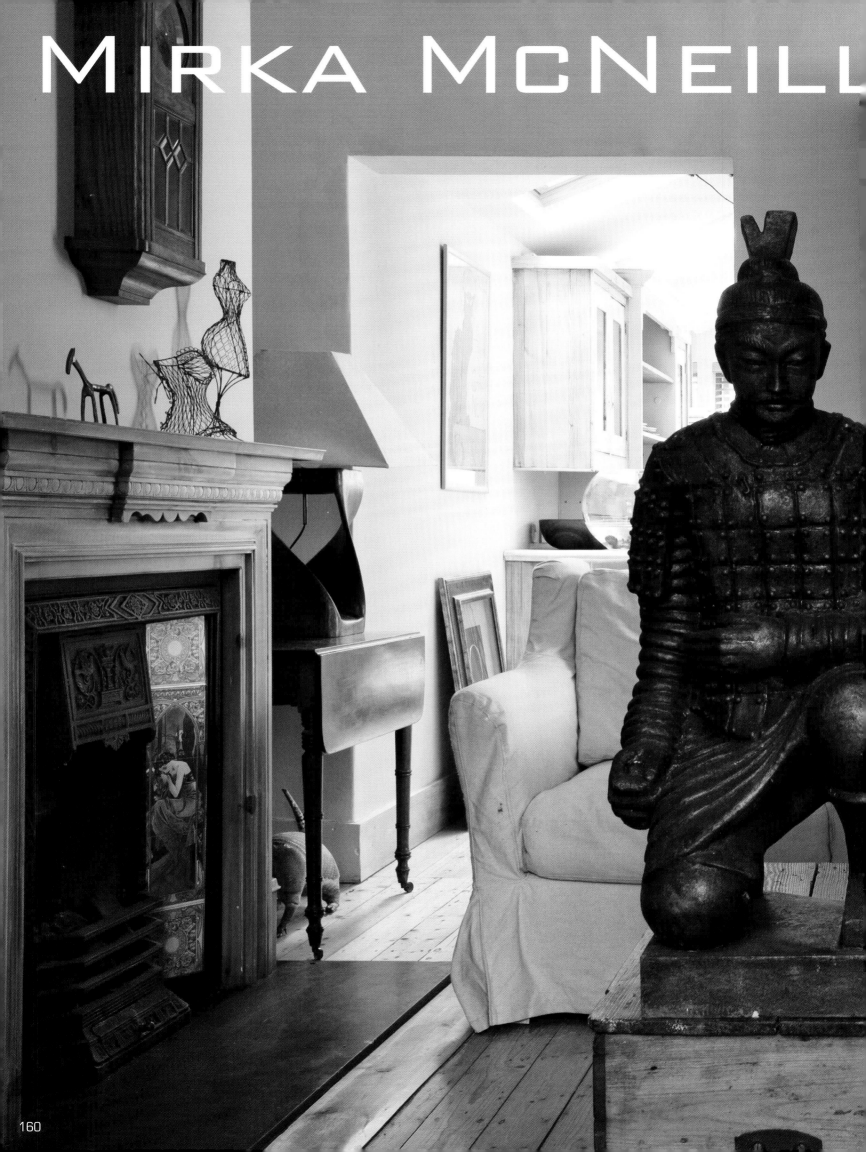

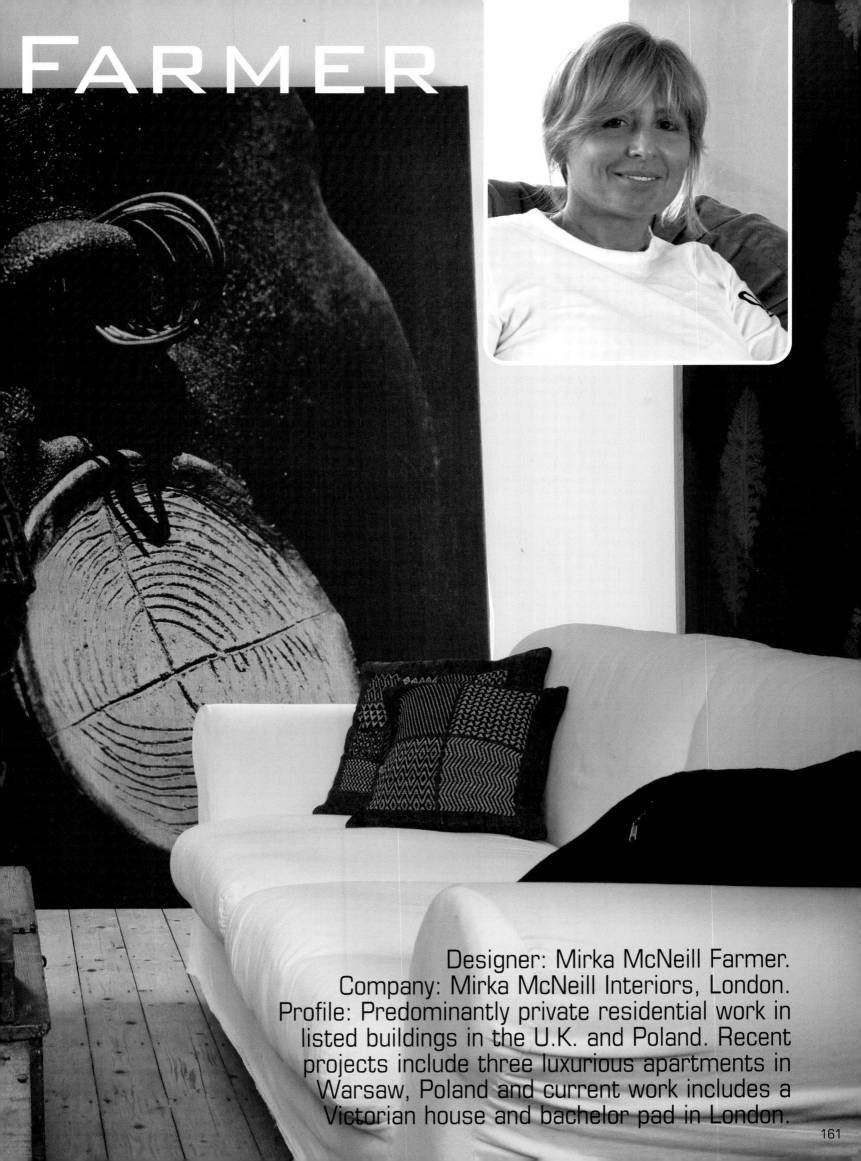

FARMER

Designer: Mirka McNeill Farmer.
Company: Mirka McNeill Interiors, London.
Profile: Predominantly private residential work in listed buildings in the U.K. and Poland. Recent projects include three luxurious apartments in Warsaw, Poland and current work includes a Victorian house and bachelor pad in London.

An ambitious perfectionist, Mirka feels physical pain in an ugly interior. Favourite architect Jean Nouvel, a passion for designing and a weakness for shopping, preferably in London's Neal Street.

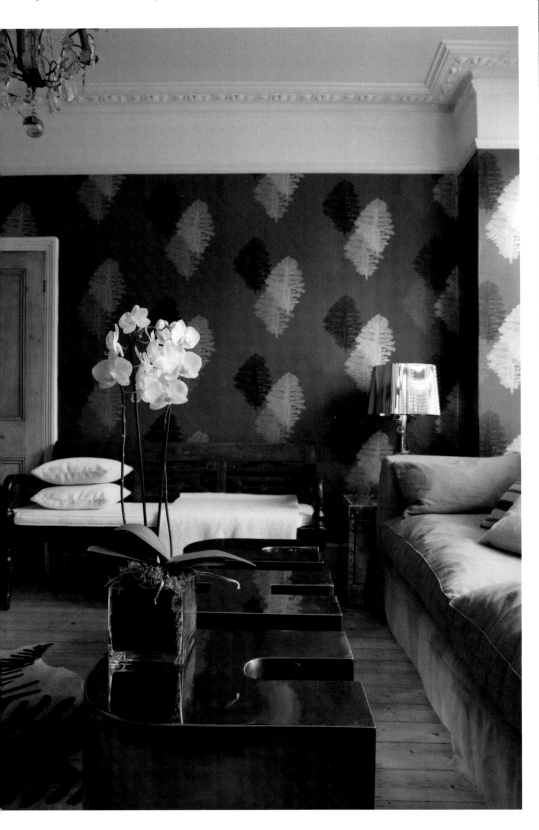

She likes Che Guevara, Bob Dylan, Kate Moss.

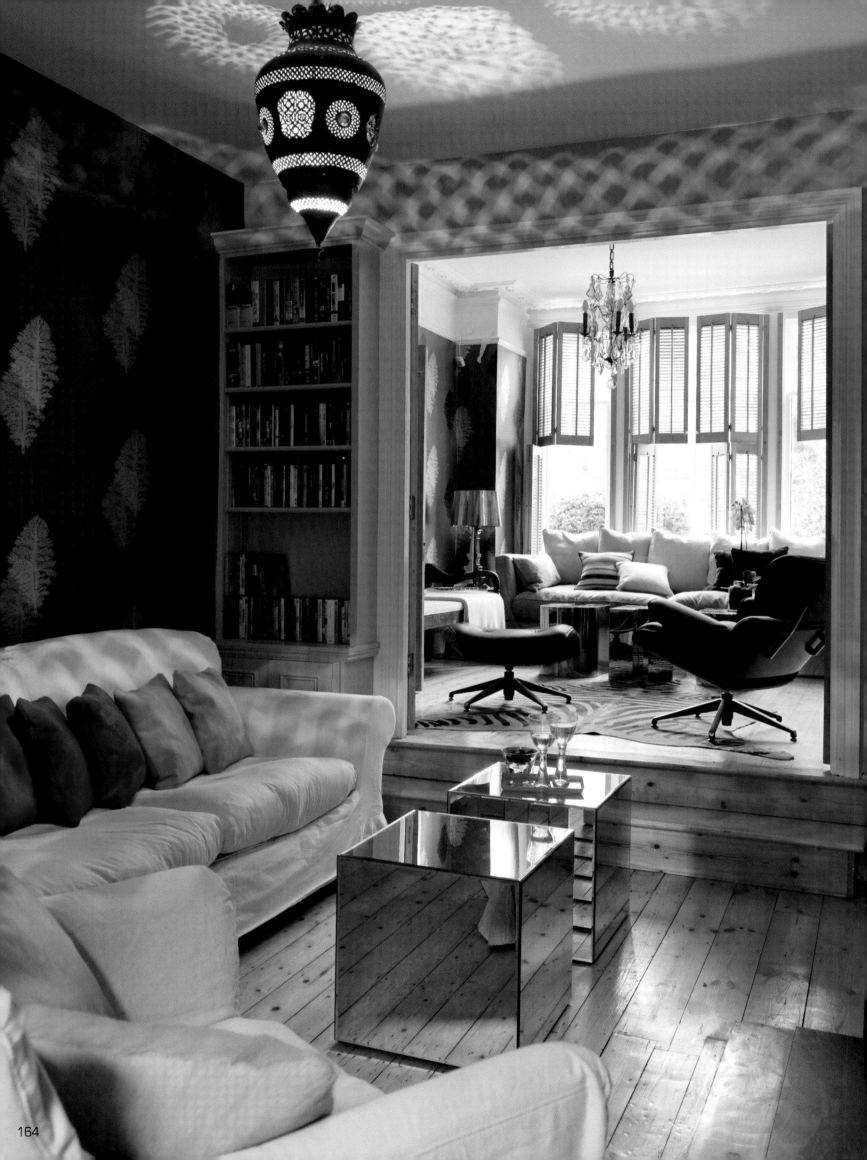

Inspired by the spirit and history of her home town Warsaw, she's risen like a Phoenix from the flames.

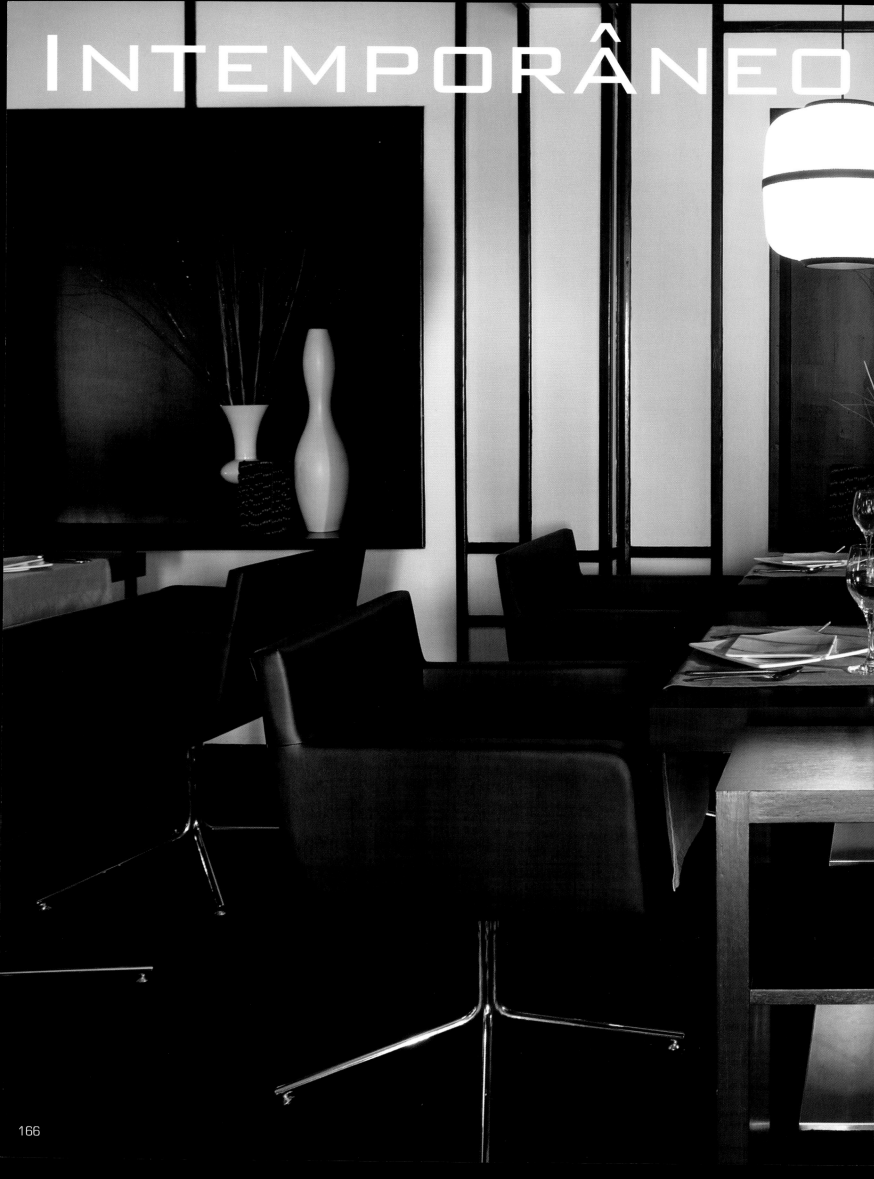

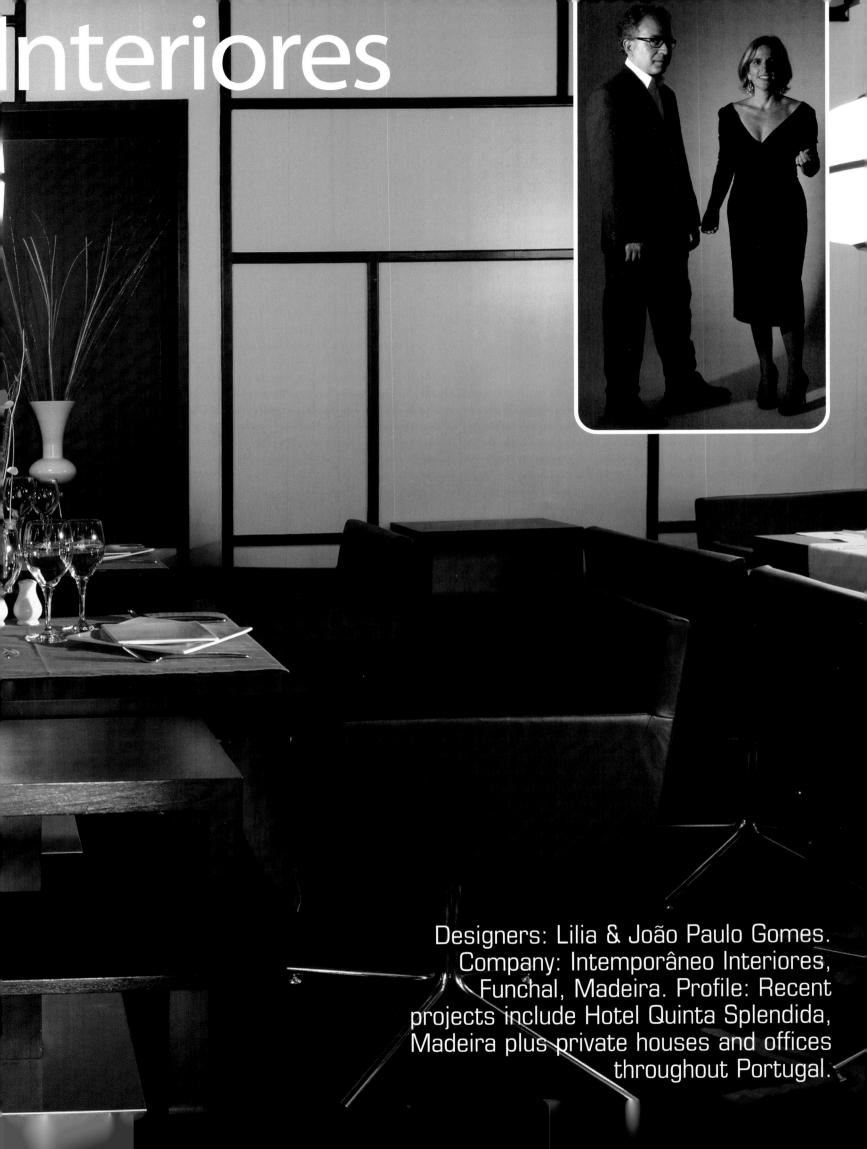

Interiores

Designers: Lilia & João Paulo Gomes. Company: Intemporâneo Interiores, Funchal, Madeira. Profile: Recent projects include Hotel Quinta Splendida, Madeira plus private houses and offices throughout Portugal.

Healthy eating Madeira islanders who like to keep it simple. Happiness and sex are their recipe for long life. Paris for pleasure and cooking for fun. João makes cakes, Lilia makes friends. Favourite food anything home made. Favourite bottle, Madeira wine. Favourite uniform Air Portugal. Her extravagance Armani and heels; his, Prada and Portuguese art. His secret crush Gisele Bündchen, hers Jude Law. João's epitaph will be 'gone but not forgotten'. Lilia's 'excuse me I can't stand up'.

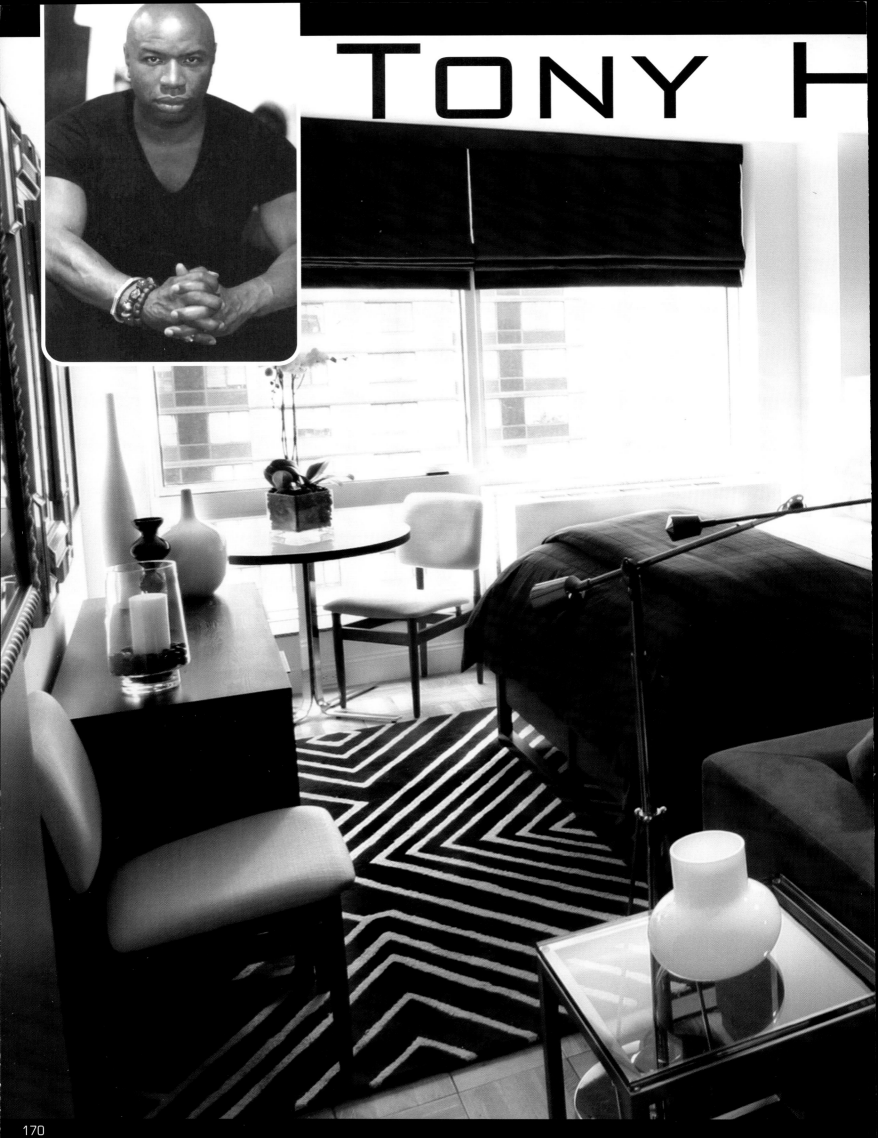

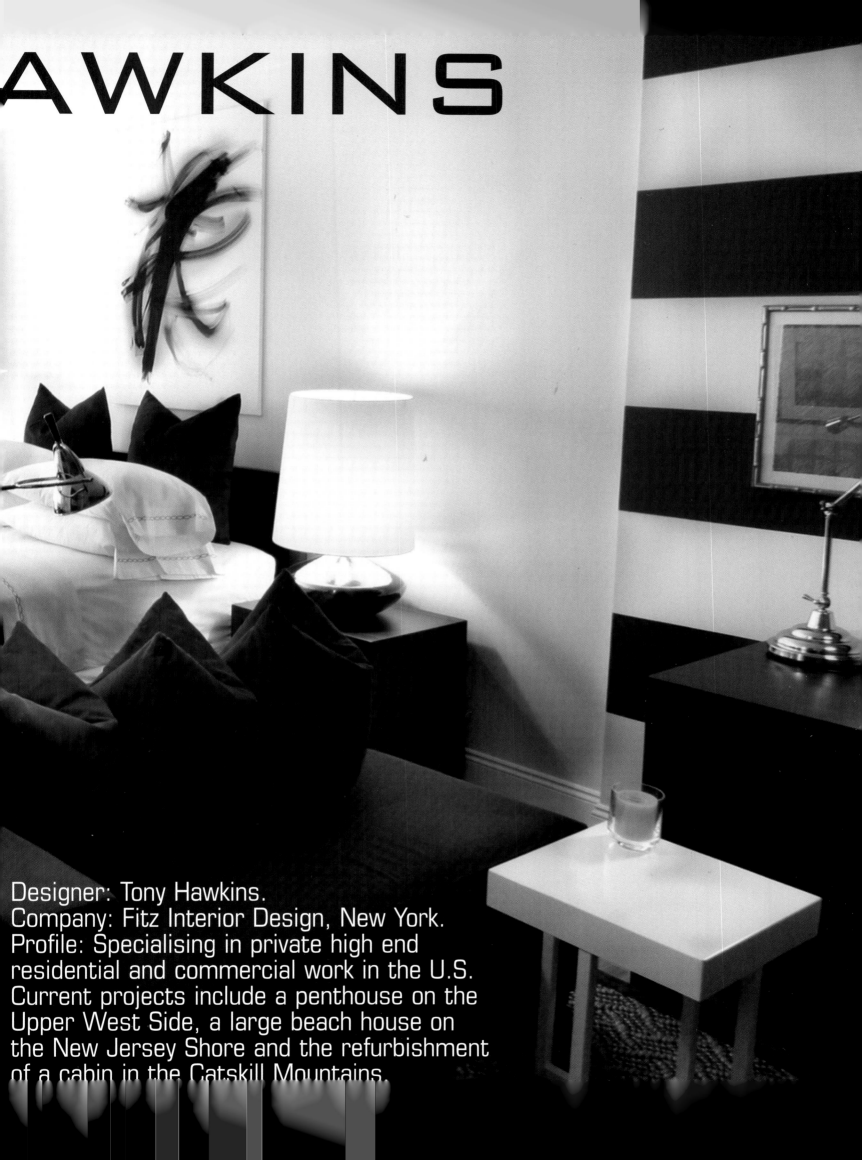

AWKINS

Designer: Tony Hawkins.
Company: Fitz Interior Design, New York.
Profile: Specialising in private high end
residential and commercial work in the U.S.
Current projects include a penthouse on the
Upper West Side, a large beach house on
the New Jersey Shore and the refurbishment
of a cabin in the Catskill Mountains.

Unimpressed by Sarah Palin and Titanic. Political hero Barack Obama, favourite architect Adrian Smith. Fantasy job to redesign Windsor Castle, unfulfilled ambition to own it. Best skill, decorating. Secret of long life, comfort food. Favourite takeaway Cuban, best drink Grey Goose with a splash of cranberry. Happiest with great night life, the craziest thing he ever did was wear only a sarong at Gay Pride N.Y.C 1994. Favourite saying 'destiny is not left to chance, it's a matter of choice'.

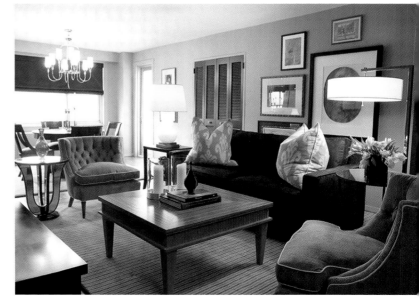

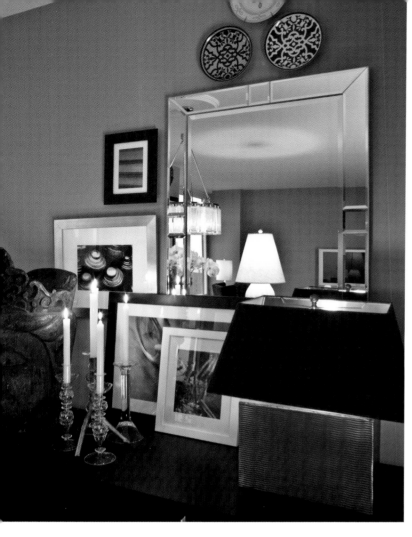

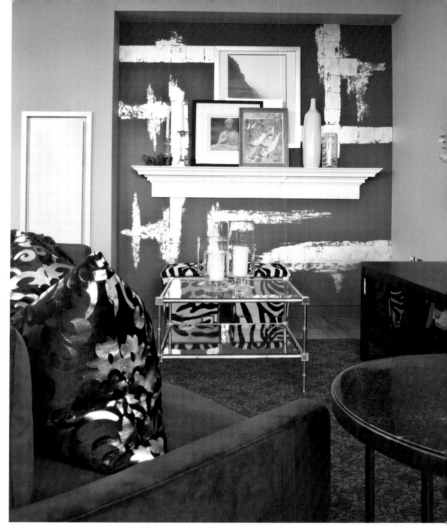

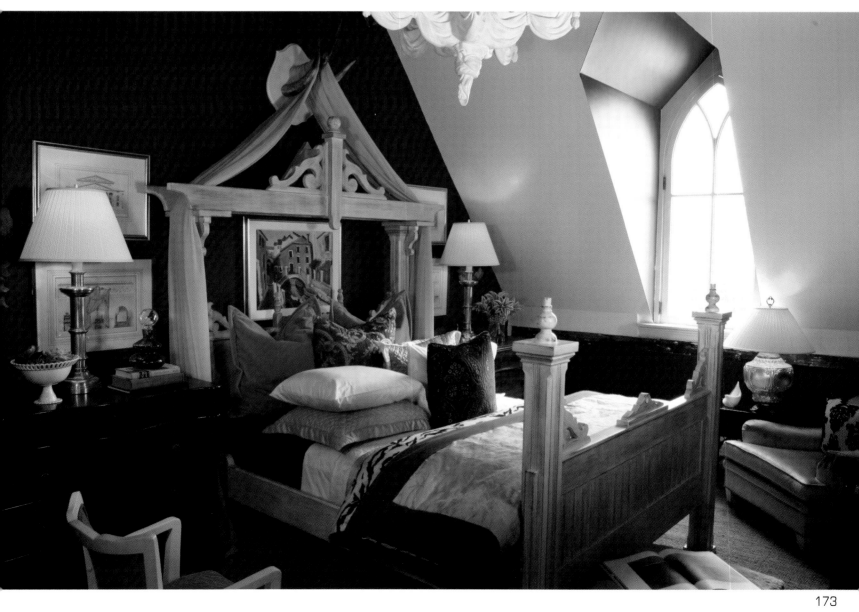

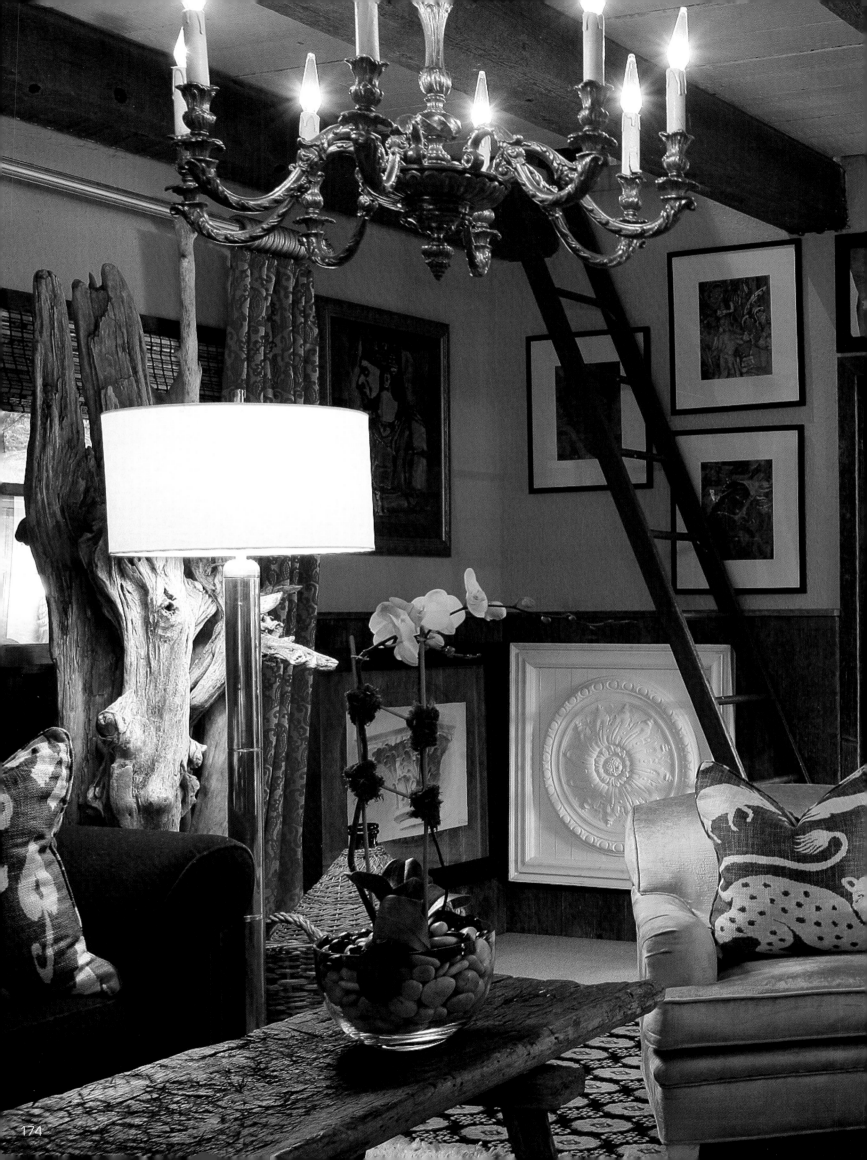

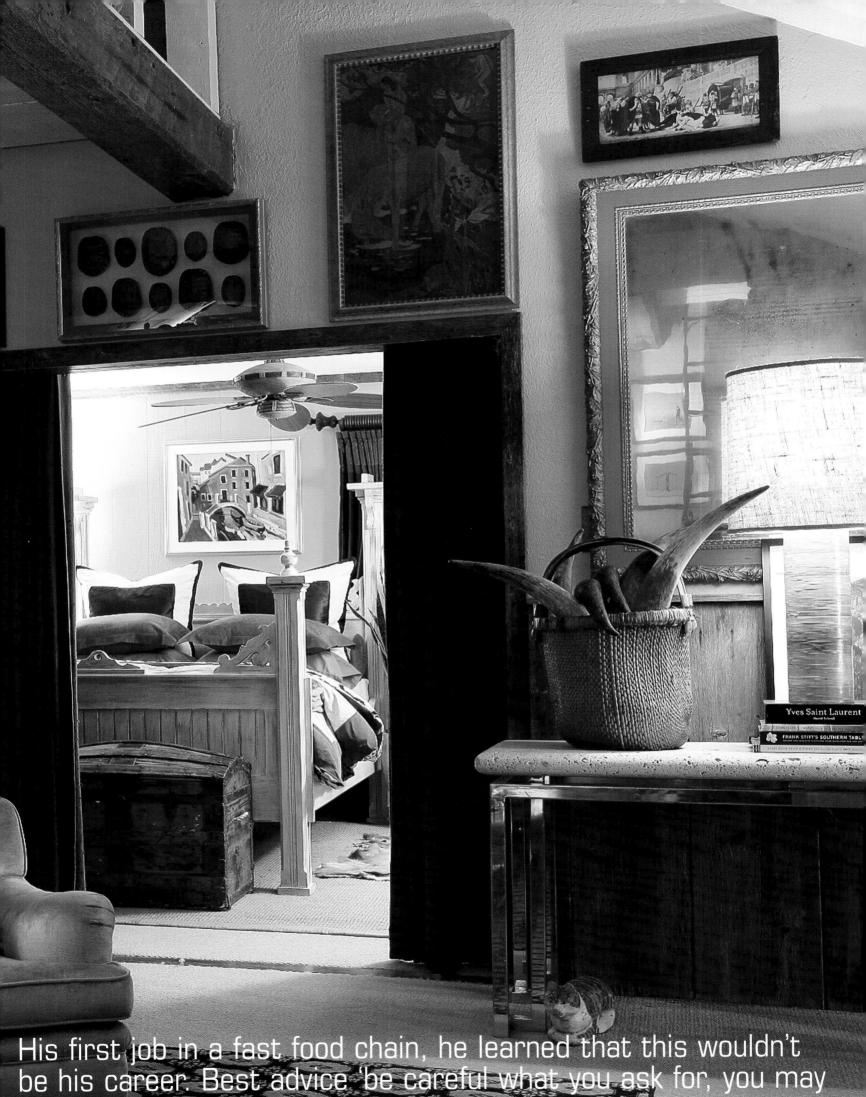

His first job in a fast food chain, he learned that this wouldn't be his career. Best advice 'be careful what you ask for, you may get it'. His epitaph will be 'I came. I saw. I created'.

Designers: Nick & Christian Candy.
Company: Candy & Candy, London.
Profile: Predominantly private commissions internationally, specialising in houses, yachts and jets. Current work includes two apartments in Belgravia and La Belle Epoque, Monte Carlo. Recent projects include work for private clients in Palma, Dubai and London.

Watch collector, partial to the finer things in life, Nick's home town is Monaco, inspiration sailing around the Med in his yacht Candyscape. Favourite shopping Rodeo Drive, best car The Maybach, favourite sport Grand Prix. Best home comfort Crème de la Mer lip balm, fragrance Michael Kors. Most memorable meal at Gobbi, Florence. Best hangover cure McDonalds. Favourite holiday Thailand. First job as an accountant taught him to change career. Secret crush Emily Blunt, favourite model Naomi Campbell, uniform Nurse. Admires Richard Rogers, would like to have met Winston Churchill. He'd nominate his father for sainthood for being the backbone of the business. Secret to long life getting the balance right.

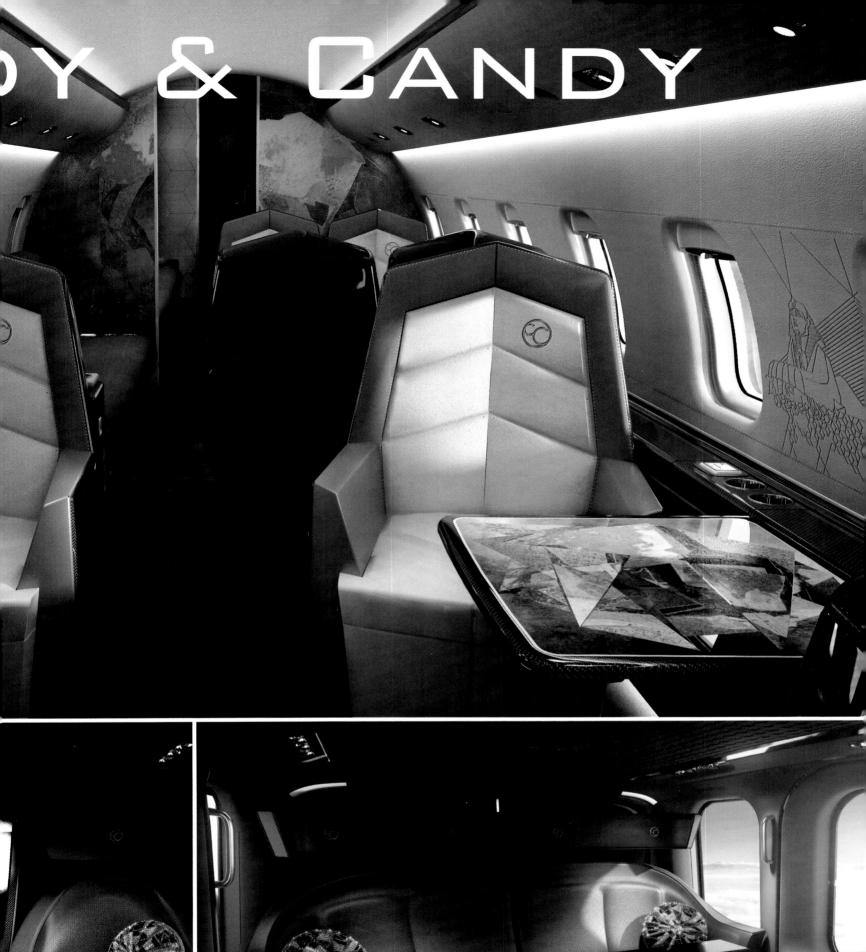
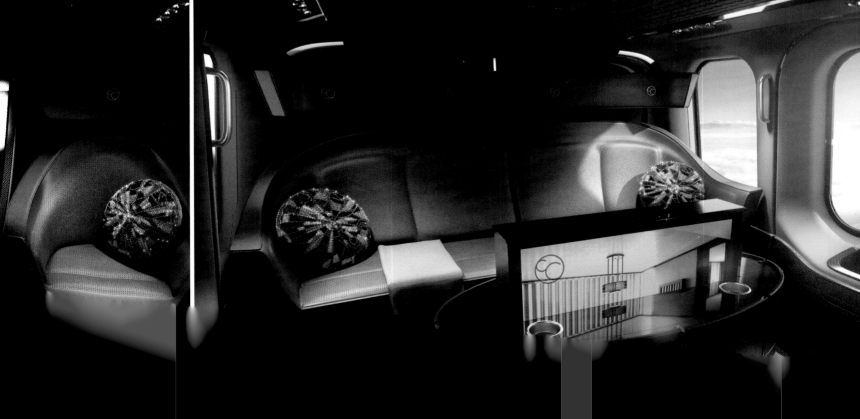

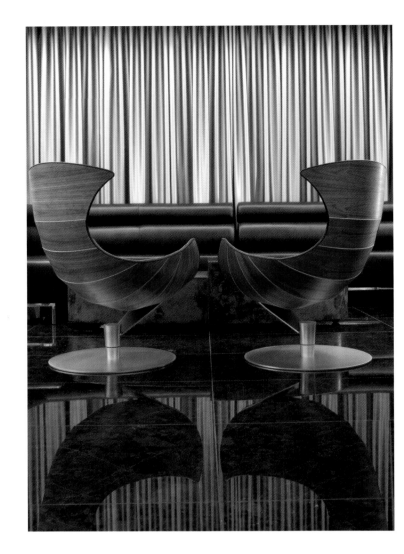

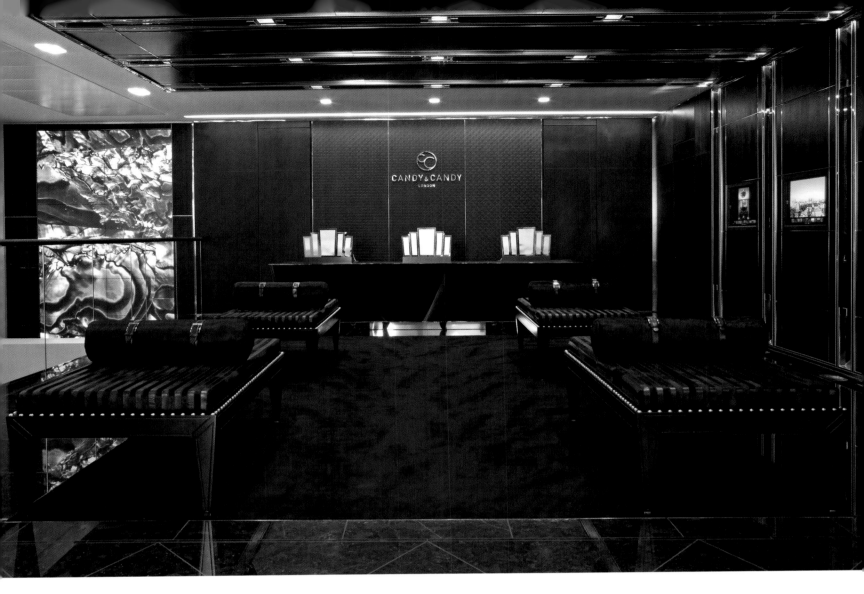

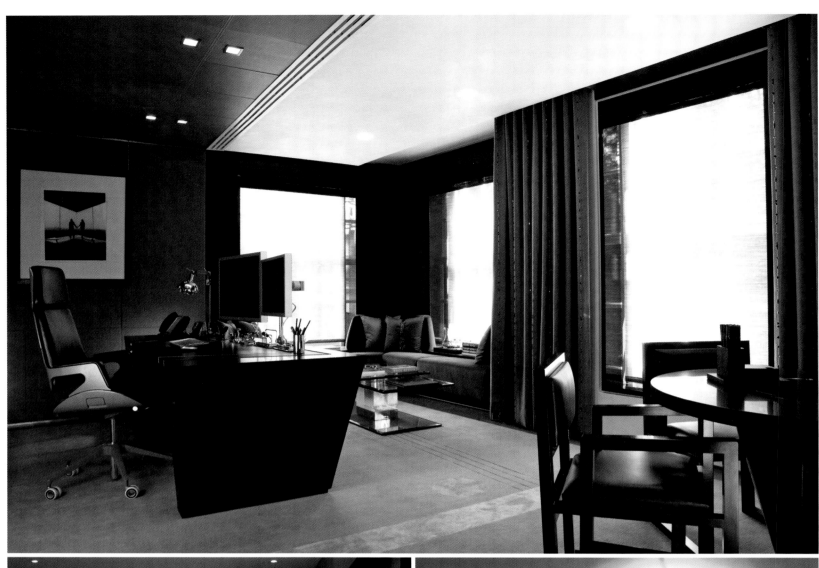

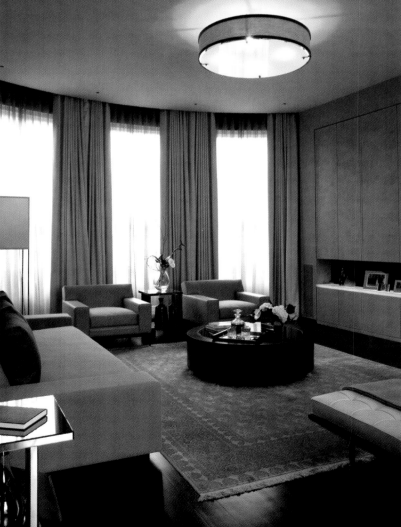

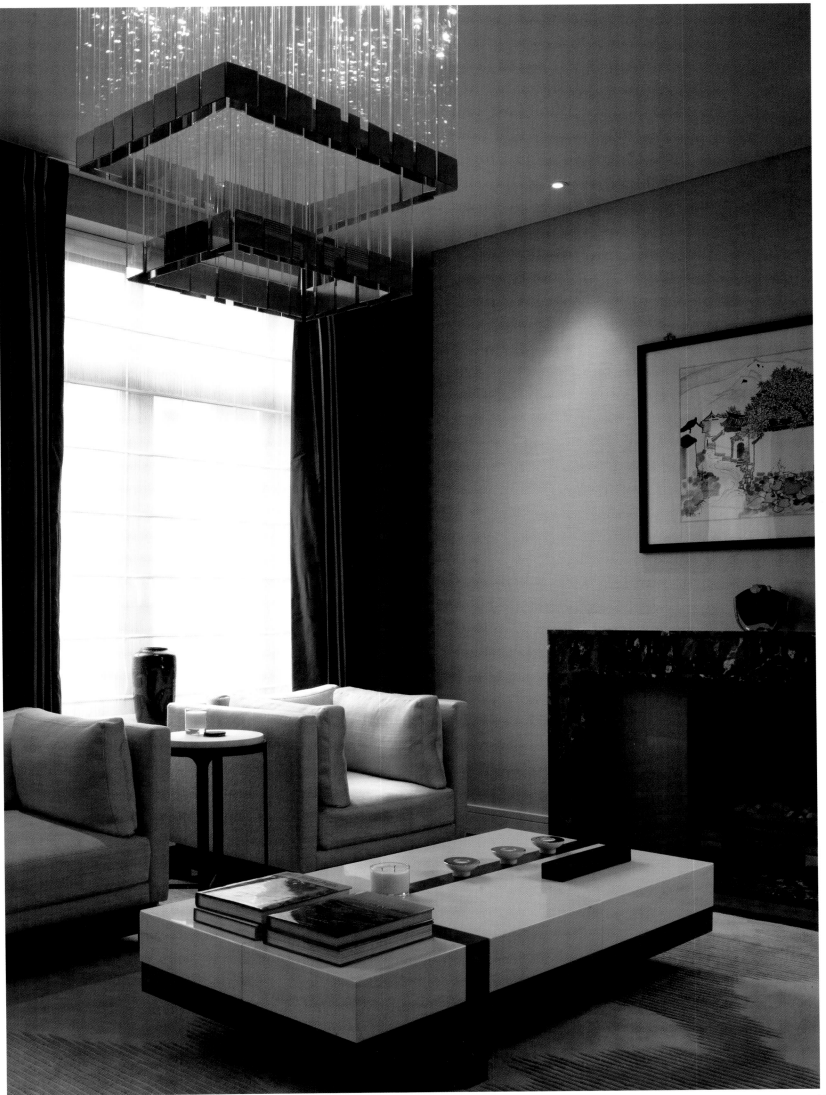

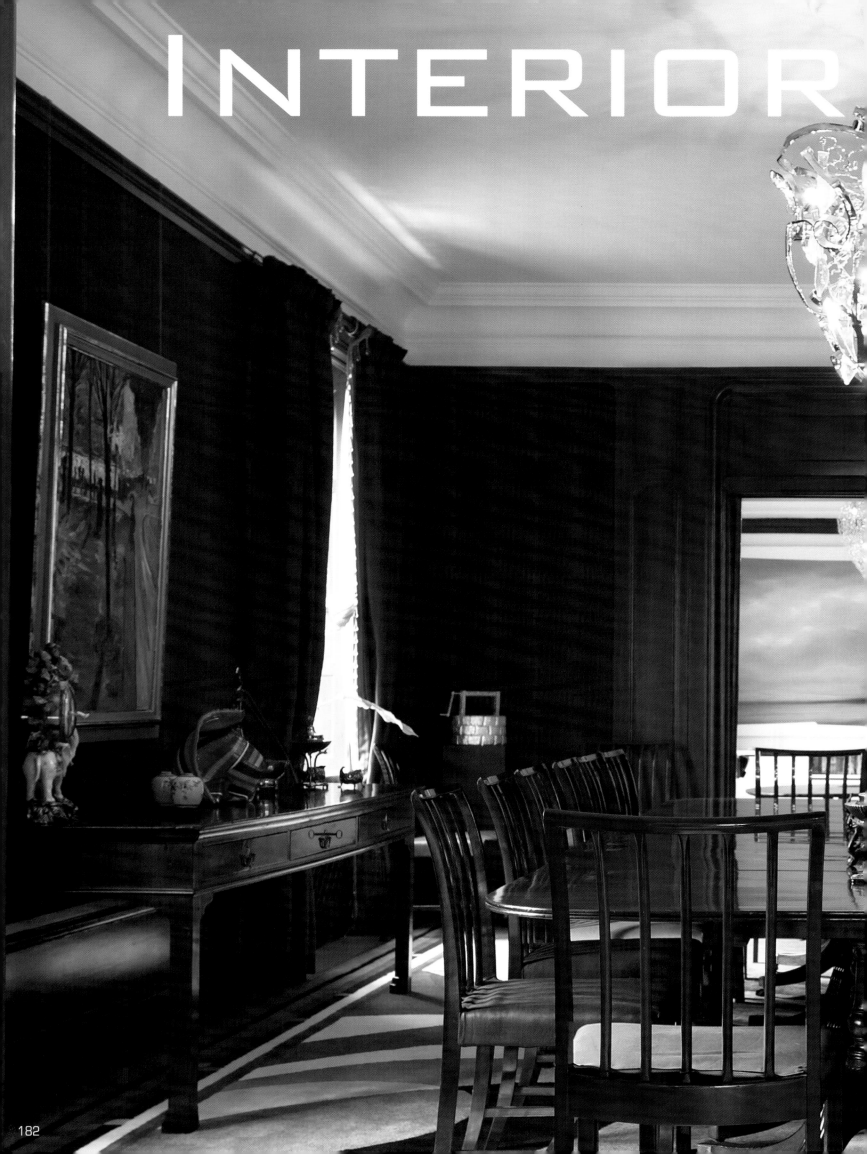

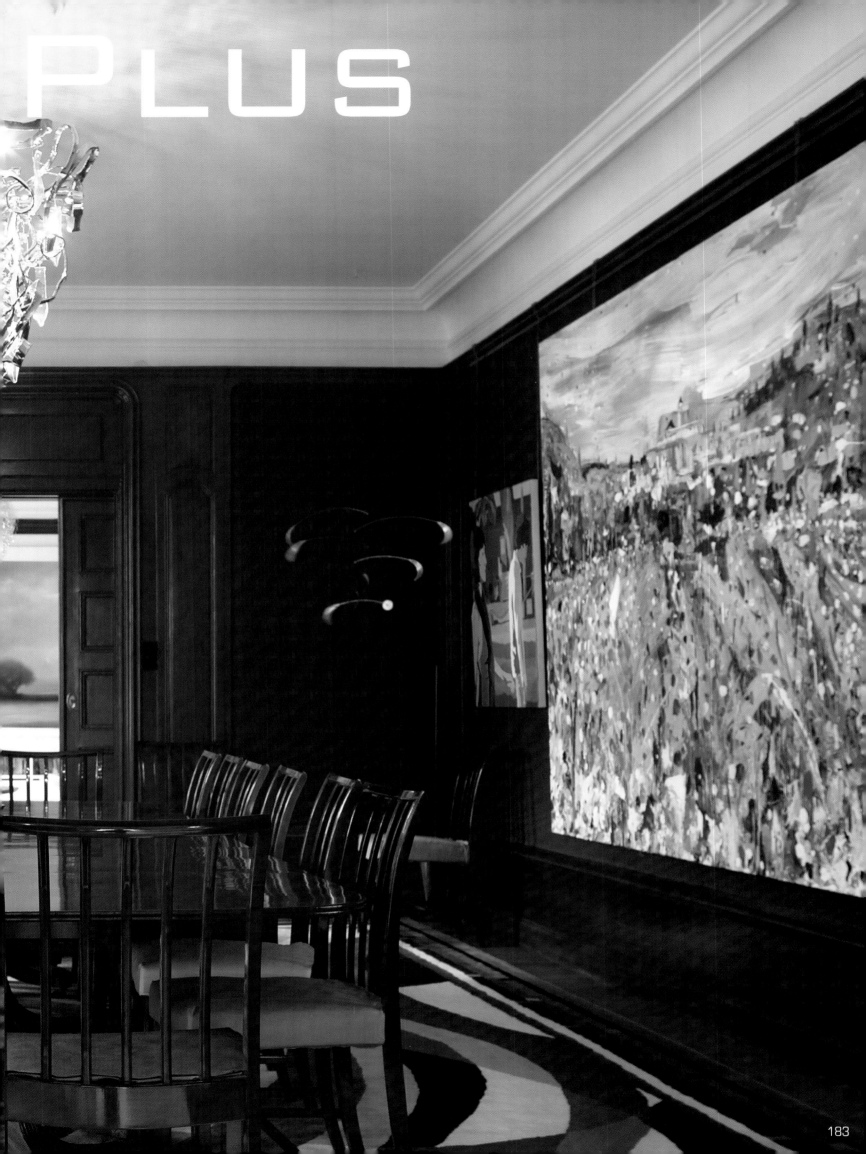

Wannabe stripper who's hot to trot, greatest extravagance his horses. When Eric's not cracking the whip in jodhpurs, cashmere and striped socks are his everyday outfit, hopefully with trousers. He'll dress to impress and wore a uniform belonging to the Danish King at his last fancy dress party. Happiest on a full stomach and with economic satisfaction, least happy remembering his gym teacher called the Gherkin. Eric's epitaph will be 'private - keep off'.

Designer: Erik M. Andersen.
Company: Interior Plus,
Stockholm, Sweden.
Profile: Specialising in high
end private and commercial
projects predominantly in
Scandinavia. Recent work
includes a large flat in
Stockholm, a country house,
showroom and art gallery.
Current projects include a
large apartment for a
Swedish pop star.

JOE BLACK
THE TAILOR

Design Directors: Paul Hecker, Kerry Phelan & Hamish Guthrie. Company: Hecker, Phelan & Guthrie, Victoria, Australia. Profile: Predominantly retail and residential in Australia, Shanghai, Kuala Lumpur and India. Recent projects include The Ivy, Sydney, Bistro Guillaume at Crown Casino, Fjäll Ski chalet, Falls Creek, Victoria. Current work includes Watermark on Balmoral Beach, Domaine Chandon Experience bar and restaurant Coldstream, Yarra Valley and Collette Dinnigan retail store.

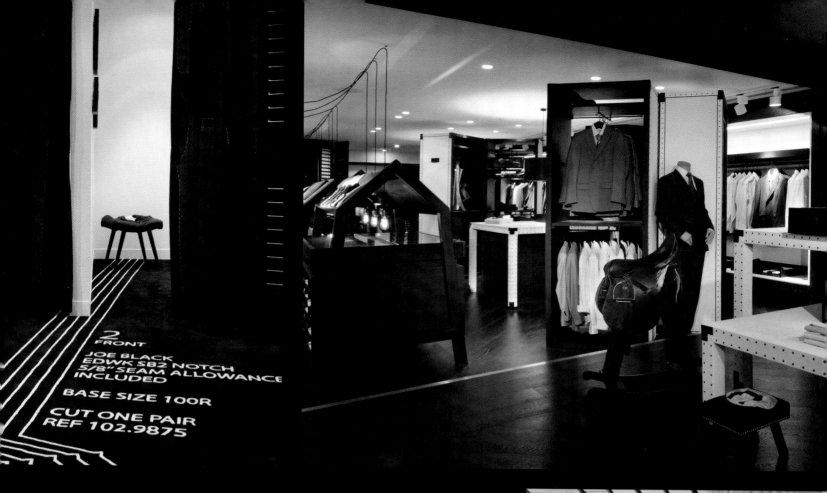

Paul would represent Australia in an international modelling competition. Best outfit a floral Pucci boiler suit. Favourite saying 'I'd rather be mutton dressed as lamb than mutton dressed as mutton'. He'd meet Oprah to nominate her for sainthood and Hitler to ask 'what was your problem?'. Favourite takeaway, hamburger and chips, or Lean Cuisine from the petrol station. Loves Lautner, Lanvin and Linda Evangelista. Greatest skill, talking. Secret of long life, good blood pressure, best advice from his doctor 'take blood pressure tablets'. If he isn't listening to Cat Stevens, he falls asleep with the TV on and dreams about The Antiques Road Show. Paul's a Bower Bird, a collector of many things and anything Royal Copenhagen. Fantasy job, a big ship, greatest extravagance furniture, happiest rearranging it.

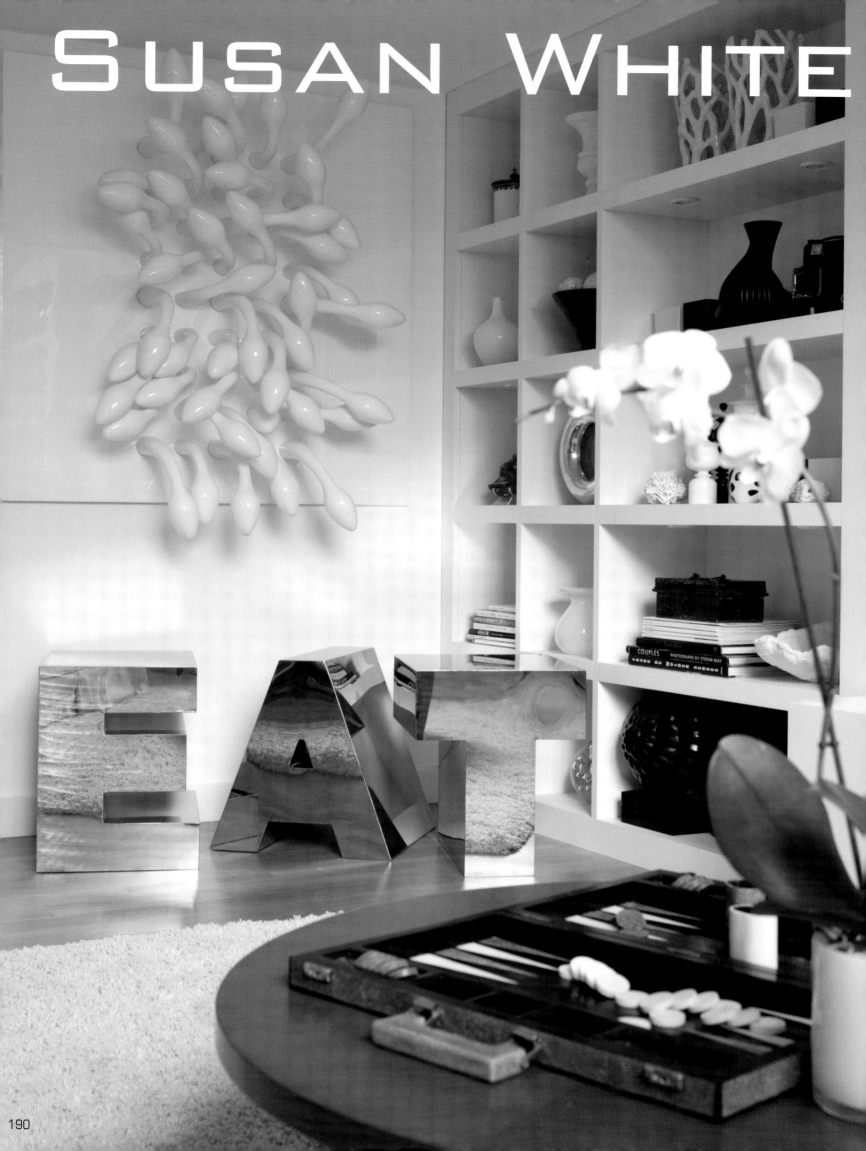

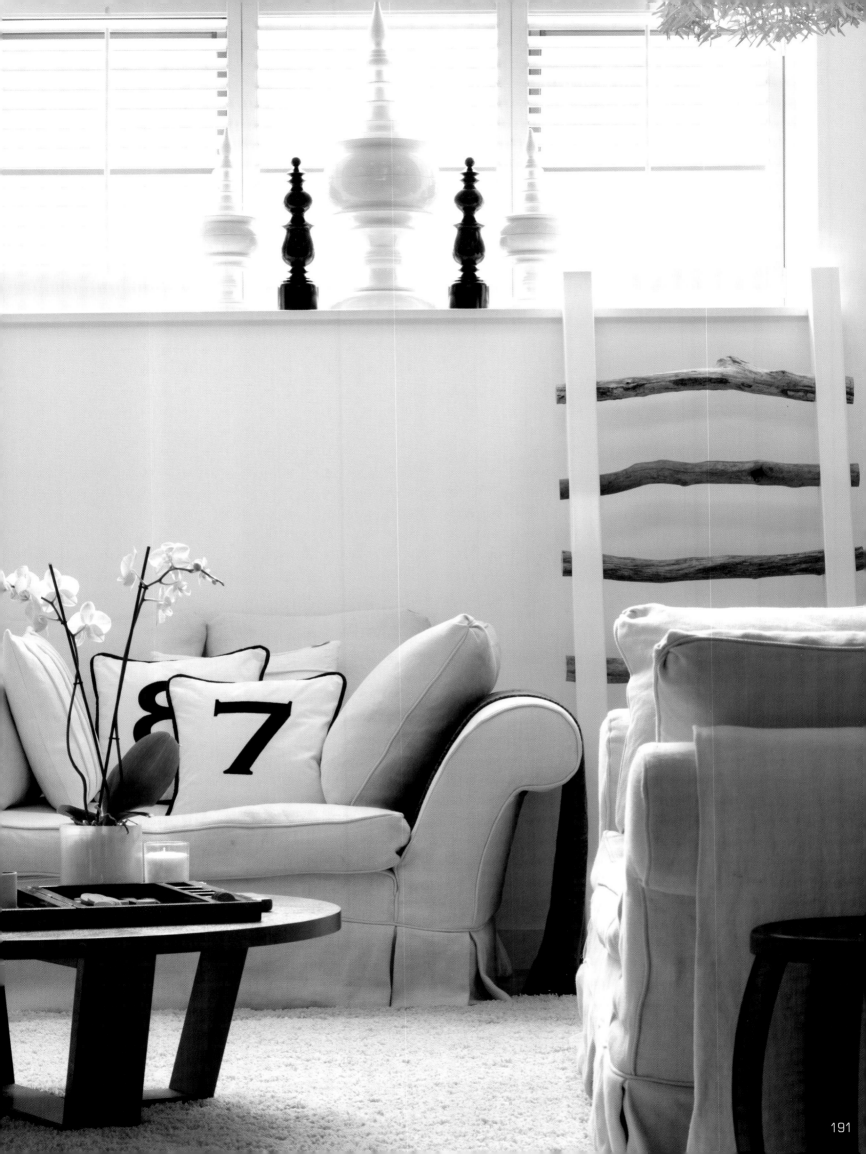

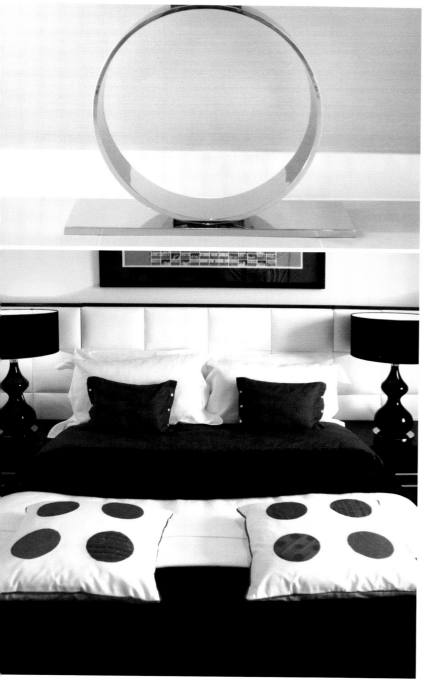

Designer: Susan White. Company: Phoenix Interior Design, Ockley, U.K. Profile: Privately owned practice based in an old converted milking parlour set in beautiful countryside. They specialise in high end work for private clients and celebrities plus commercial projects mainly across Europe. Current work includes the private residence of a high profile actor, a central London pied à terre and a Grade II listed hotel conversion in North London.

Susan finds clarity when walking her dogs and inspiration from the peace and quiet of her home town, where slippers and a cup of tea are her favourite comfort. Susan's best skill is hearing not just listening. Proudest of her team and resourceful in business, for Susan decorating is not a process, but a journey and destination. Her epitaph, 'I told you I was ill.' Favourite saying 'God pays debts without money.' She wishes she were Doctor Doolittle or Howard Carter. Loves Jimmy Choos, Hugh Jackman, Frank Lloyd Wright, Nat King Cole and diamonds.

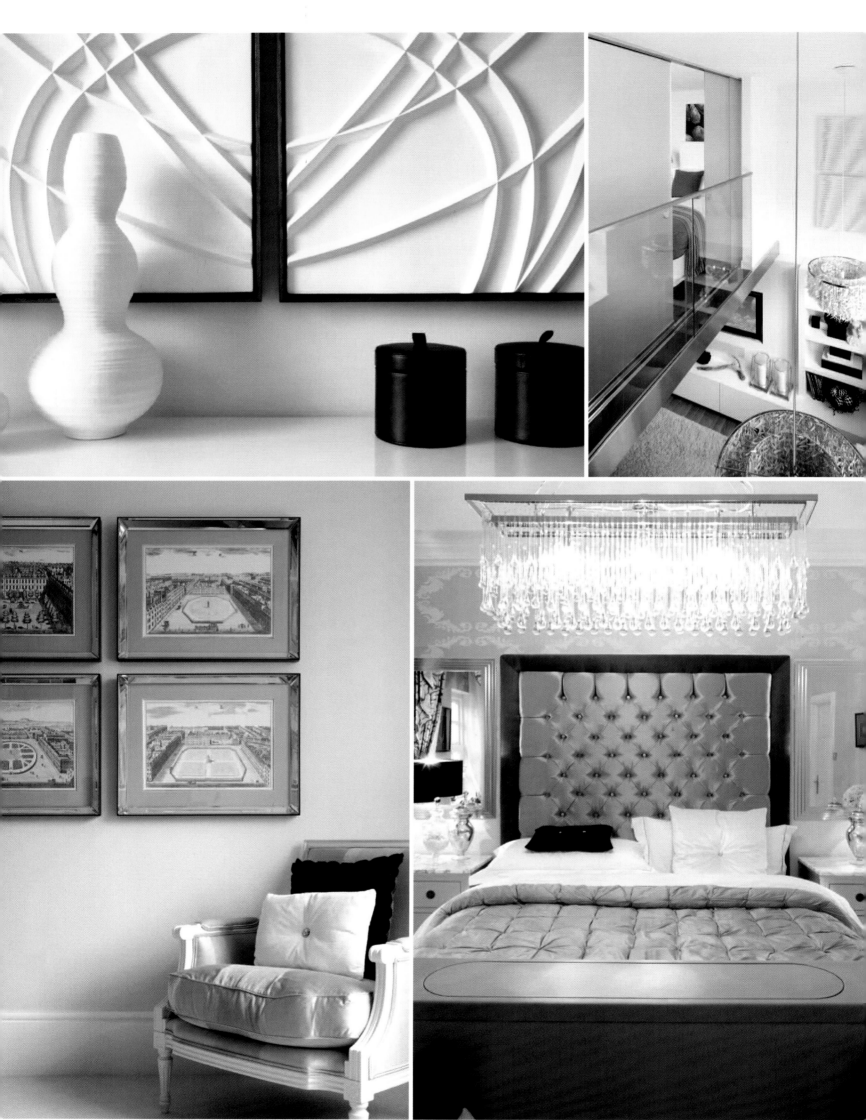

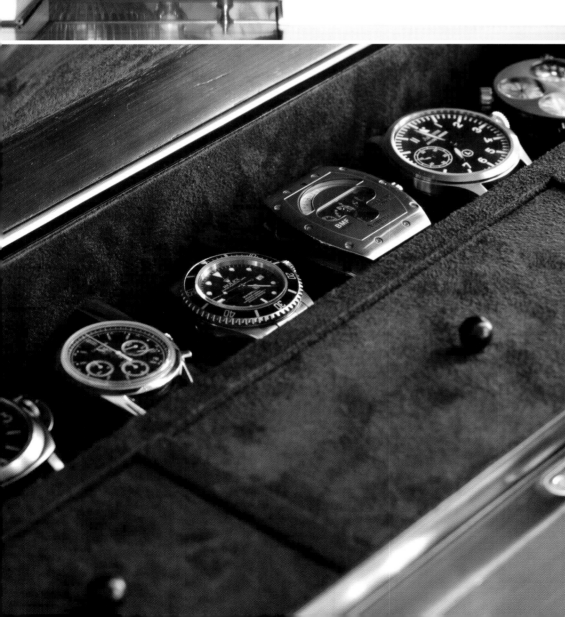

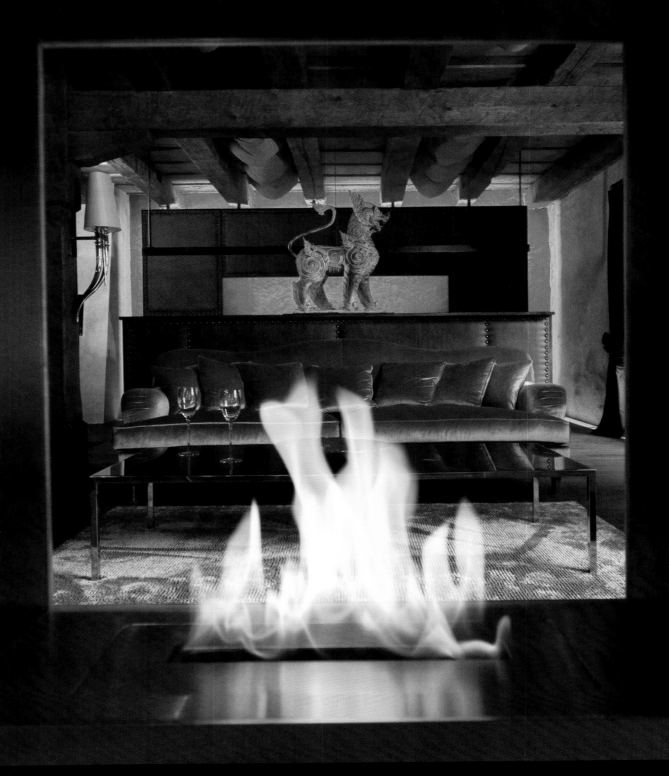

Designer: Markus Wyttenbach. Company: Wyttenbach Innendekorationen, Thun, Switzerland. Profile: Historic showroom and workshops situated in a former granary on picturesque Lake Thun, gateway to the Alps. Projects include alpine chalets, apartments, hotels, yachts and event decoration in Switzerland, Europe and America. Recent work includes a seaside house in Finland, a mountain chalet with bespoke furnishings and various suites of a hotel.

Markus has his priorities right. Favourite saying, 'never say never'. A positive thinking perfectionist he'd rather age happily and healthily than elegantly, as long as he can ski. Favourite home comfort, lying in a hot bath under a starry sky in front of his alpine chalet. Greatest extravagance, Ragusa chocolate. A country boy at heart, he began his career as a saddler, it taught him to be meticulous. Earliest memory, gathering chestnuts in a park, his childhood ambition was to become a farmer. The secret of long life is 'taking only short steps', as long as nobody treads on his feet.

JI YUN

Designer: Ji Yun.
Company: Honyo Decoration &
Design, China.
Profile: Predominantly private
residences including some
commercial work. Recent projects
in Beijing include a modern villa, a
flat and a café. Current work
includes a traditional Si He Yuan
(traditional courtyard with houses)
near to the Summer Palace,
three sets of model rooms in
Weifang, Shandong Province and
a villa in Qinhuangdao, Hebei
Province, China.

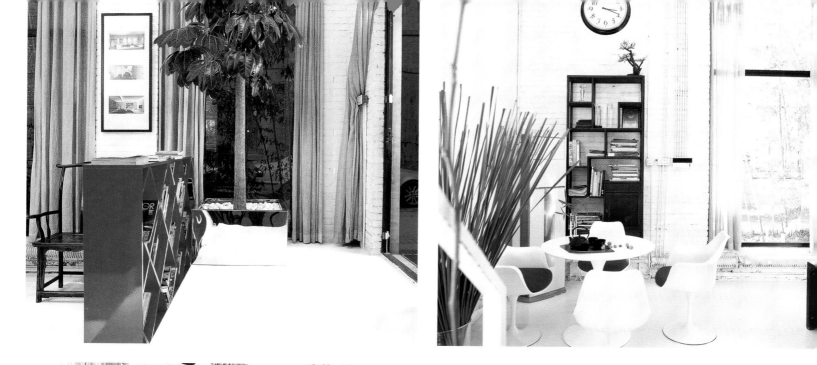

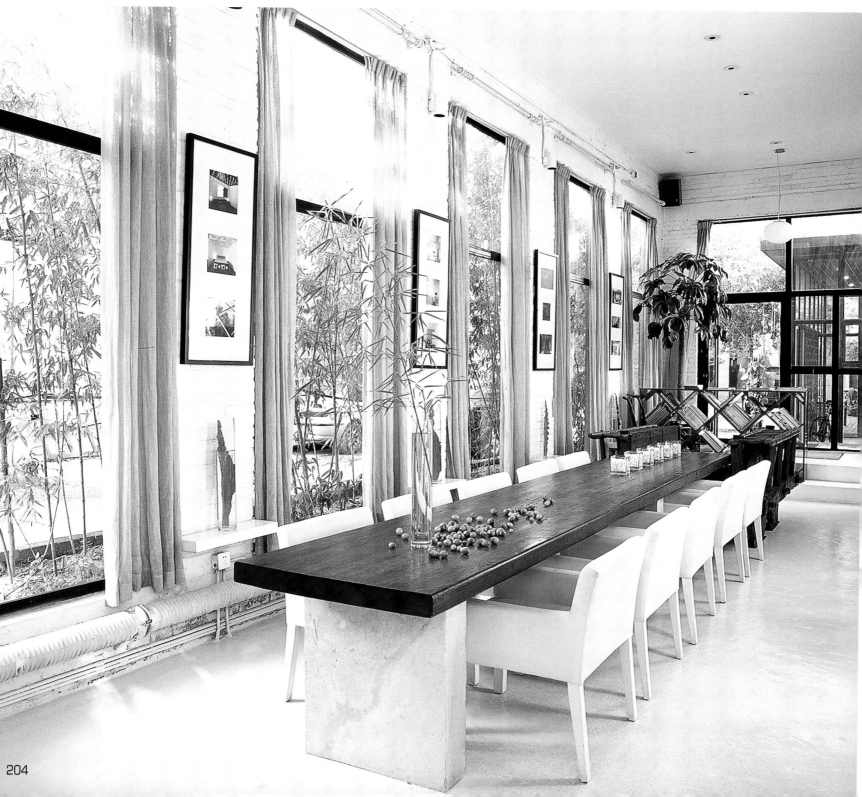

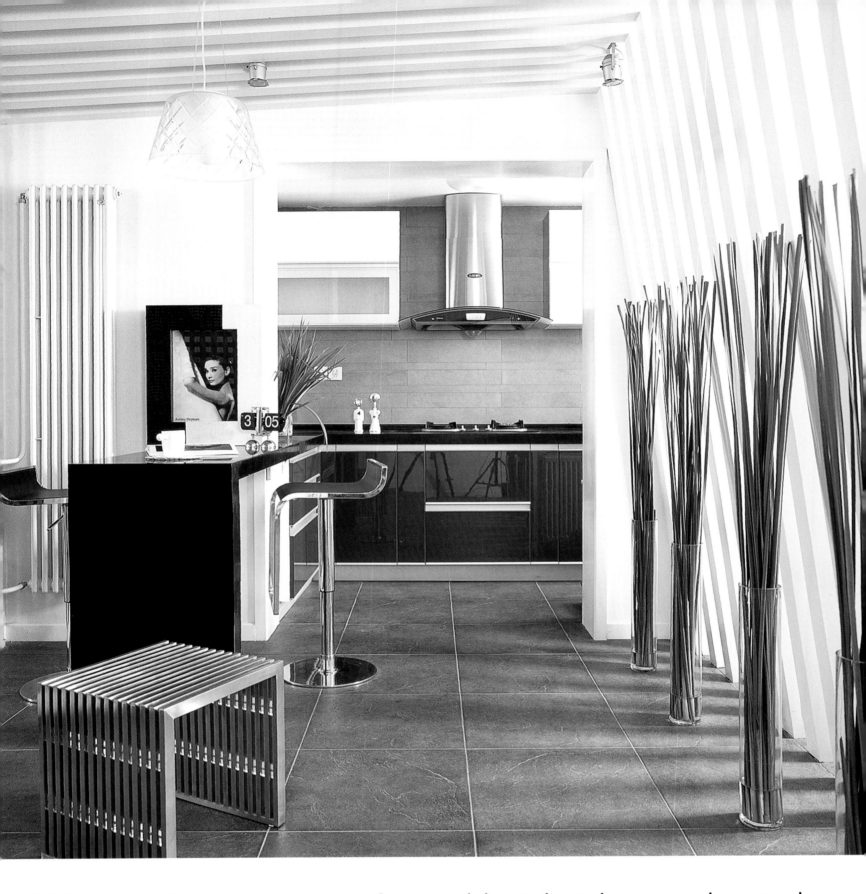

Ji Yun got into his career by accident but is now devoted to it. Dreams of worldwide recognition for Chinese design. Most valued things in business sincerity and persistence. Favourite architect I. M. Pei. Best skill confidence, curiosity and collecting tea sets. His epitaph will be 'As heaven maintains vigour through movements, a gentle man should hold the outer world with a broad mind'.

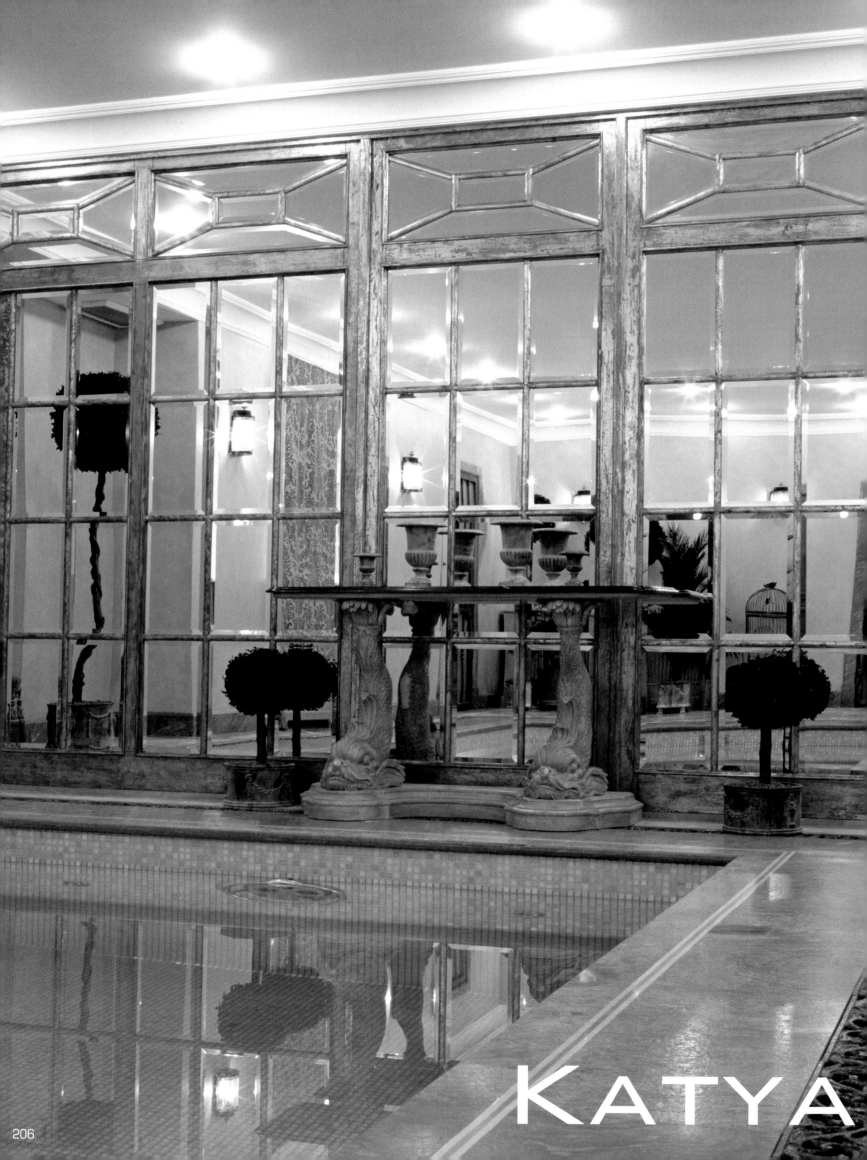

KATYA

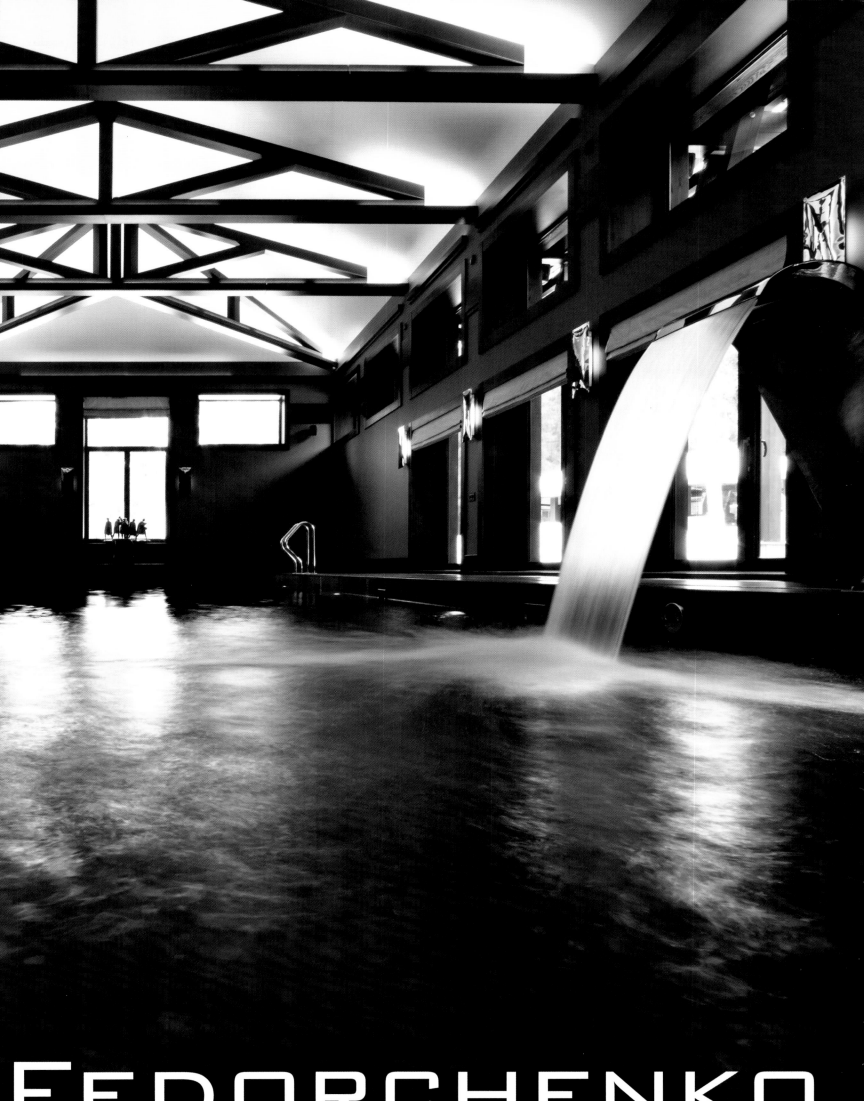

FEDORCHENKO

Designer: Katya Fedorchenko.
Company: Katya Fedorchenko Architectural
Bureau, Moscow.
Profile: Specialising in private and commercial
interior construction in Moscow, France, Italy
and the U.K. Recent projects include private
modern houses, a country house for horse
lovers and two classical style apartments.

A mountain skier,
passionate about travel.
Stunt woman Katya would
like to join a French
équipe to visit the Arctic.
Favourite holiday, with
the man she loves, the
worst, without him.
Chicer than ever, Katya is
now dressed in
Yamamoto, fragranced in
Comme des Garçons 3
and shops in Avenue
Montaigne.

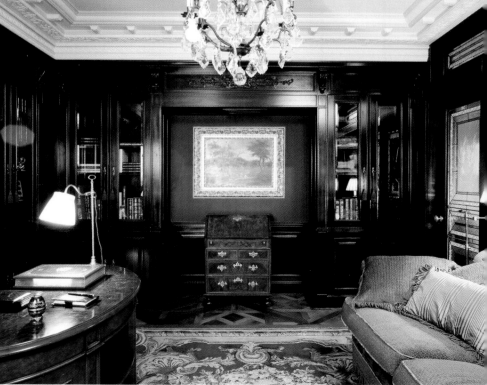

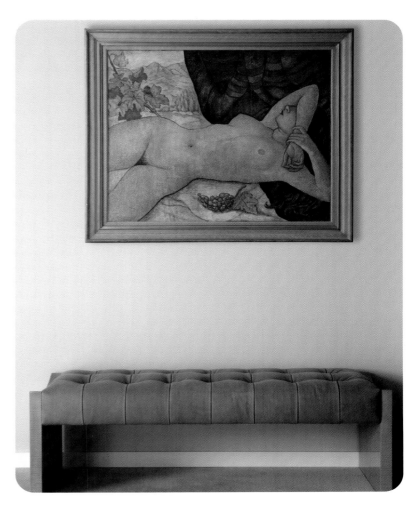

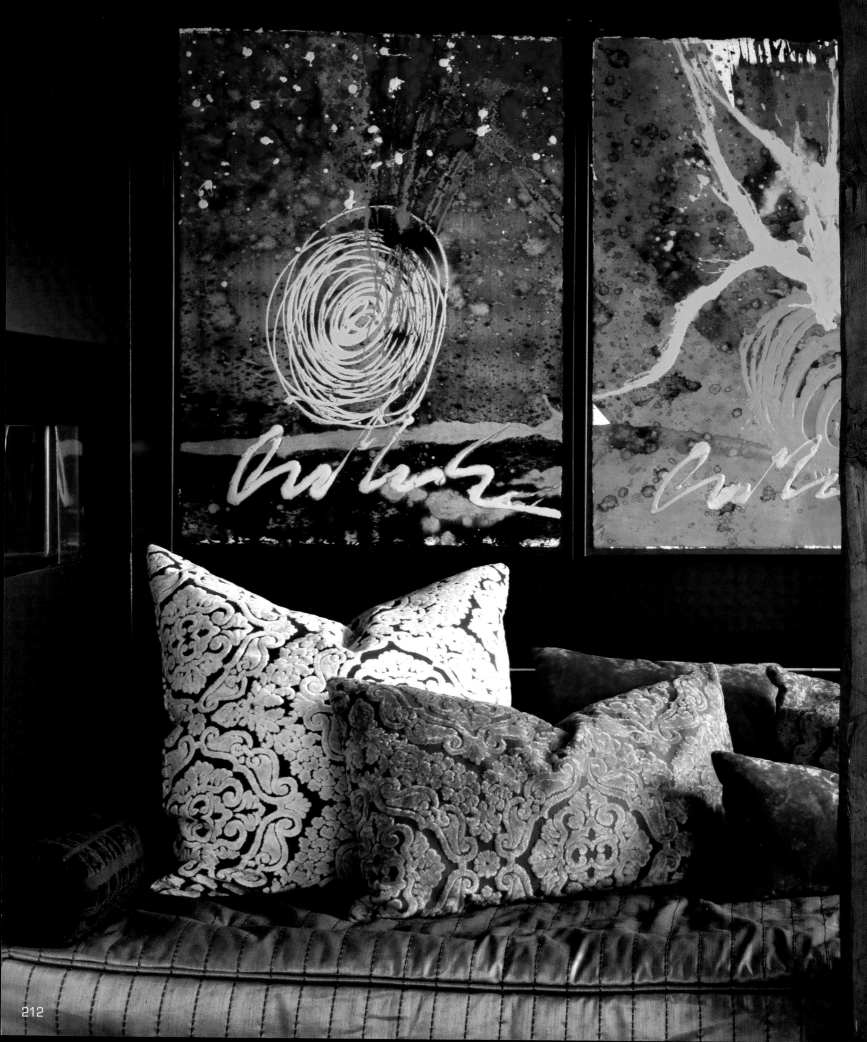

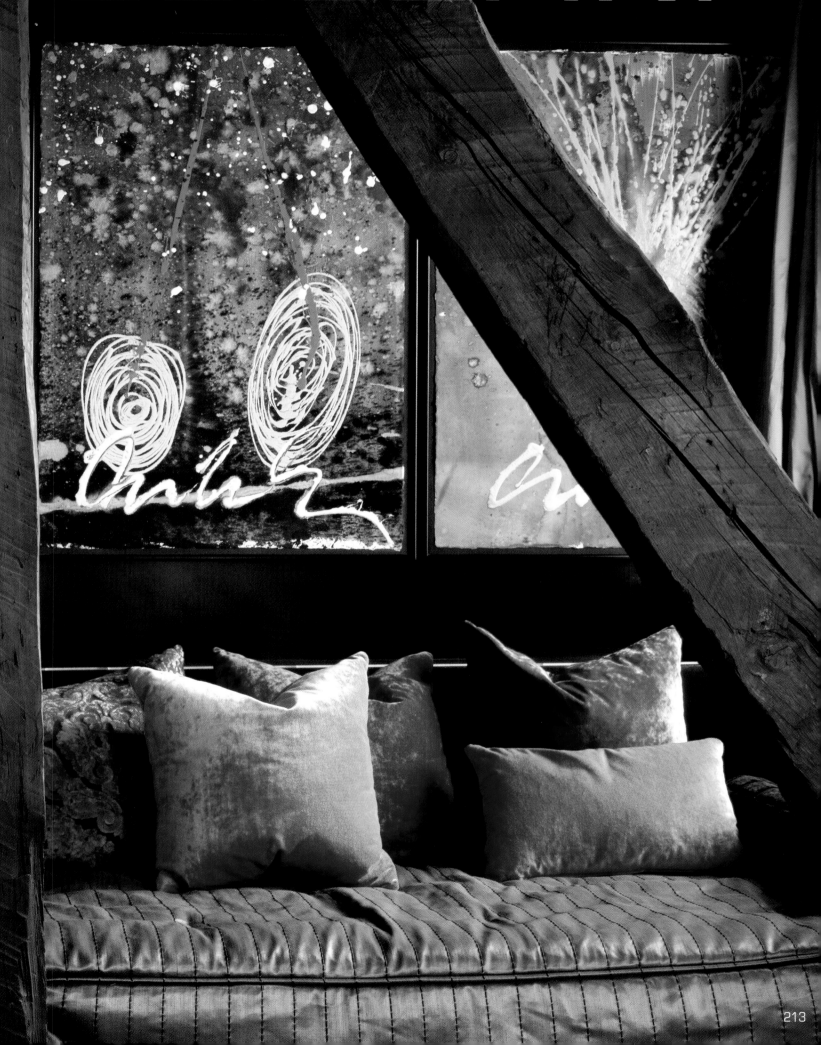

Designer: Claudia Pelizzari.
Company: Archiglam, Brescia, Italy.
Profile: Tailor made work for private houses, hotels and spas. Recent projects include a palace on the Grand Canal, Venice, a penthouse in Rome and a tree house in Tuscany. Current work includes villas in the Ukraine and Malaysia plus a farmhouse in Tuscany.

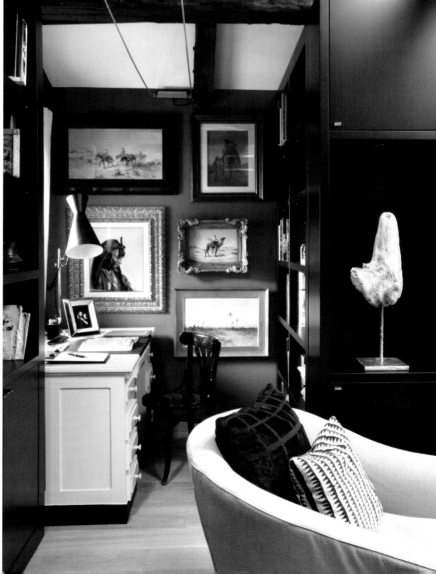

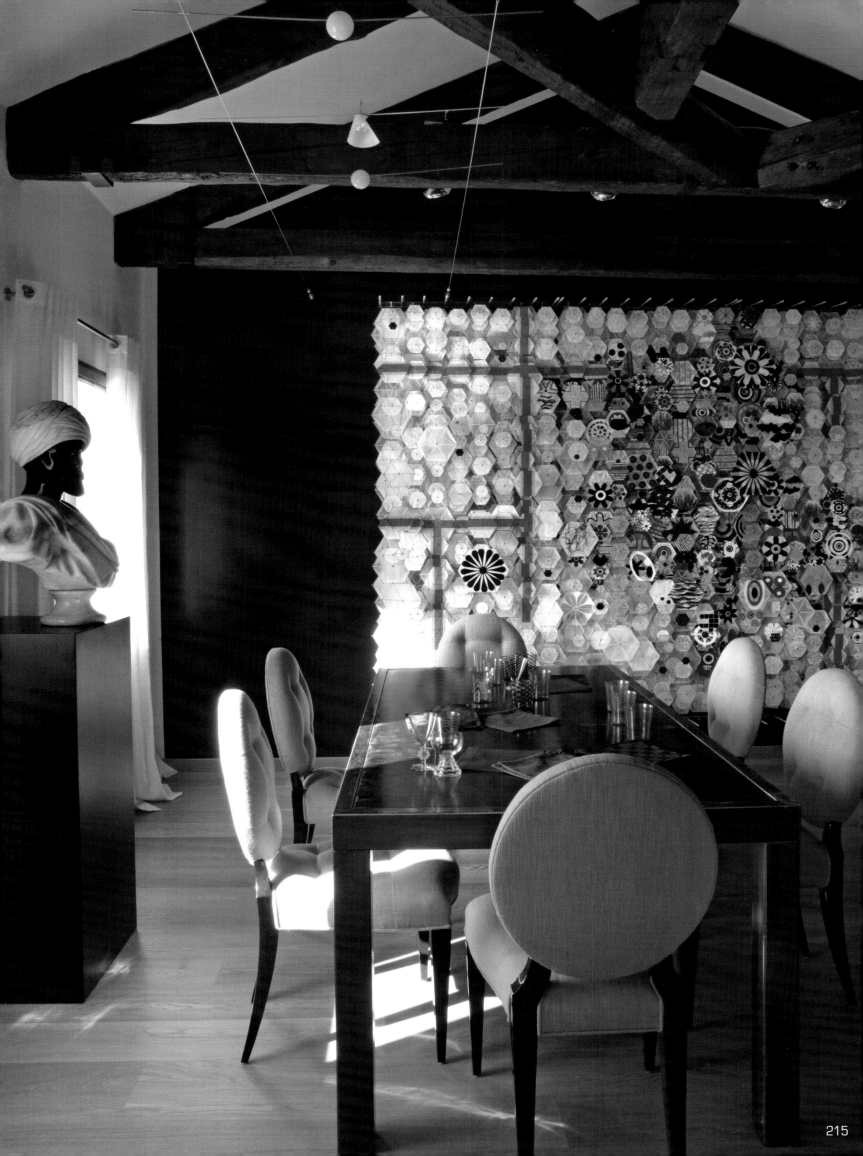

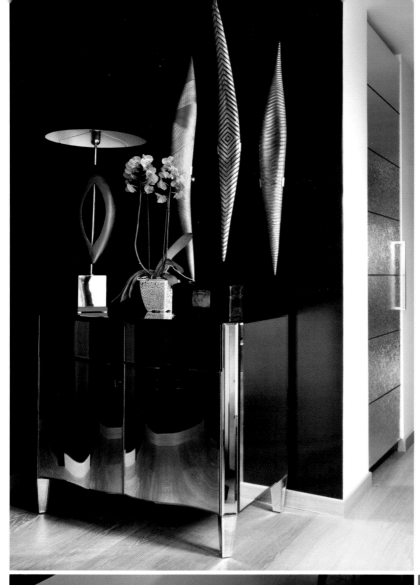

Cool, creative fashionista, Claudia sees the world with a smile. Prada and positive thinking are the secrets of long life. Happiest under the sun with a book or shopping in London's King's Road. A country girl at heart, Claudia's earliest memory is climbing almond trees in her grandmother's garden. In business her greatest skill is gauging a design scheme by a client's dress sense. A trendsetting decorator, she dreams of designing houses in Beverly Hills and a hotel in the snow. Irritated by arrogance and fast food, she cries at the movies, loves the theatre and Disneyland.

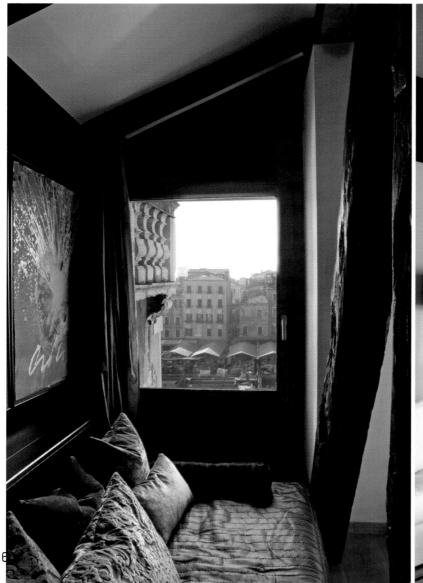

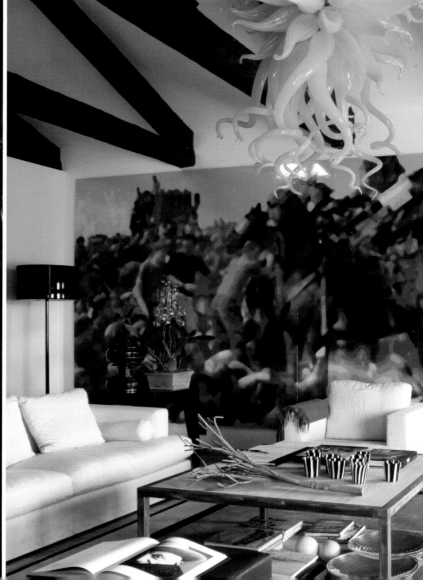

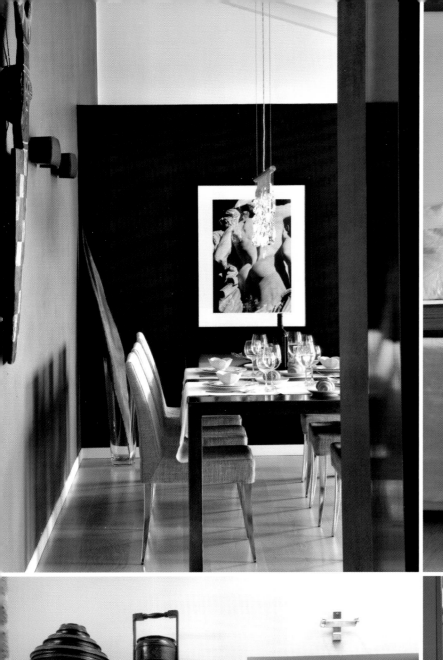
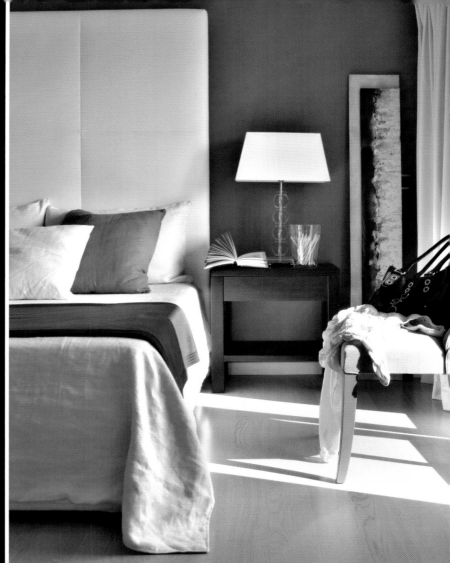

KUSTER

Designer: Eric Kuster.
Company: Eric Kuster Interior Stuff, The Netherlands.
Profile: Private and commercial work internationally, specialising in complete design concepts for houses, restaurants, hotels, boats, planes and offices. High profile clients include saxophonist Candy Dulfer and footballer Ruud Gullit. Erik's portfolio includes villas and penthouses in Marbella, Dubai, Moscow and Bali. Most recently he has opened showrooms in Amsterdam, Dubai and Moscow, with Egypt and Slovenia to follow soon.

Night owl and fantasy DJ for whom wireless internet connection is the greatest home comfort. Loves wrist watches, 5 star hotels, Blue Blood jeans and Kate Moss. Amsterdam is his inspiration and air miles his reward. Favourite saying 'work hard, play hard.' He does both. Eric thinks he will age well, it's cost a fortune so far. Happiest opening new showrooms for his own furniture collections, he dreams of becoming a world wide lifestyle brand.

Sera's greatest extravagance is bubble baths. Favourite fragrance Agent Provocateur, designer Galliano, model Gisele, architect David Bristow. Favourite meal at The Tawaraya Inn, Kyoto, Japan. Sera listens to romantic French music and Gill Scott Heron. Favourite holidays sailing and swimming around exotic islands. Home is London, inspiration Portobello Road. Favourite home comfort her children.

Designer: Sera Hersham Loftus. Company: Sera of London. Profile: Work is international, ranging from private homes and apartments, boutique hotels, beach houses and night clubs. Current work includes a Georgian house in St Johns Wood, a mews house in Primrose Hill and a Cotswold cottage. Recent projects include a beach house in Sri Lanka, an exotic dance club in Soho and a house boat in Amsterdam.

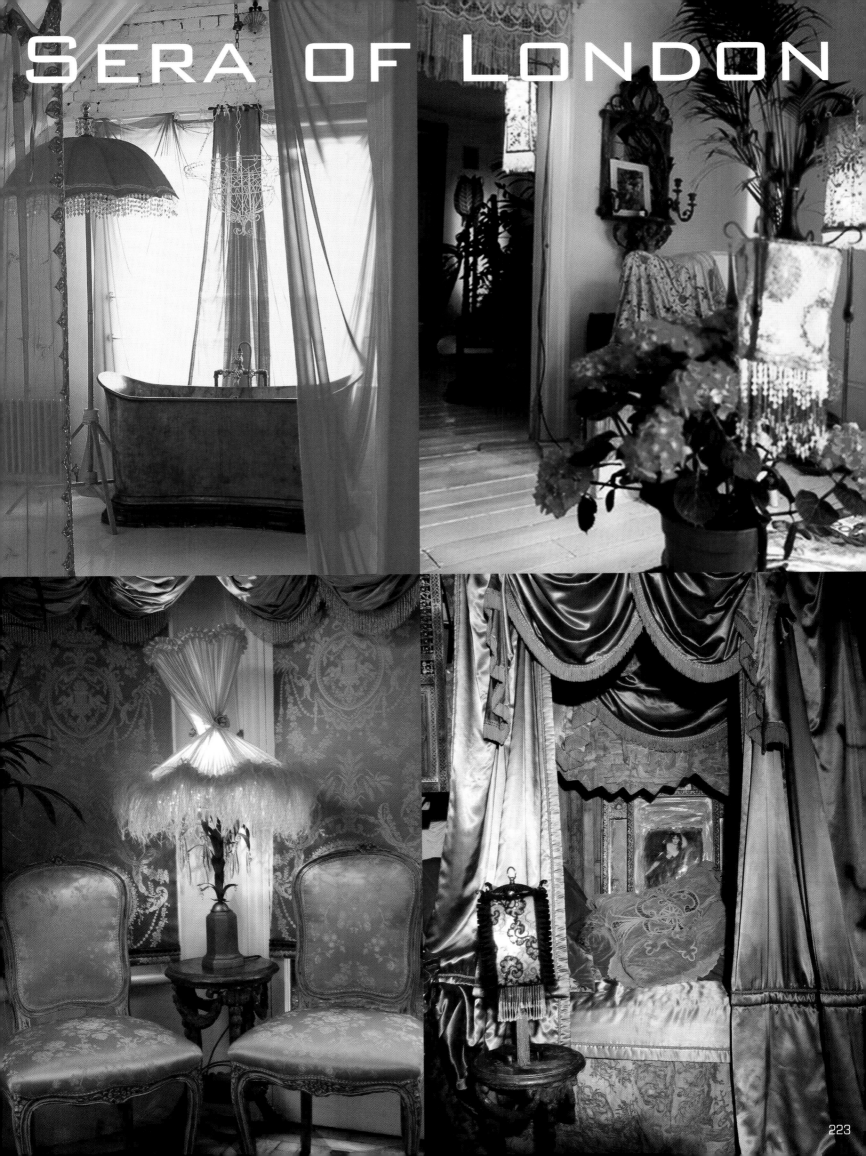

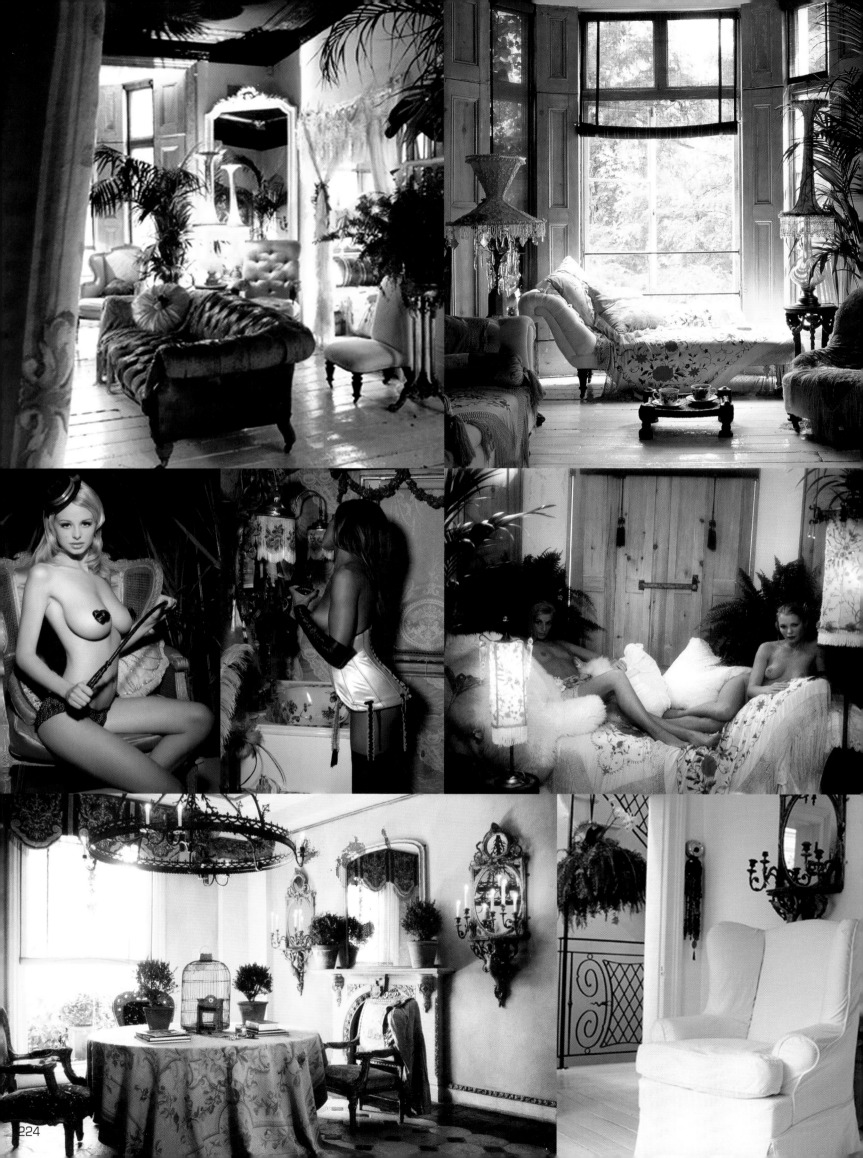

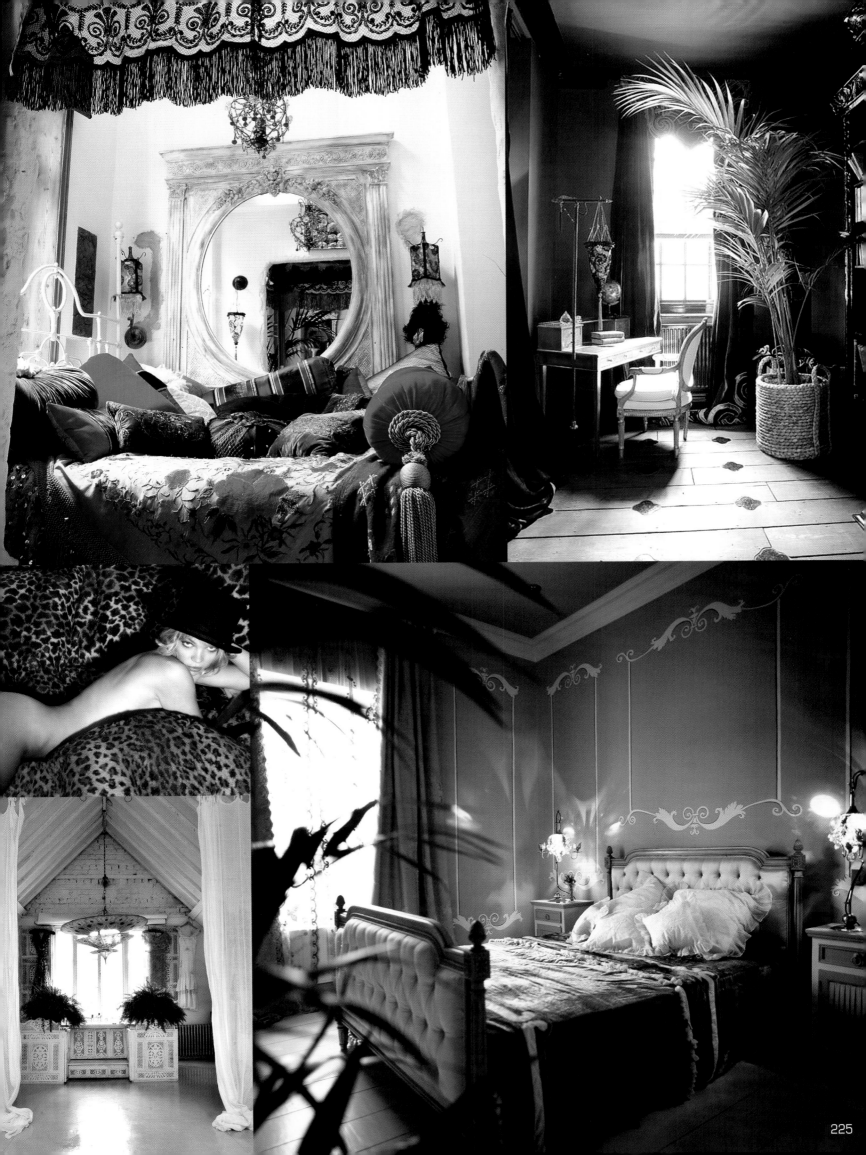

Designers: Susan Salisbury & Jessica Earle. Company: Classic Country Pub Design, Warwickshire, U.K. Profile: Design practice specialising in bars, restaurants and hotels. Recent projects include a boutique hotel in Cheshire, a bar and restaurant in Surrey and a pub in Essex. Current work includes a chalet in Austria, a bakery and delicatessen in Beaconsfield and a country pub and restaurant in Northamptonshire.

CLASSIC COUNT

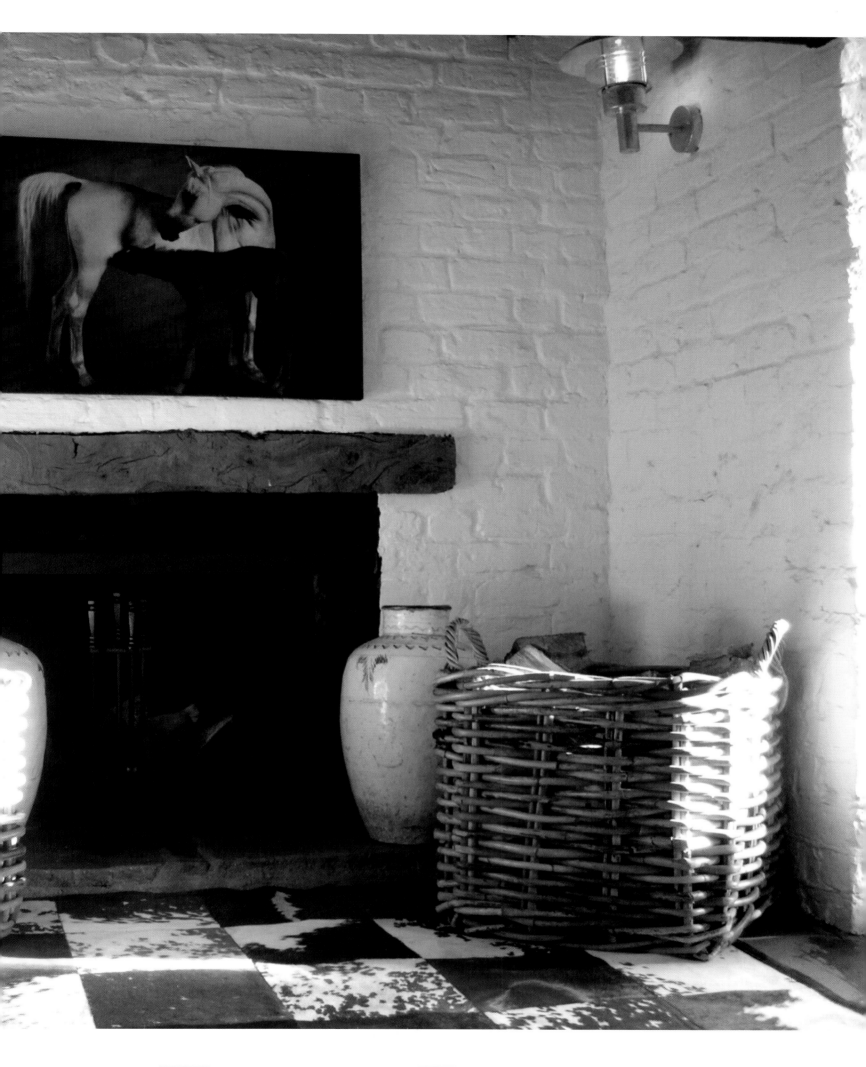

RY PUB DESIGN

Sue's most memorable meal barbequed mackerel on the beach in St Mawes. Favourite shopping Klooster-straat, Antwerp, worst holiday Vegas. Home comforts; log fire, cashmere socks, Côté magazines. Sue believes in ghosts, her grandmother appears as a Robin.

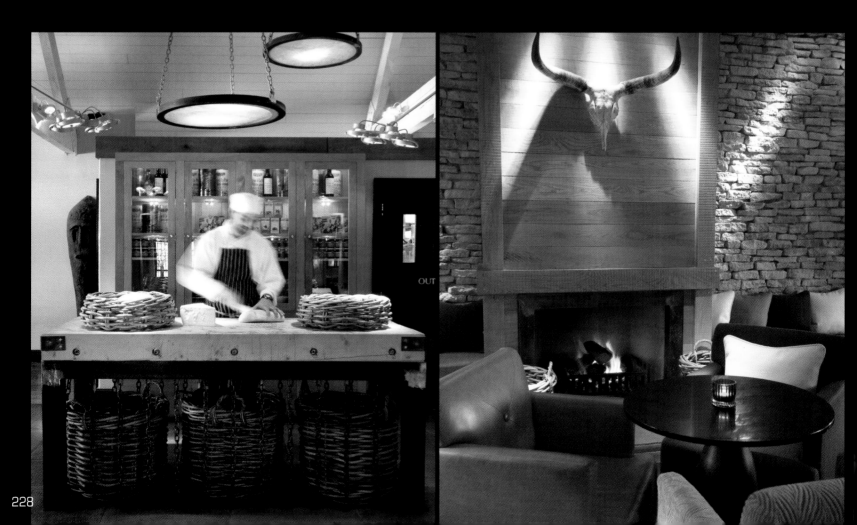

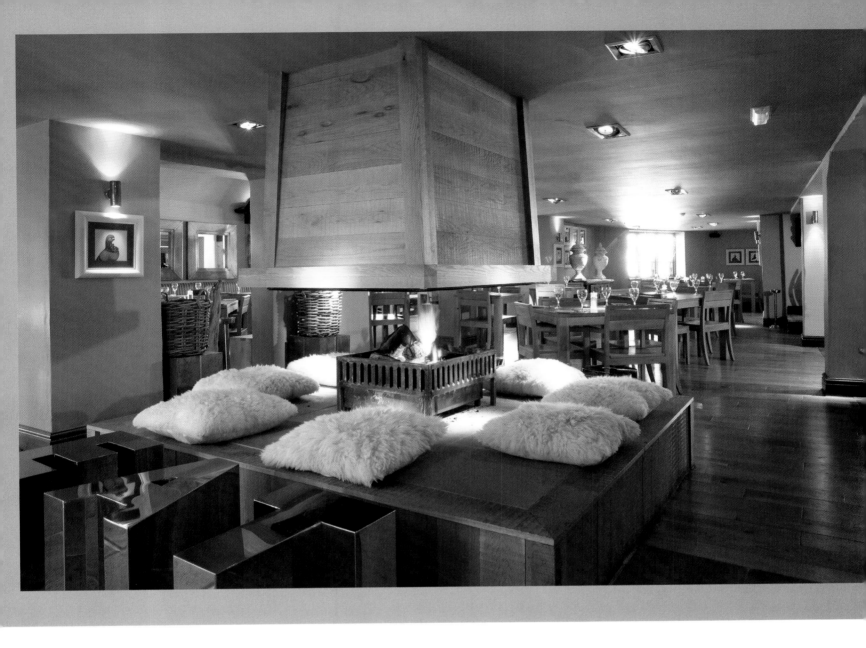

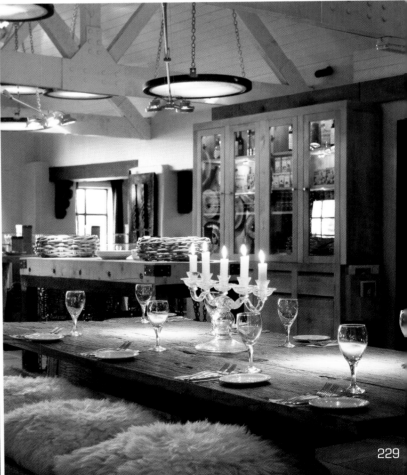

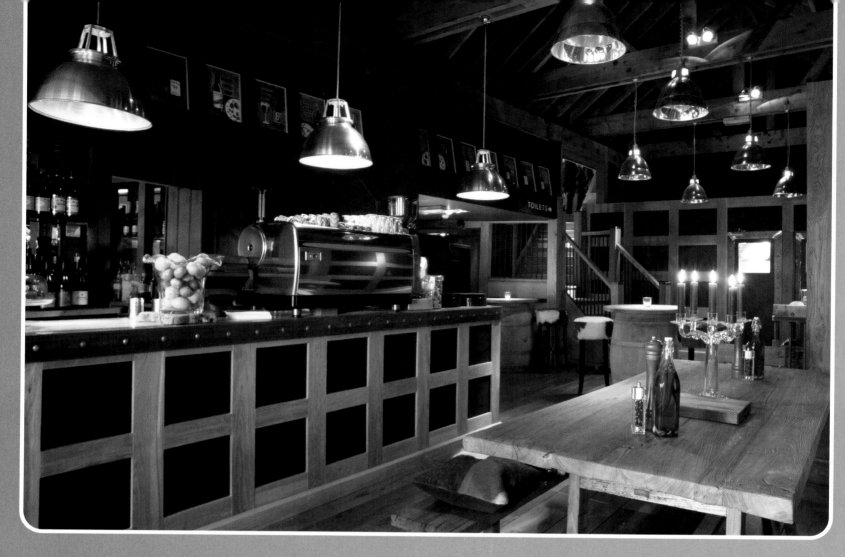

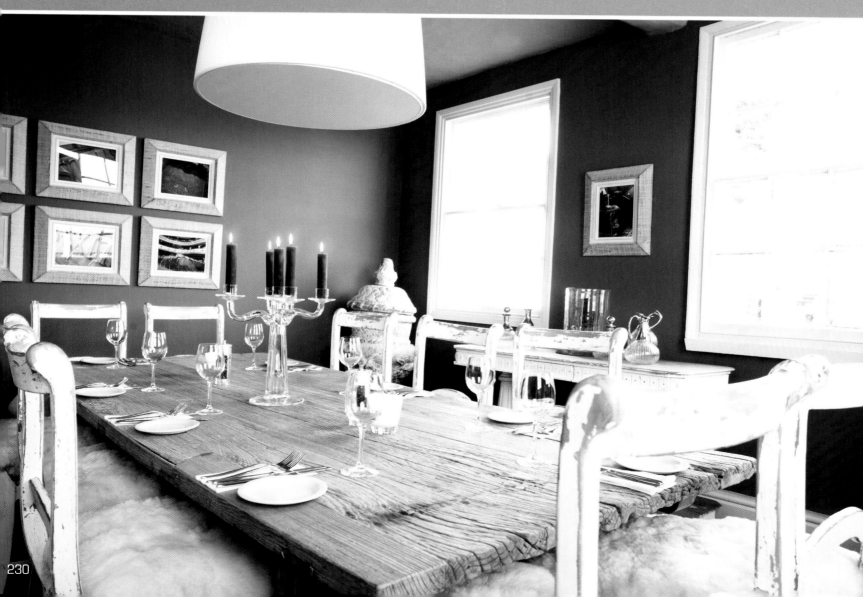

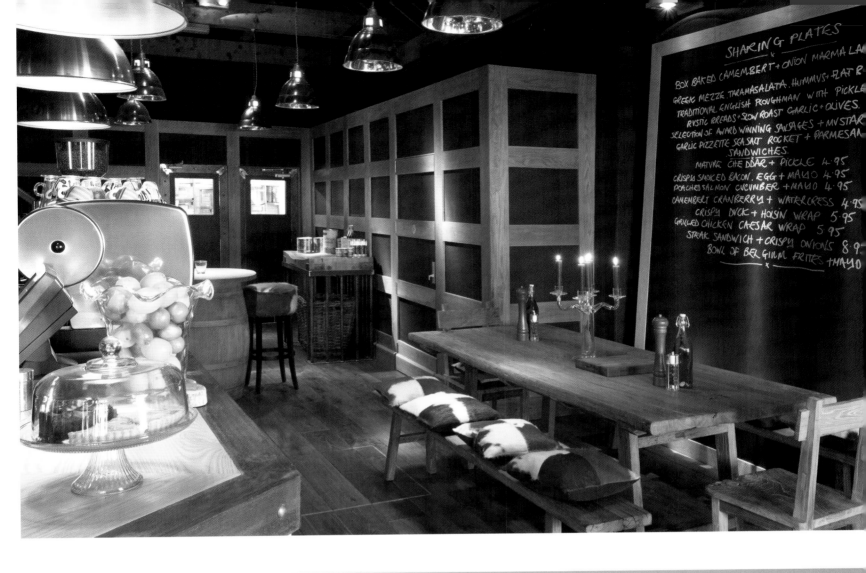

Jessica's earliest memory, picking primroses. First job selling ice creams. Most memorable meal oysters in Honfleur, favourite takeaway Crispy Duck pancakes. Best shopping trip Isle-sur-la-Sorgue, best holiday Soulac, French Atlantic coast. Jessica's ambition to be fluent in French. Her sport croquet, extravagance vintage cars. Her epitaph 'Are we there yet?'

231

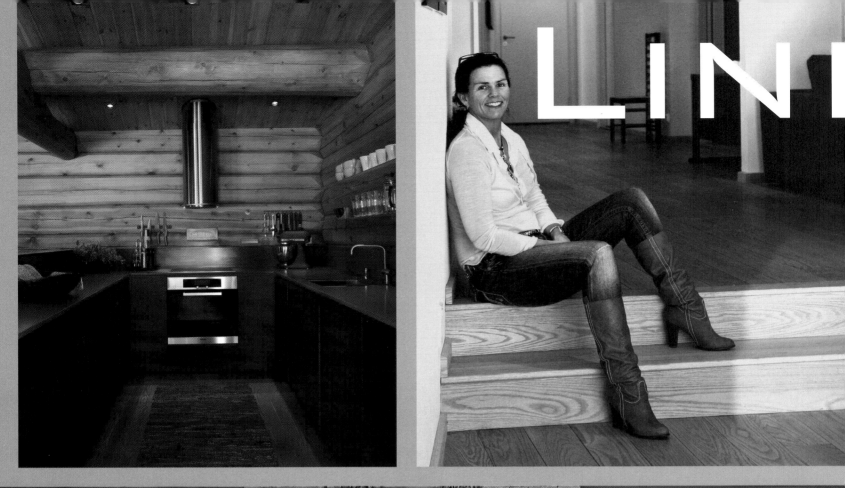

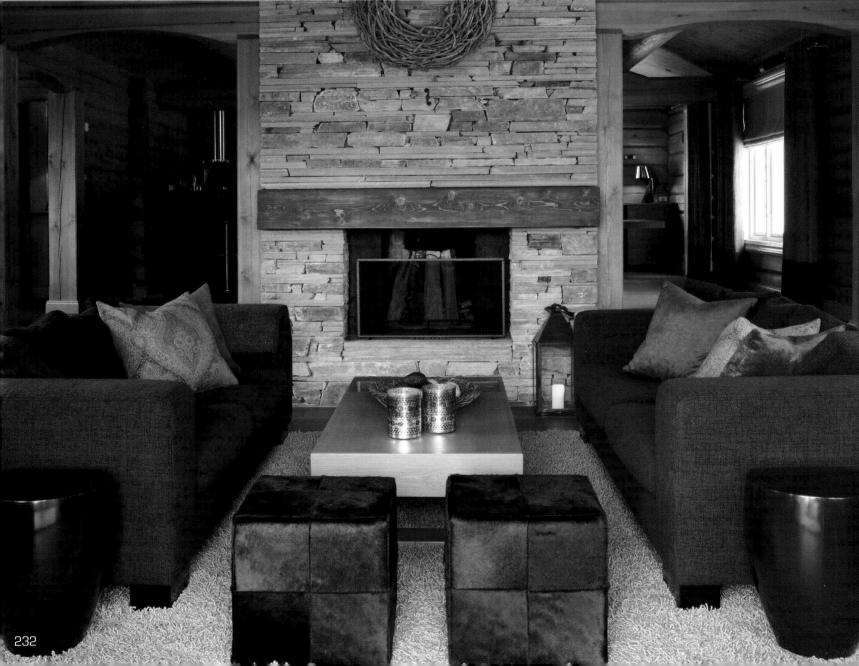

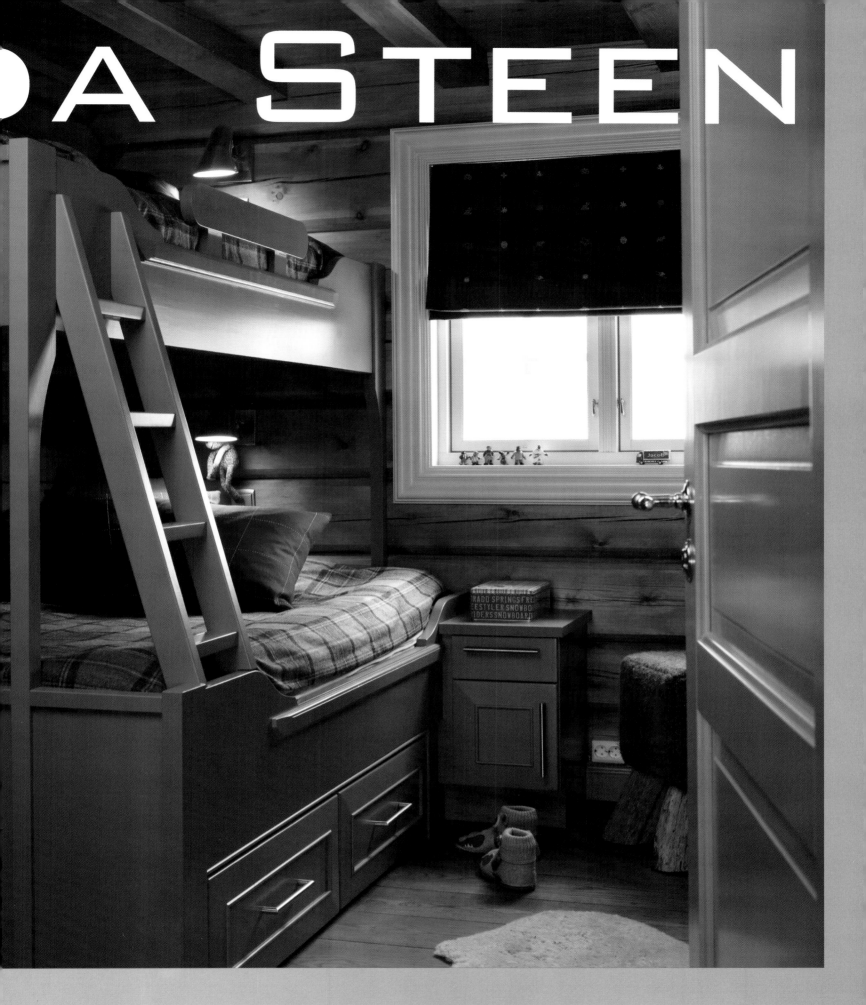

Designer: Linda Steen. Company: Scenario Interior Architecture, Oslo. Profile: Established in 1985 by owner Linda Steen, Scenario is one of the largest interior architecture companies in Norway. Their work includes offices, private houses, apartments, cottages, holiday homes, restaurants, hotels, educational buildings, shops and showrooms. Current projects are all in Norway and include a mountain village cottage in Rauland, Hewlett - Packard's main office in Fornebu, near Oslo and an exclusive indoor range of international designer boutiques and a restaurant in Eger, Oslo.

With a need for speed, energetic Porsche driving Linda loves a good workout. She thrives on the nature and buzz of Oslo, her favourite holiday is her summer house on the south coast of Norway. The best advice is 'always fight for the ideas you believe in'. The most important thing at work, to have fun.

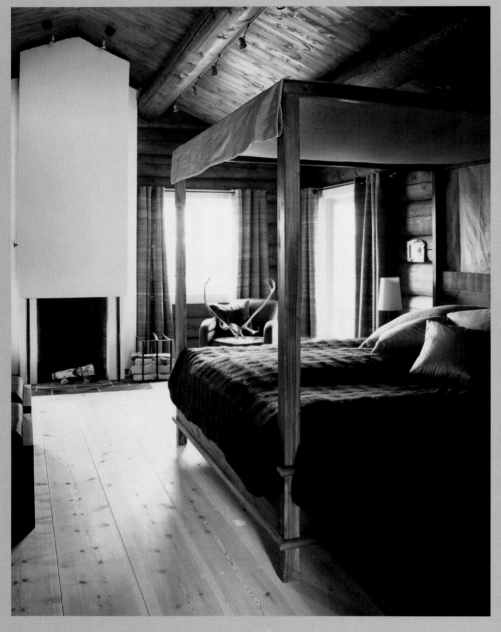

Favourite saying 'only dead fish swim with the stream'.

Linda's proudest moment is making her company a professional business, where she is a great collector of talented employees.

Designers: Marc Hertrich & Nicolas Adnet.
Company: Studio Marc Hertrich & Nicolas Adnet, Paris.
Profile: A company of 20 staff, specialising in luxury hotels, restaurants and private houses worldwide. Recent works include Boutique Hotel EastWest, Geneva, 1835 White Palm Hotel, Cannes and Club Med, Bali. Current projects are Sofitel Hotel, Casablanca, Moofushi Constance Group Resort, Maldives and Oberoi Hotel, Marrakech.

Parisian masters of French savoir faire, Marc and Nicolas exude passion and enthusiasm. A family background of cabinet makers, studies in art history and curiosity led them into interior design. Marc learned everything working in a Swiss palace in Geneva, Nicolas discovered his eye for detail at a French Couture house. Marc is a skilled draughtsman and Nicolas, a chef. Their favourite sport is strolling, preferably in Rome, as long as they return with a pair of Berlutti shoes and a rhinoceros curio to add to the collection. They dream of having magic powers and would ride to the Arctic on a Ludwig II sleigh.

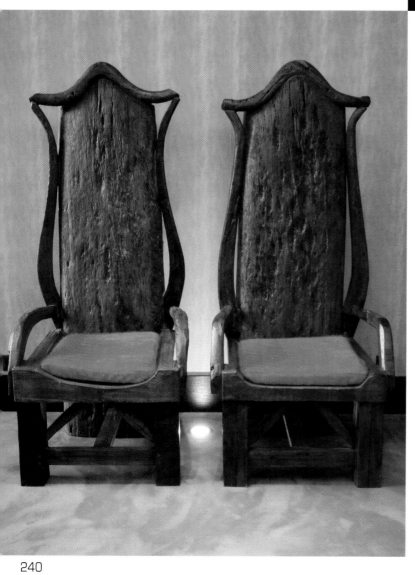

CHAMELEON

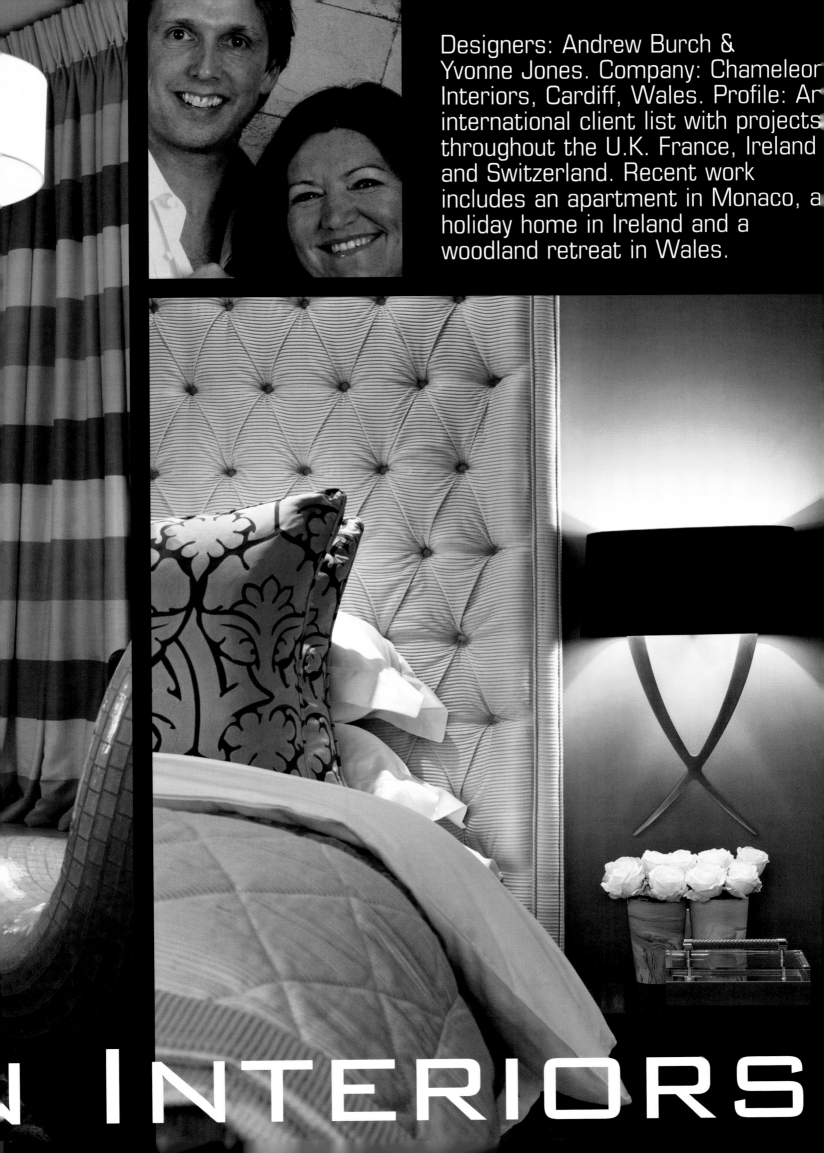

Designers: Andrew Burch & Yvonne Jones. Company: Chameleon Interiors, Cardiff, Wales. Profile: An international client list with projects throughout the U.K. France, Ireland and Switzerland. Recent work includes an apartment in Monaco, a holiday home in Ireland and a woodland retreat in Wales.

INTERIORS

Andrew is a would be fashion stylist who once dressed as a boiled egg.

favourites: designer Vivienne Westwood, model Naomi Campbell.

Yvonne's first job was as a stylist for a French company travelling all over Europe. Favourite takeaway Moroccan, shopping Marrakesh, designer Missoni. Best holiday sailing in the Grenadines. Best man George Clooney, she'd have him dress in combat gear.

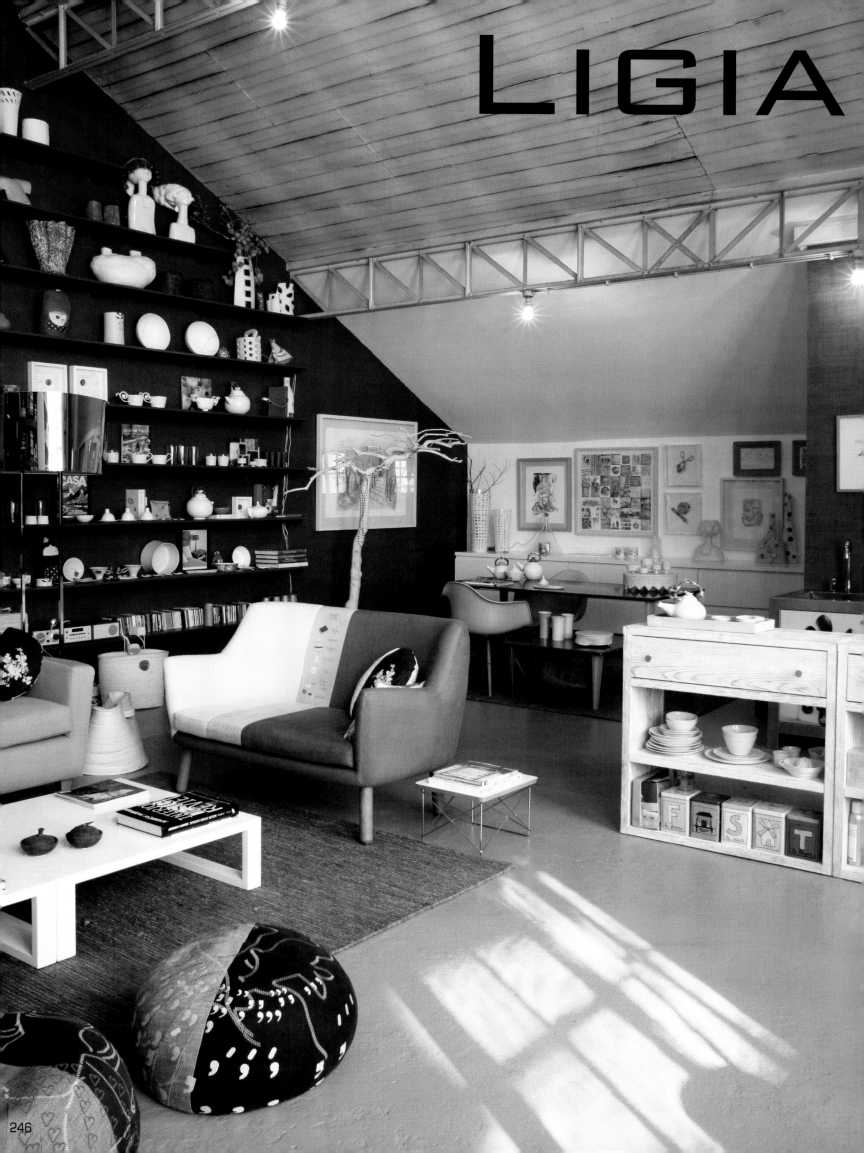

CASANOVA

Designer: Ligia Casanova.
Company: Atelier Ligia Casanova,
Lisbon, Portugal.
Profile: Recent work includes a
glass front beach house, a hospital
and a complex of restaurants.
Current projects include a hotel
in the north of Portugal.

Her first job in Advertising, taught her to deal with stress. Ligia's childhood ambition was to become an astronaut and go to the moon, she'd go now. If she were Prime Minister her first priority would be to extend every weekend to four days.

Favourite home comfort her bed, last fancy dress outfit her pyjamas back to front. Fantasy job, pensioner. Ligia would represent Portugal in an international competition for the 10 metre run, 100 metres is too far. Her secret to long life is laughing.

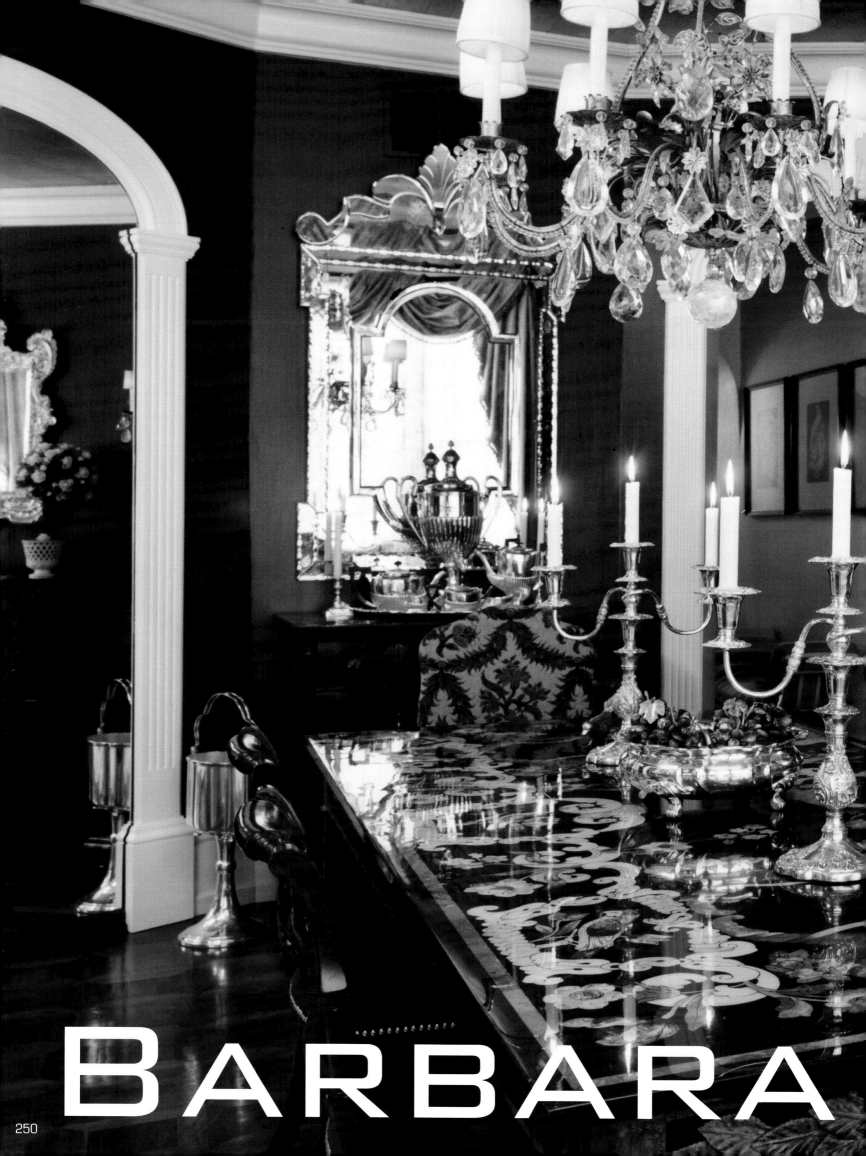

BARBARA

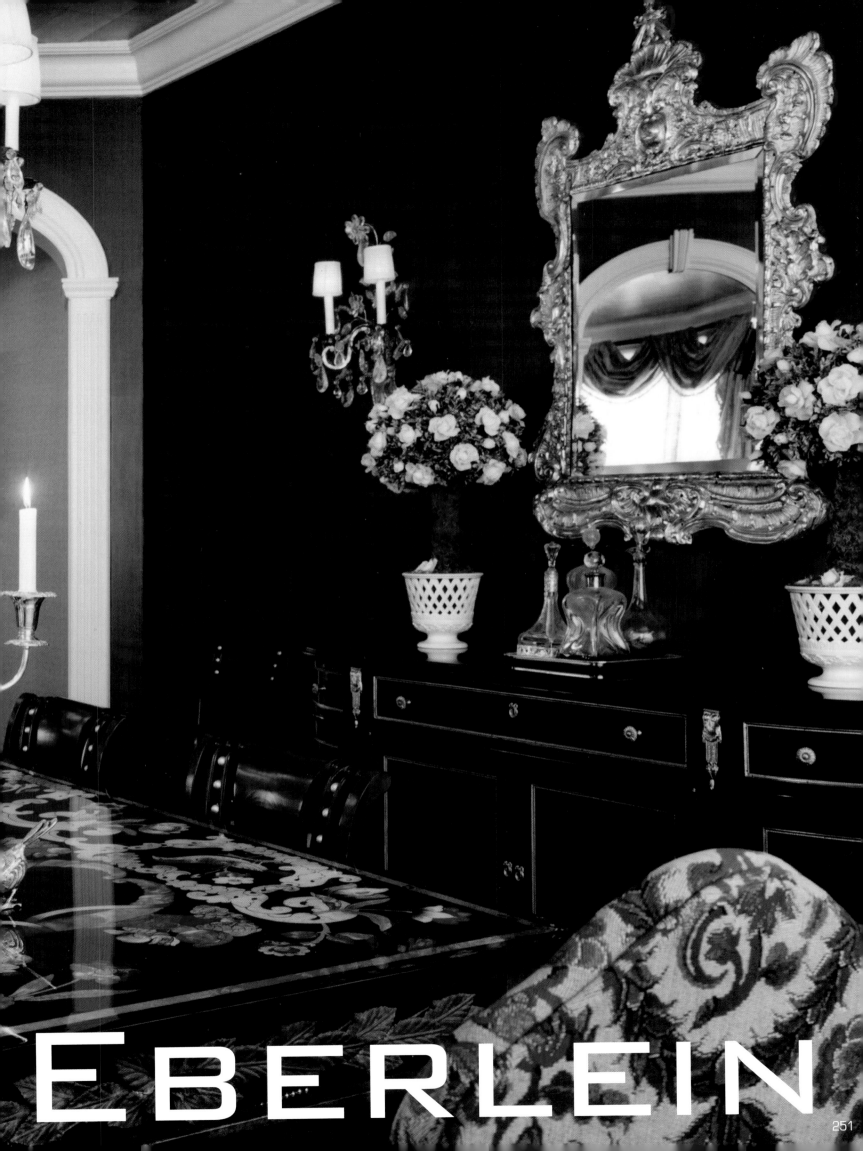

EBERLEIN

Designer: Barbara Eberlein. Company: Eberlein Design Consultants, Philadelphia, U.S.A. Profile: Specialising in a broad range of high end projects with a reputation for expertise in the restoration of historic buildings. Recent work includes a neoclassical penthouse for an antiques collector, a manor house in Philadelphia and a gracious Georgian house set in 600 acres. Recent projects include the ongoing refurbishment of the library, reception rooms and dining rooms of The Union League, Philadelphia and a contemporary house in Beverley Hills.

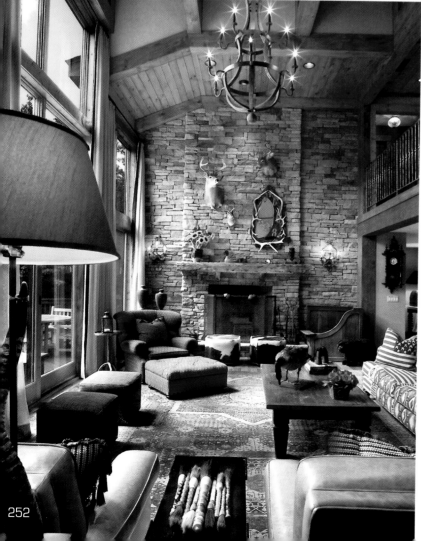

The coolest teenager. Barbara once ran onto a football pitch in the middle of a game to stand on her head with the cheerleaders. Childhood ambition, gymnast. Earliest memory ballerina wallpaper in her bedroom. Favourite home comfort colour, greatest extravagance shoes. Everyday outfit 'cute dress and heels especially on a construction site'. Would most like to meet her next husband. Self confidence makes her life easier. She'd nominate herself for sainthood and represent her country in an international competition for kissing. Favourite shopping Paris, perfume YSL Rive Gauche, holiday India, political hero Ghandi. Obsessive passion got her into interior design, fantasy job, even more work. She believes gentleness to be the secret to long life. Best skill empathy, favourite saying 'I never repeat gossip, so listen closely'. Unfulfilled ambition to write a joint memoir with her six siblings. Her epitaph will be 'a loved and loving woman'.

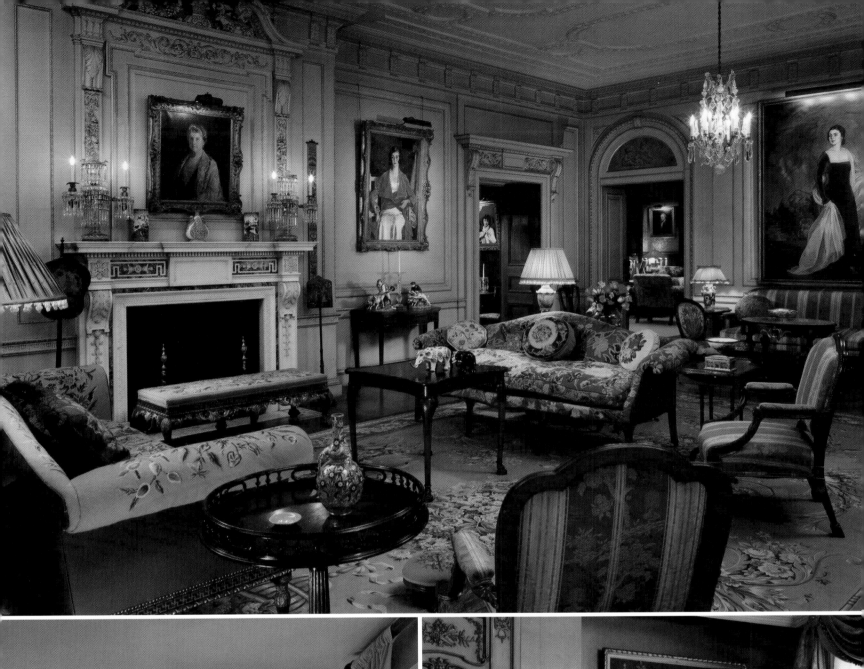

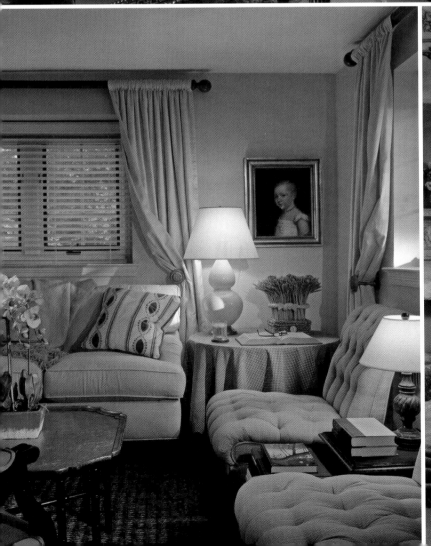

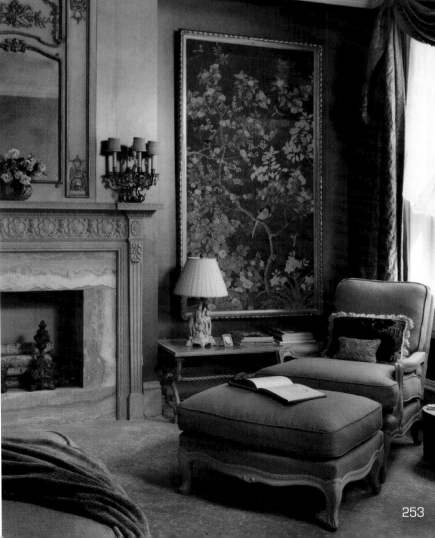

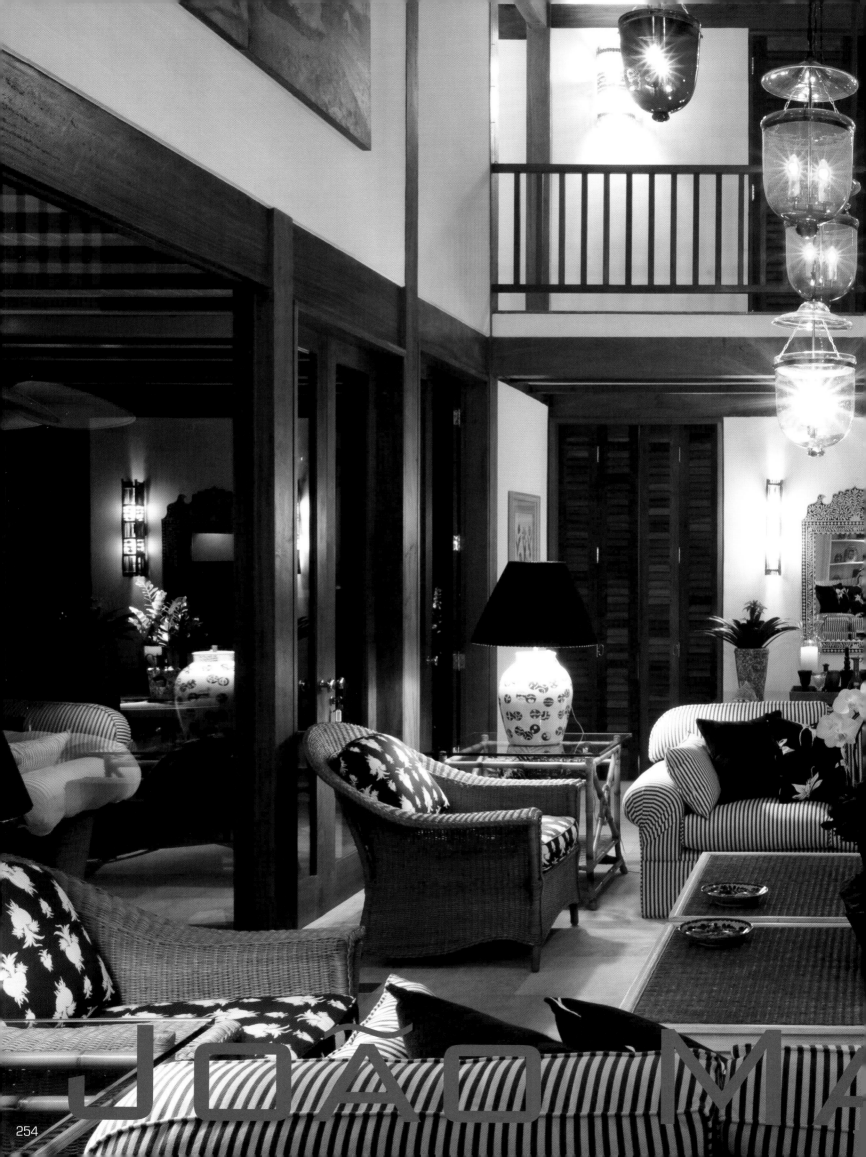

JOÃO M

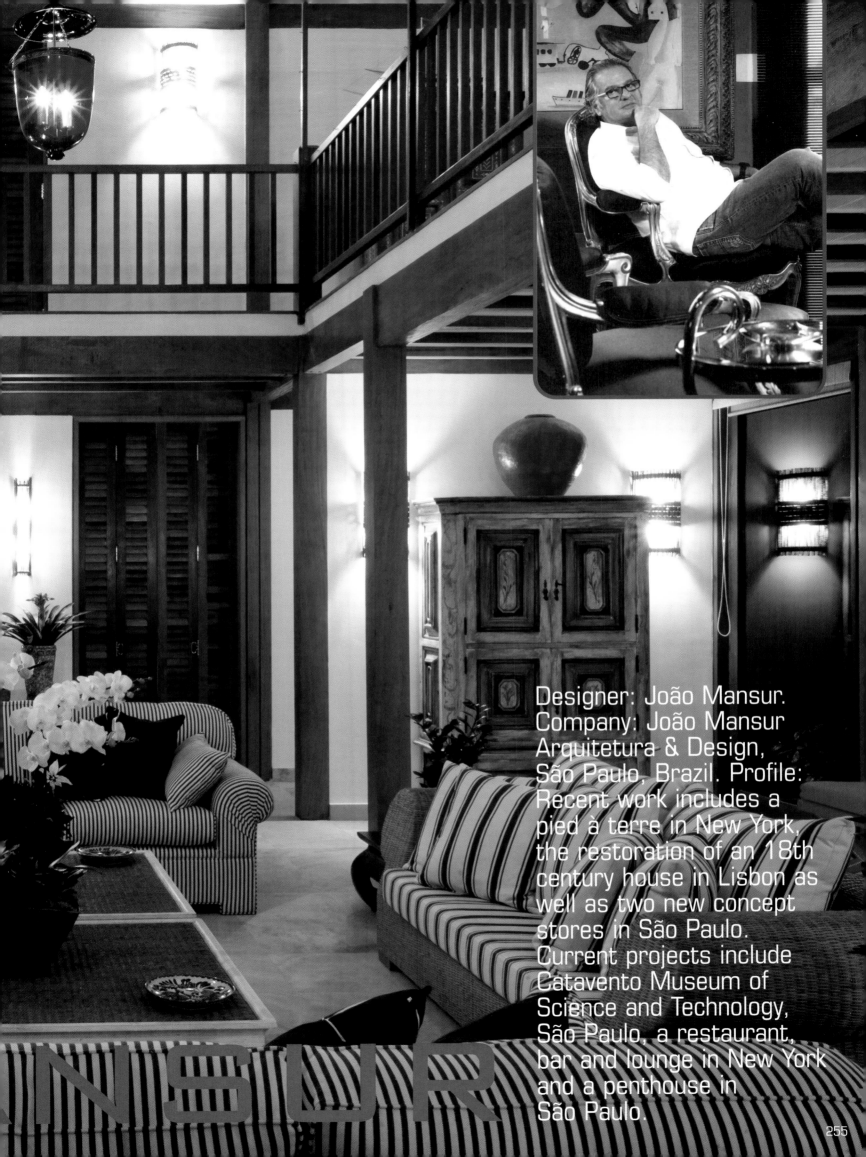

Designer: João Mansur.
Company: João Mansur
Arquitetura & Design,
São Paulo, Brazil. Profile:
Recent work includes a
pied à terre in New York,
the restoration of an 18th
century house in Lisbon as
well as two new concept
stores in São Paulo.
Current projects include
Catavento Museum of
Science and Technology,
São Paulo, a restaurant,
bar and lounge in New York
and a penthouse in
São Paulo.

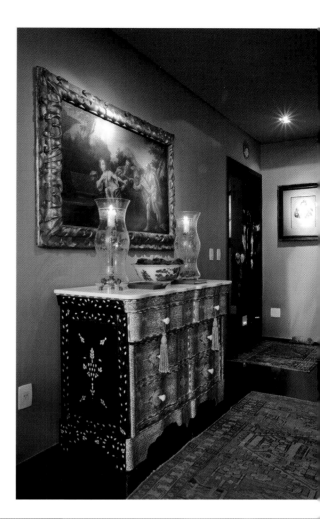

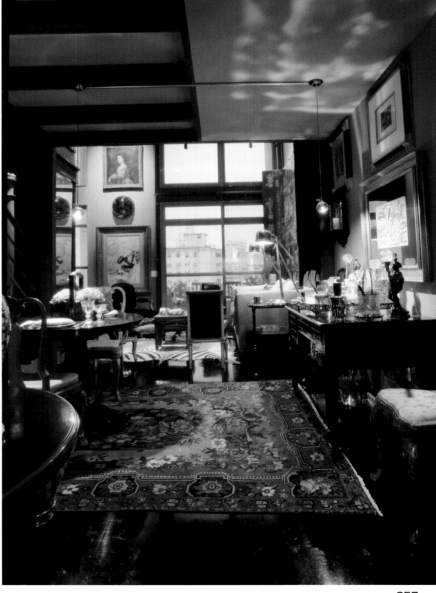

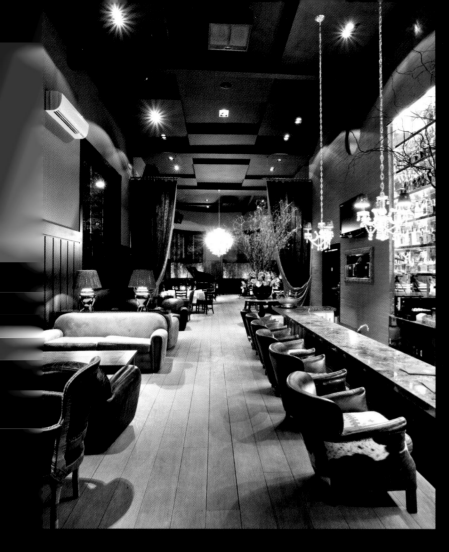

Sensible and stylish, conservative and cool, João is an urbanite and passionate traveller, for whom Rio is the greatest influence. Fantasy sceneographer for the opera and collector of 18th & 19th century furniture and oriental art. Spinning his clients' dreams into reality is his great skill. When he was a little boy he recounts seeing on a beach in Rio a lost penguin colony which had run away from Antarctica.

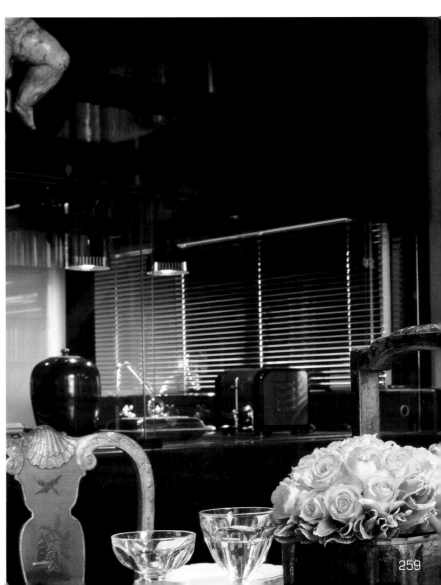

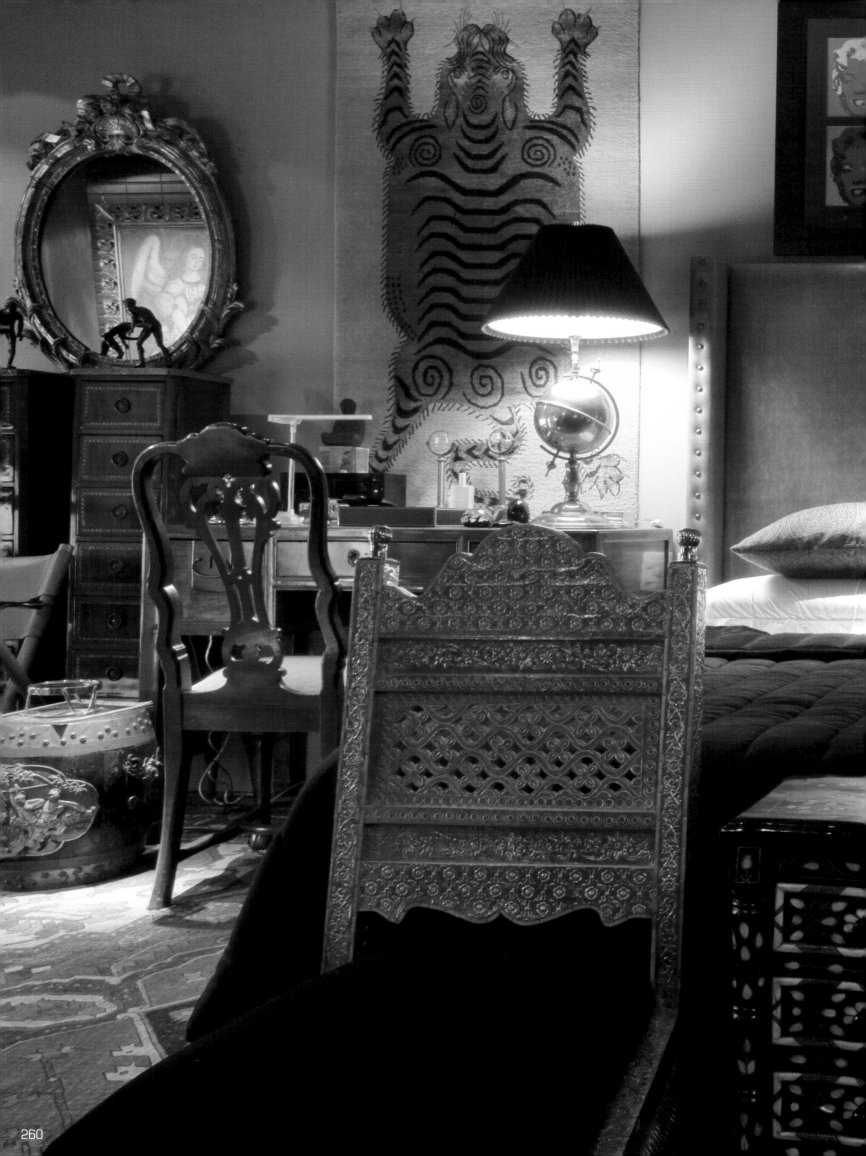

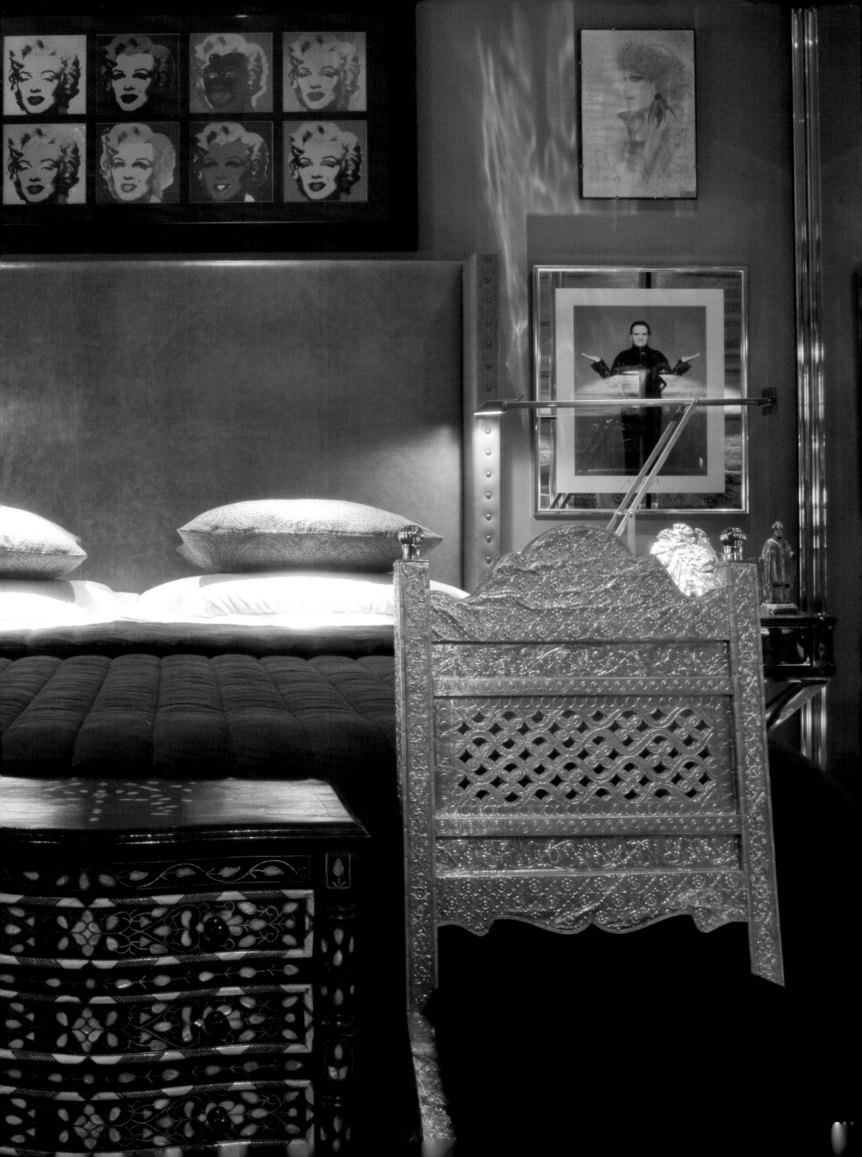

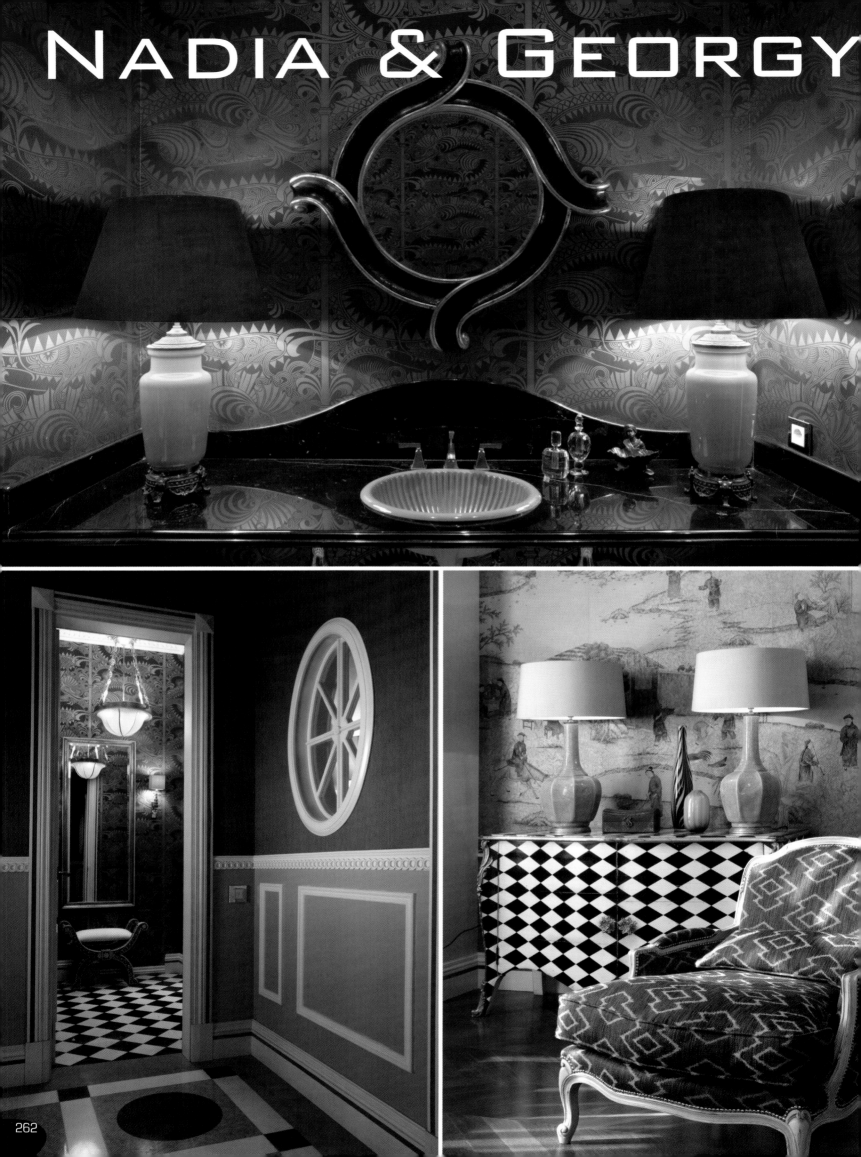

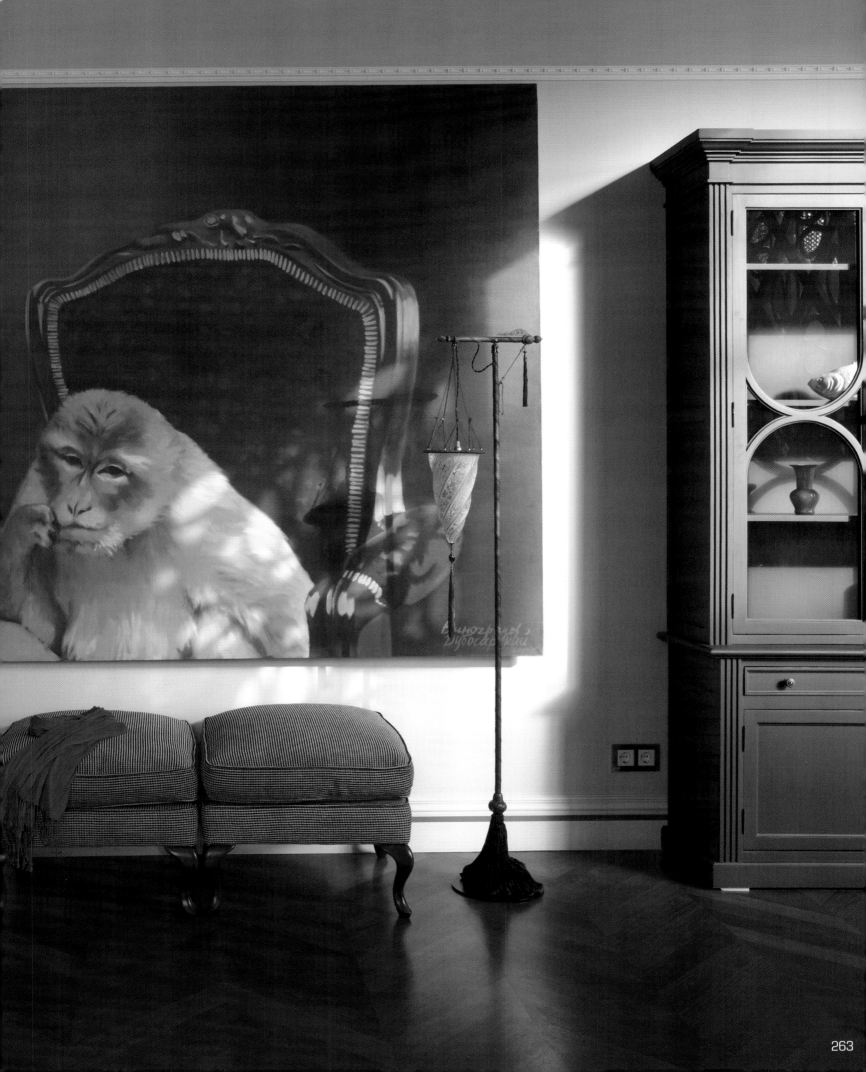

As a child Nadia walked through the Kuskovo country estate parks and palaces, admiring the porcelain and interiors and peering into luxurious ballroom mirrors pretending to be a small Countess Sheremetyeva. A favourite hobby was making intricate dolls houses, her career followed. Size matters for green fingered giant Georgy. His best skill is tree planting, his fantasy job a sculptor. The craziest thing he did was grow so tall. He's inspired by Moscow's scale but nervous of big crowds of children. His favourite fashion model, Pinocchio. For the financial crisis, Georgy blames ghosts. He thinks fast food is the secret of a long life.

Designers: Nadia and Georgy Ananiev.
Company: Architecture and Design Bureau, Moscow. Profile: Specialising in private architecture and construction in Moscow. Recent projects include townhouses, apartments and a Spa in Moscow.

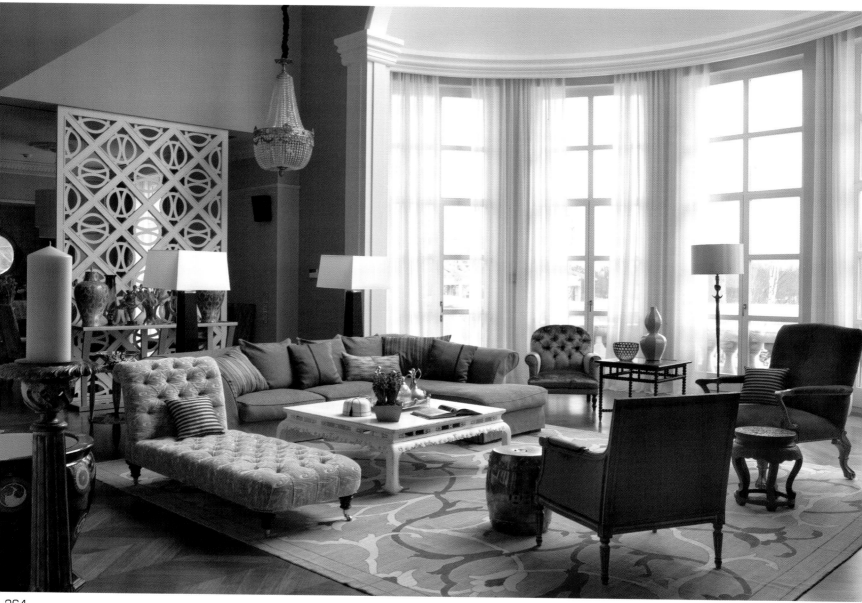

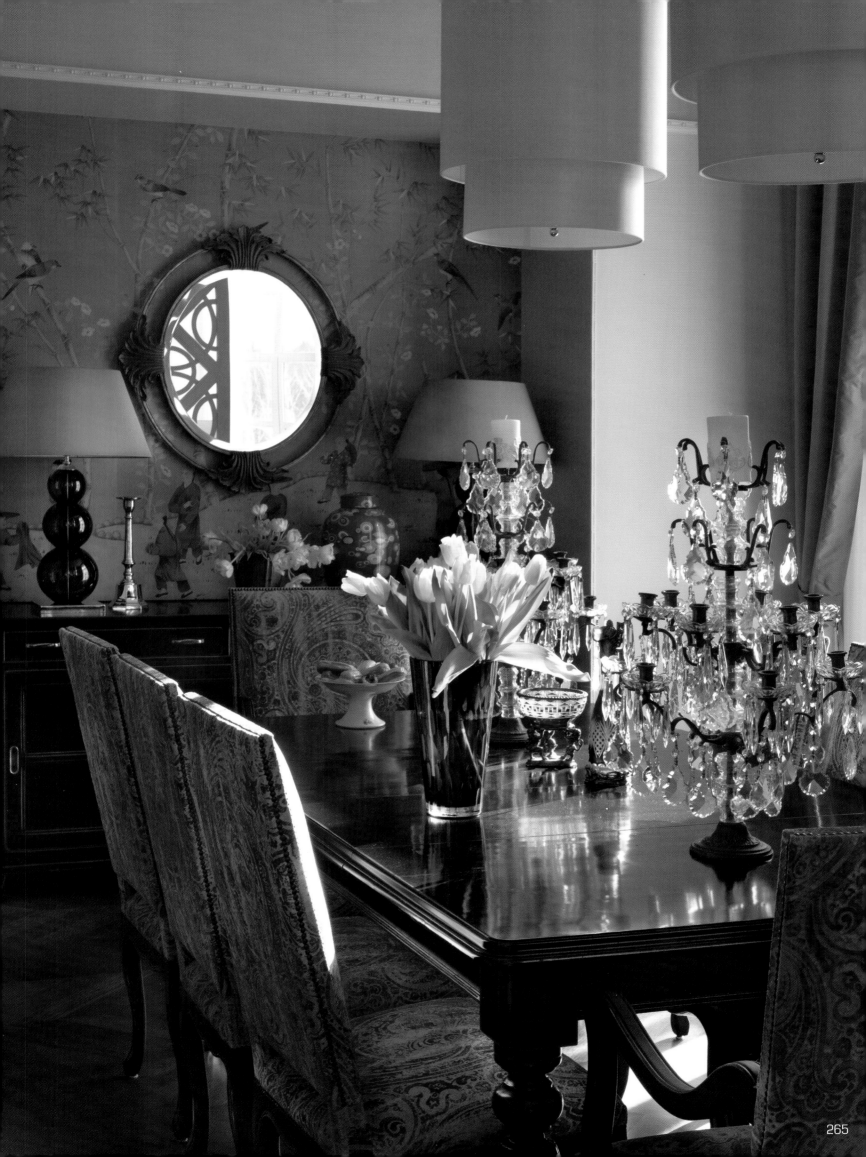

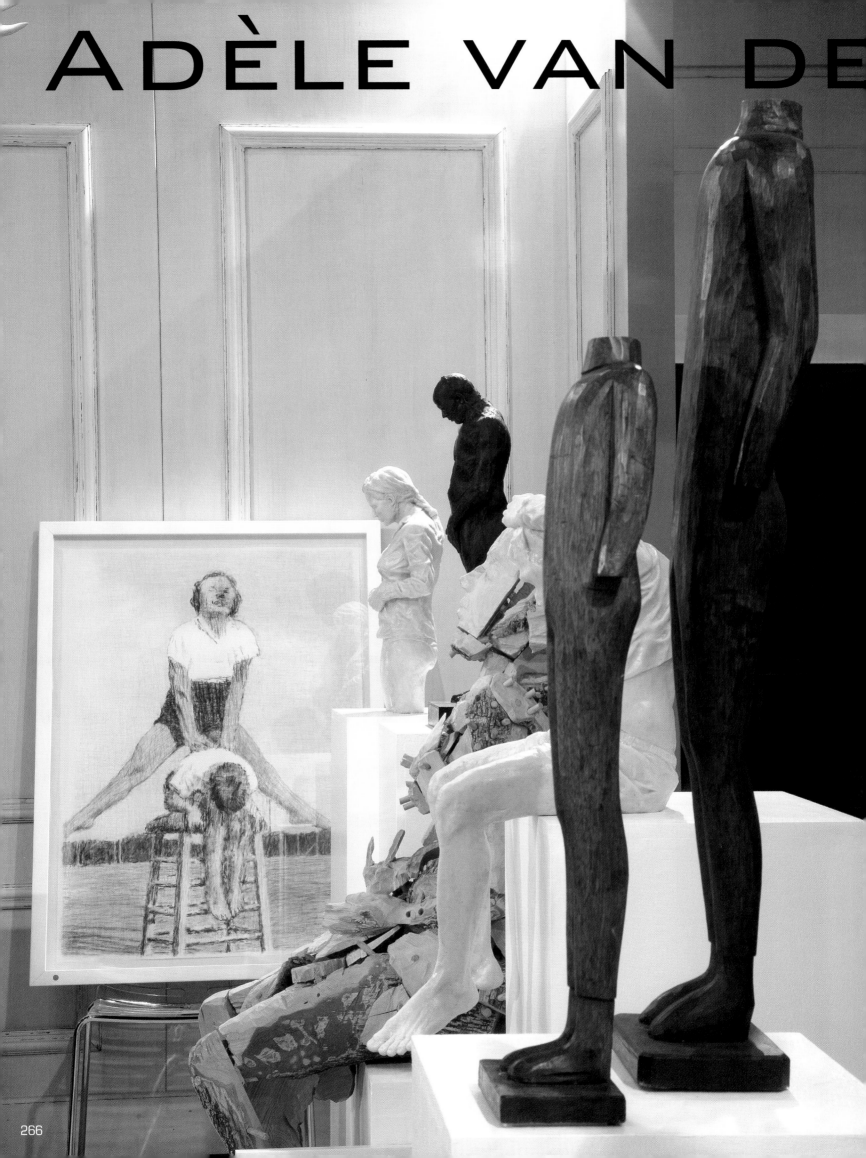

R MERWE

Designer: Adèle van der Merwe.
Company: Adèle van der Merwe Interiors,
Pretoria, South Africa. Profile: A small well
established company providing an exclusive
service to a niche market. Their portfolio
consists of high end residential and
commercial interiors and boutique hotels.

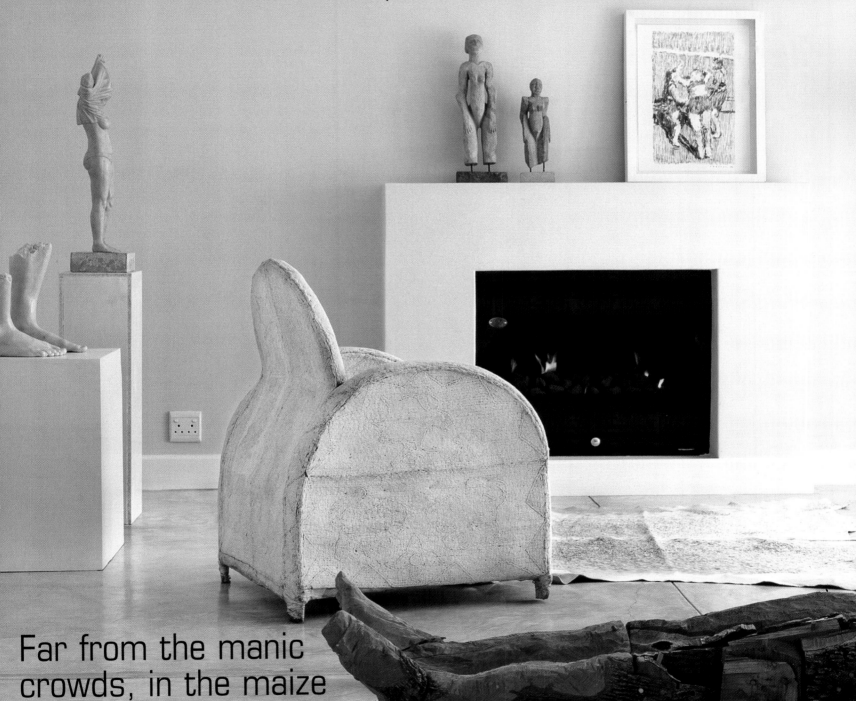

Far from the manic
crowds, in the maize
fields of her agricultural
hometown of Frankfort, South Africa, the people are
her inspiration, for their hospitality and sincerity.

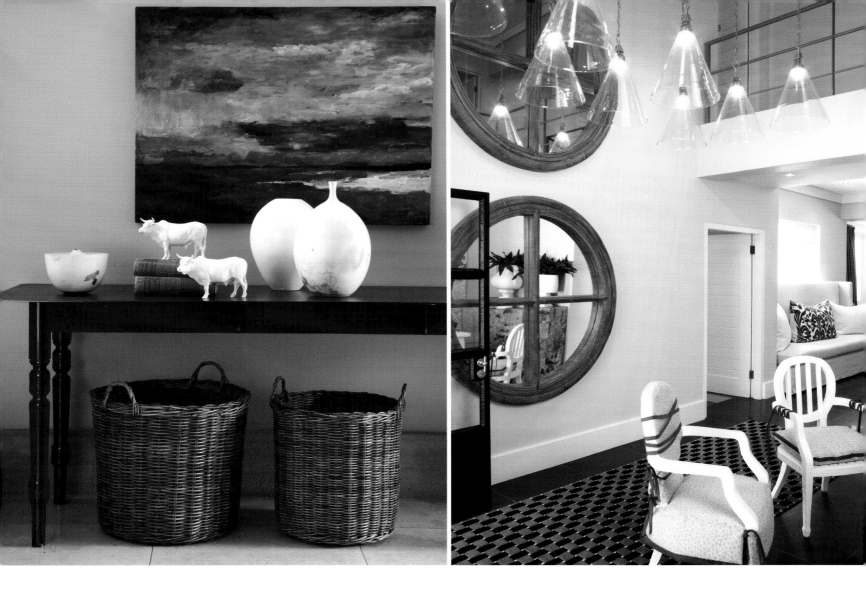

Adele's first job as a farm worker taught her to be humble and unafraid of getting her hands dirty. Her epitaph 'step softly, a dream lies buried here'. Self discipline and self acceptance are the secrets of long life and patience is her best skill.

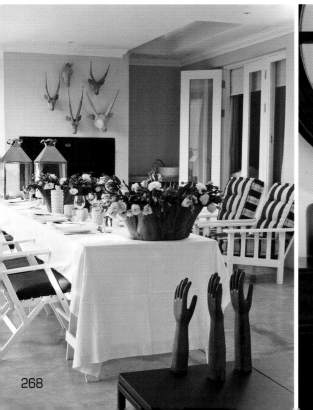

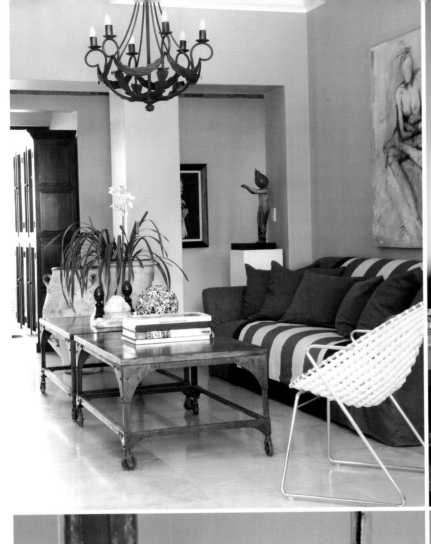

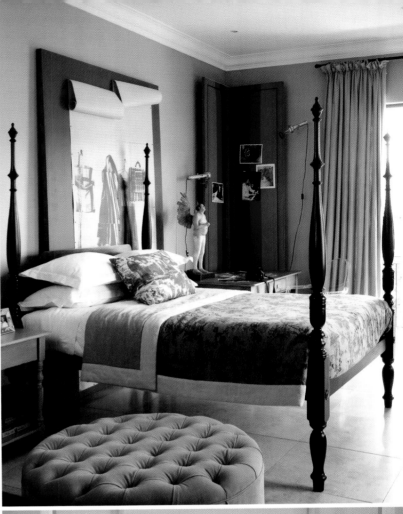

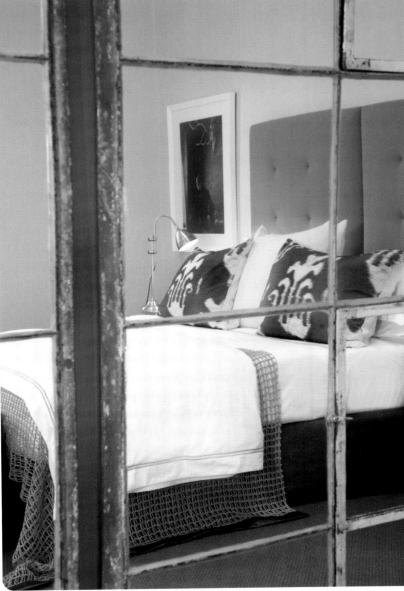

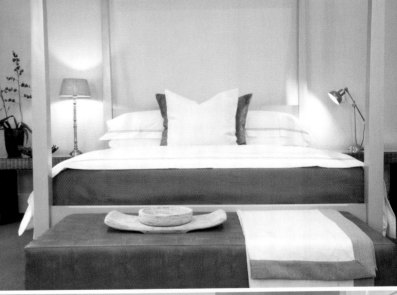

Designer: Tessa Proudfoot. Company: Tessa Proudfoot & Associates, Johannesburg, South Africa. Profile: Recent projects include a modern take on a Cape Dutch homestead on a wine estate, an apartment overlooking the Atlantic Ocean and a luxury game lodge built amongst the thorn trees on the banks of the river Crocodile. Current work includes a modern thatched family house with mountain and sea views, an old farmhouse in Johannesburg and a lodge in Madagascar.

TESSA PR

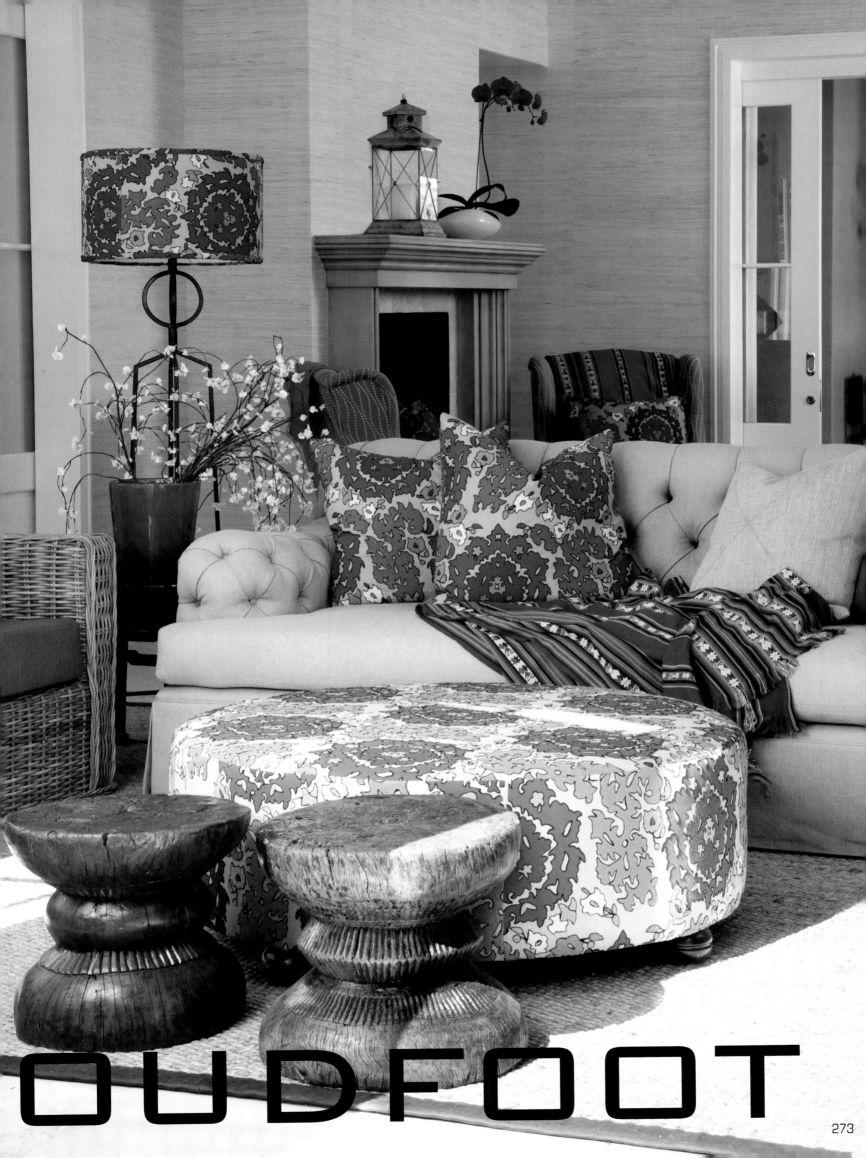

OUDFOOT

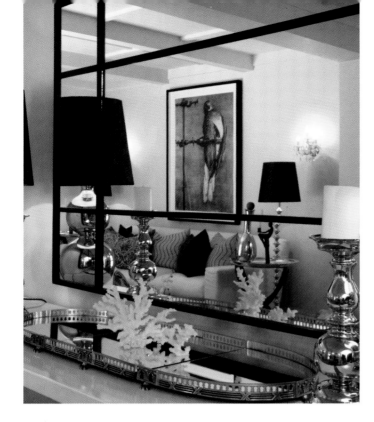

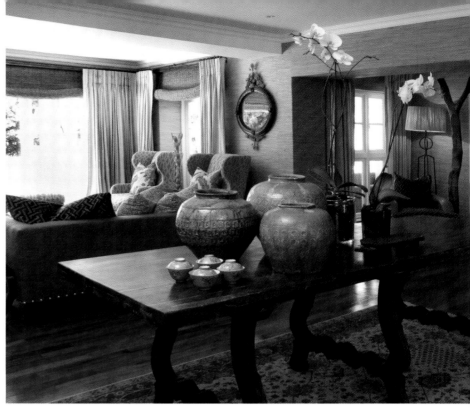

Last fancy dress, Puss in Boots (Louboutins.) **Home town Empangeni South Africa.** Earliest memory eating mangoes in the pool at Christmas in Zululand. **Greatest influences the ancient culture alongside old fashioned colonialism, intense tropical heat, vast blue skies and seas and the smell of vegetation.**

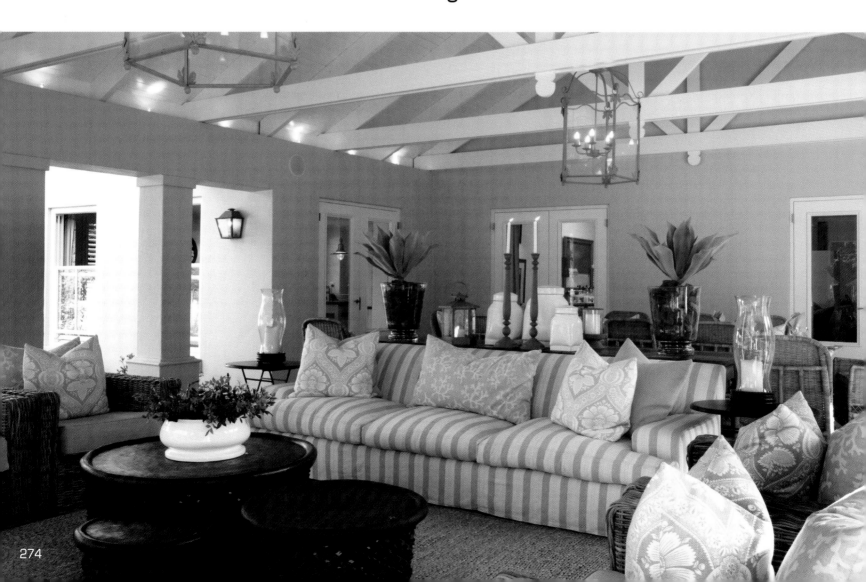

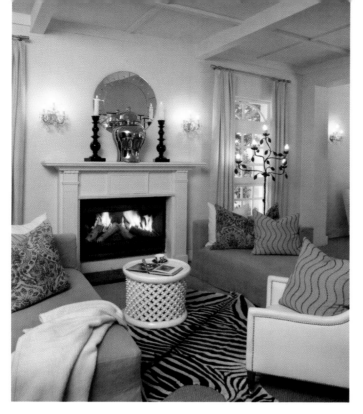

Tessa's secret to long life, laughter and wine. Favourite holiday - skiing at Beaver Creek, Colorado, best airline first class. Everyday outfit, anything skinny with sandals. An endurance shopper whose greatest extravagance is anything that promises instant age defiance.

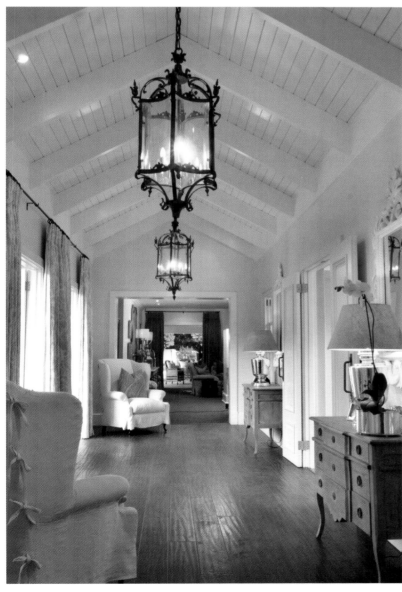

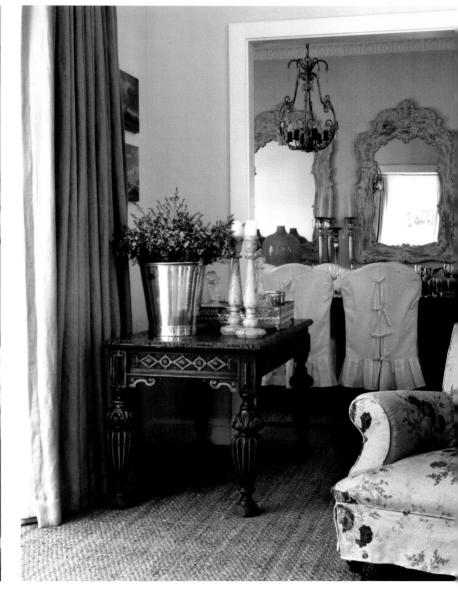

Best shopping Harvey Nichols, Barneys, Fred Segal. Fragrance Fig, by L' Artisan Parfumeur. Secret crush Bill Clinton, car convertible mini, hero Mandela.

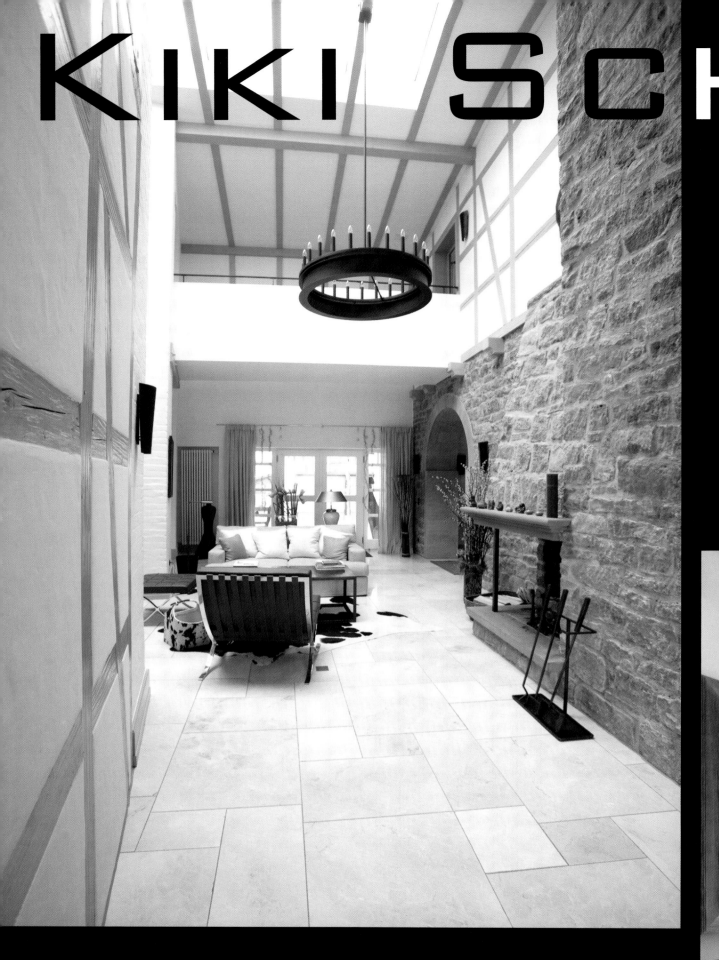

Designer: Kiki Schroeder. Company: Kiki Schroeder Design, Munich. Profile: A team of 7 working internationally in the residential and commercial market with a main office in Munich and showrooms in Vienna and Hamburg. Kiki describes her style as timeless and contemporary with heart and soul.

OEDER

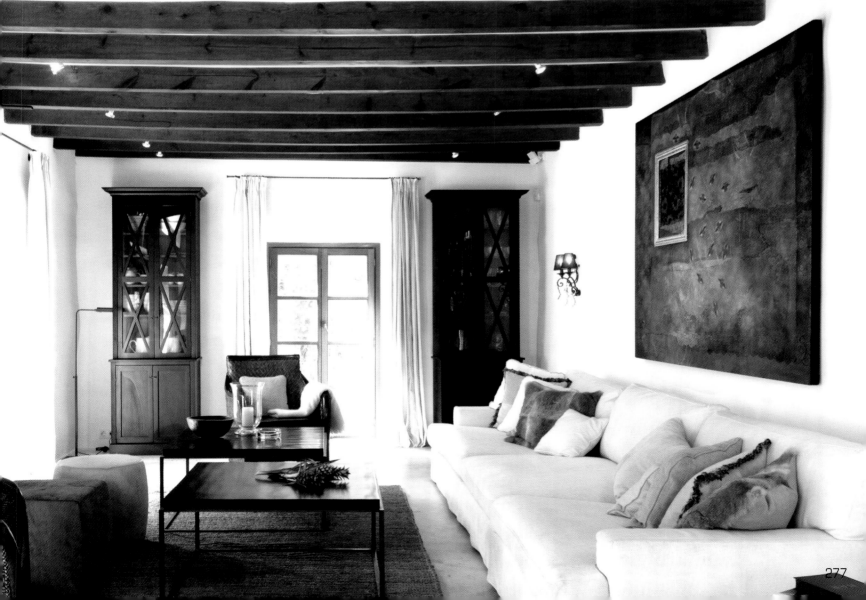

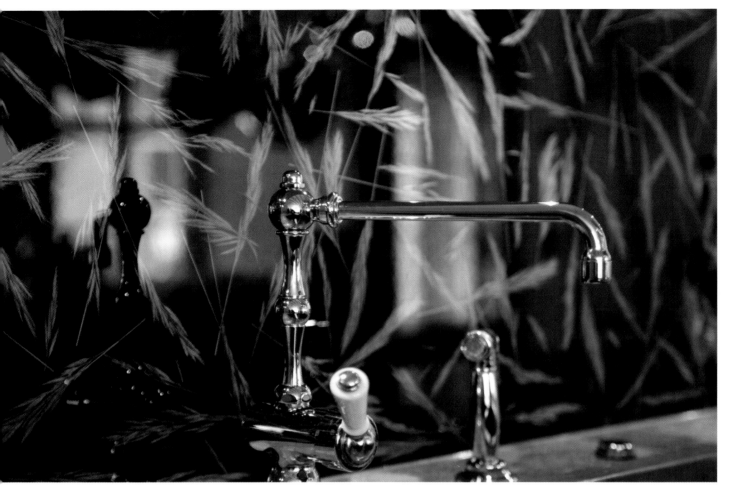

Kiki has dreams of designing a sailing boat and drifting off to Mallorca in Ralph Lauren dresses, surrounded by friends, family and the scent of almond blossom. Her inspiration is Hamburg and political hero Obama, of whom she has great expectations.

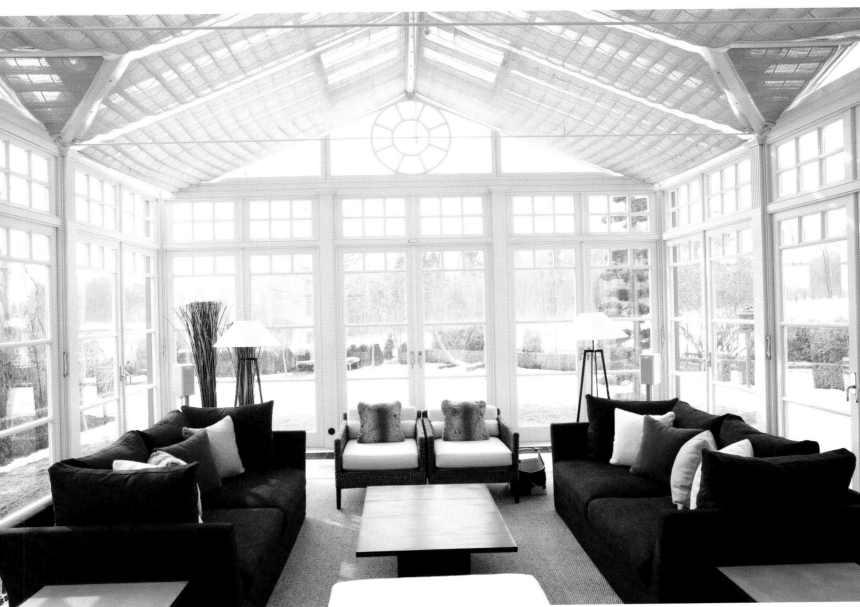

Kiki's earliest memory is laying in her parents' bed with a baby bottle of hot chocolate, her greatest luxuries are the bath and architect Frank Gehry.

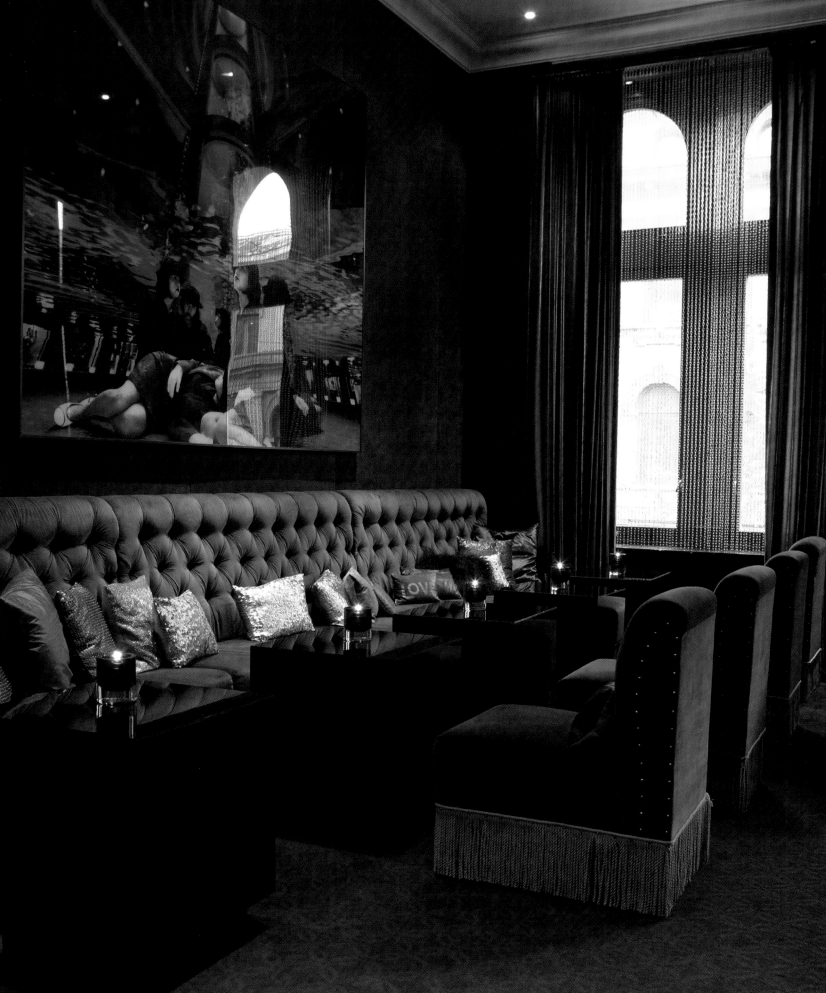

ANEMONE

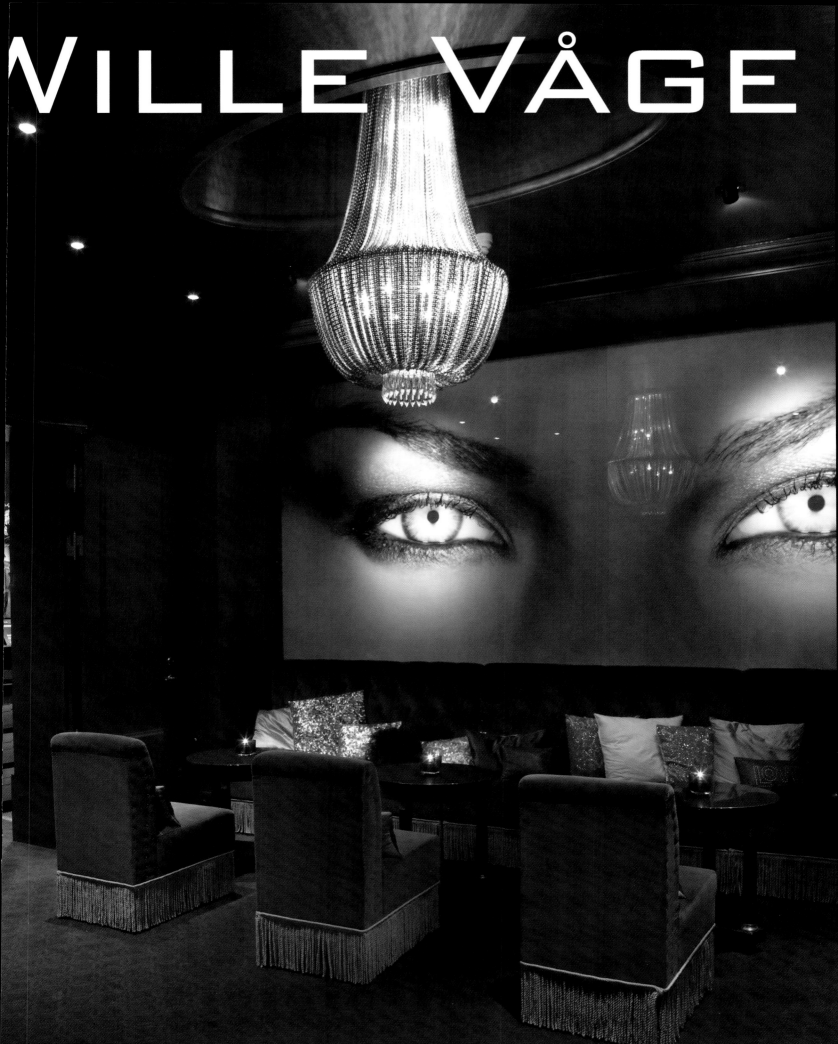

WILLE VÅGE

Designer: Anemone Wille Våge. Company: Anemone Wille Våge Interior Design, Oslo. Profile: Specialising in high end private work from cottages to palaces plus some hotels and restaurants predominantly in Norway, Sweden and France. Recent work includes Choice Hotels Scandinavia head office, Oslo, restaurant Eik Annen Etage, Hotel Continental, Oslo and a villa in St Tropez. Current projects include a villa in St Maxime, France, a villa and a penthouse in Oslo.

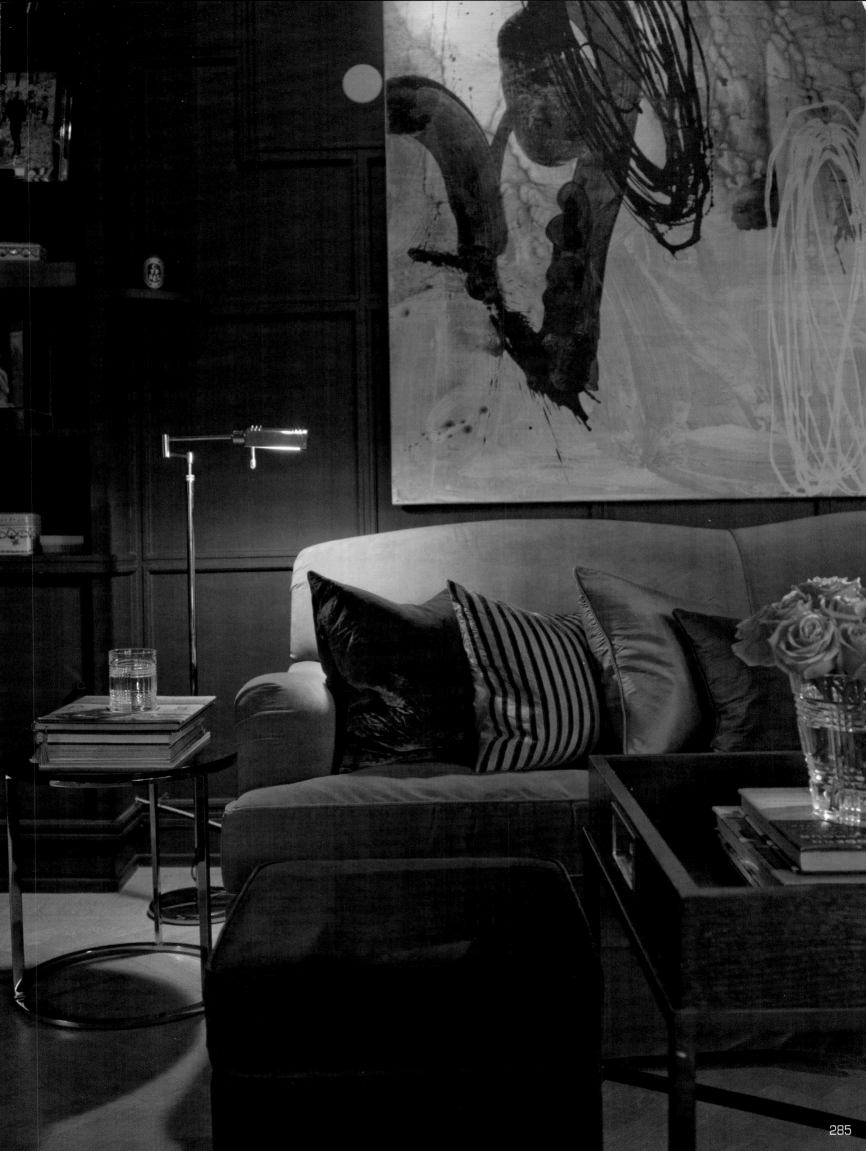

Favourite shopping street, Pimlico
favourite designer Diane Von Furst
comfort being served a late supper
canopy bed, watching Poirot. Dream
grand palazzo in Venice. Anxious to
remaining listed buildings in Norwa
house is her extravagance.

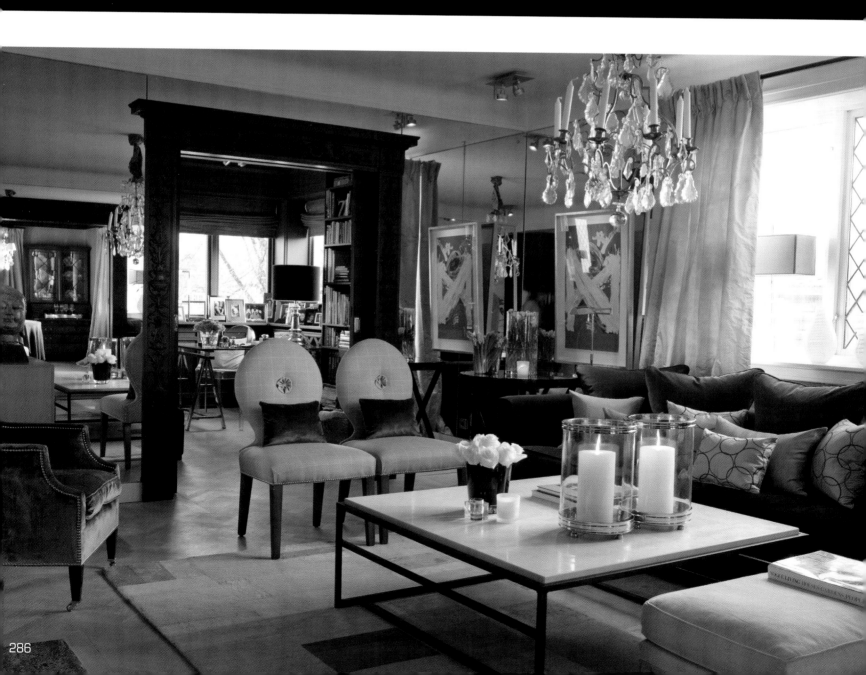

Road, London,
nberg. Her home
tucked up in her
s of decorating a
conserve the last
v. Her country

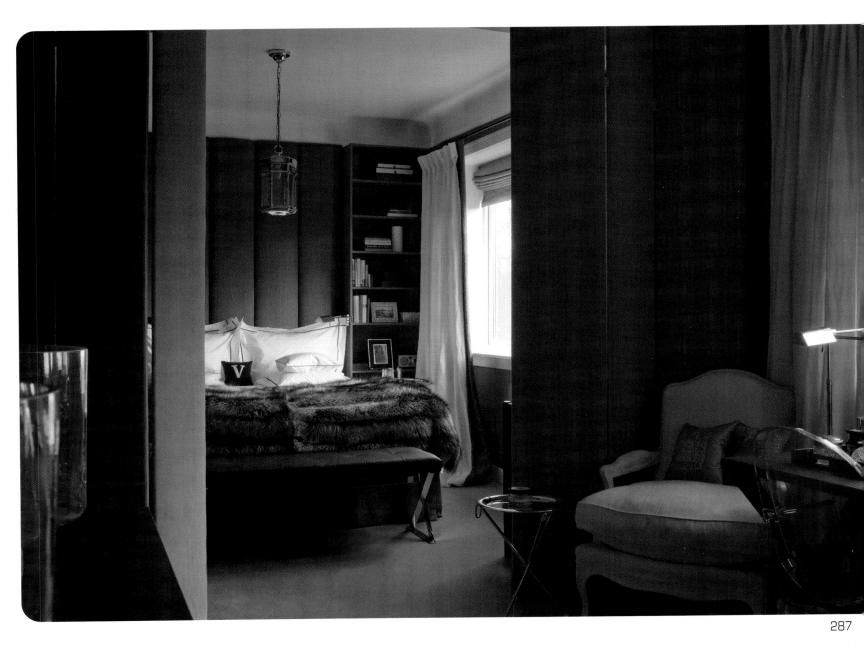

Designer: Ana Maria Guimarães de Vieira Santos. Company: Ana Maria Guimarães de Vieira Santos Architecture and Design, São Paulo, Brazil. Profile: Team of 40 employees working on residential and commercial projects in Brazil, U.S.A, Europe and U.A.E. Recent work includes a spa in Qatar, a house in Florida and beach homes in São Paulo.

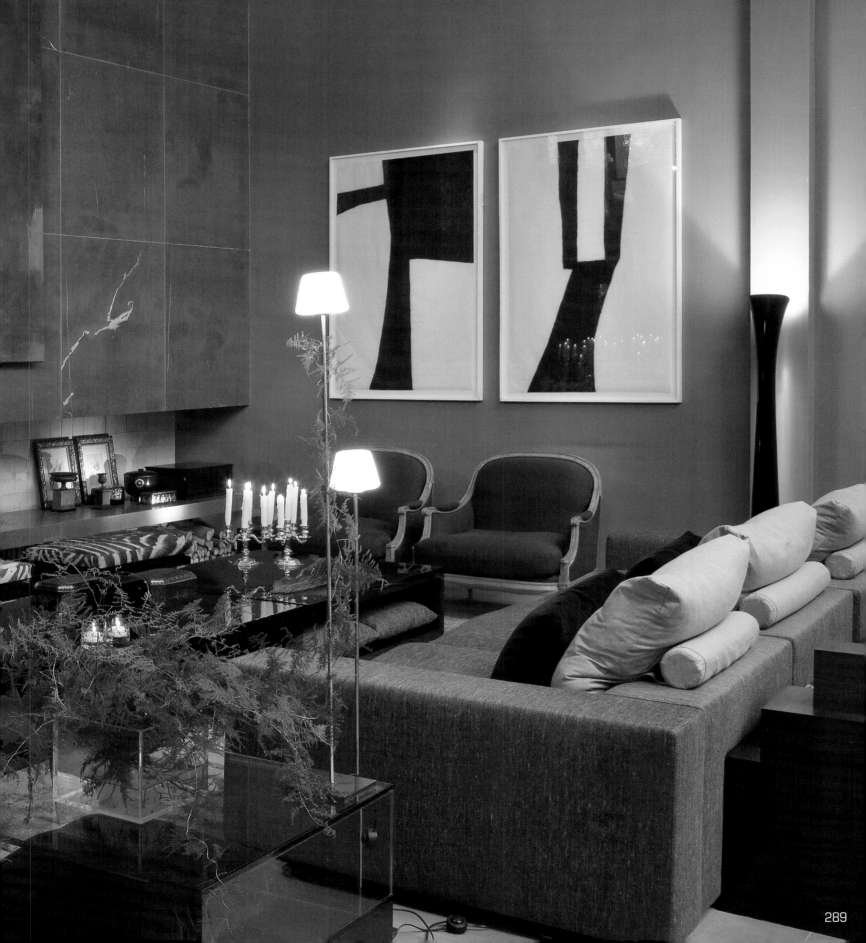

JIMARÃES DE EIRA SANTOS

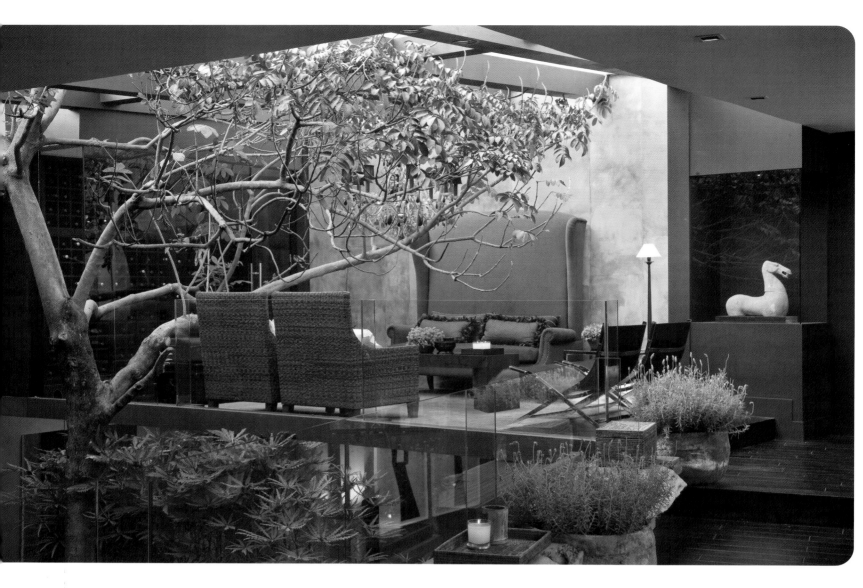

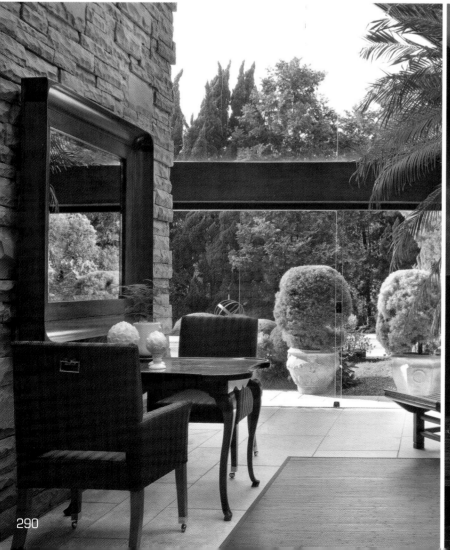

Ana is a casually dressed positive thinker who believes the secret of long life is being happy and working hard. She dreams of decorating spas and hotels.

Ana has an unfulfilled ambition to own a helicopter, she'd also like to star in Sex and the City, with George Clooney as her ideal date. She thinks that decorating is about balance, believing in what you do and having respect for the client. Japanese is Ana's favourite takeaway food and her most memorable meal lunch at Alberto Pinto's office in Paris. Favourite designer Valentino, most overrated Versace. The best advice she ever received is 'you have given your children wings, let them fly'.

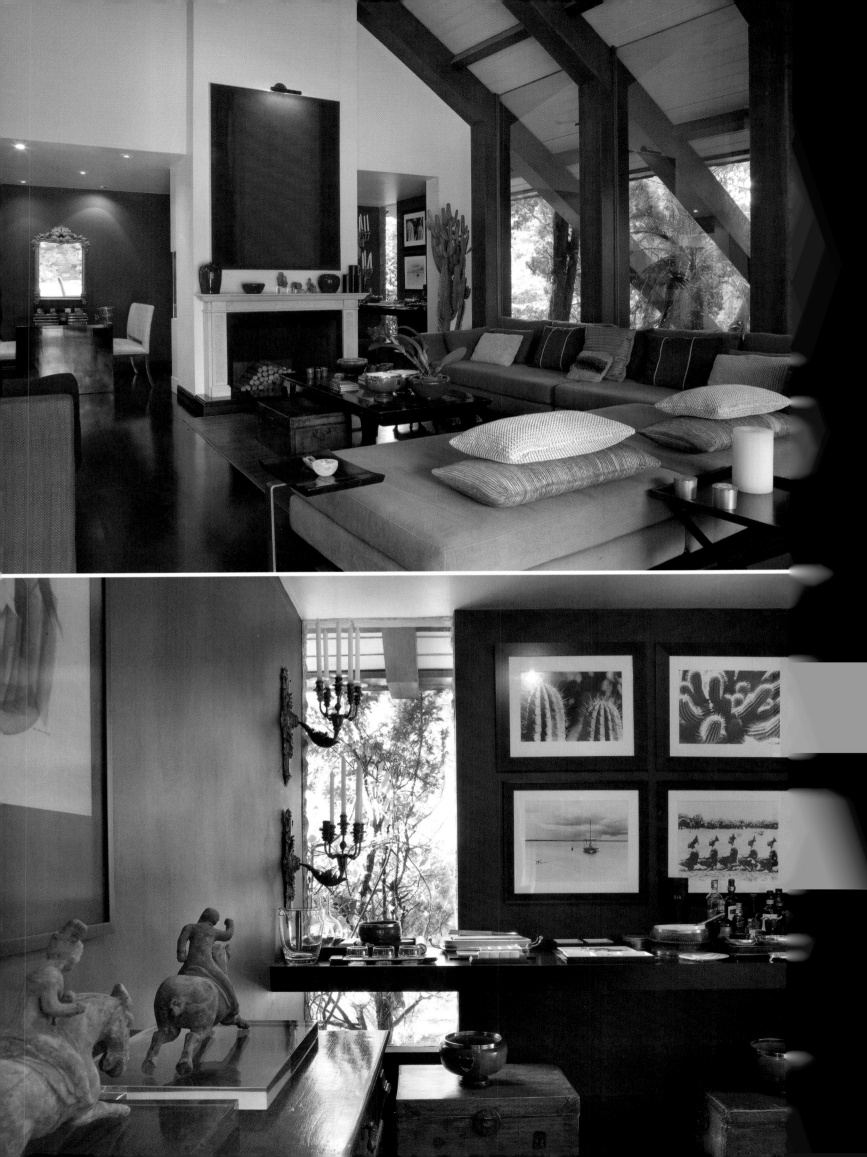

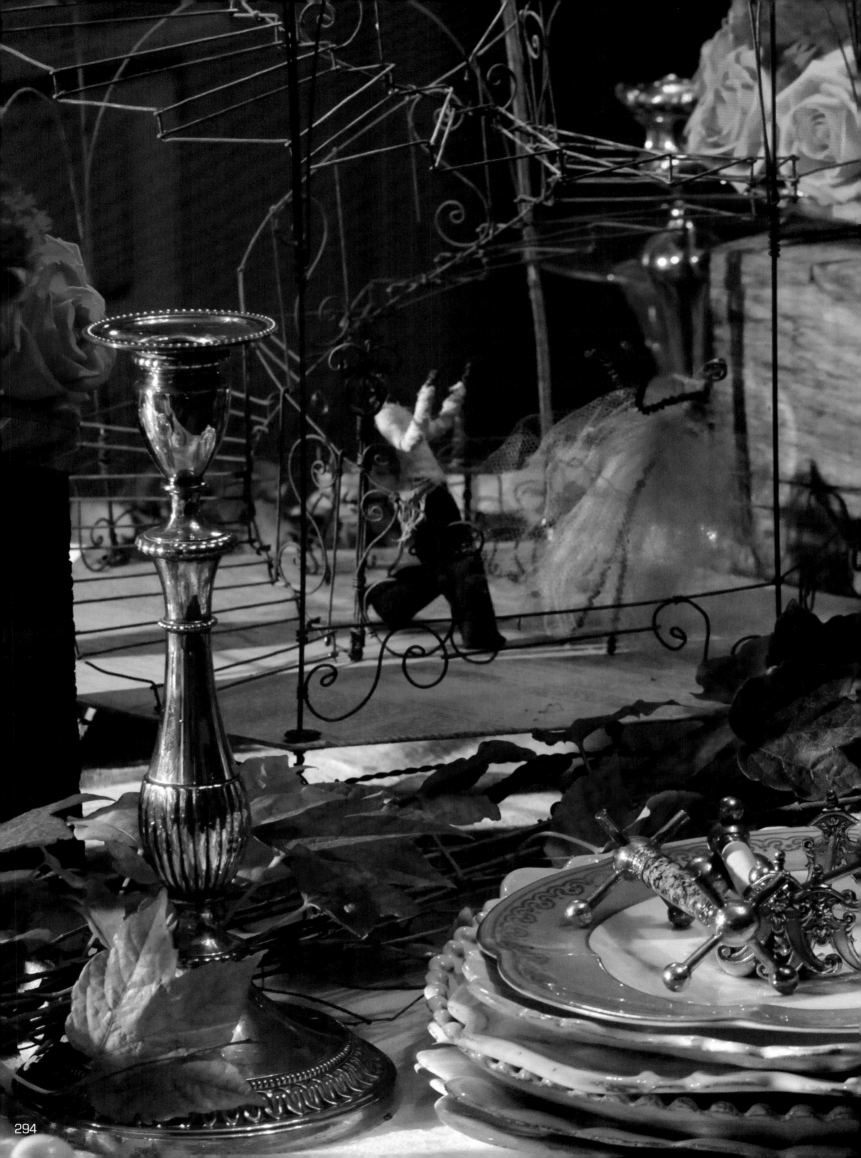

Designer: Enrica Fiorentini Delpani. Company: Studio Giardino, Brescia, Italy. Profile: An association between Carlo Fiorentini and Enrica Fiorentini Delpani specialising in private and commercial projects predominantly in Italy and France. Recent work includes the renovation of an old house, a beauty centre and the refit of a 60m yacht. Current projects include the refurbishment of an old palace and a private museum.

Optimism and sunshine are the secrets of long life for Enrica. She's happiest finding a lost object or cooling off on her bicycle with an ice cream. Unfulfilled ambition, to be able to cook and dreams of writing a recipe book and laying a beautiful table. Favourite architect Palladio, book Liaigre, best holiday Ramatuelle, France. Her greatest extravagance going out with her pyjamas and coat on.

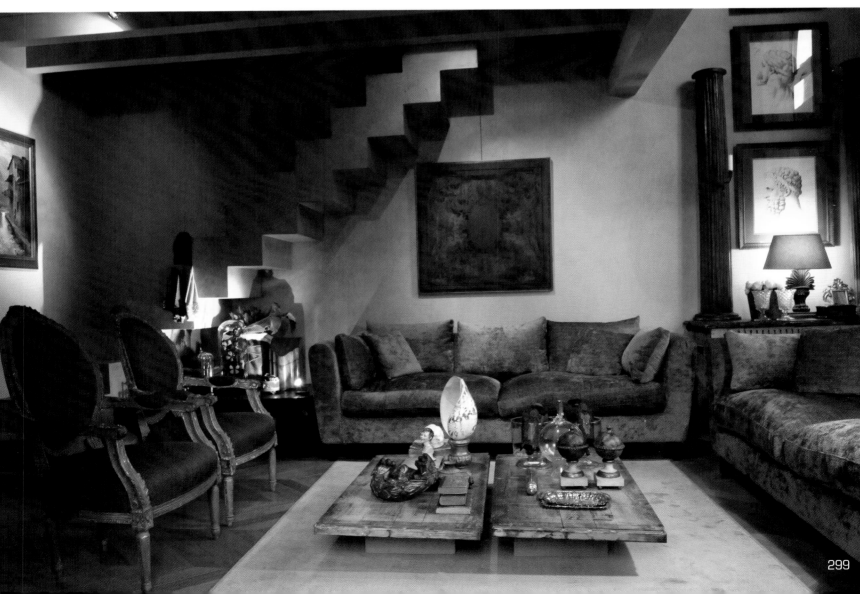

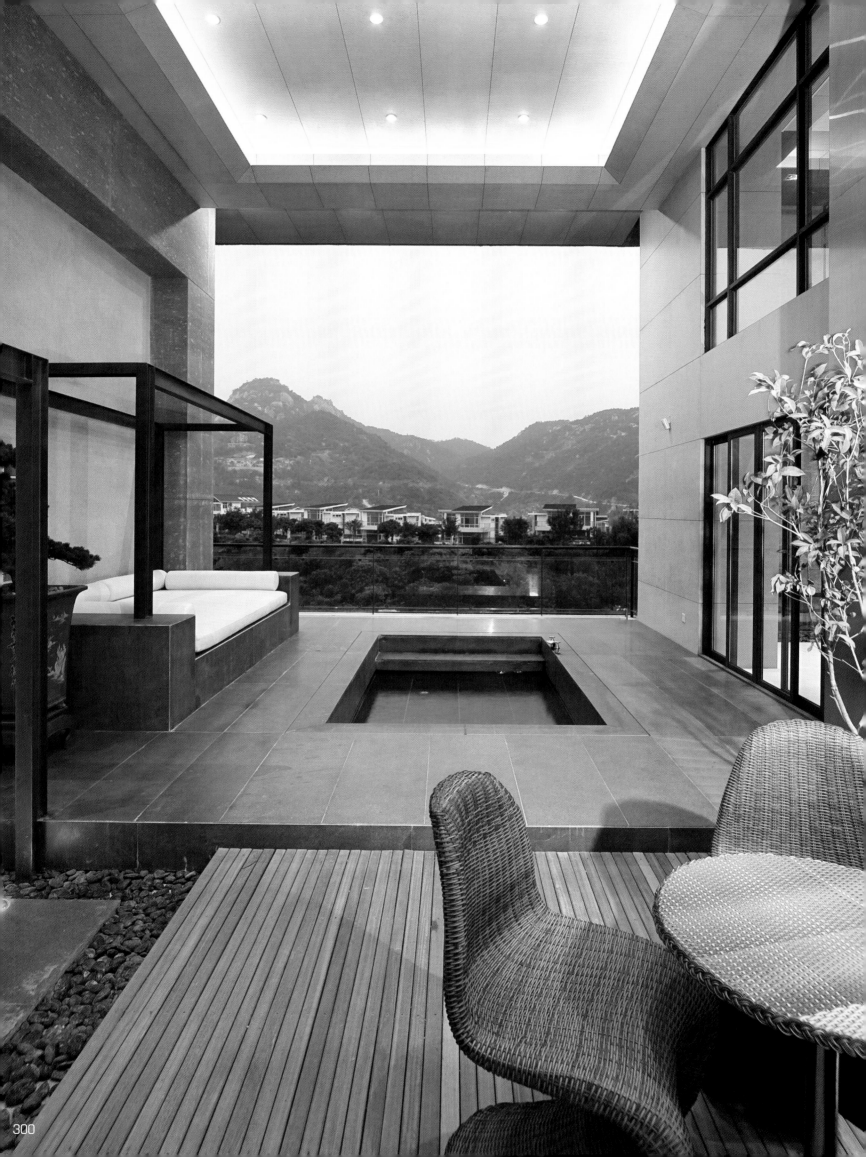

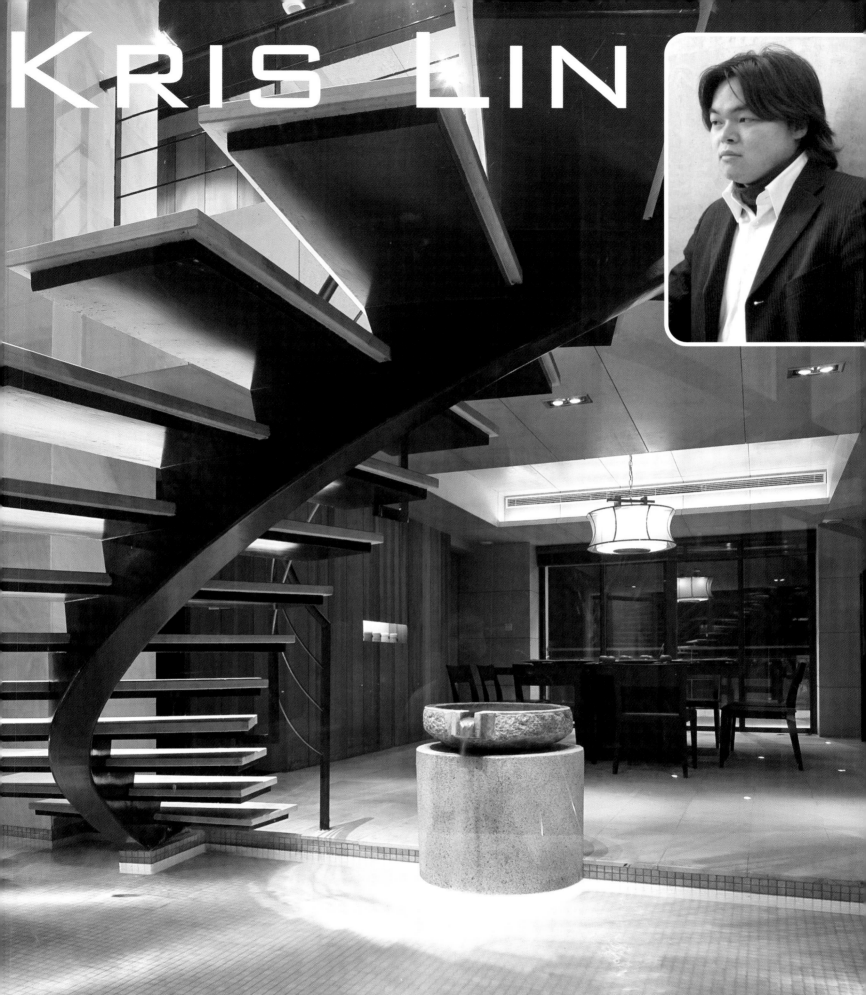

KRIS LIN

Designer: Kris Lin. Company: KLID (Kris Lin Interior Design) Shanghai, China. Profile: Award winning practice specialising in commercial work predominantly in Shanghai. Recent work includes the SAC Beiganshan Art Centre, Shanghai. Current projects include show flats in Shanghai and Fuzhou and a restaurant in Lian.

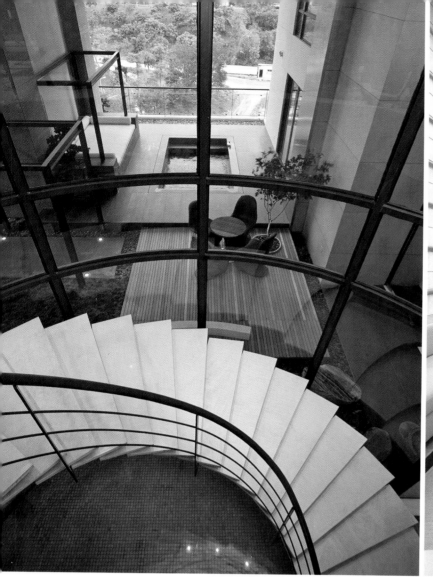

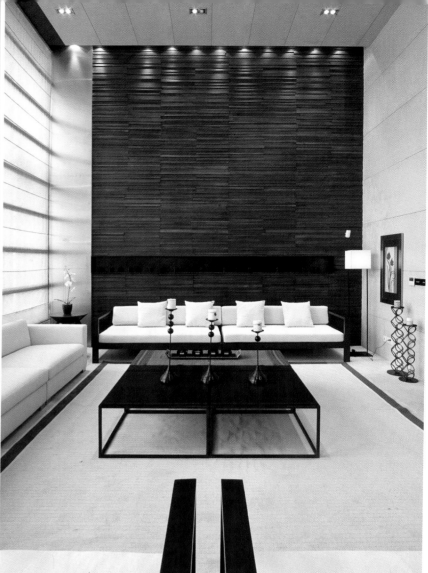

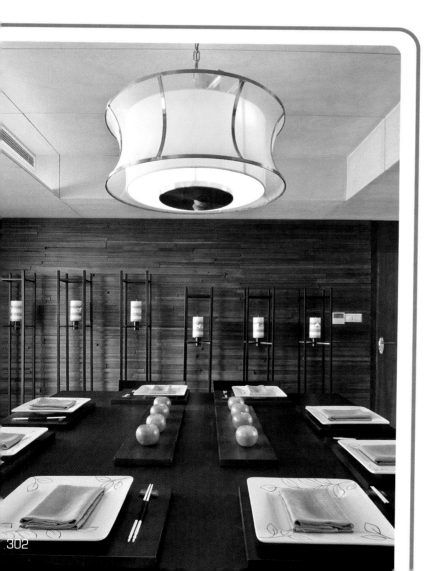

Kris's home town is Kaohsiung, Taiwan, his inspiration the wind on the beach. Favourite shopping Nanjing Road, Shanghai, favourite perfume Chanel no 5. Best sport baseball, he's a player and it's his favourite uniform. Childhood ambition was to play in the Olympics. Fantasy job, interior designer. Least favourite teacher Mr Hung, for Maths. First job working for McDonald's, he likes the food. Happiest with his family and listening to U2, his hero Bono. Ideal date Jessica Alba. His secret for long life 'smiling'.

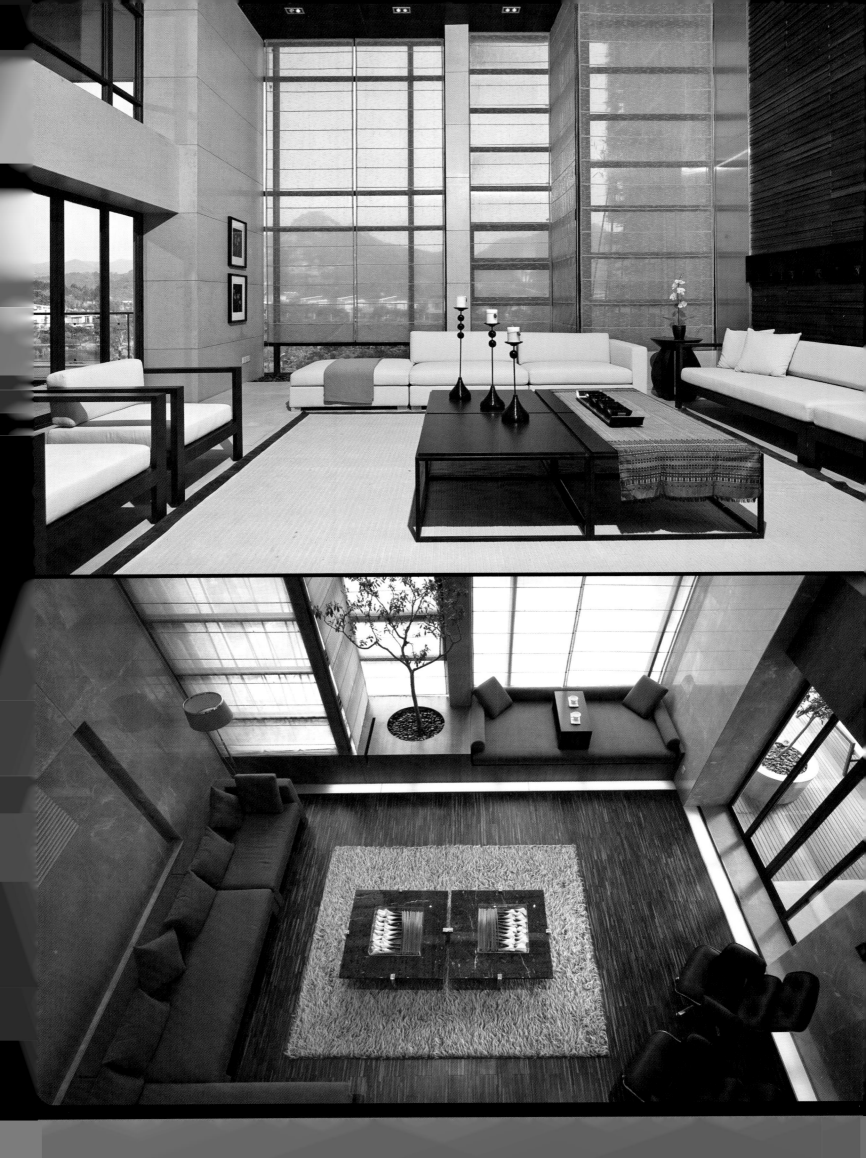

Designers: Irina Markidonova & Ilona Menshakova.
Company: Sisters' Design, Moscow, Russia. Profile: Small
company founded by sisters Irina and Ilona specialising in
private residential apartments in Russia. Current work
includes several apartments in the historical centre of
Moscow, a wooden house in the countryside and a private Spa.

Sirens from the Baltic coast, where endless beaches, cool breeze and thick mist around deep blue seawater inspire Irina and Ilona to incorporate this sense of space and freedom into their interiors. Happiest in the morning at the start of a new day, they dream of a clutter free world and decorating a Spa hotel in the French or Italian Alps. Vivid early memories are of pine trees touching the edge of the sky and feeding nuts to ginger squirrels. Ambitious as a team since childhood, Irina would design and make clothes, Ilona would model them. At their last fancy dress party they wore penguin costumes. Walking with an art historian in Venice was a favourite holiday, their worst 'any hell can become a paradise with good wine and nice company'. Most memorable meal chocolate fettucini in a creamy mushroom sauce by Alessandro Farci, most memorable man Vicente Wolf.

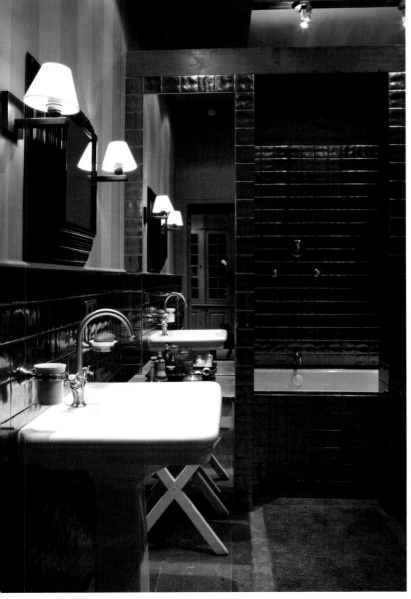
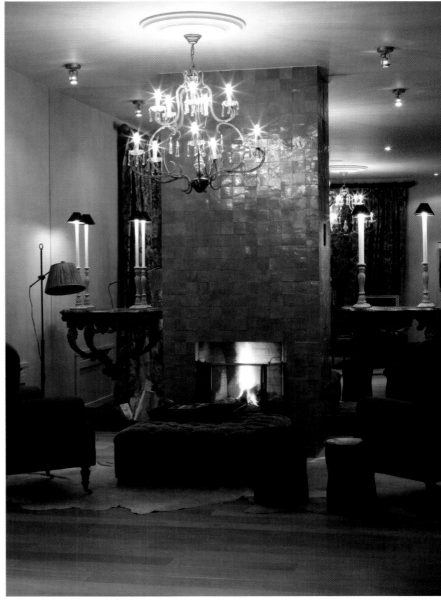

GARRY COHN

Designer: Garry Cohn with design team Brian Jennings and Aoife Rhattigan.
Company: Garry Cohn, Dublin, Ireland, London and New York.
Profile: Specialising in the creation and delivery of hotels, spas, leisure and retail environments. Recent projects include the Style Club, Dublin, the Cliff House Hotel and Spa, Waterford and Escada Laurel showroom New York City plus Heythorpe Hotel, England.

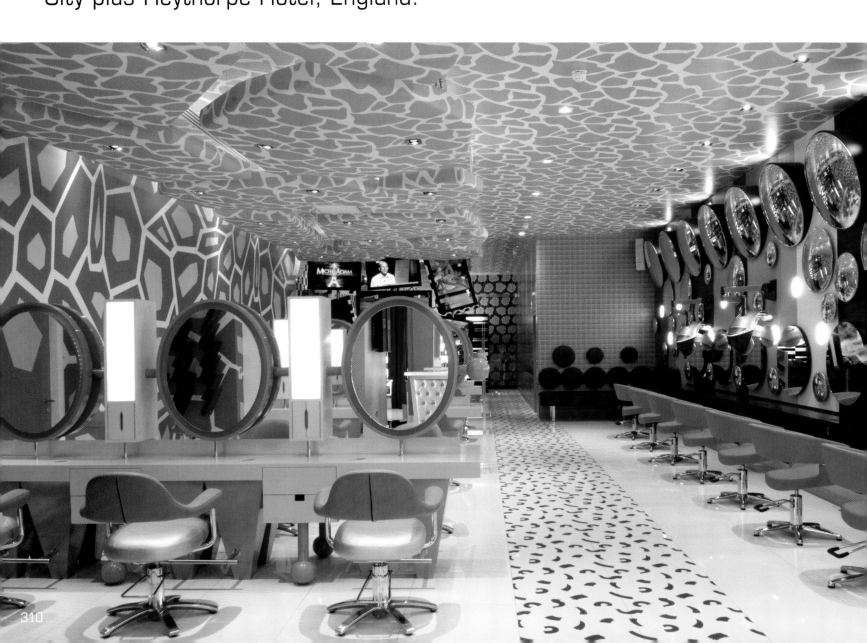

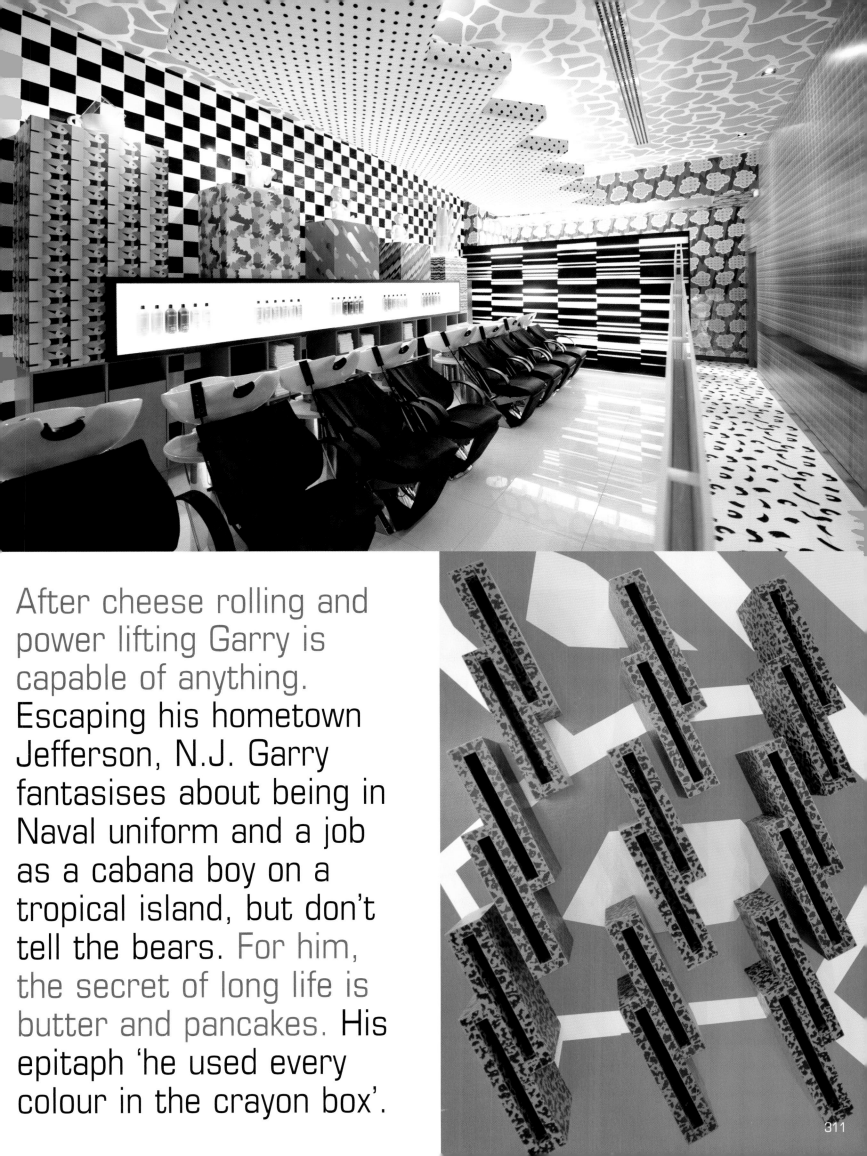

After cheese rolling and power lifting Garry is capable of anything. Escaping his hometown Jefferson, N.J. Garry fantasises about being in Naval uniform and a job as a cabana boy on a tropical island, but don't tell the bears. For him, the secret of long life is butter and pancakes. His epitaph 'he used every colour in the crayon box'.

Anne Noordam

THONG LEI

Designers: Thong Lei & Anne Noordam. Company: Decoration Empire, DA Gouda, The Netherlands. Profile: Founded by Thong Lei and Anne Noordam in 1987. Work is predominantly private and international with some commercial projects. Recent work includes a castle in Belgium, penthouses in Amsterdam and Cannes and an old manor house in the Netherlands.

Un-cool teenager, he's cool now. Thong's favourite saying 'no guts, no glory'. He has his fantasy job, his political hero Winston Churchill. Happiest surrounded by beautiful things or lying on a beach. He collects 13th Century Song porcelain from China and shops for antiques in Paris' Rue des Rosiers. Favourite model Inès de la Fressange, favourite fashion designer Coco Chanel. Most memorable meal, a self caught lobster cooked on a fire on a deserted beach in the Caribbean. Favourite holiday Mustique, best car ever made, the Maserati 3500 GT from 1964. Secret to long life 'do things you like, for positive energy'.

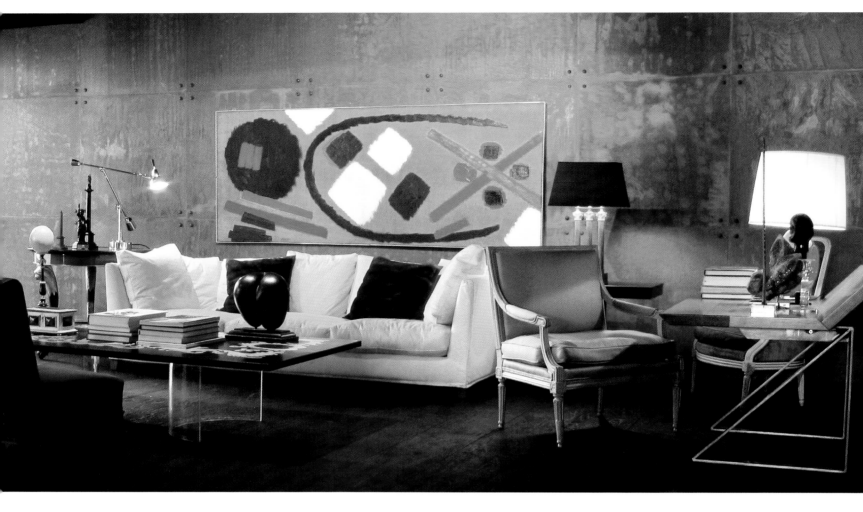

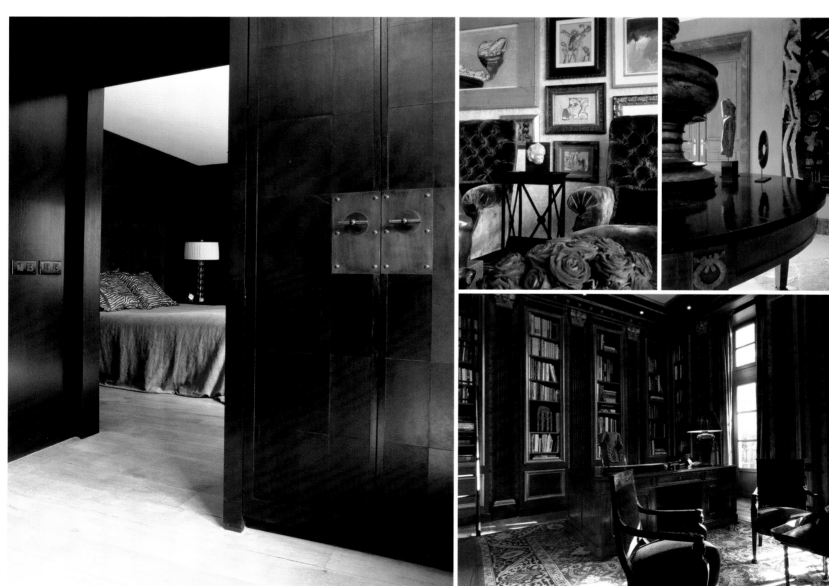

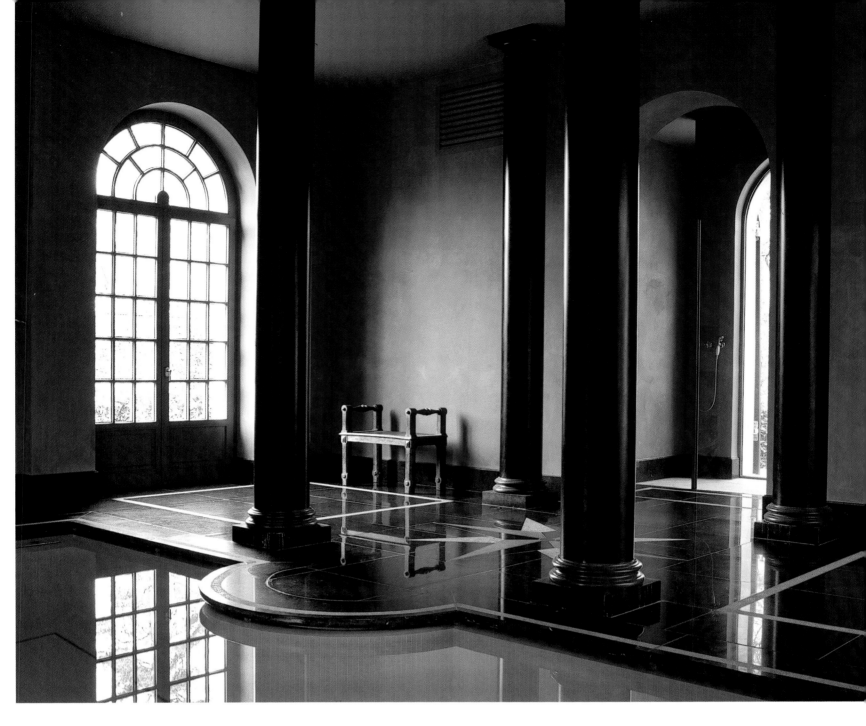

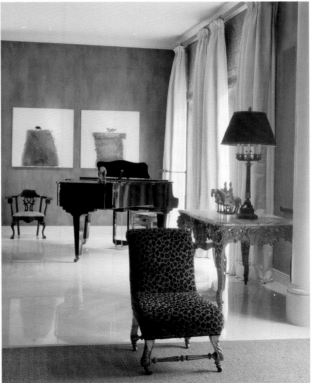

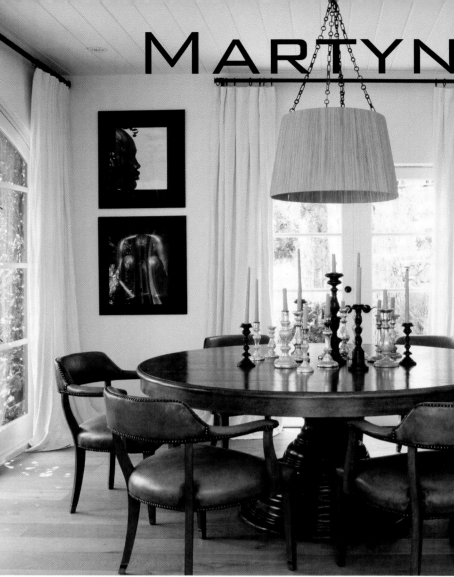

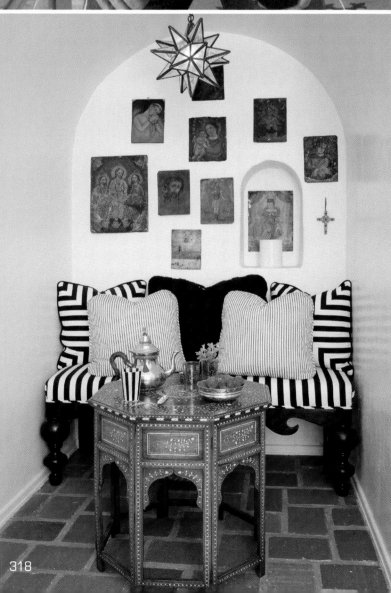

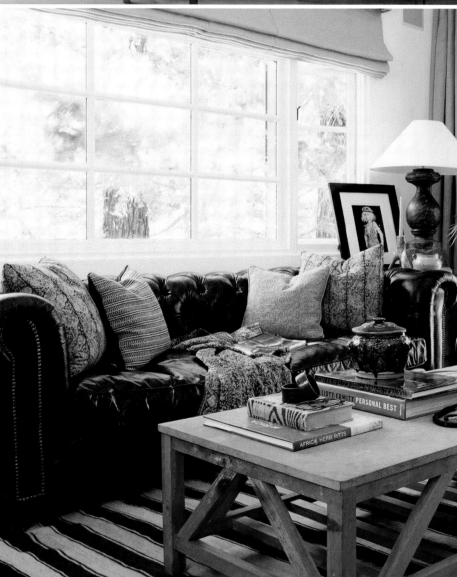

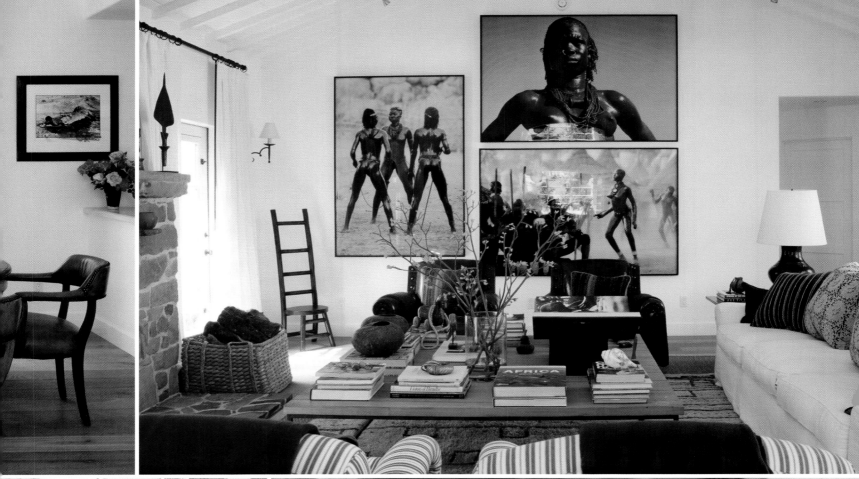

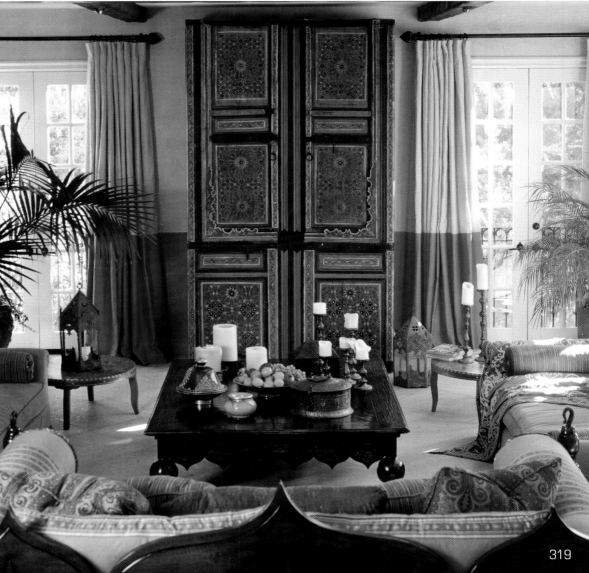

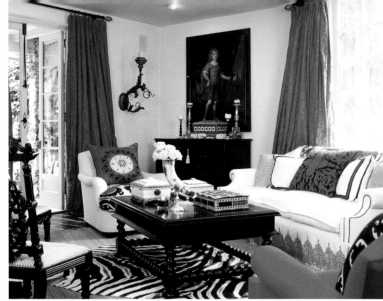

Designer: Martyn Lawrence-Bullard.
Company: Martyn Lawrence-Bullard Design,
California, U.S.A. Profile: A full spectrum of
interior design and architectural services as well
as own fabric, furniture and home fragrance
collections worldwide. Recent work includes the
Jimmy Choo corporate offices, the award winning
Colony Palms hotel and Spa in Palm Springs plus
the restoration of renowned Richard Neutra
residence, the homes of Hollywood luminaries
Edward Norton, Christina Aguilera and Kid Rock.
Current projects include a Moorish villa for Cher,
a glamorous penthouse for Sir Elton John, a 12th
Century castle in Umbria and a residence for
Jimmy Choo/Halston director Tamara Mellon in
New York City.

Poster boy, made in England and
settled in L.A. Martyn's dream
job to redesign Buckingham
Palace, his attitude to
decorating, complete comfort.
When he's not in Virgin's upper
class lounge, he's in bed
watching an old movie with a
glass of Barolo and a box of
chocolates, comforted by King
size cashmere blankets. Best
advice ever received 'learning to
love yourself is the greatest love
of all'. International beautification
is his mission, Martyn's greatest
extravagance his watches. Best
skill global shopping, most
nervous of the bill. He'd date The
Beckhams – both of them and
revisit Rome to be blown away
by the architecture. Worst
holiday Tenerife – ghastly. His
epitaph will be ' he lived, he
loved and he decorated…a lot'.

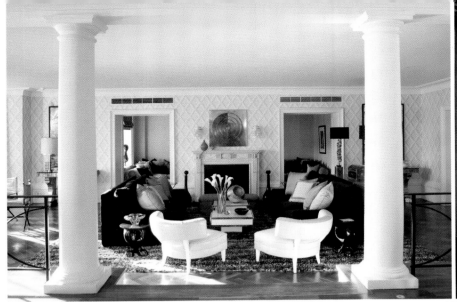

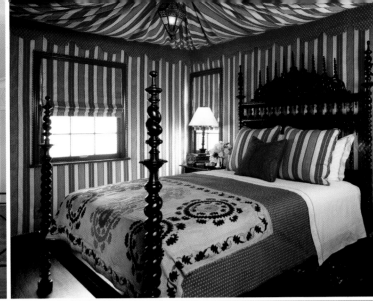

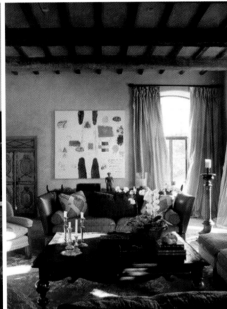

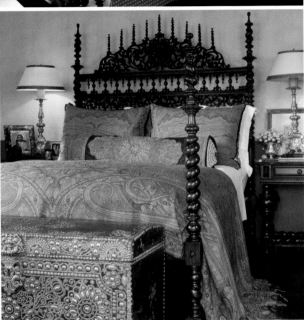

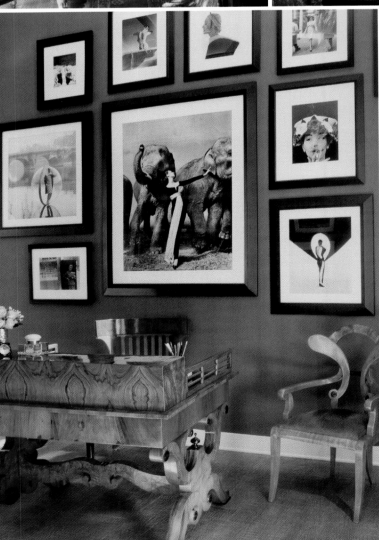

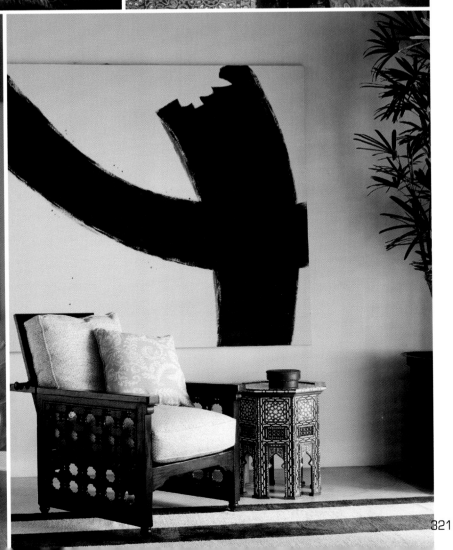

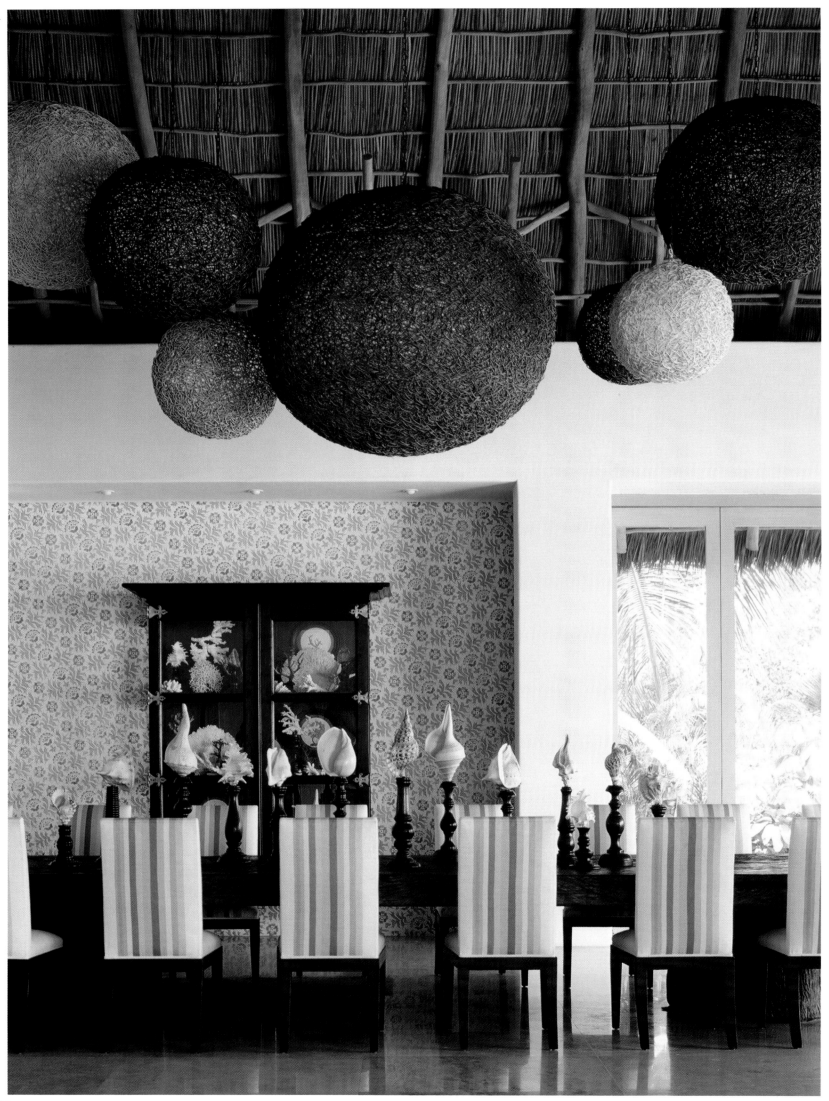

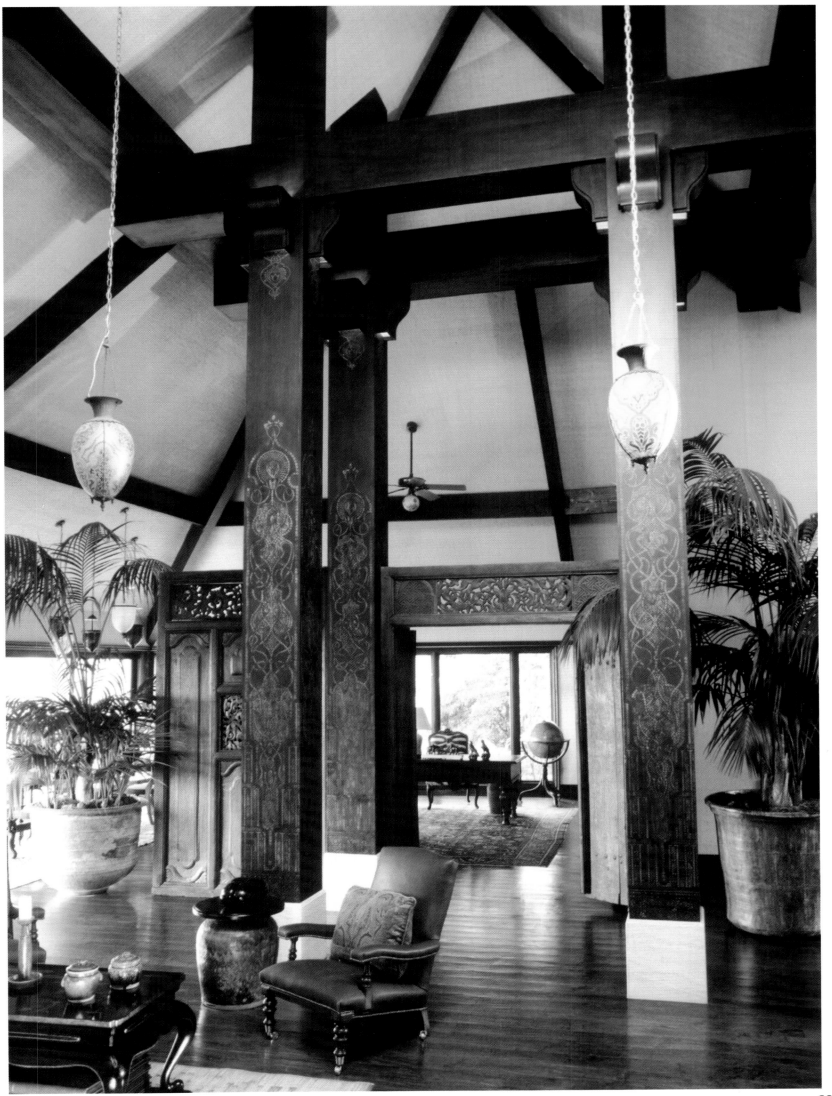

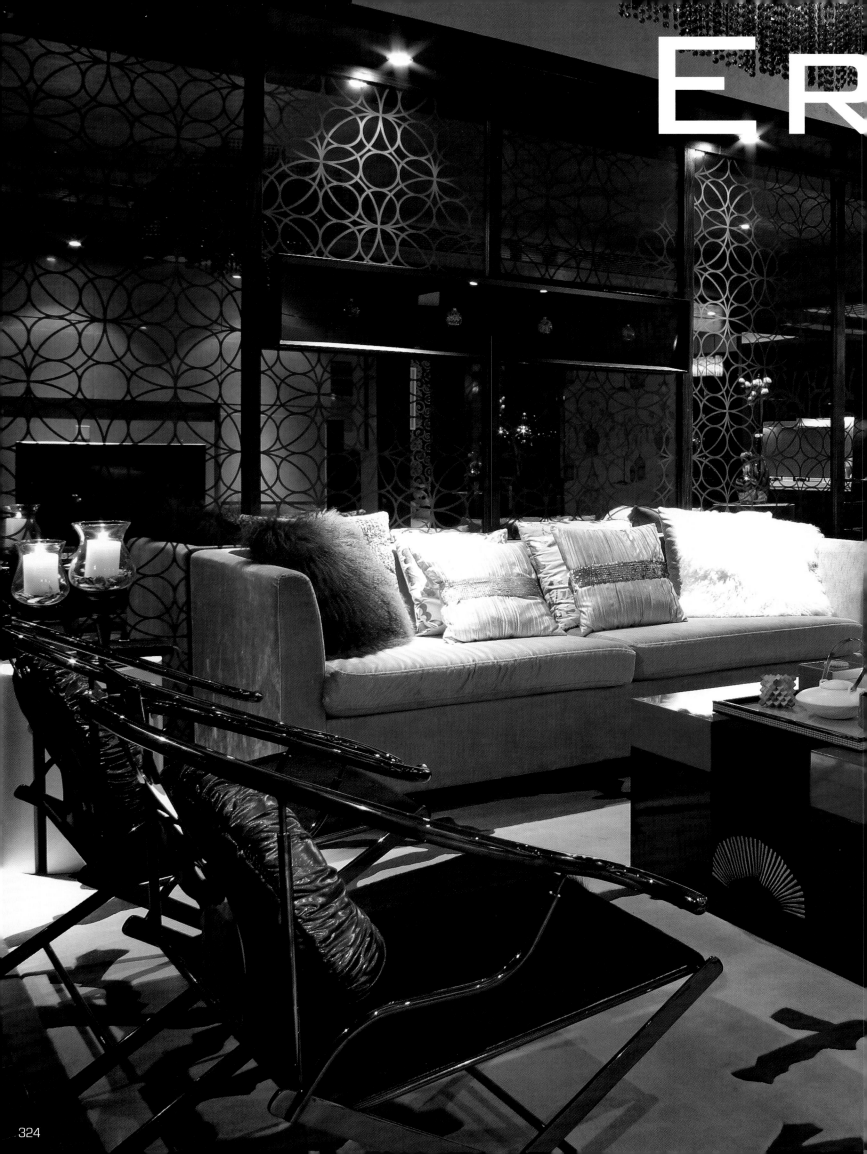

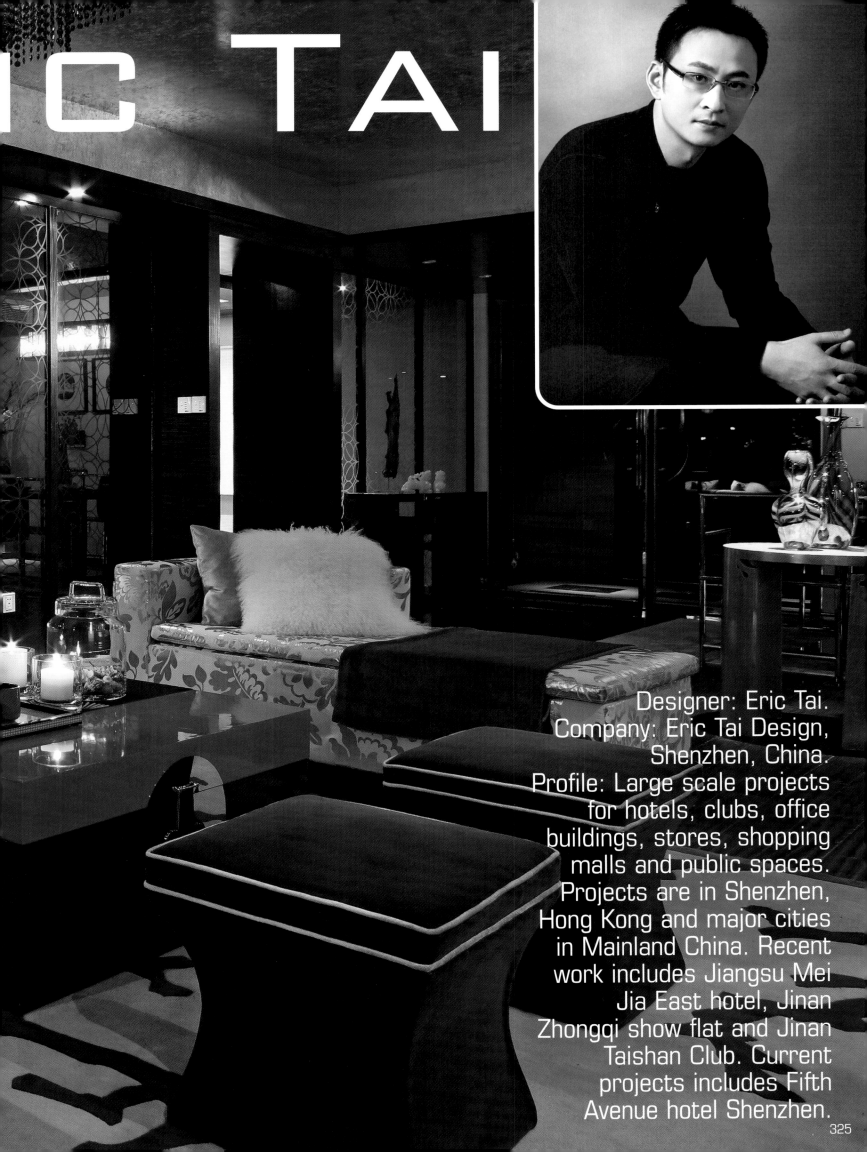

IC TAI

Designer: Eric Tai.
Company: Eric Tai Design,
Shenzhen, China.
Profile: Large scale projects
for hotels, clubs, office
buildings, stores, shopping
malls and public spaces.
Projects are in Shenzhen,
Hong Kong and major cities
in Mainland China. Recent
work includes Jiangsu Mei
Jia East hotel, Jinan
Zhongqi show flat and Jinan
Taishan Club. Current
projects includes Fifth
Avenue hotel Shenzhen.

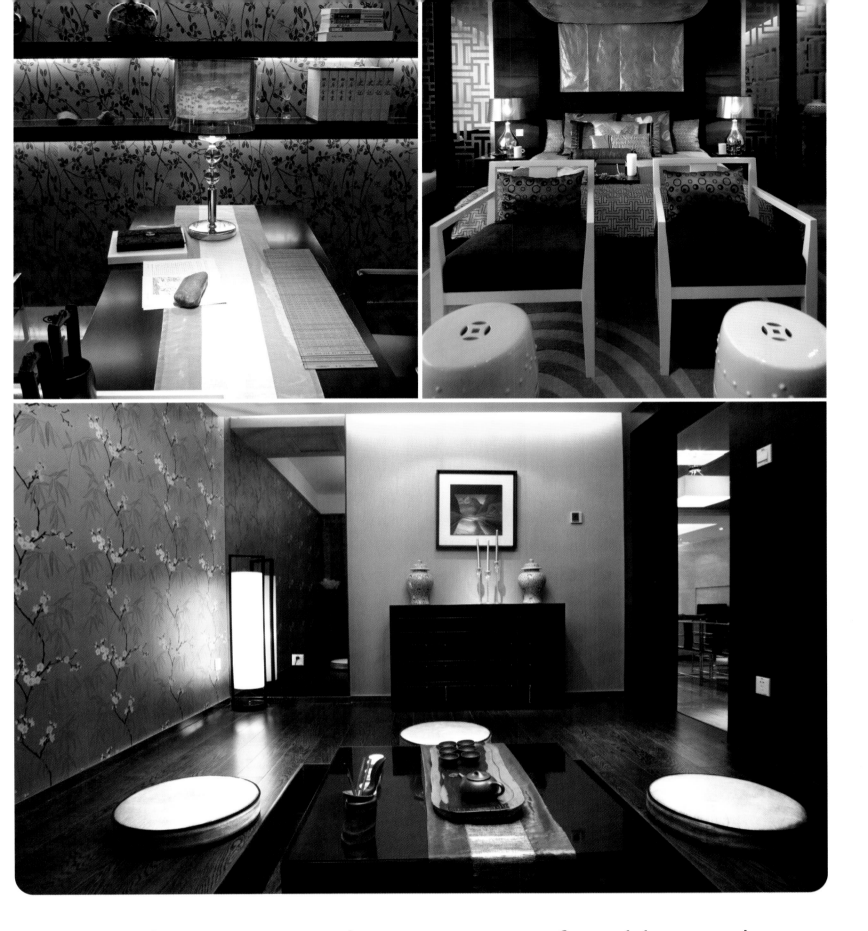

Eric is a keen geographer, nervous of nothing and happiest in his career. His home and inspiration is China, favourite takeaway food fried rice and noodles, his political hero Deng Xiaoping. Best transport ever made, the bicycle. Loves Hip Hotels and Banyan Tree.

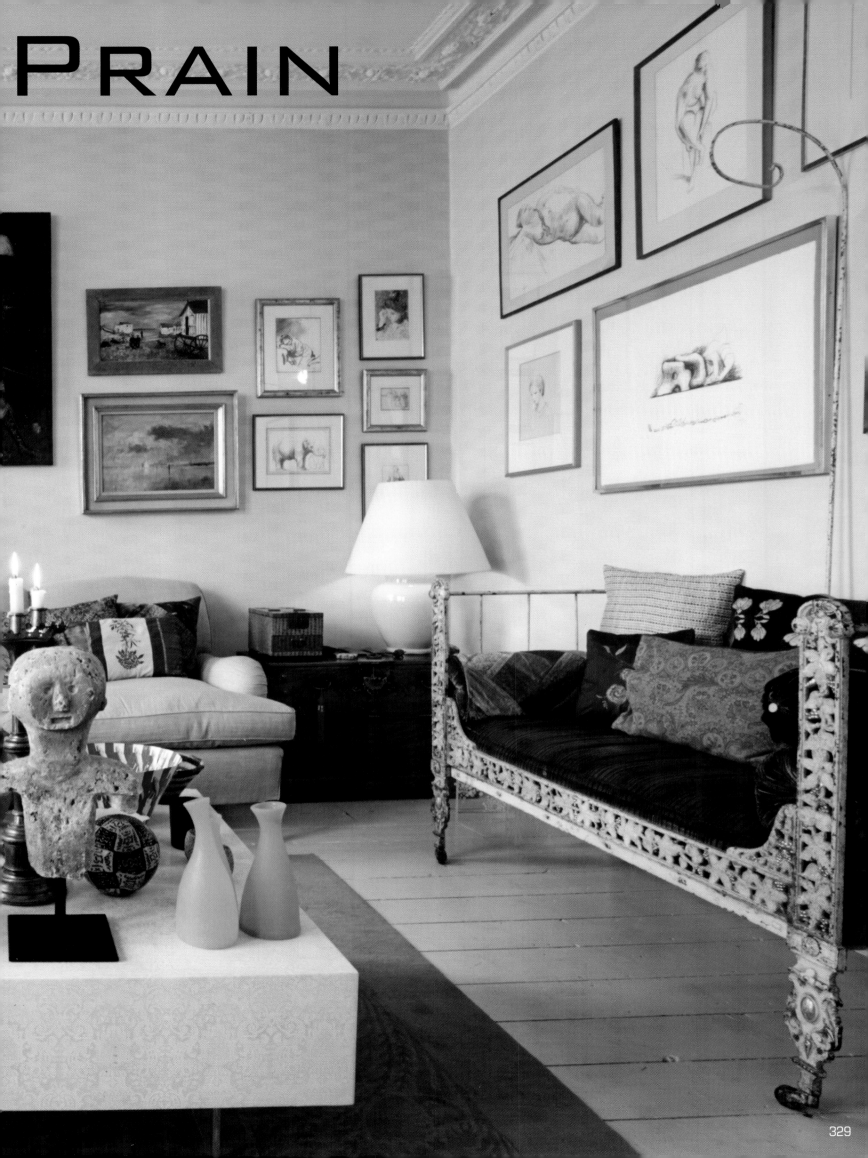

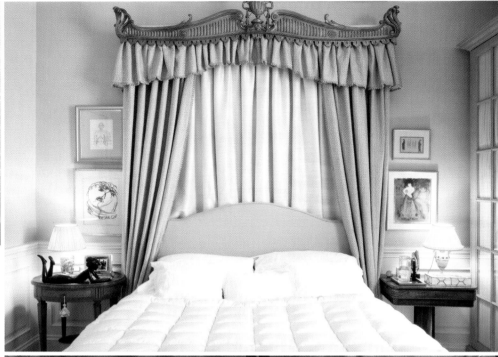

Designer: Christopher Prain.
Company: Christopher Chanond Interior Design, U.K.
Profile: Predominantly private houses worldwide specialising in turnkey solutions. Recent work includes a house on the Crown Estate, a lateral flat in Kensington and a modern retreat in Notting Hill. Current projects include four London mews houses, a restaurant and bar in Bangkok and a house in Regent's park.

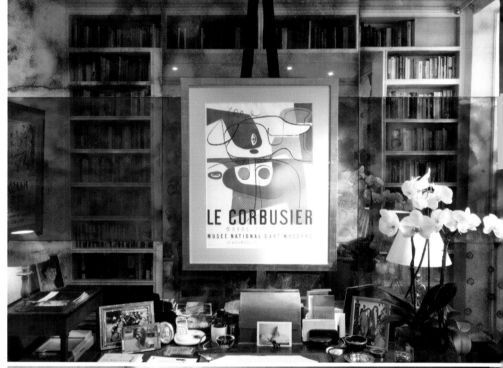

He'd like to design Chelsea barracks in the hope that it would still be there in 300 years, like The Royal Hospital. Christopher's favourite architect Inigo Jones, design book David Hicks, everyday outfit a good navy suit. He got into interior design on the advice of a friend. Favourite shopping Borough Market, best holiday Piedmont, for the food. London is home, its tradition and forward thinking, his inspiration. Favourite sport, cricket, home comforts two warm dogs, favourite scent - good soap.

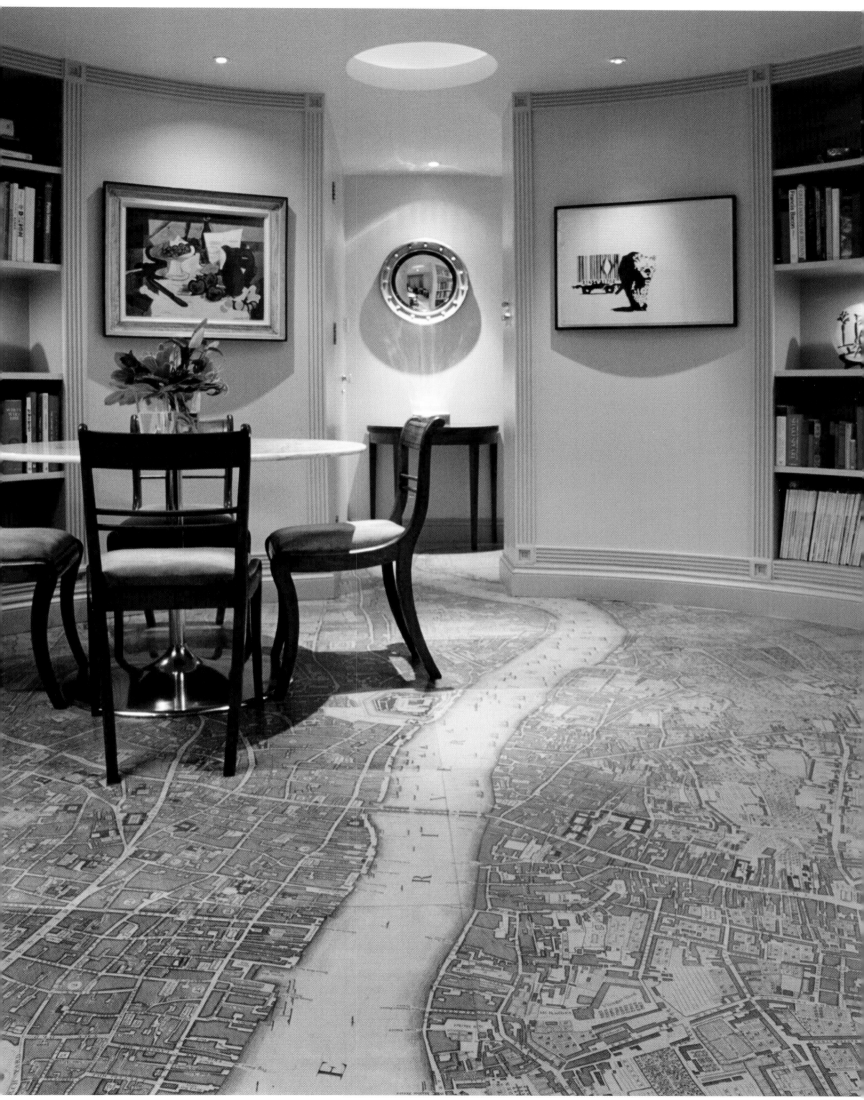

LUCIA VAL

Designer: Lucia Valzelli. Company: Dimore, Brescia, Italy. Profile: Private and commercial work in Italy, Europe and the Caribbean. Recent projects include the refurbishment of a château and spa, a loft apartment and the full restoration of a villa. Current work includes the installation of a fully equipped private sitting room with swimming pool in the basement of a 15th century mansion and the renovation of a country house estate in a wildlife park.

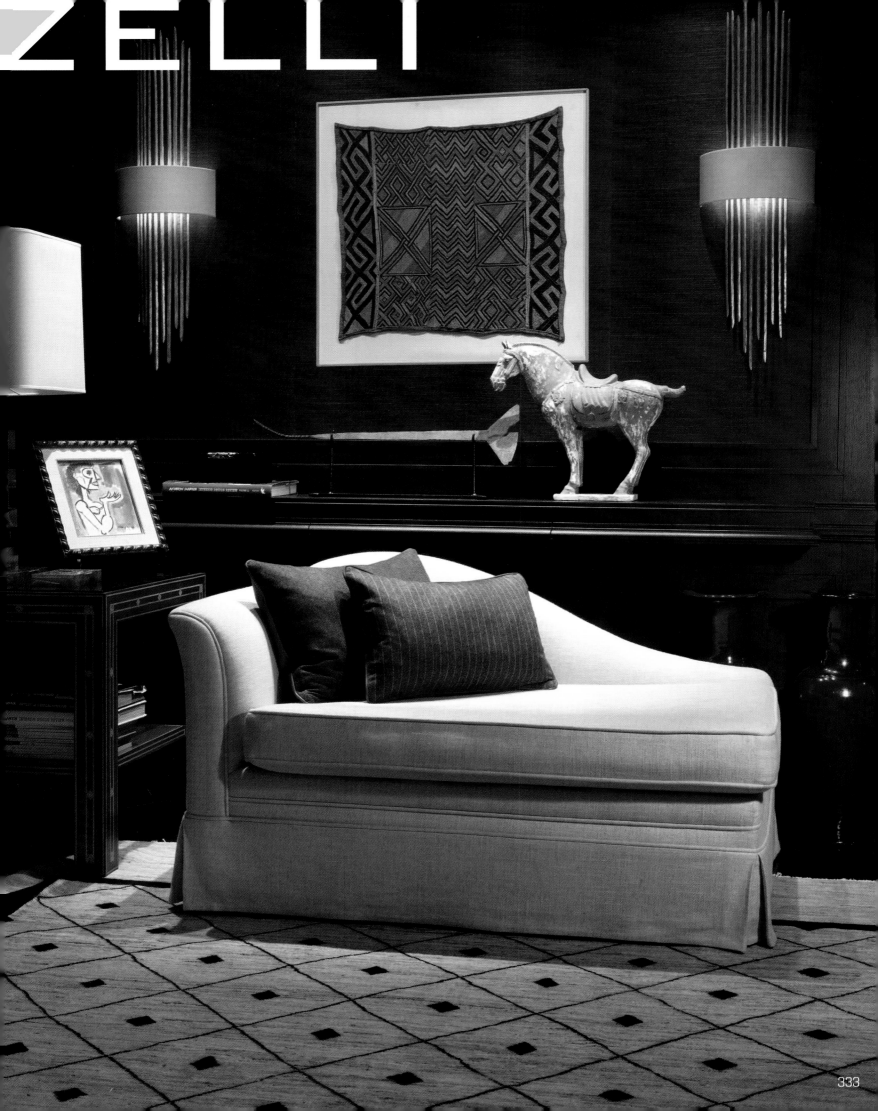

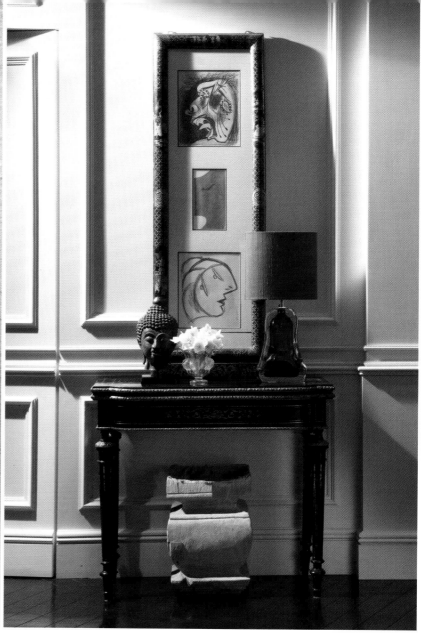

She's a true Leo, a purring lioness who's happiest basking in the sun. Lucia thinks Carla Bruni is overrated and Roger Rabbit's bitten off more than he can chew. Her most memorable meal, roast lamb on an island in the Med. Favourite home comfort warm light and jazz music, her cup is Baccarat, her glass always half empty of Italian champagne. Lucia's childhood ambition was to dance on ice, favourite sport skiing. Earliest memory a present from her mother, a wonderful Barbie house. Shopping's her hobby, for handbags and shoes, her everyday outfit kingsize Prada bag, turkey Moleskine and mini Montblanc. Favourite car ever made, Jaguar E-type coupe in black. Every Barbie needs her Ken, Lucia would have Sean Connery. Favourite saying 'sempre solo per passione – always and only for passion'. Her epitaph 'try later'.

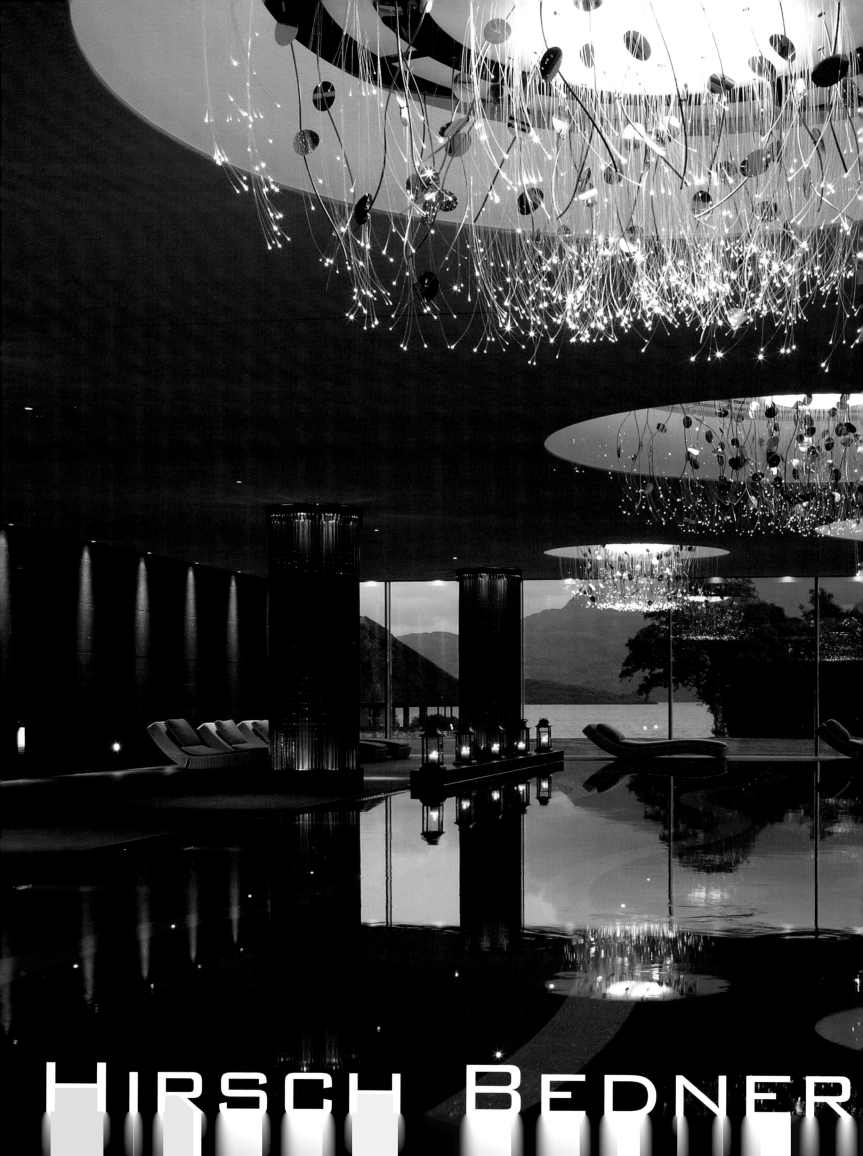

HIRSCH BEDNER

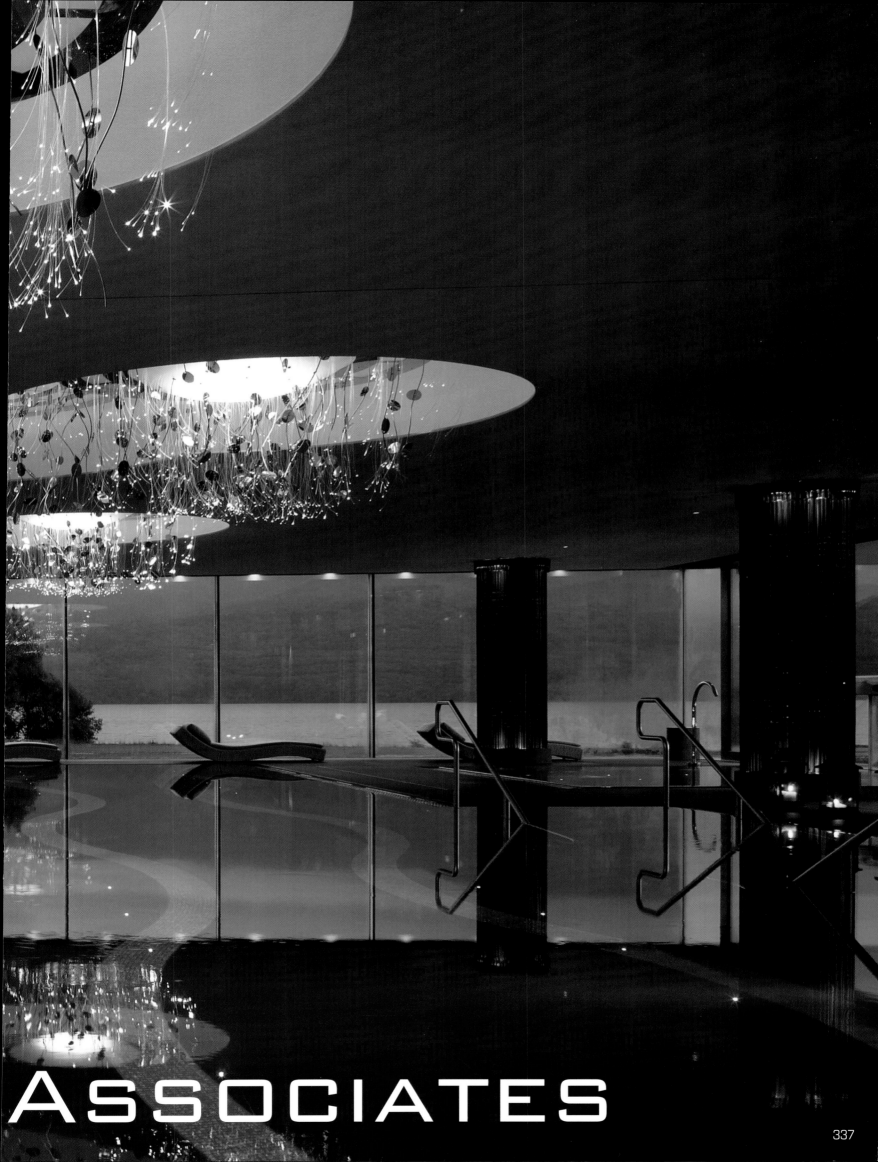

ASSOCIATES

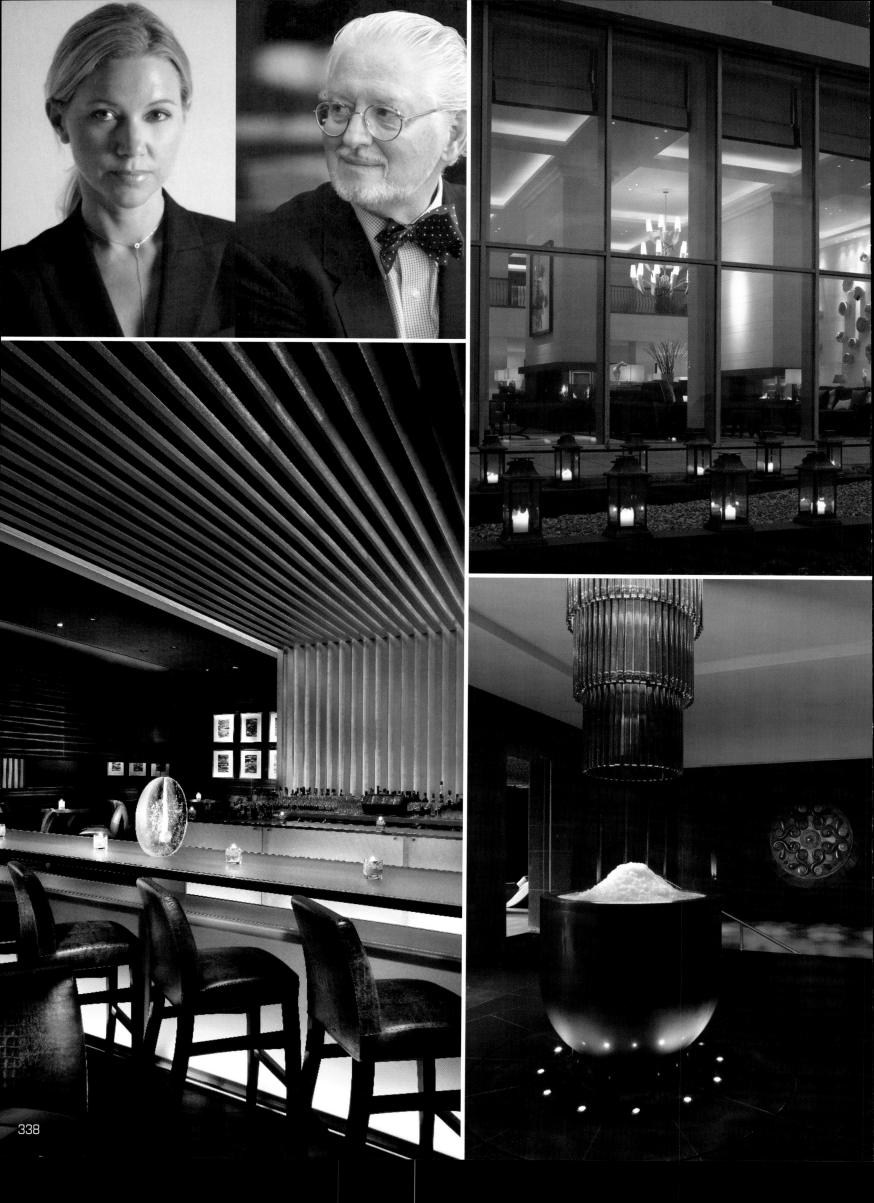

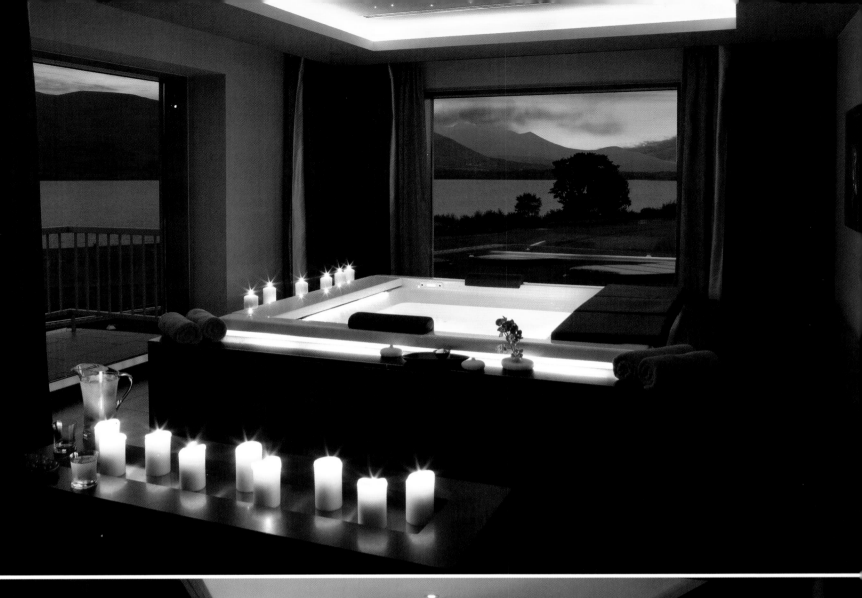

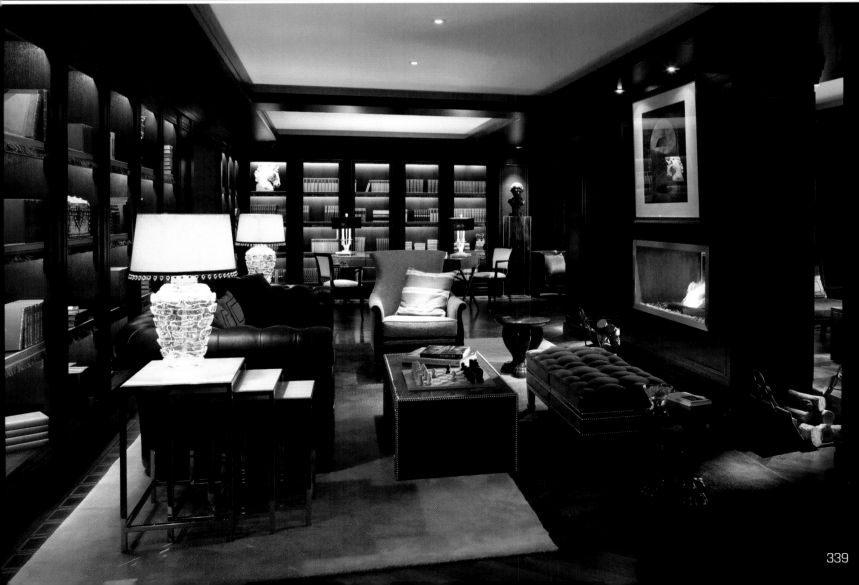

C.E.O: Michael Bedner. Designer: Inge Moore. Company: Hirsch Bedner Associates, California, U.S.A. Profile: With over 400 design professionals and 13 offices internationally HBA specialise in top end interior design worldwide with over half their current projects located in the Pacific Rim countries. Work includes premier hotels and resorts to individual boutique hotels, spas, casinos, cruise ships and private residences. Recent examples include St Regis, Mandarin Oriental, Shangri-La, Ritz-Carlton and Four Seasons.

For Michael happiness is a dog called Sammy. Favourite home comfort to sit with him and watch the sun set over the ocean. Earliest memory a Detroit Tigers baseball game. Home is Malibu, inspiration the laid back lifestyle. Childhood ambition to be an architect, his favourite Buckminster Fuller. Best musician The Rolling Stones, model Claudia Schiffer, car 1957 Chevy Bel Air. Secret crush Susan Sarandon. Favourite holiday Sundays, greatest extravagance family time. Last fancy dress a penguin costume. Every day outfit bow tie and tweed sports jacket.

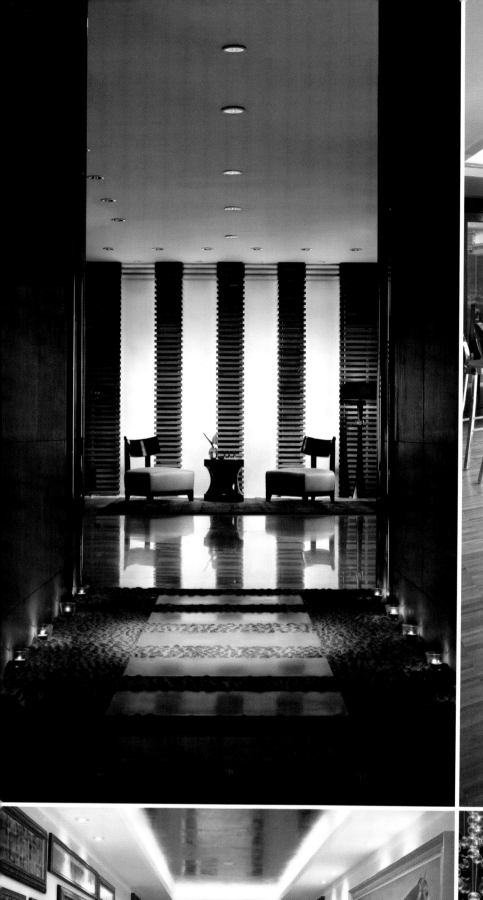
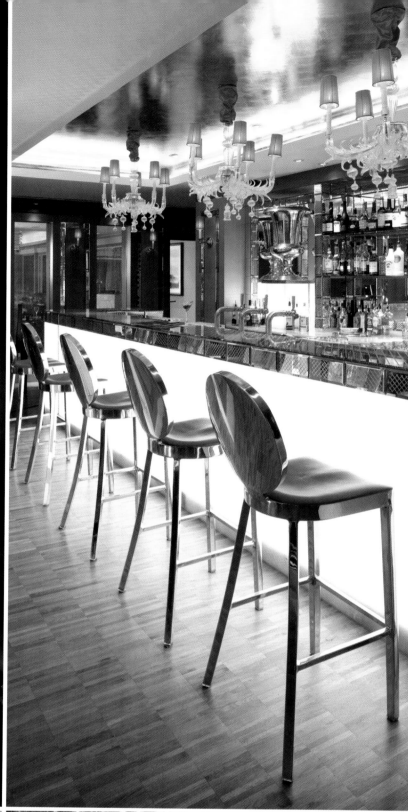
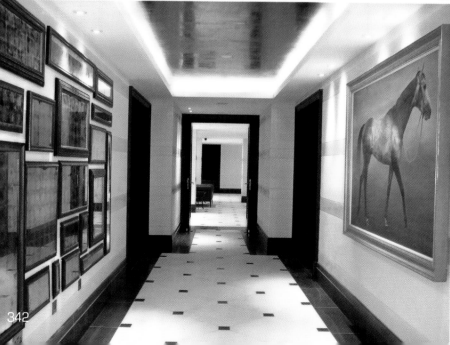

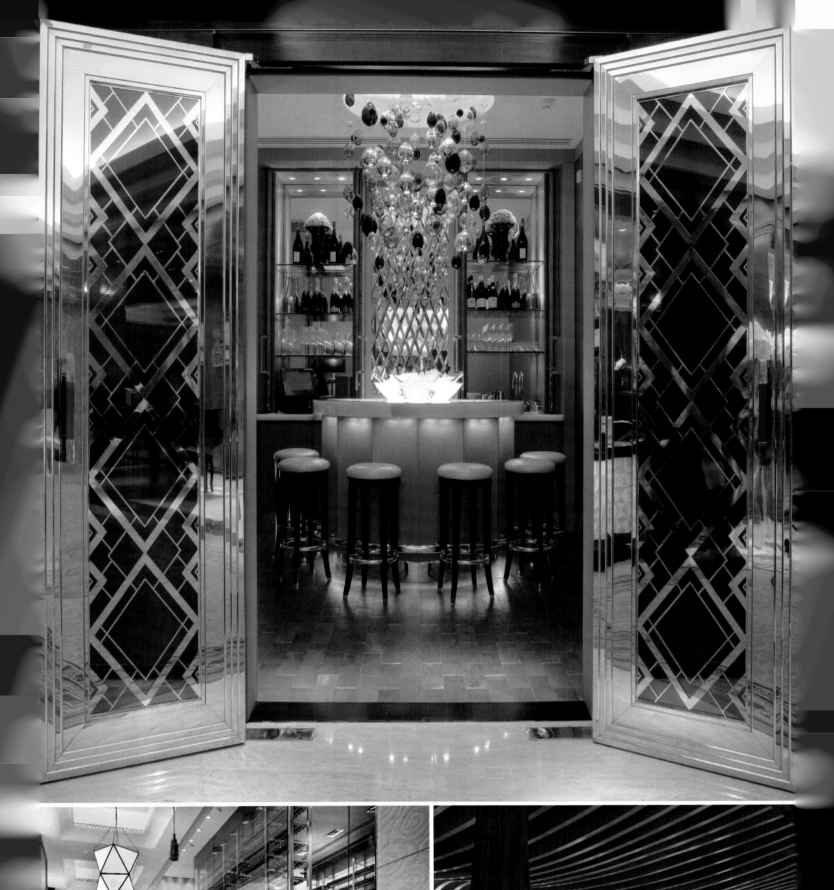

GARUDA

Designer: Suzanne Garuda.
Company: Garuda Design, Belfast,
N. Ireland. Profile: Specialising in residential projects plus hotels and offices. Recent projects include the K. Club, Straffan, Co. Kildare for the Ryder Cup, Killeen Castle, Co Meath hosting the Solheim Cup in 2011 and a private residence in Walton Street, London. Current work includes new offices at Windmill Lane Recording Studios, Dublin, a villa in Rabat, Morocco and an office in Pall Mall, London. Clients include U2, Enya and the Guinness advertisements.

Watching the clouds go by from her Silver Cross pram is Suzanne's earliest memory. Donegal in the rain her worst holiday. If she were to spend more time up in the clouds it would be on a long haul Emirates flight sitting next to Leonardo da Vinci. As a child Suzanne dreamed of becoming an artist but her unfulfilled ambition is becoming a singer, she's a fan of Joni Mitchell. Central heating and the washing machine are Suzanne's favourite home comforts, Belfast and real people, her inspiration. The most memorable meal was dinner on the roof of the Palazzo Rondinini, The Chess Club in Rome where her husband proposed. Suzanne's greatest extravagance is 'me time' and she'd shop in Via Condotti. Proudest career moment; painting in the state rooms in the Kremlin whilst maintaining her sanity. Collects teapots and ammonites.

DESIGN

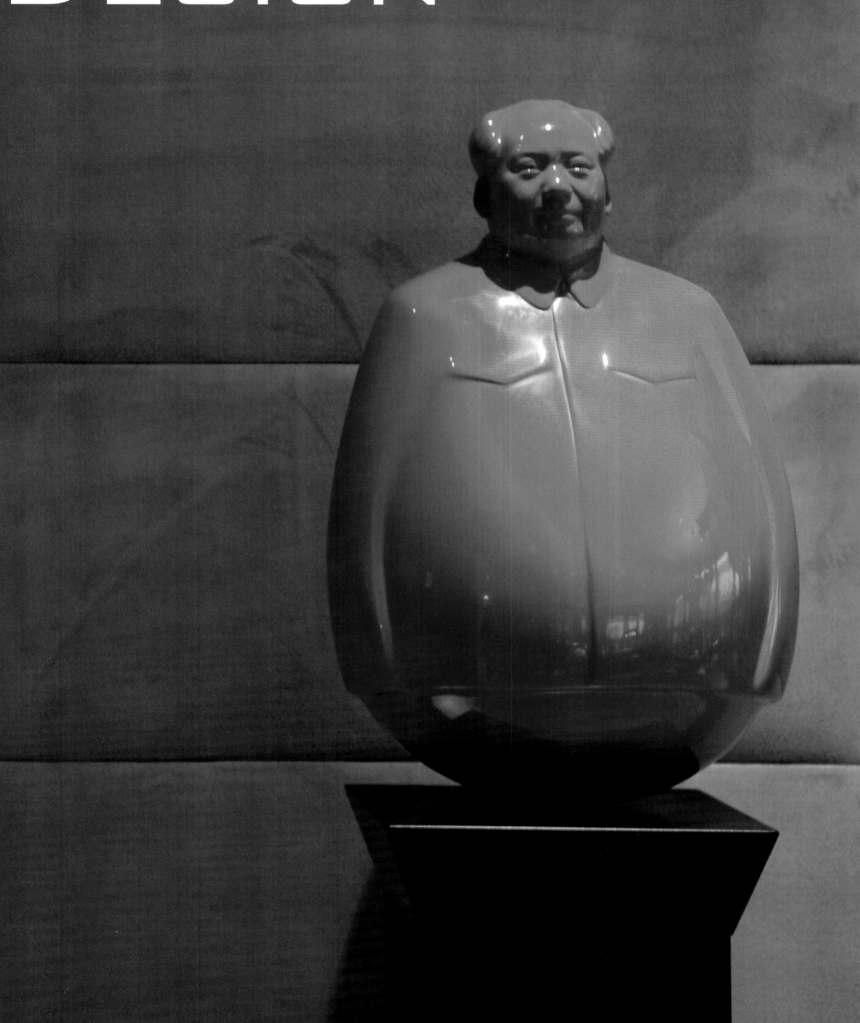

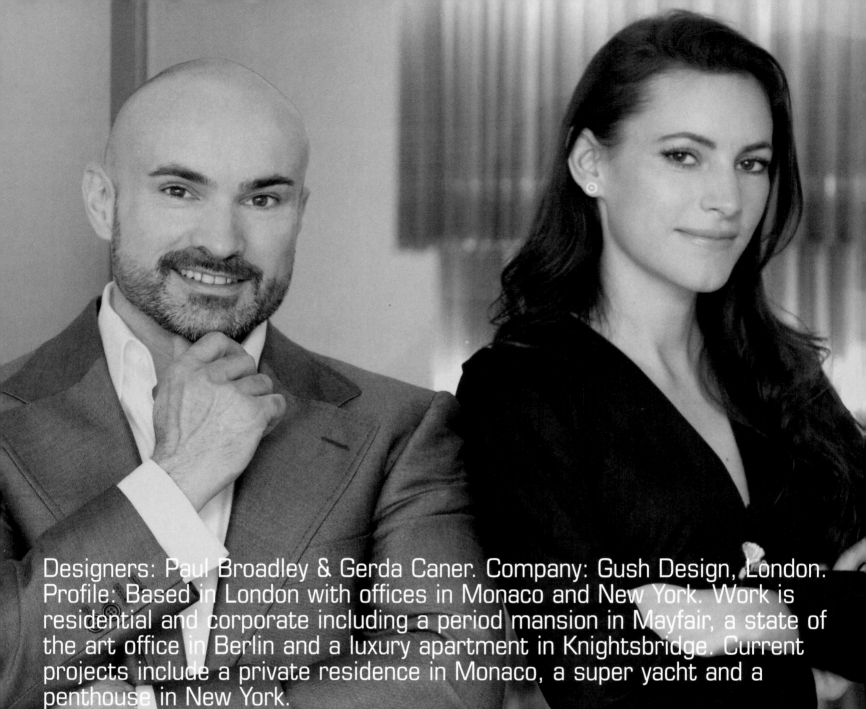

Designers: Paul Broadley & Gerda Caner. Company: Gush Design, London. Profile: Based in London with offices in Monaco and New York. Work is residential and corporate including a period mansion in Mayfair, a state of the art office in Berlin and a luxury apartment in Knightsbridge. Current projects include a private residence in Monaco, a super yacht and a penthouse in New York.

Caber tossing, cycling enthusiast, Paul's dream is to be a master chef. Earliest memory tipping his brother out of a wheelbarrow. Most memorable meal raw herring, childhood ambition to become a vet, adult ambition to travel the world in a VW Camper van. Favourite holiday cycling in Friesland, worst Agadir. Happiest buying flowers in Columbia Road. Political hero Harvey Milk, music hero David Bowie. Nervous of heights but proudest of an 8m high chandelier. From Vienna with love, Gerda would represent her country in an international competition for Austrian cakes, favourites Schaumrolle and Sacher Torte. Inspiration: Biedermeier, Jugendstil, Mozart. Fantasy job, fashion designer. Favourite shopping Paris, architect Rem Koolhaas, food healthy. Most like to meet Matt Damon.

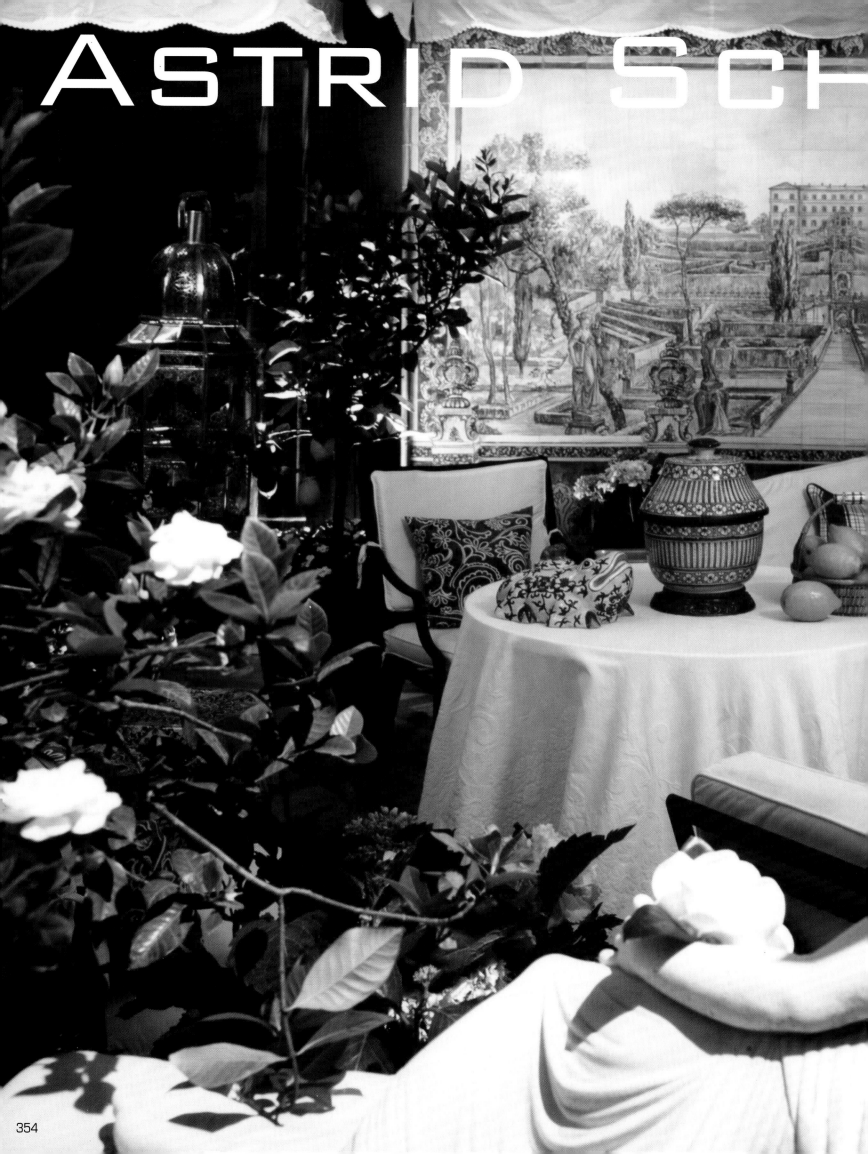

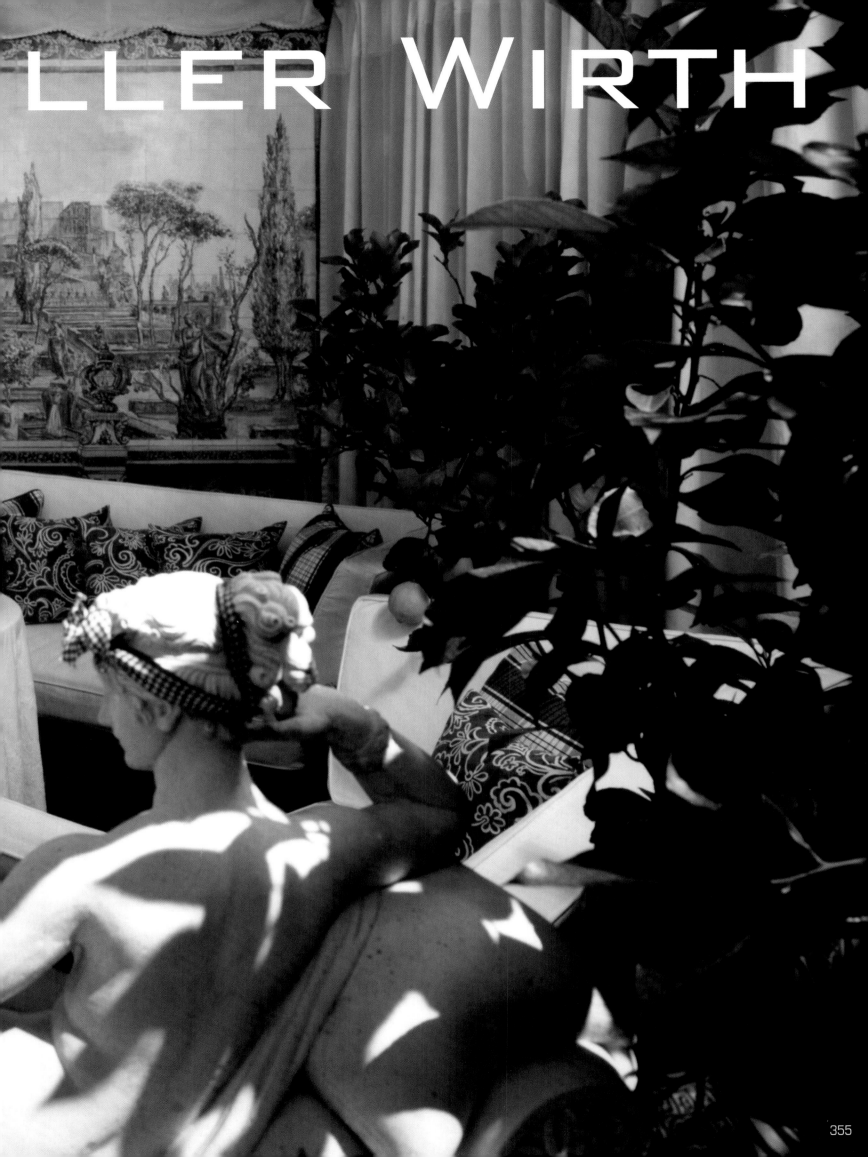

Designer: Astrid Schiller Wirth.
Company: Astrid Schiller Wirth, Rome, Italy.
Profile: Recent projects include two apartments in Las Vegas, a castle in Tuscany and the third floor of Hotel Hassler, Rome.

Mother of four Astrid's favourite saying is 'the distance between dream and reality is courage.' Her proudest work, The Hotel Hassler, Rome has her stylish fingerprints all over it, even on its perfume Amorvero, which she created. If Astrid were to represent her country in an international competiton it would be for cooking, she's a master chef. Her most memorable meal was in her grandmother's kitchen. Loves Gandhi, Porsche, Mozart, Ferragamo and laughter.

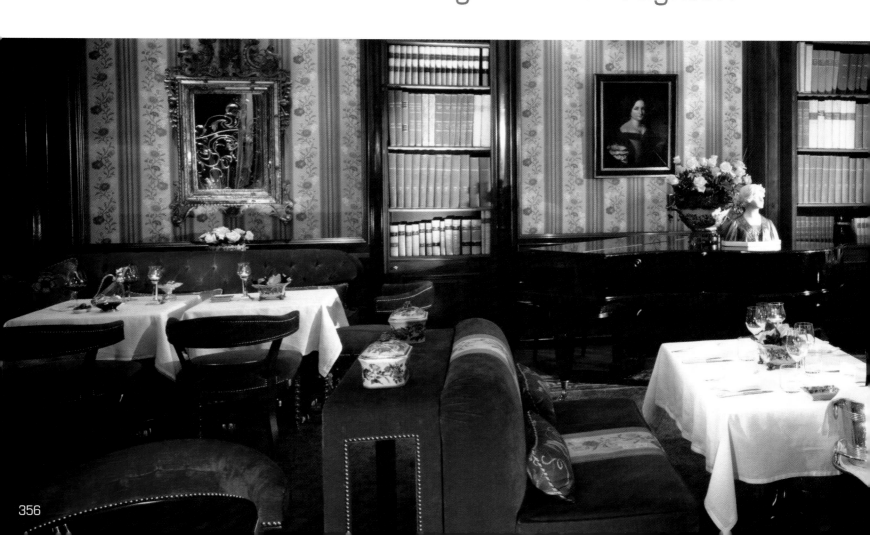

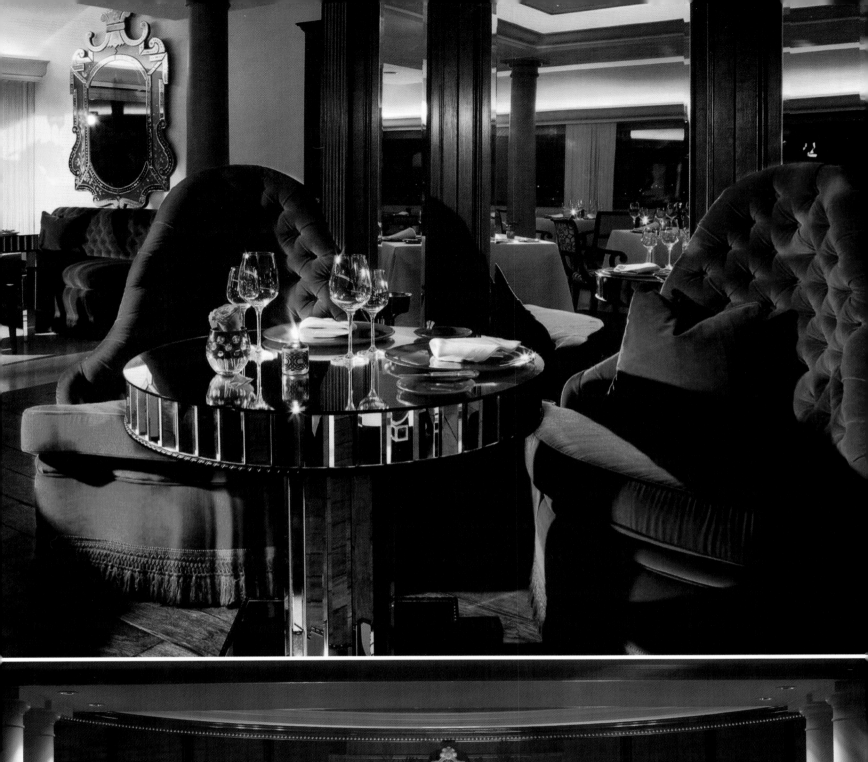

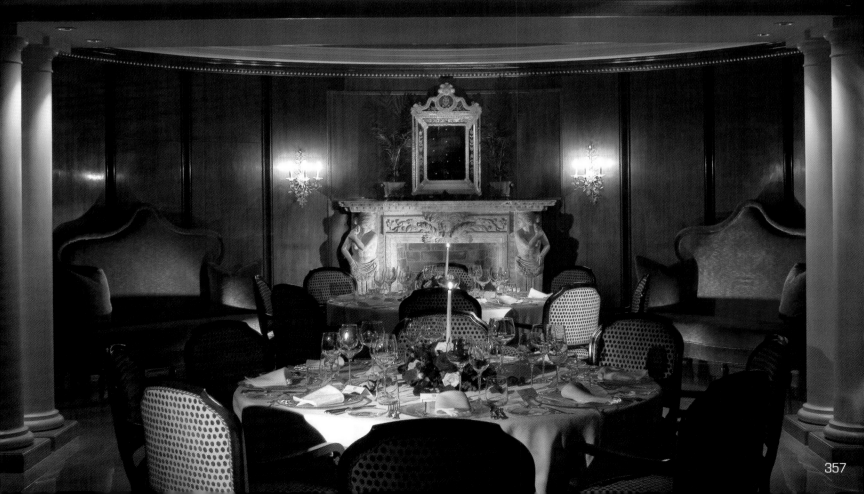

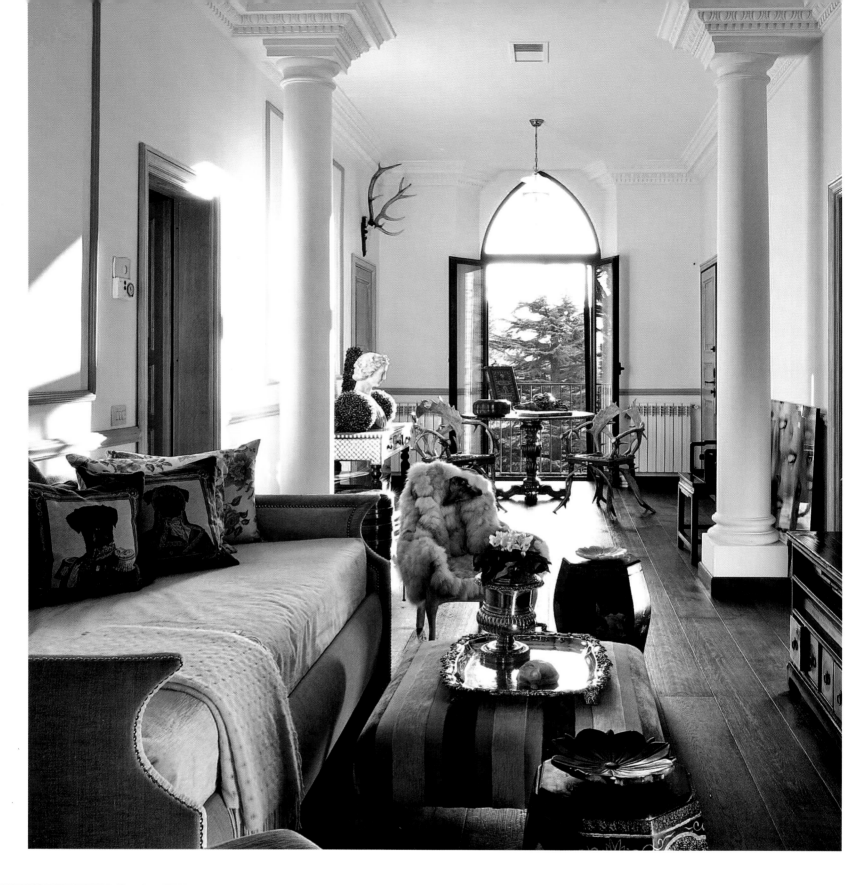

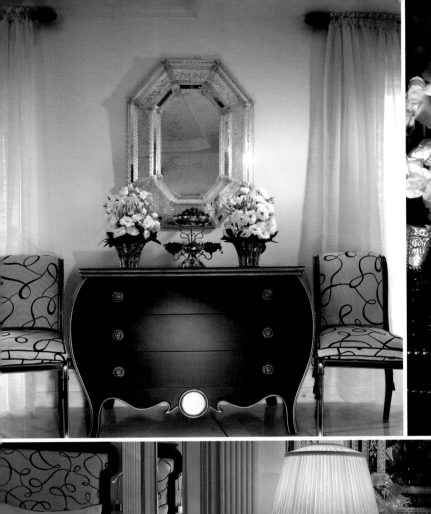
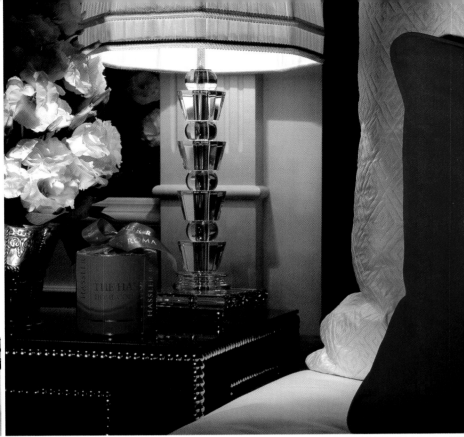
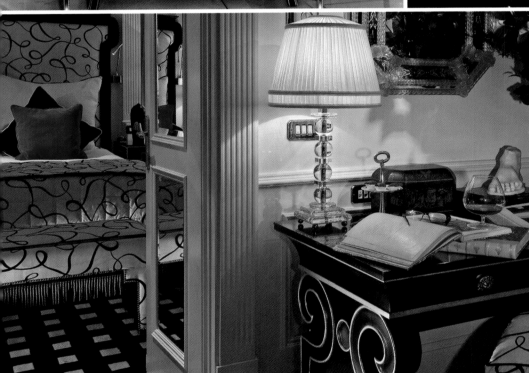
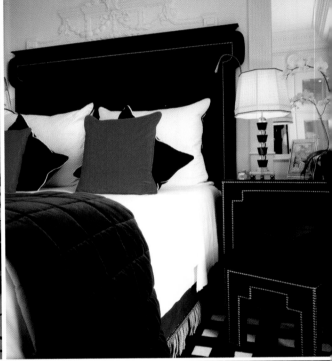

Designers: Seyhan Özdemir & Sefer Çaglar. Company: Autoban, Istanbul, Turkey. Profile: Specialising in commercial projects in Turkey and internationally. Recent work in Istanbul includes Angelique Restaurant and Bar, The Marmara Hotel and Marco Centre gourmet supermarket. Current projects include restaurants in Hong Kong and Madrid, and two stores, an airline catering firm and an office and education centre in Istanbul.

A keen photographer who's inspiration is nature, Sefer's home town is Niğde. His earliest memory is getting sneakers. Now his favourite shoe designer is Pierre Hardy. A scooter makes his life easier, low blood sugar and success make him happy. Favourite meal in Namos restaurant Mykonos. Best holiday a road trip around Europe, worst in Bodrum. Favourite musician of all time Moloko. Best car Mercedes 300SL Gullwing. He'd most like to date Daryl Hannah. Best advice he received 'the roots of an oak tree through the storm grow stronger'.

TOBAN

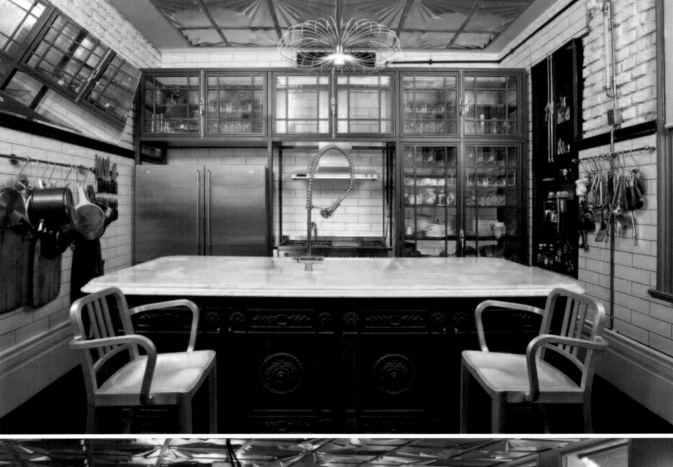

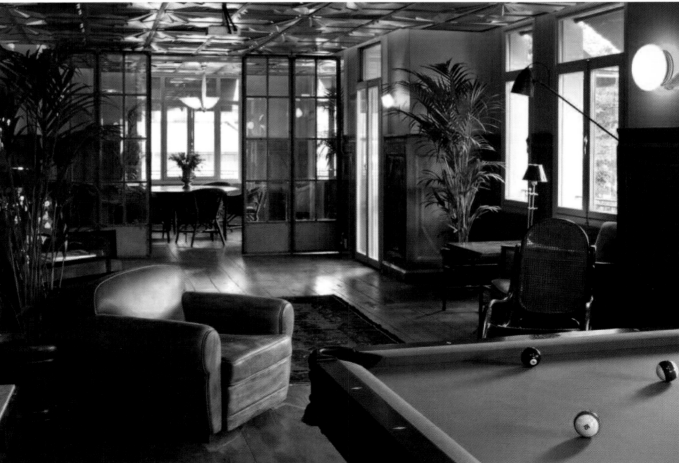

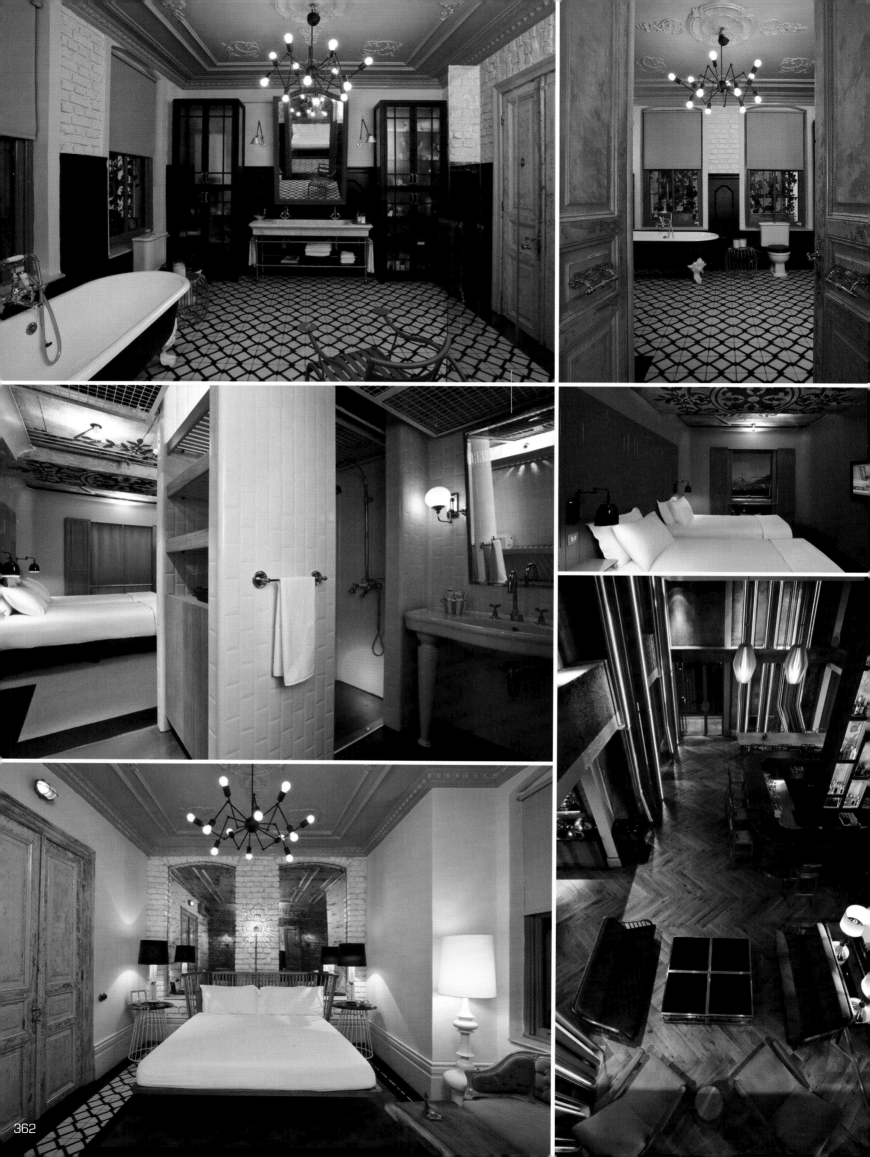

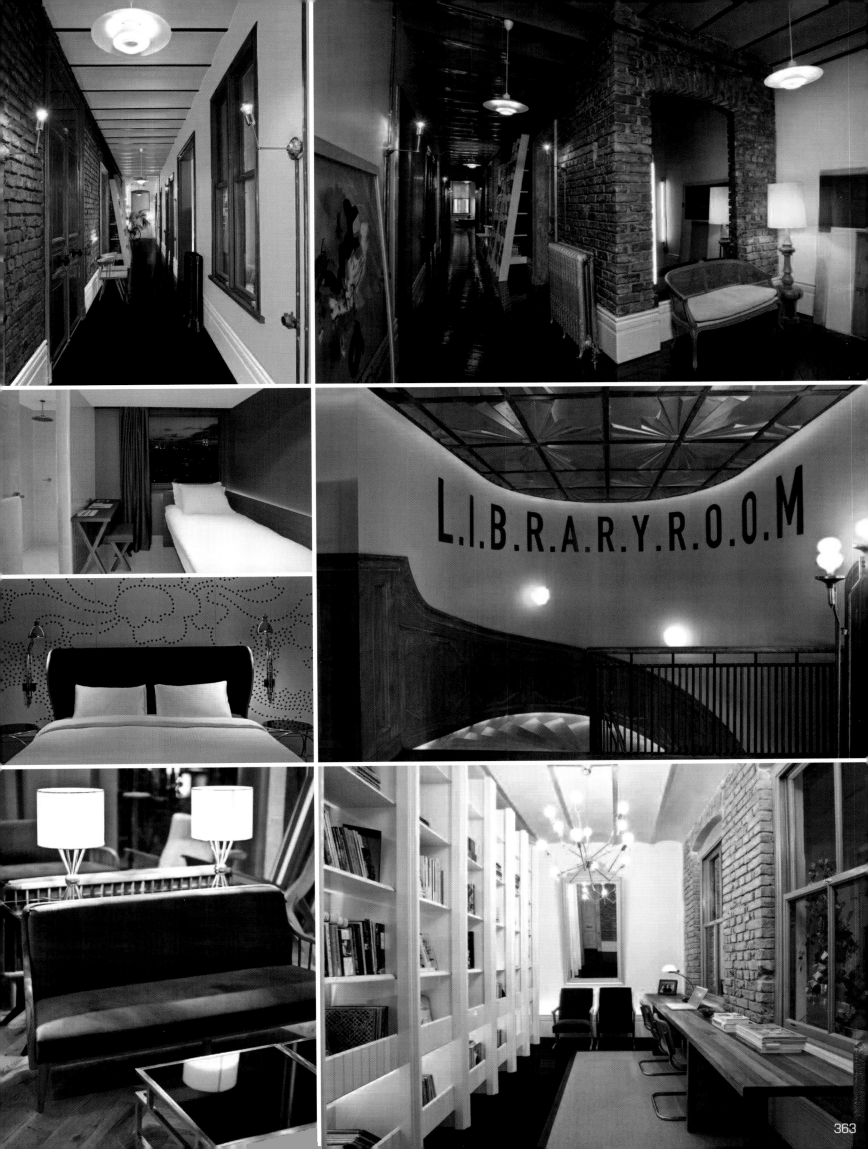

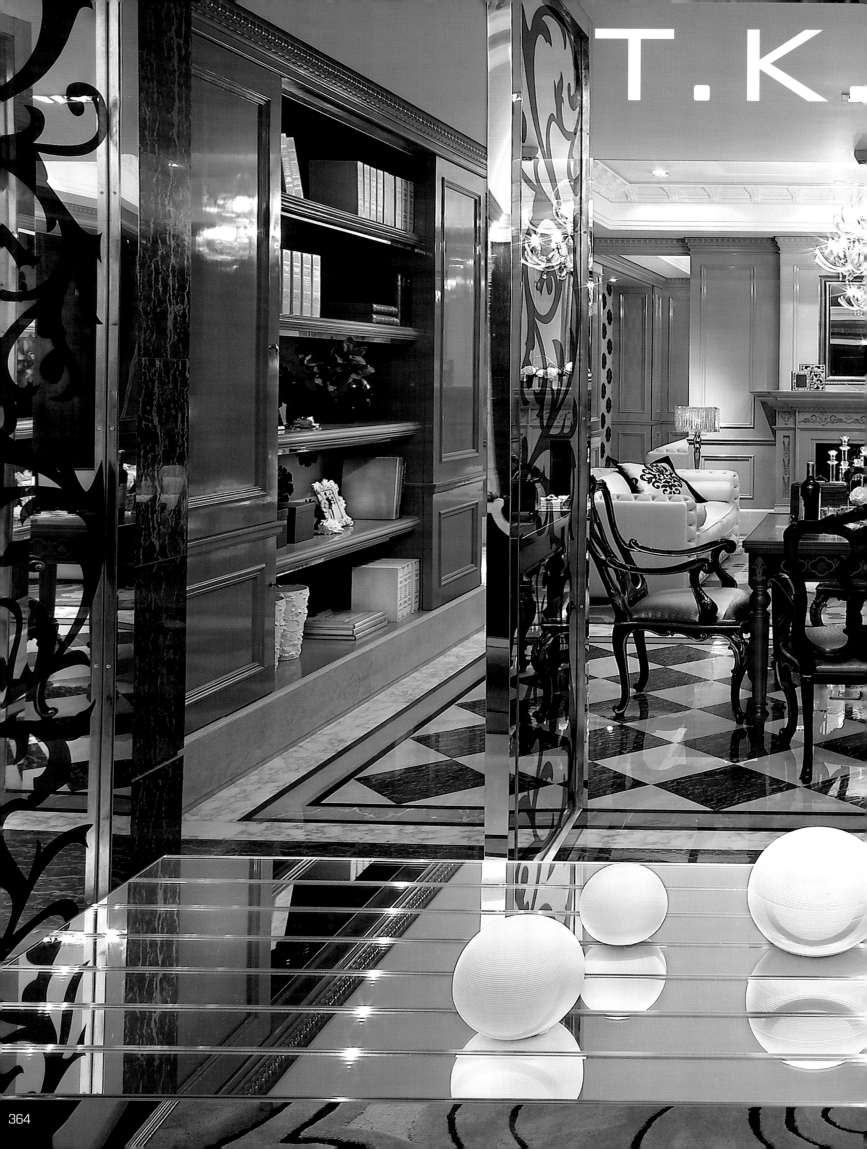

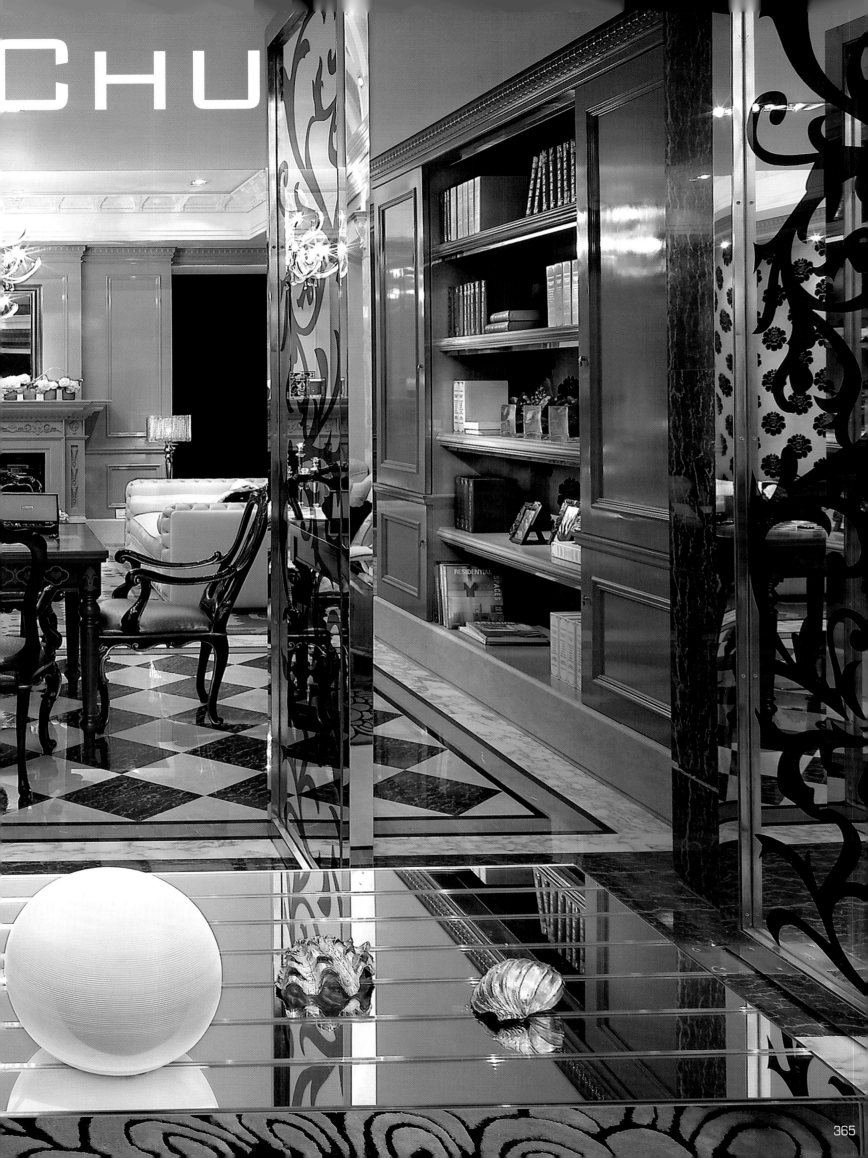

Designer: T.K.Chu.
Company: T.K. Chu Design Group, Taiwan.
Profile: High end residential and commercial work throughout China and Taiwan.

Home is Taipei, his inspiration its growth from a small village into an international metropolis. It was disappointment at its architecture that led to his career. His attitude to decorating 'a reflection of our present life and requirements'. Favourites; Chinese New Year, Genghis Khan, Beethoven, Omotesandō, Prada handbags and I.M. Pei. Best homemade food, sesame burger and coriander leaves. Best skill sketching, favourite saying 'go find someone better than me'. His epitaph 'Eat well, sleep well and work hard'.

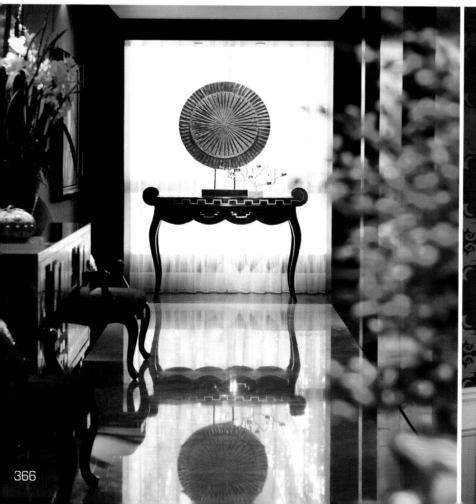

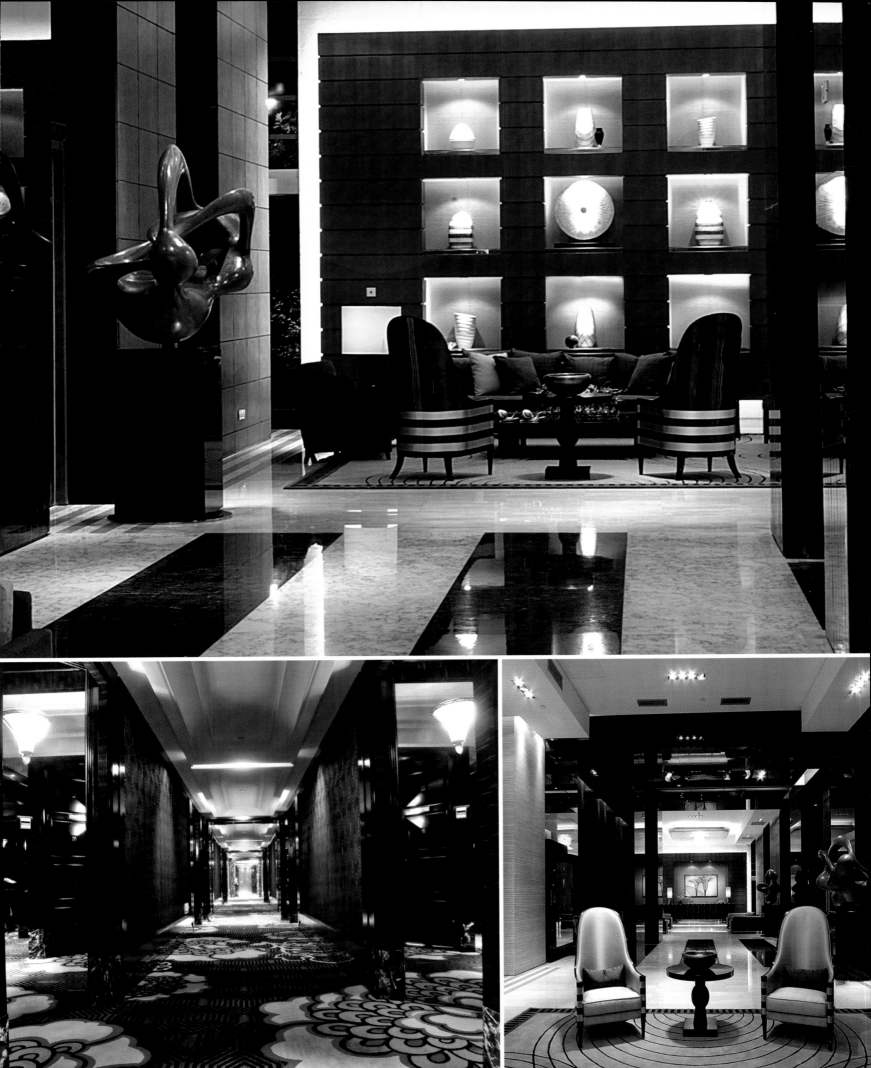

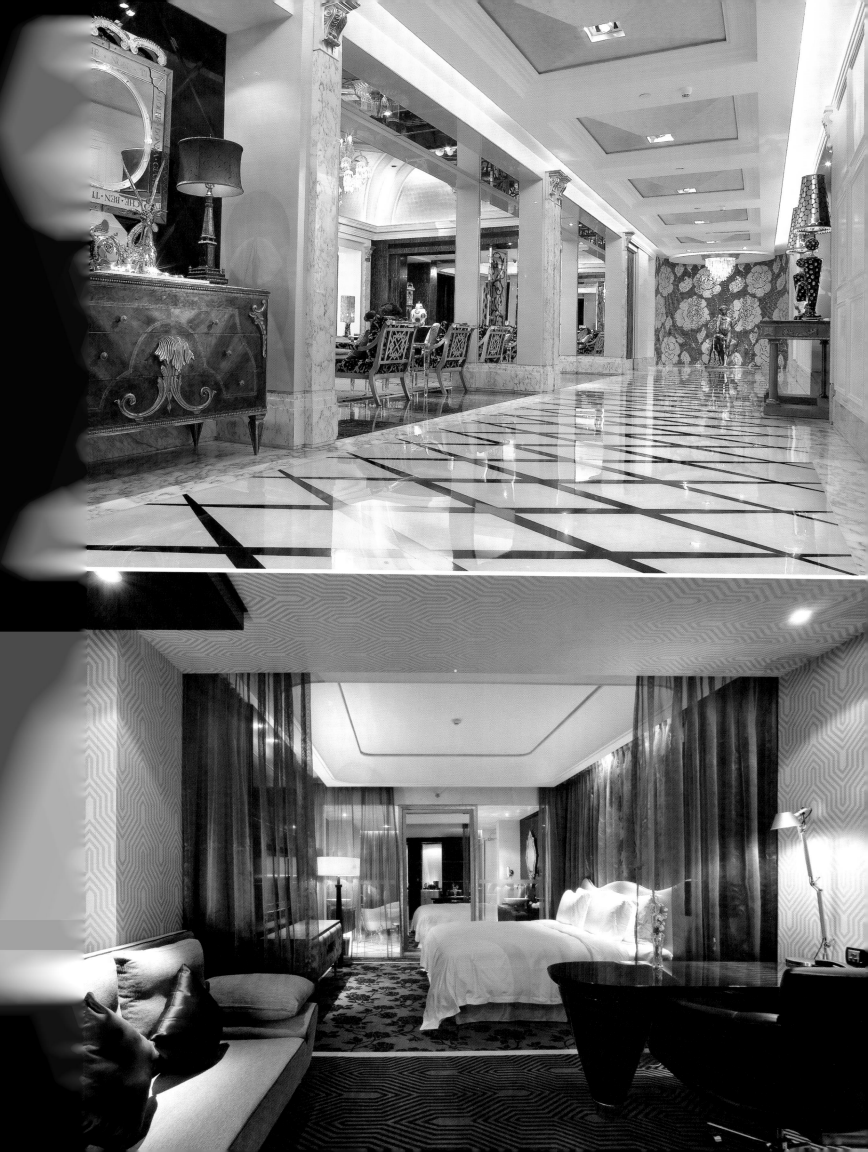

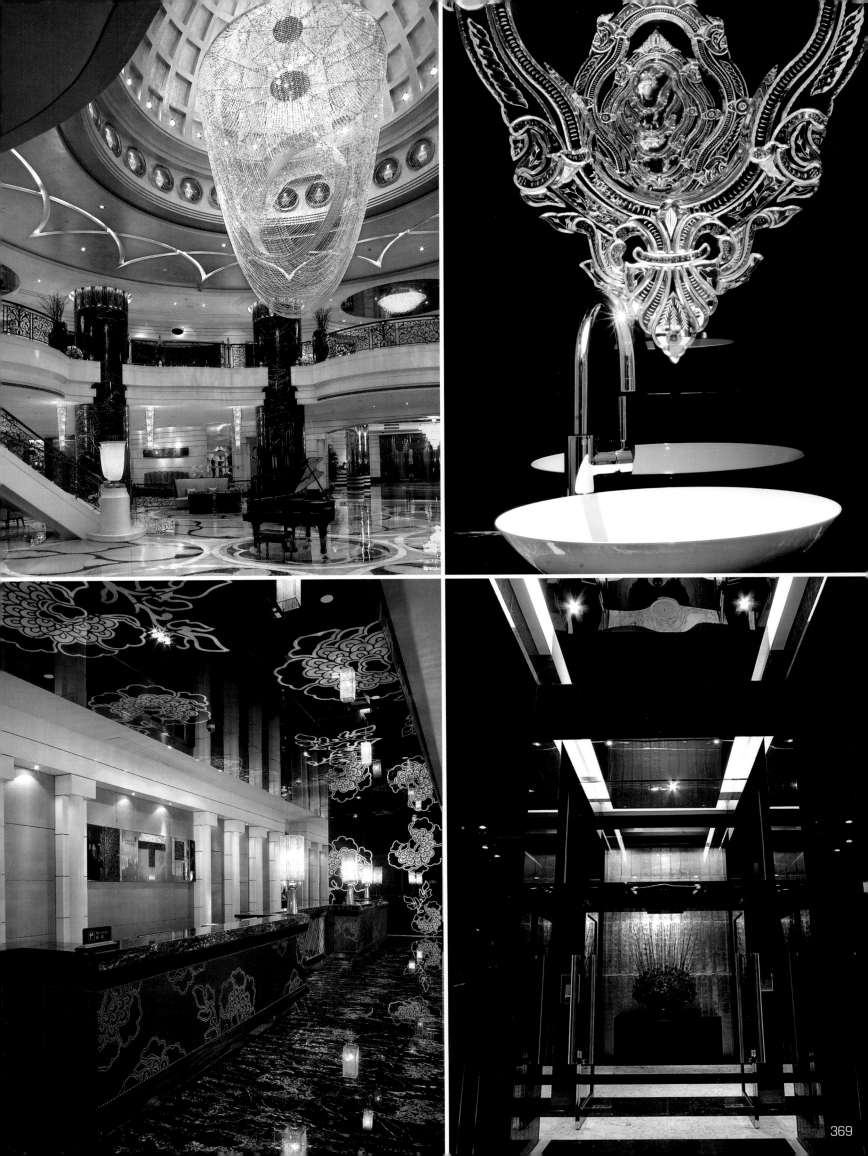

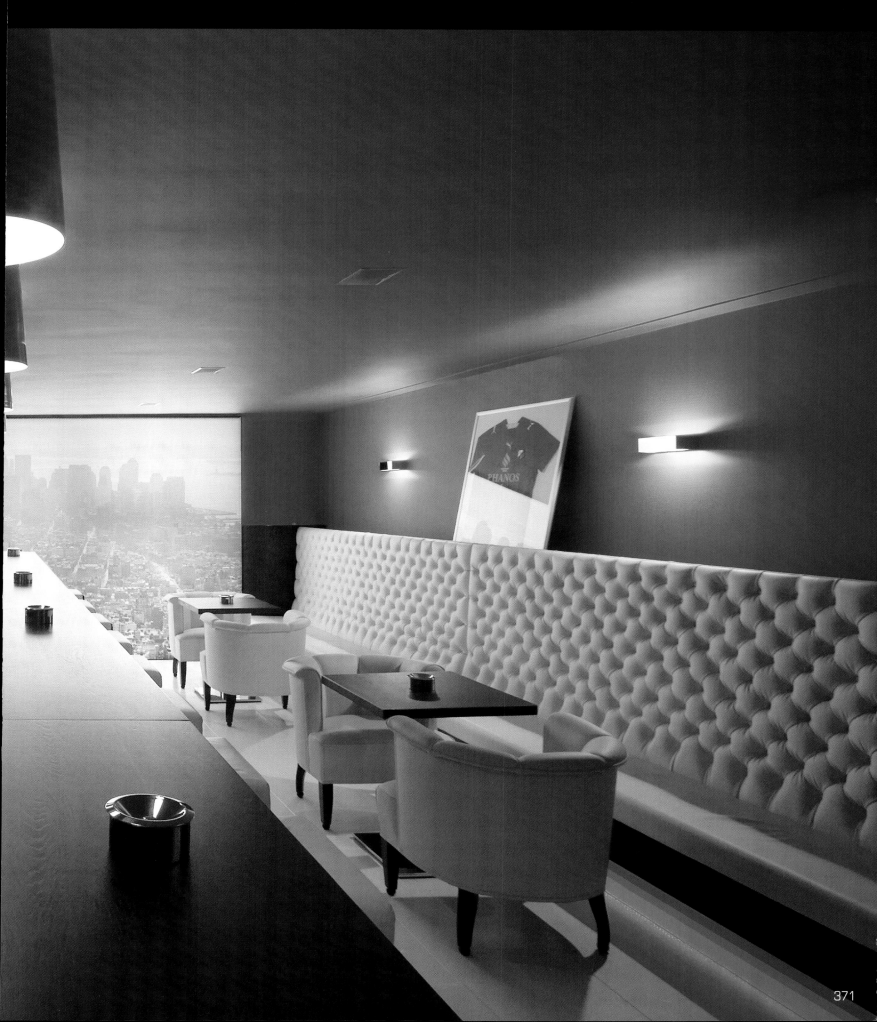

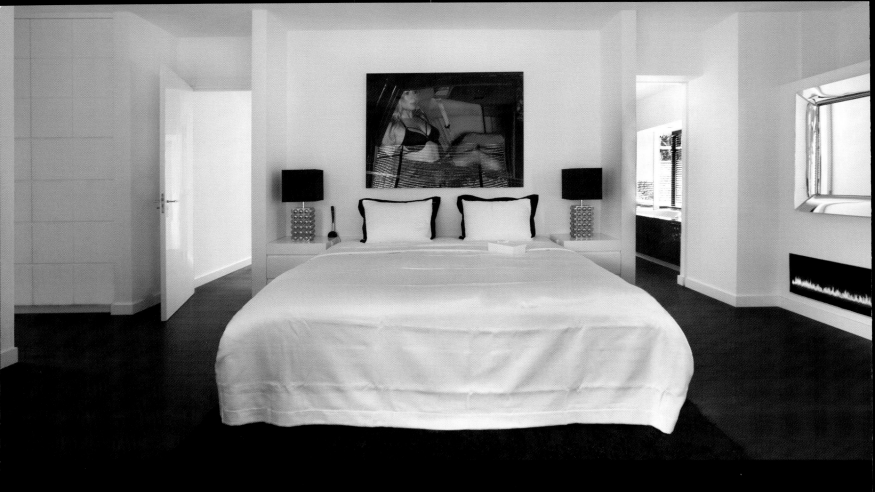

Designer: Jan des Bouvrie. Company: Het Arsenaal, Naarden, Holland. Profile: Specialising in high end residential and commercial work internationally. Recent projects include a villa in St Tropez, a theatre in Antwerp and a villa in Curacao. Current work includes second homes in a golf park in Harderwold, Holland, the design of three villas in Grimaud, France and a complete urban plan in Almere, Holland.

A passionate designer whose childhood ambition was to look and listen. Extravagances: art, classic cars, watches. Favourites: Porsche, Philippe Starck, Warhol. Best shopping, Soho New York, favourite holiday St Tropez. Most memorable meal on the rocks in Capri. Favourite perfume Comme des Garçons, musician Aretha Franklin, designer Gaultier, political hero Kennedy. His secret to long life, 'no stress and no regrets'.

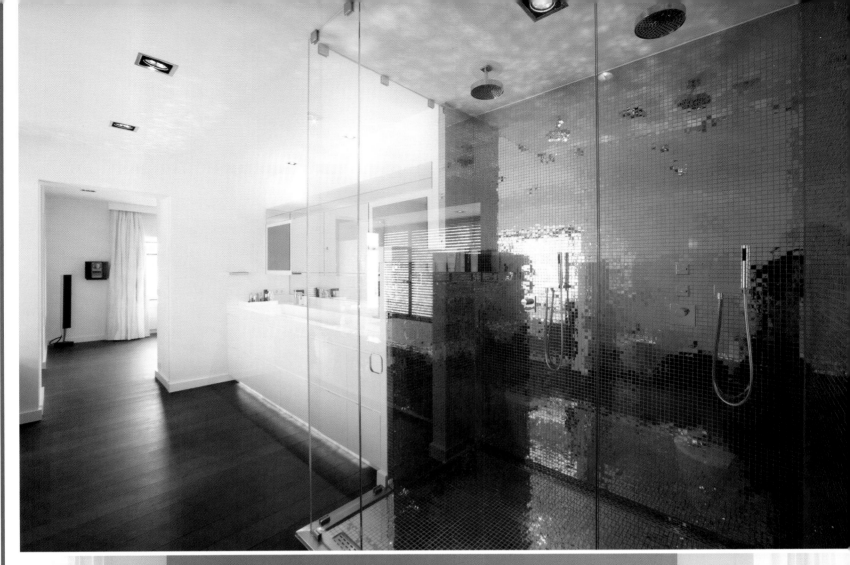

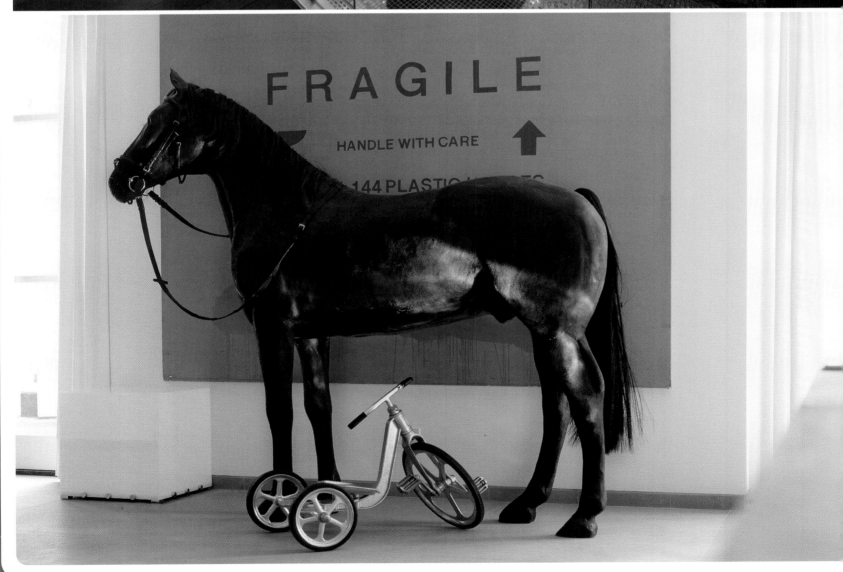

HONKY

Designer: Chris Dezille.
Company: Honky Interior Architecture & Design, London.
Profile: Specialising in a wide range of award winning bespoke interiors both residentially and commercially. Current projects include an apartment for a Premiership footballer, the refurbishment of a property in Regent's Park and a complete interior specification of a 15,000 sq ft residence in St Georges Hill.

Too cool for school, Chris attended dance classes and performed in musicals. **Likes football, supports Arsenal.** After meeting an interior designer he never looked back. **Self belief and determination have won him success.** Favourite architect Giuseppe Terragni. **Greatest extravagance a Harley.** Favourite car ever made Porsche 356 super coupe. **Favourite airline Virgin, food Japanese, music John Lennon, fragrance Black Orchid by Tom Ford, cabin seat, alone.** Favourite home comfort returning to be greeted by his family.

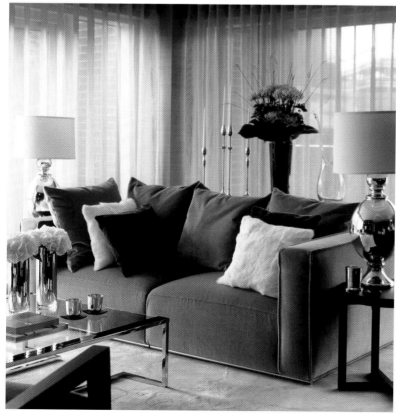

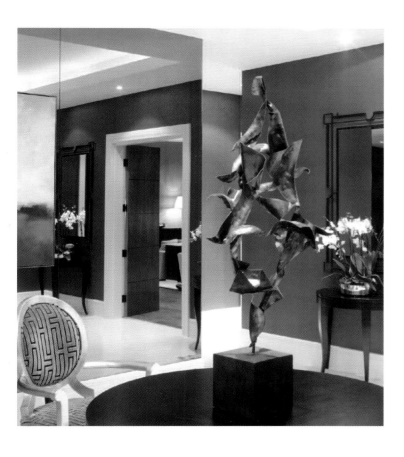

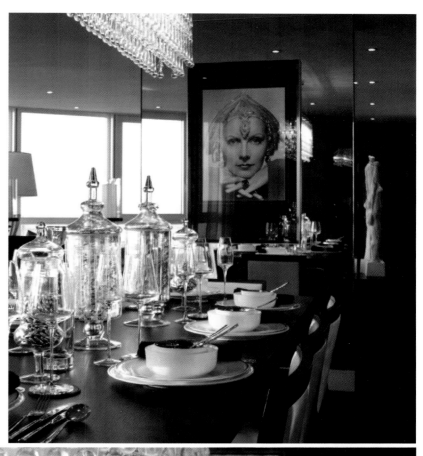

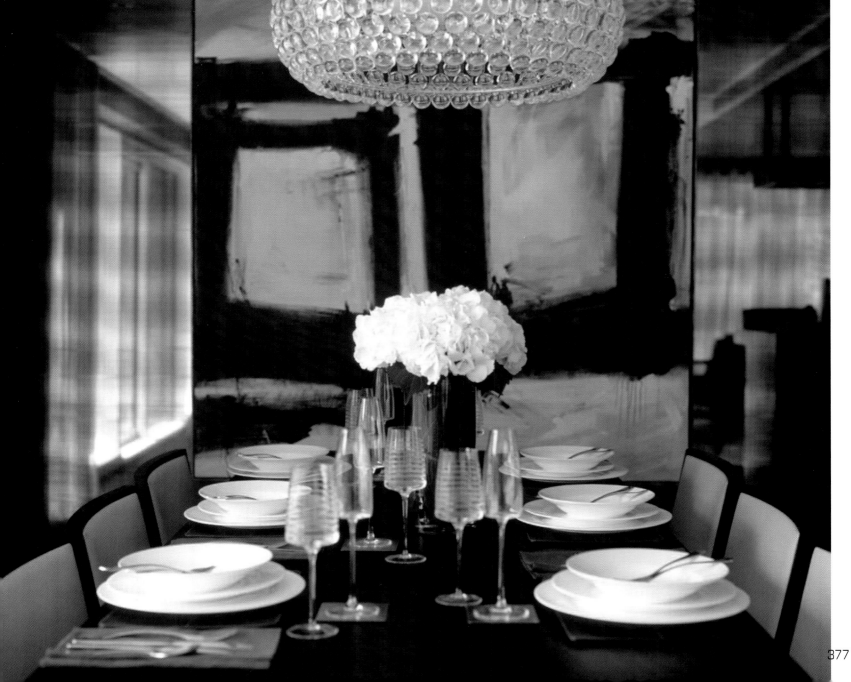

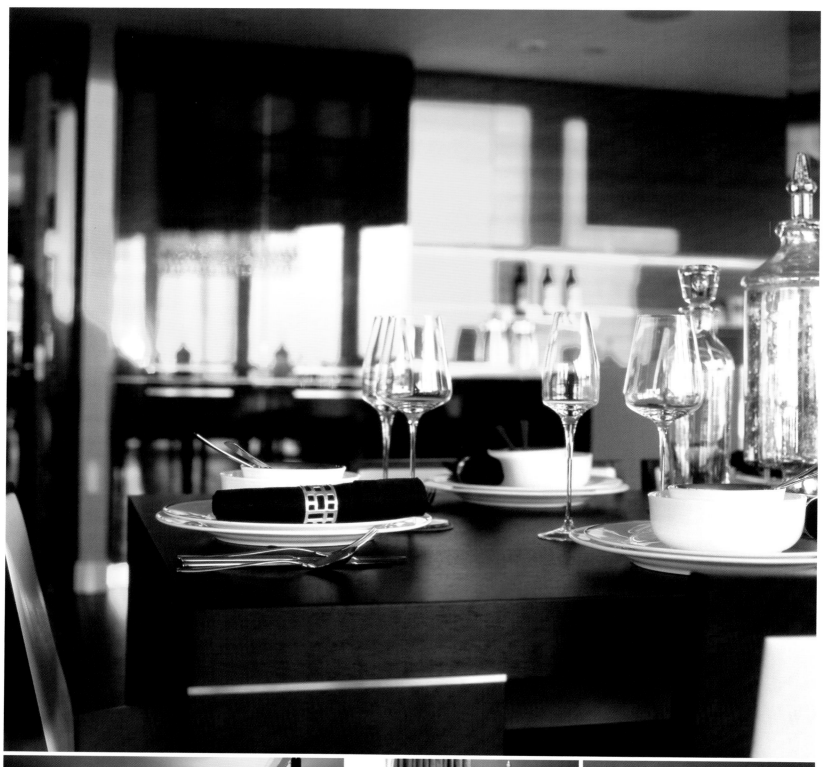

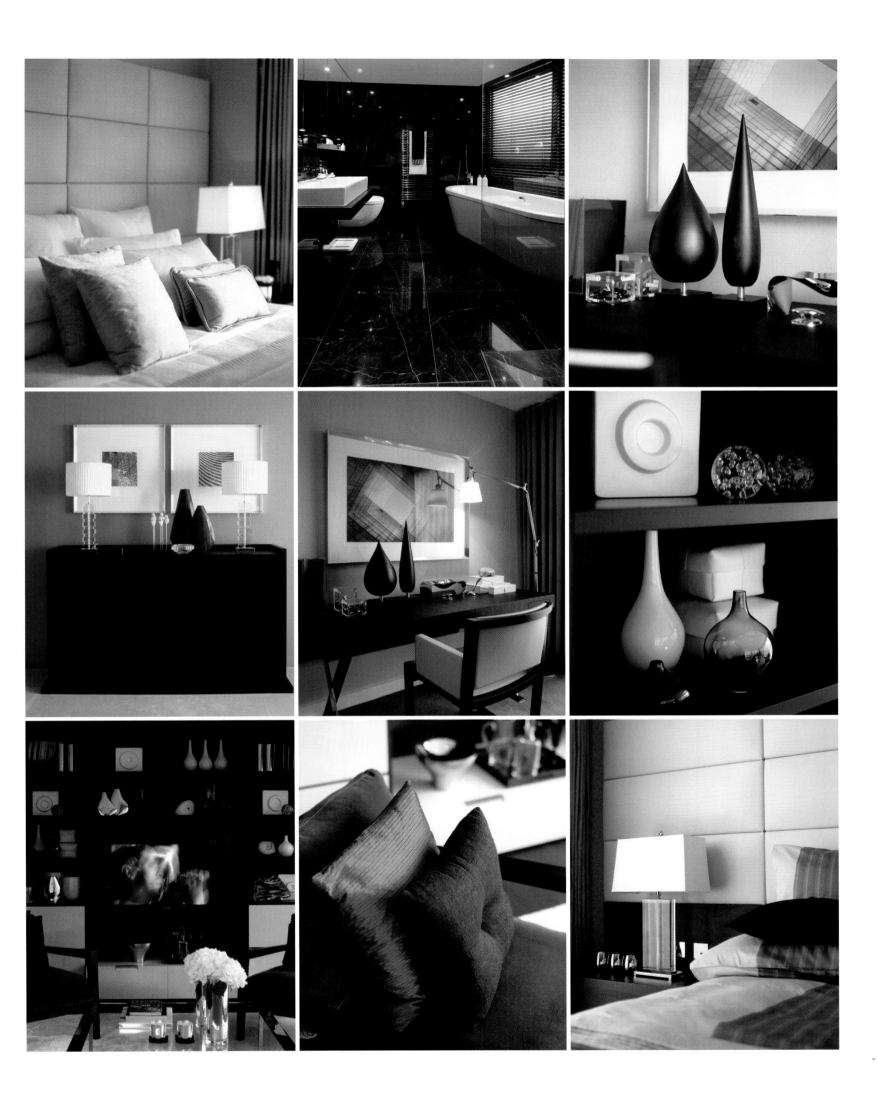

FEDERICA

hotel

PALACIOS

Post

Designers: Federica Palacios (and team: Magali de Tscharner, Andréane Reber, Marco Ferranti & Camilla Bellord). Company: Federica Palacios Design, Geneva, Switzerland.
Profile: International projects including private residences and boutique hotels. Recent work includes Hotel Post Zermatt, a chalet in Gstaad and a country house in the south of France. Current projects include a townhouse in London, a family residence overlooking Lake Geneva and Grand Hotel Park Gstaad.

Buenos Aires is home, Latin spirit her inspiration. By her own admission a teenage nightmare, she's cooler now. She collects match strikers. Favourite saying 'less is more'. Favourite car Aston Martin, best holiday Maldives. Most memorable meal Hotel de Paris, Monaco. Best advice received 'there's always a solution'. Love is the secret of long life. Most important business quality: integrity.

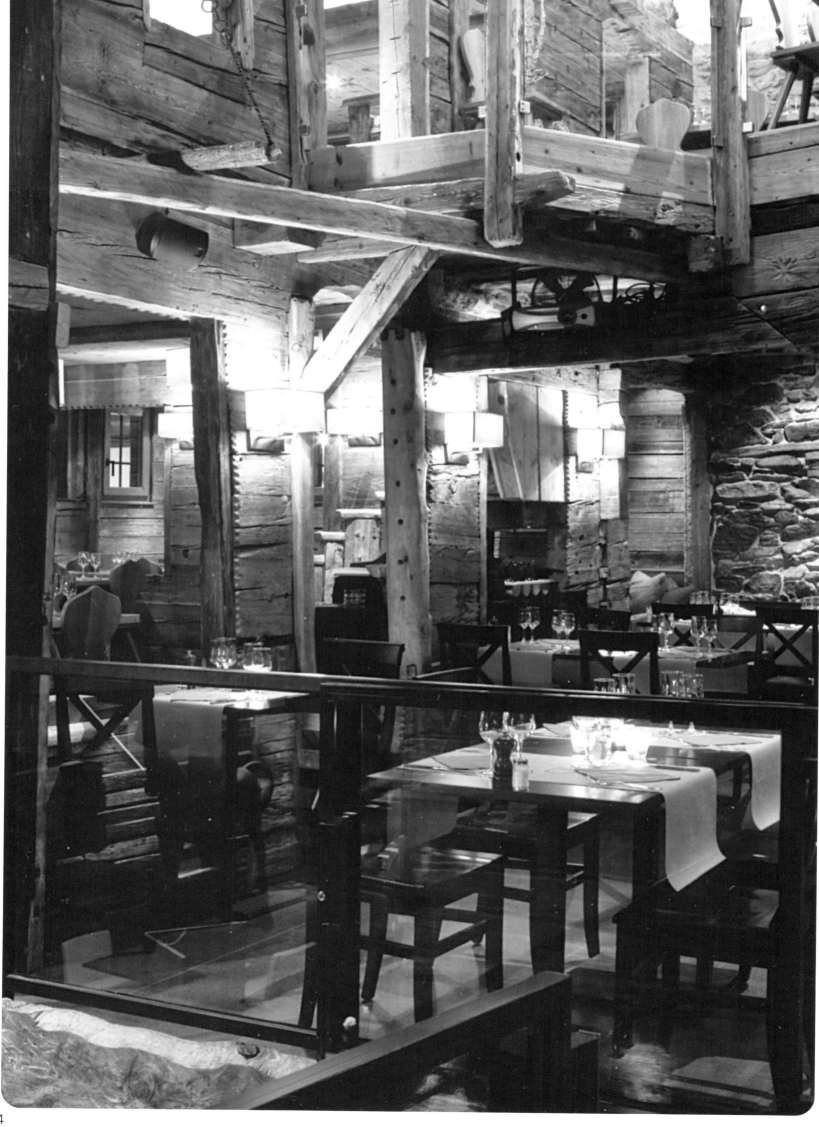

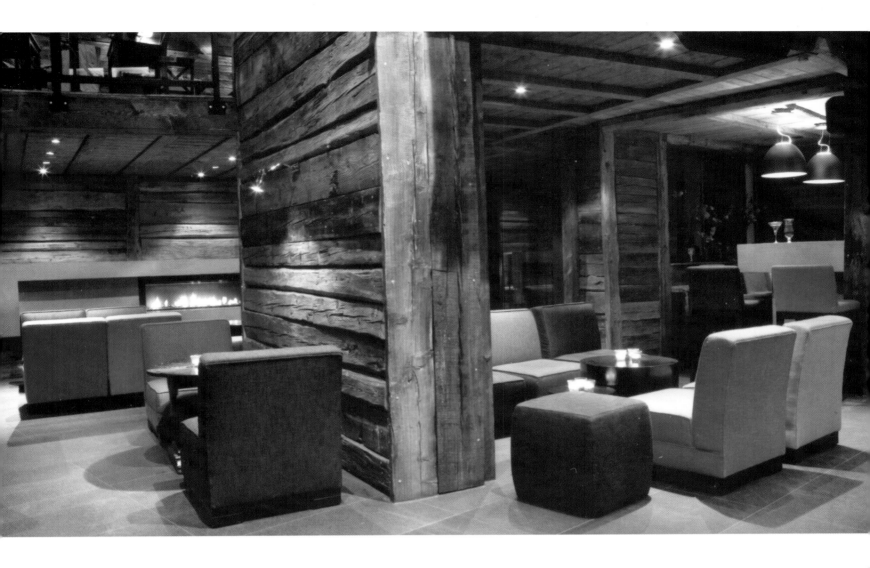

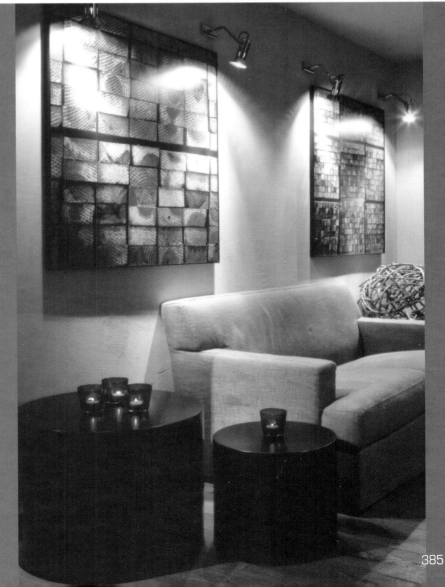

NICKY DOBREE

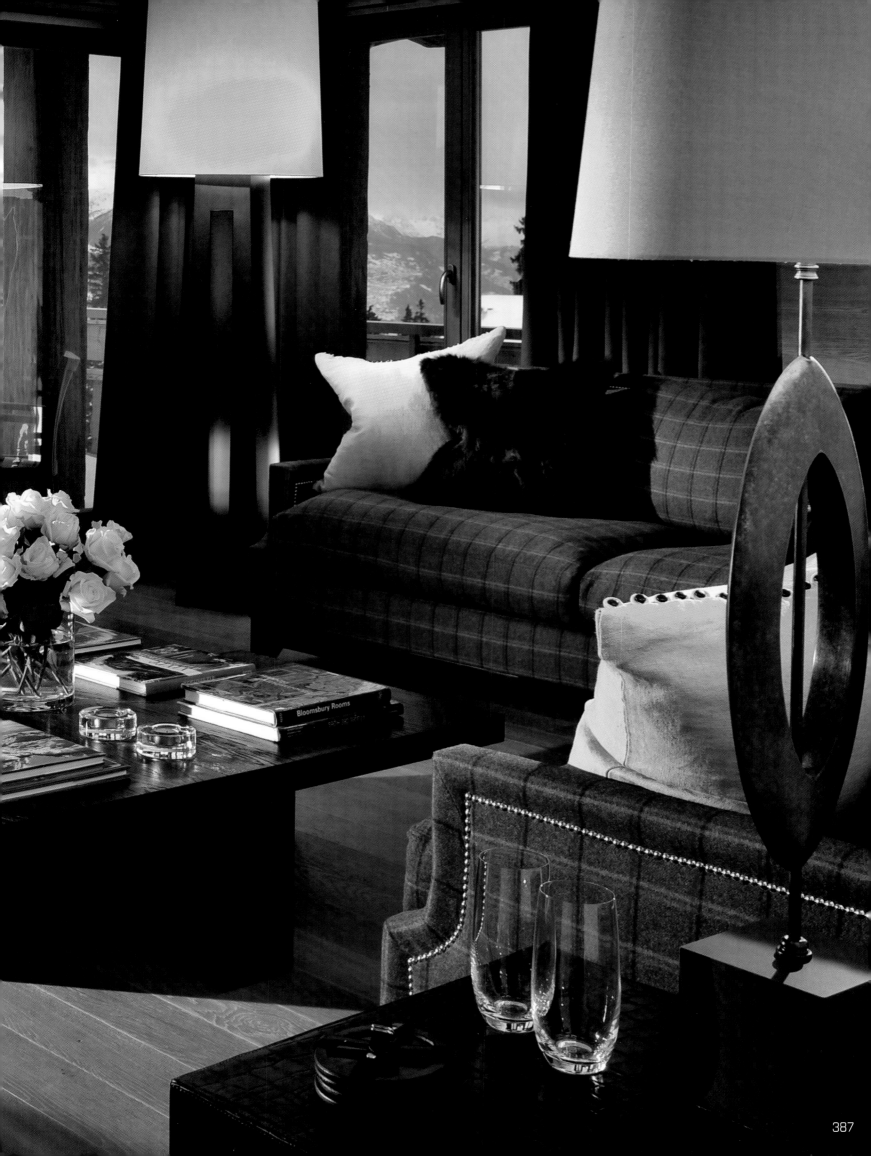

Designer: Nicky Dobree.
Company: Nicky Dobree Interior Design.
Profile: International designer specialising in luxury ski chalets and high end residential interiors. Current work includes a Chalet in Val d'Isère, a villa in Italy and a family home in London.

Cultured communicator who does nothing by halves. Nicky dreams of castles in the sky and has a secret crush on the Coke ad man. She's a dancing queen and avid skier who's serious about tennis. High door handles are the earliest memory, her childhood ambition to be a designer was always in the blood. For Nicky, decorating is about creating intimate and sophisticated spaces in which to relax, unwind and entertain. The best advice she ever received 'believe you can achieve.' Sir John Soane is her favourite architect and the Bugatti 57 her favourite car. Sea urchins on a boat in Corsica are the most memorable meal and clean sheets and fresh flowers her favourite home comforts. Paris for shopping, in rue Vieille du Temple. Nicky's epitaph will be 'she gave her all to all that she did'.

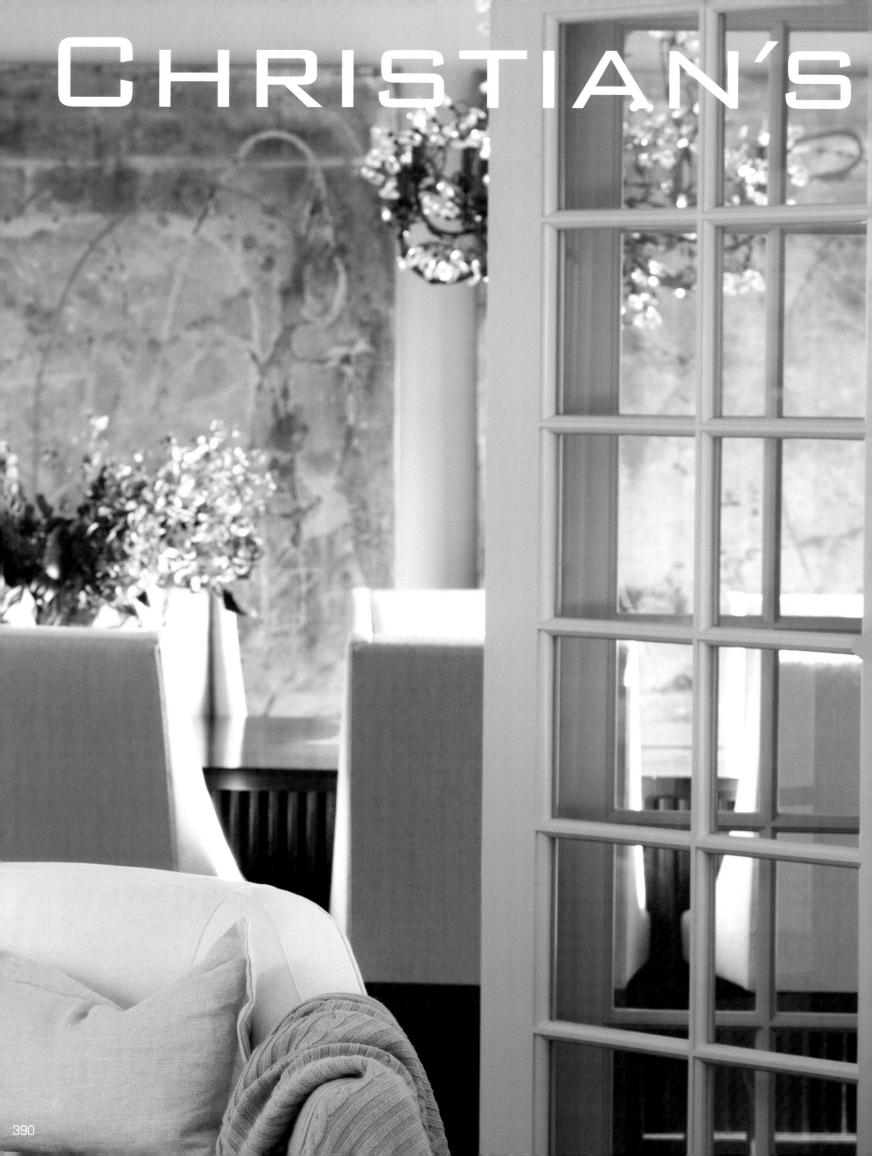

CHRISTIAN'S

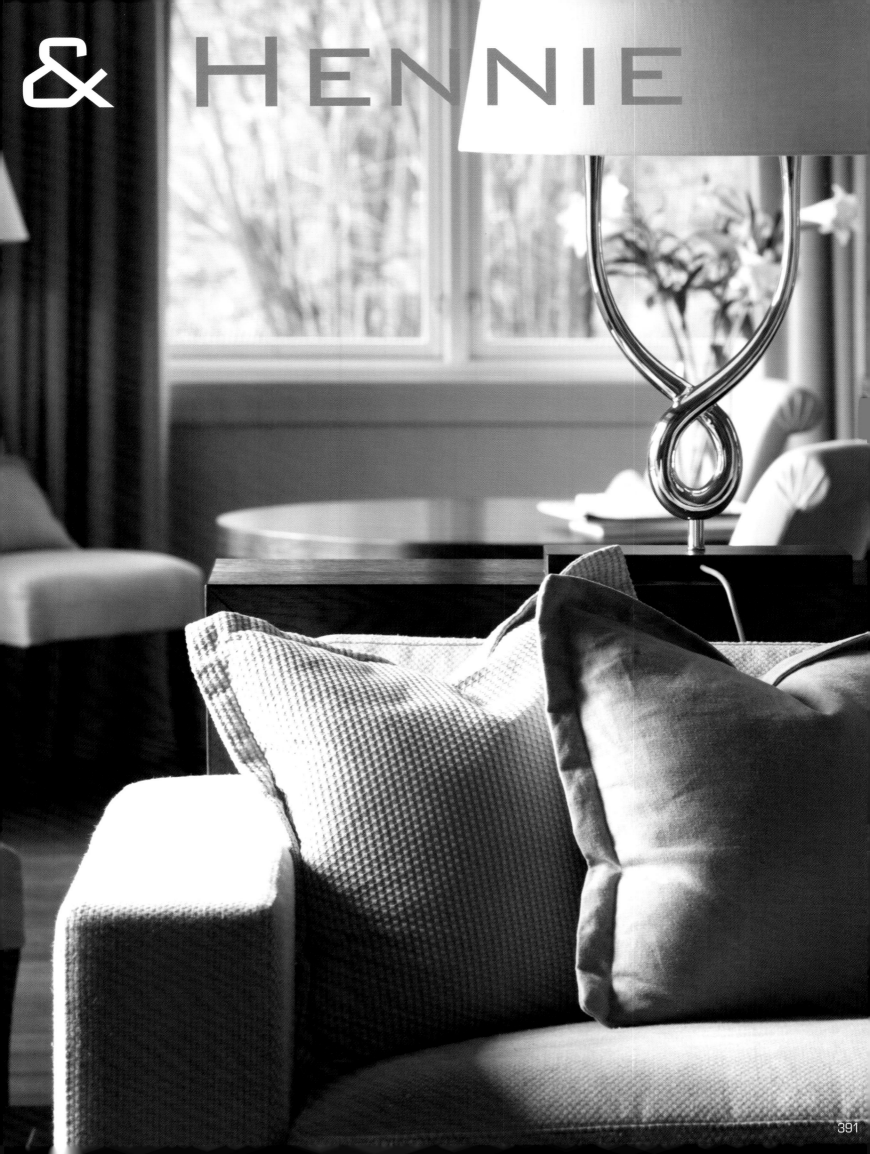

Helene lives her dream in her ever changing job. She believes that good communication is the key to a successful project. Her extravangance is taking time, to sit and people watch in Rome accompanied by a cappuccino. Arnstein Arneberg is her preferred architect and Armani her favourite fashion designer. She would nominate her mother for sainthood and believes that love and slow food are the secrets of long life. Helene's inspiration comes from watching Oslo's spectacular changing seasons. Her disapproval in life is injustice and she strongly believes that 'what comes around goes around.'

CHRISTIAN'S & HENNIE

Designer: Helene Hennie.
Company: Christian's & Hennie, Oslo.
Profile: A small practice, current projects include villas in Spain and Stockholm, a seaside restaurant in the South of Norway and the restoration of an old mountain log cabin.

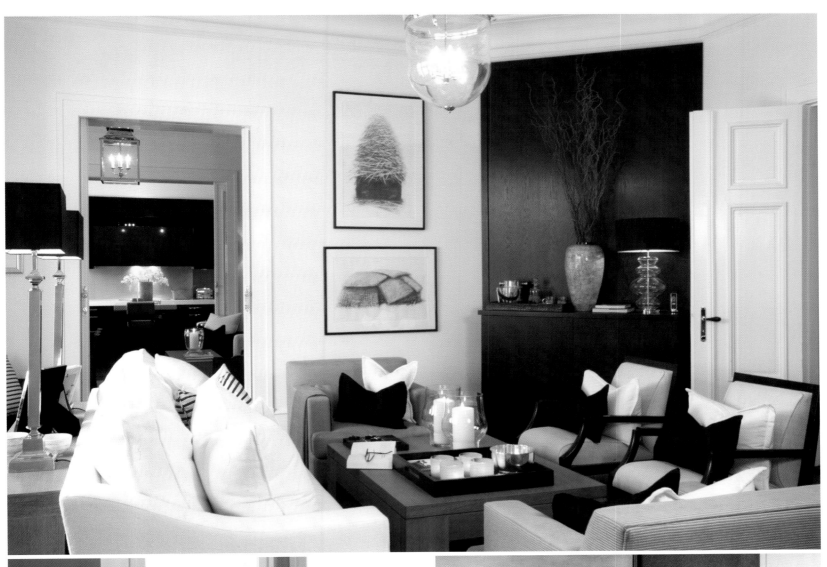

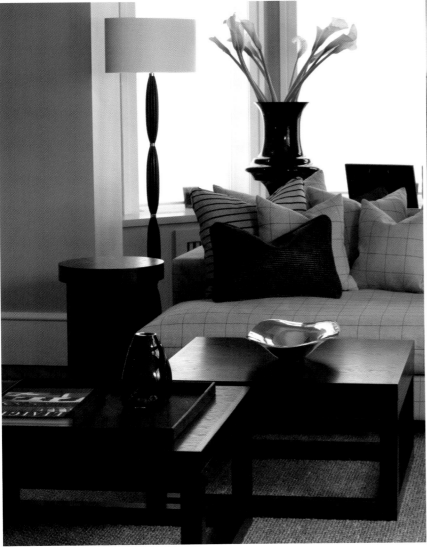

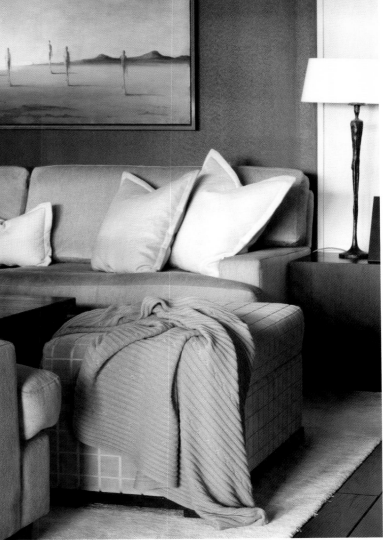

Designers: Louis Pepin &
Jean Turcotte.
Company: Atelier de L'Opéra,
Montreal, Canada.
Profile: High end work
internationally from construction
to architecture, interiors,
gardens and furnishings
including yachts and hotels.
Recent work includes private
residences in Palm Beach and
Naples, Florida plus a
showroom in Washington DC.
Current projects include
penthouses in Montreal and
Toronto and a showroom in
Los Angeles.

ATELIER D

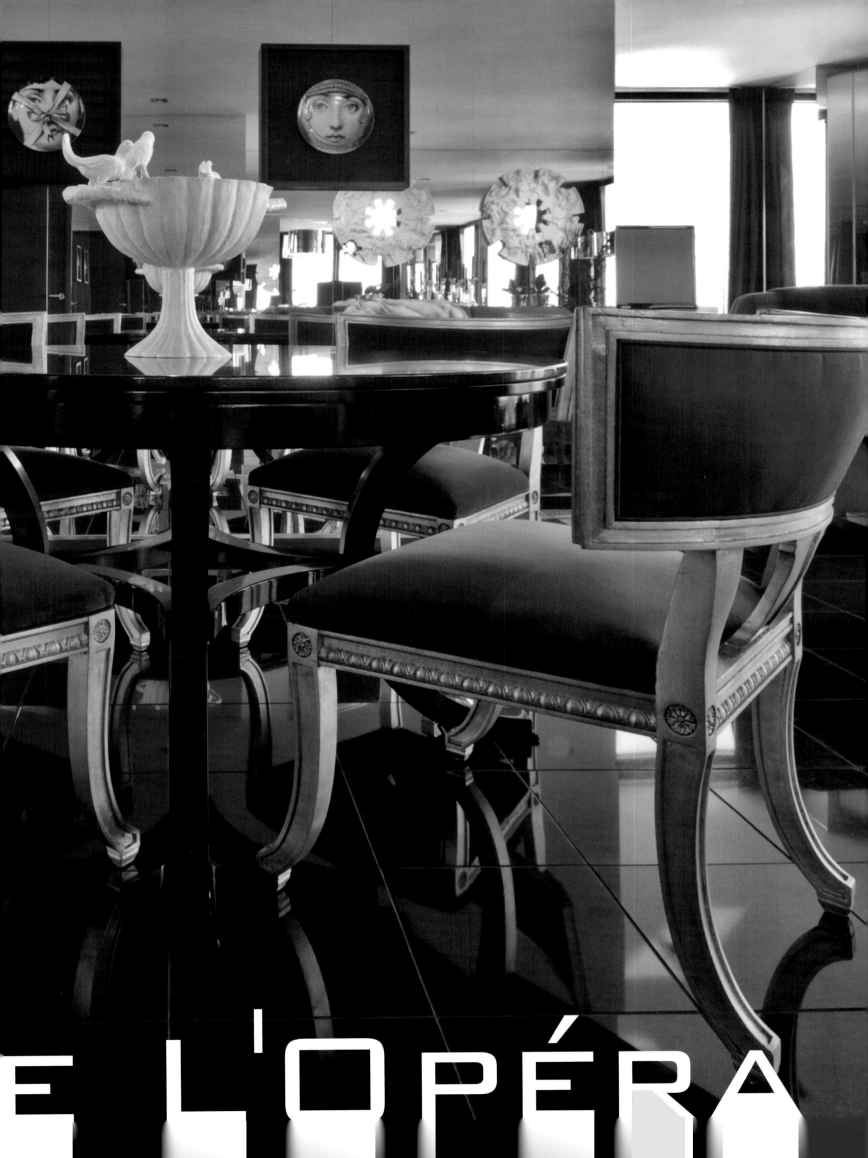

E L'OPÉRA

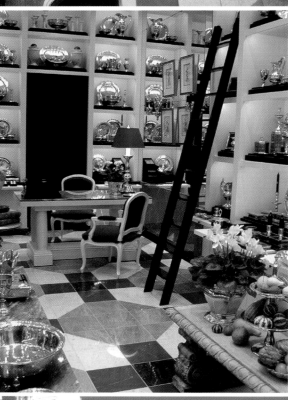

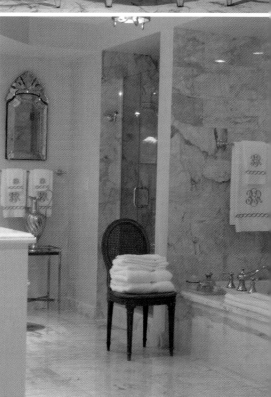

Men in black, for whom interior design is their vocation and cycling their hobby. Jean adores Prada, shopping in Fifth Avenue and the scent of gardenia. Dreams of being in an Italian Palace, fantasy job actor. Favourite architect Mies van der Rohe, best design book Christian Liaigre. When not in the saddle Louis is happiest in the kitchen cooking up a masterpiece, fantasy job chef. Most memorable meal Octopus at Babbo N.Y.C. Favourite perfume green tea and fig.

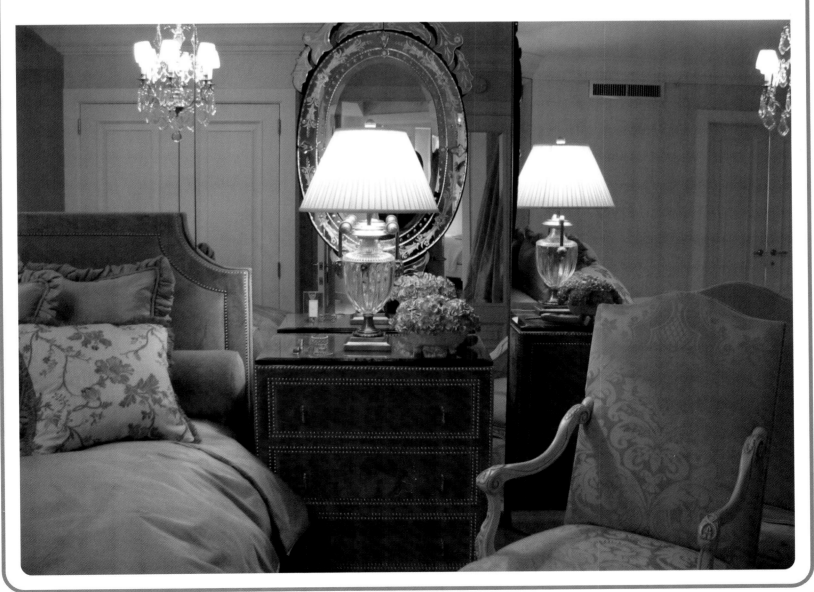

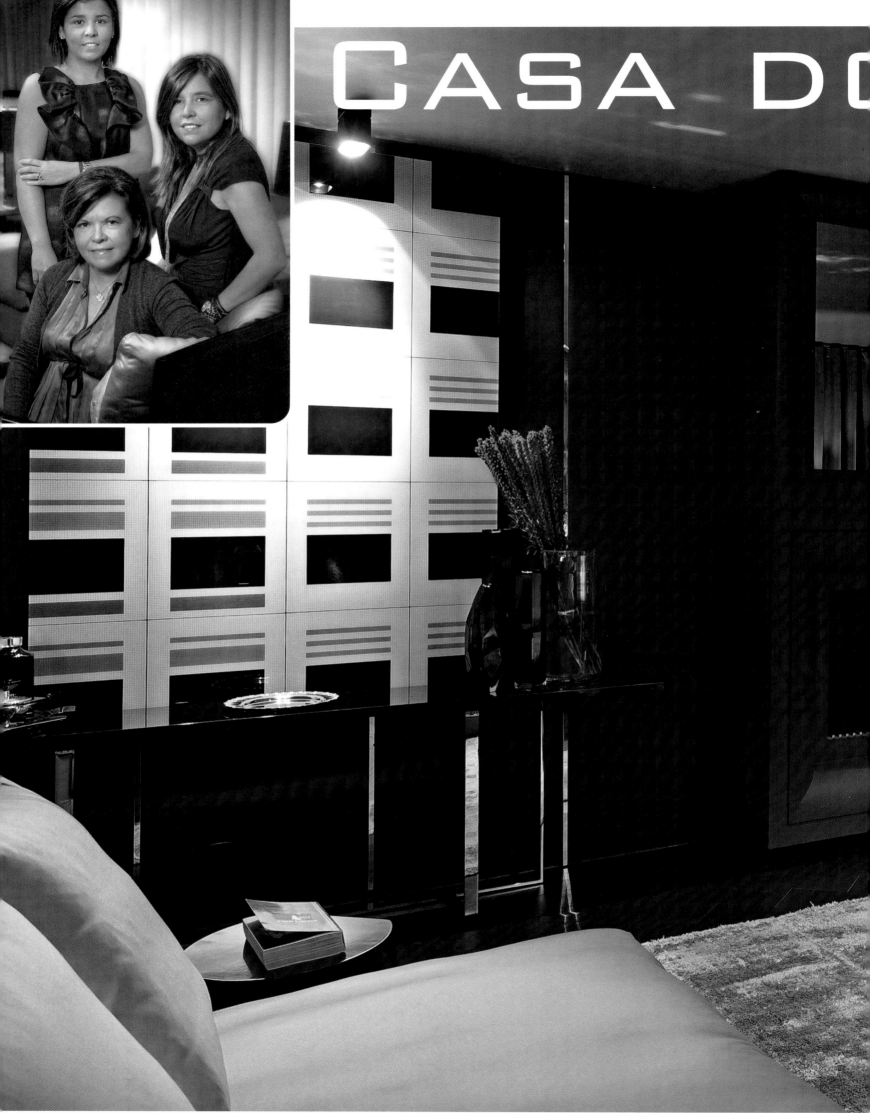

PASSADIÇO

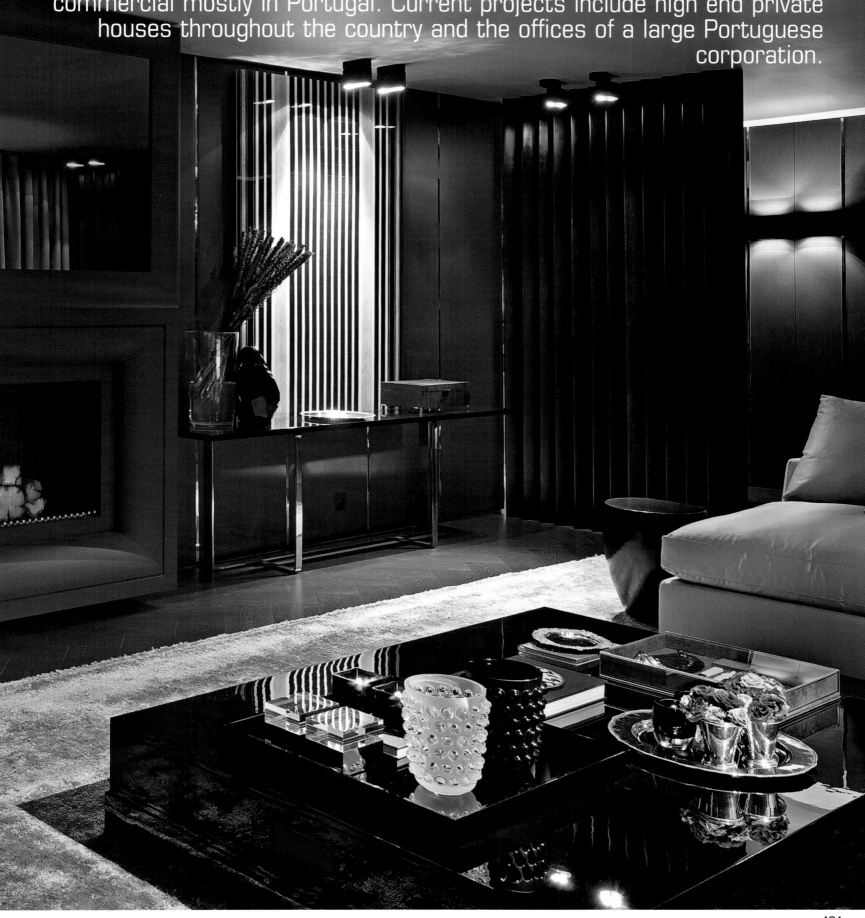

Designers: Catarina Rosas, Cláudia Soares Pereira & Catarina Soares Pereira. Company: Casa do Passadiço, Portugal. Profile: Residential and commercial mostly in Portugal. Current projects include high end private houses throughout the country and the offices of a large Portuguese corporation.

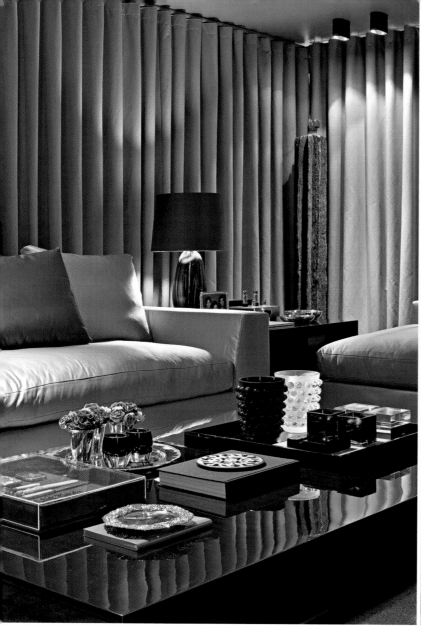

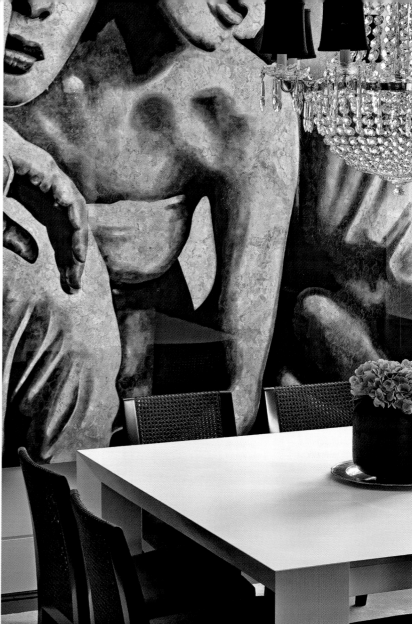

Extravagances; Lanvin, luxury hotels, Valentino, Hermès. Collects silver tea pots. Favourite car Bugatti, best skill good driver. Most memorable meal at Hotel Cala di Volpe Sardinia, best holiday St Barts. Claudia likes to swim in her heated pool and wrap herself in a cashmere blanket. Favourite saying 'beauty is a form of genius' Oscar Wilde.

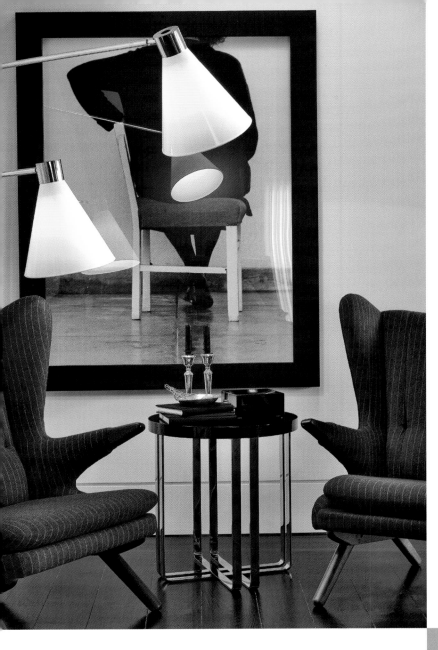

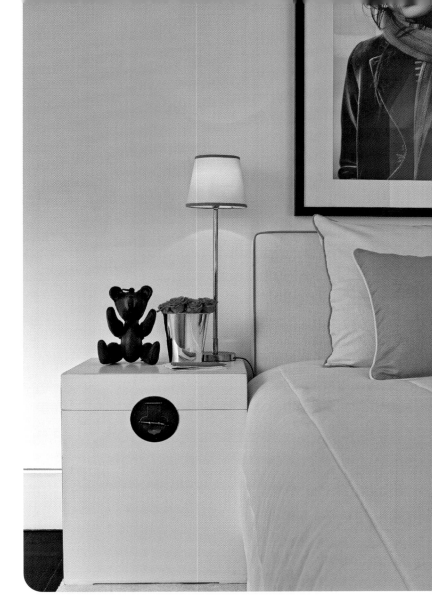

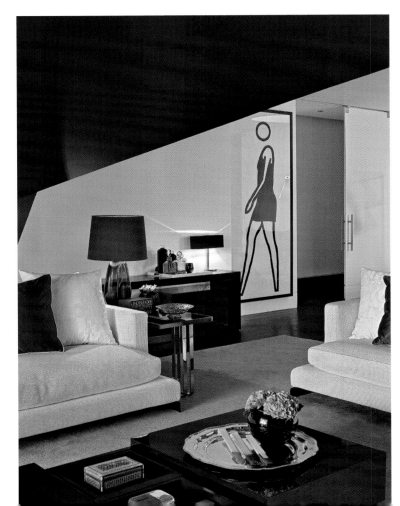

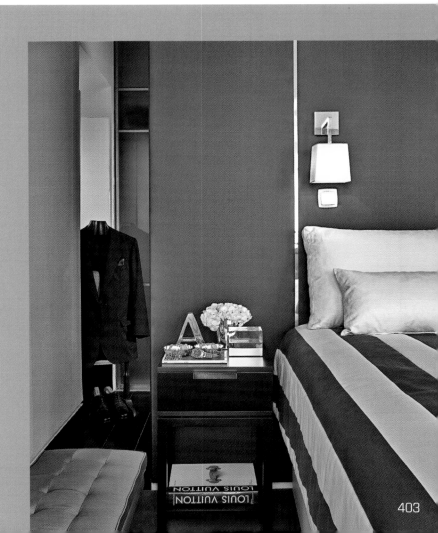

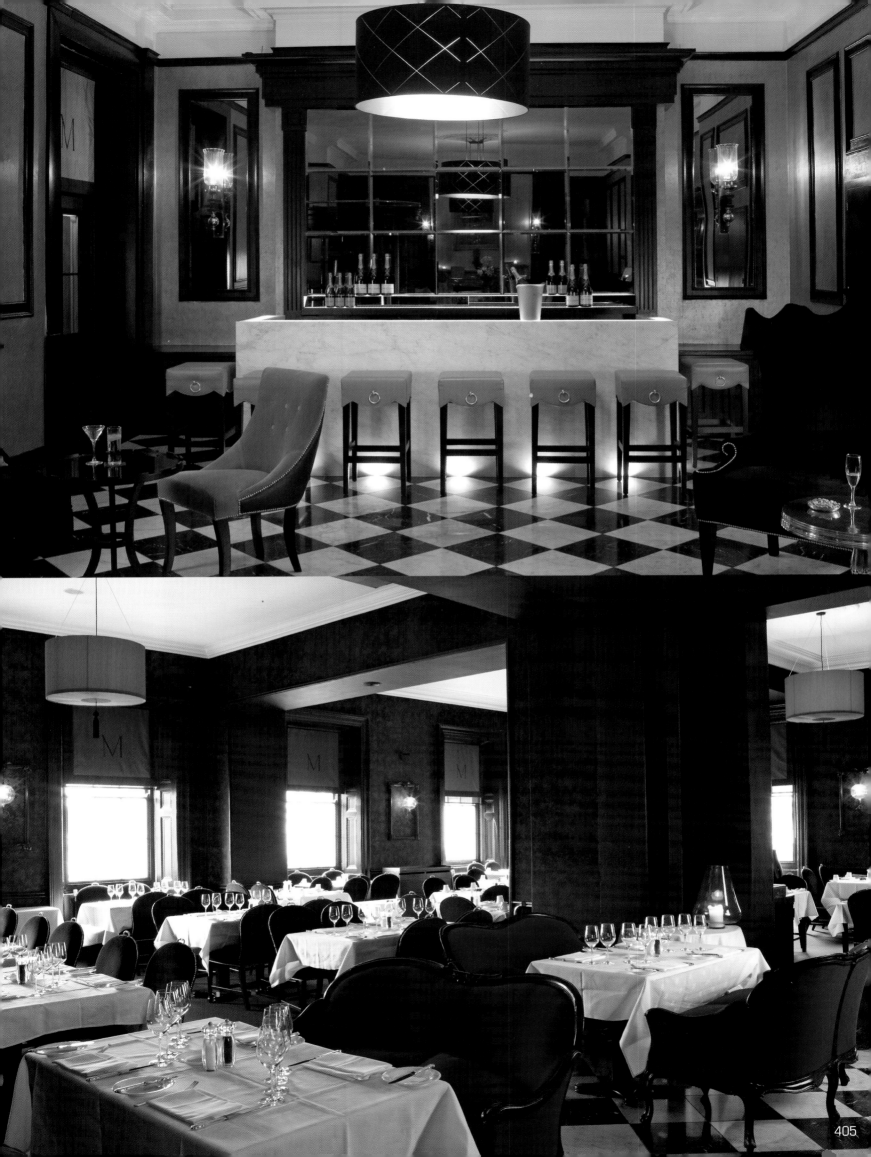

Designers: Gail Taylor & Karen Howes.
Company: Taylor Howes Designs, London.
Profile: Specialising in luxury bespoke interior design for private clients and developers. Recent work includes show apartments at Imperial Wharf, a town house and new build outside Dublin, a hotel in Galway and a flat in Montrose Place which included the installation of one of London's finest private cellars. Current projects include a luxury apartment in the Phillimores, the complete modernisation of a Georgian house with 5,000 square foot extension to include pool and wine store, a Miami style family house in Ireland and plans for Vauxhall's 50 storey high tower.

Nervous of confined spaces and holes in the road, Gail would escape London and fly Concorde to a desert island. Her luxury, line caught fish and chips, her reward champagne. Favourite holiday, Bora Bora, favourite scent, lillies. Best skill an eye for detail. First job in a sweetshop. Overeating the chocolate violets taught her moderation. Worst advice 'have one more glass this wine won't give you a hangover'. Karen's a good shot. Most memorable meal at The Fat Duck, Bray, favourite takeaway Thai. Dream car Aston Martin DB6, best honeymoon Petit St Vincent. Shopping Via Condotti Rome, designer Armani, perfume Annick Goutal, Passion. She'd like to meet Bill Clinton to hear the tales. Recurring dreams are of getting lost, she has no sense of direction. Happiest in a mountain top restaurant after powder skiing with her family. The craziest thing she ever did was run naked in Fulham trying to get her clothes back, after losing at poker. Last fancy dress costume Pussy Galore.

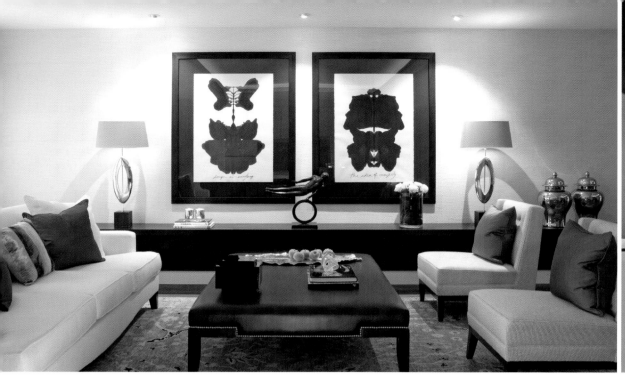

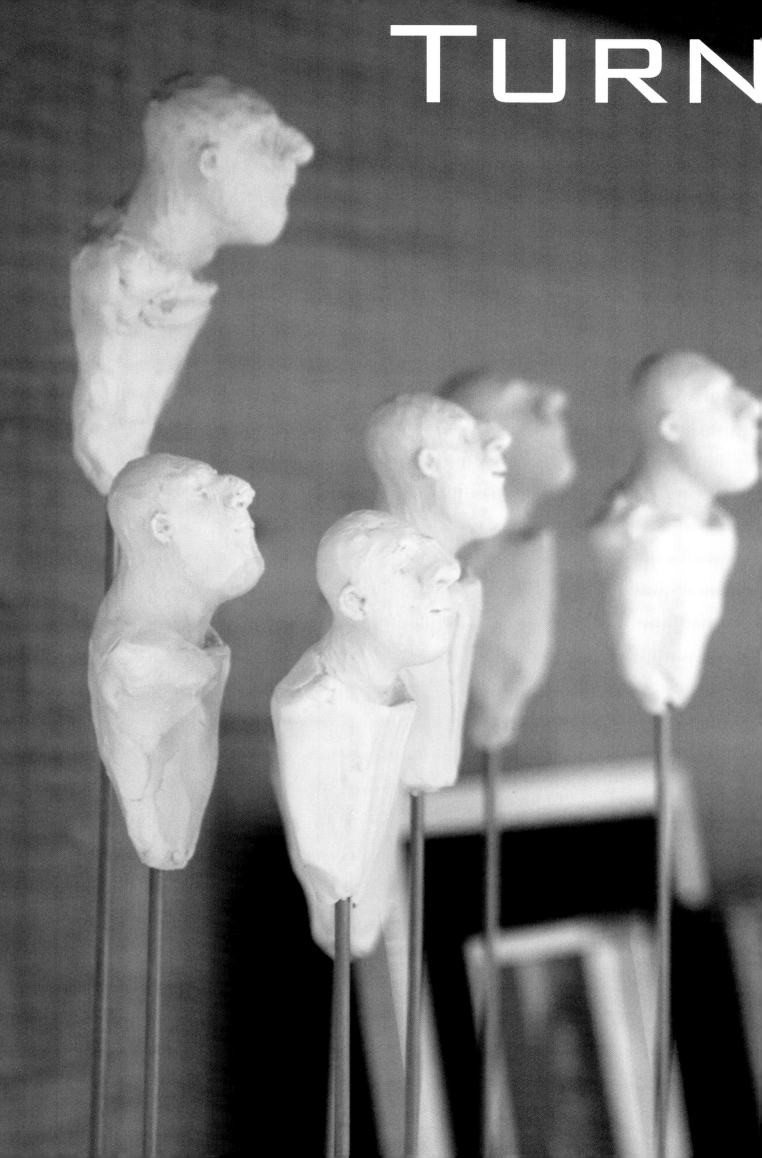

GUSTAV KLIMT
THE RONALD S. LAUDER AND SERGE SABARSKY COLLECTIONS

Designers: Bunny Turner & Emma Pocock.
Company: Turner Pocock, London.
Profile: A small team with offices in Holland Park, specialising in high end residential work and boutique hotel projects. Recent work includes the refurbishment of a listed Georgian house, a Victorian school conversion into a bachelor pad and the restoration of three flats back into a single house. Current projects include a new build beach house on Reef Island, Bahrain, a restaurant in Notting Hill and a family apartment in Chelsea.

Emma's fantasy job, a spy, but she'd have to stop talking. If she were Prime Minister her first priority would be a high speed train to the Alps, for comfort a goose down pillow. Best airline, Singapore A380 double decker, for the stewardesses, they're very chic. Favourite model Kate Moss, favourite takeaway sushi. As a child Bunny dreamed of flying, today she dreams of Viggo Mortensen. Fantasy job Formula One driver, car, Jaguar E-type. Earliest memory racing her sister on a toy tricycle. Angered by hunger, nervous of hospitals, best skill scoffing cream eggs.

DOMANI

于山，少苍穹八荒，人路两相茫。
于水，右身轻乐舞，知音著红带。
于云，聪瓶清雾凉，千秋瑙卿。
于月，醉白露无霜，长河虚洗。

On a misty moonlit,
the wind blows gently.
The moonlight falls on the earth,
covering the river with a piece of thin gauze.
Music permeates over the river,
which is dotted with several small boats.
Pretty girls with ribbons round their
waists are waiting on shore.
Afar, the mountain miles away,
on which the people is so vague that it merges
with the road and vanishes
without any trace.

GROUP

KITO

Culture the Cohesive Force of Corporation

Designers: Vincent Cheung & Ann Yu.
Company: Domani Group Ltd, Guangdong
Province, China. Profile: Specialising in high end
commercial space design, corporate planning
and business consultancy internationally.
Recent work by Vincent includes A & H Asia
Pacific office, Apollo headquarters office and an
exhibition in Kito. Current projects by Ann
include Lola and Garcia exhibitions and Kito
headquarters office.

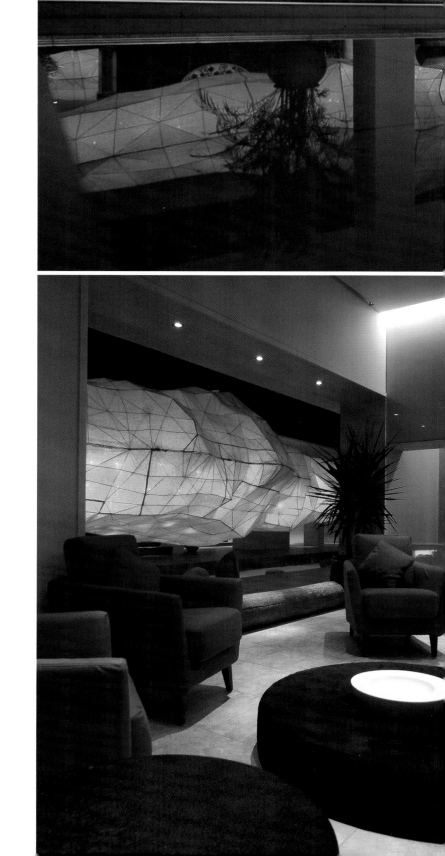

An inadvertant designer and
unimpressed by Philippe Starck,
Vincent believes he gets better
with age. Best skill linguistic
organisation and proudest of
imparting knowledge to others.
His secret to long life, serenity
and water but his favourite
takeaway food is McDonald's.
Fairytale loving Ann would be
happiest sitting next to Santa
Claus on a long haul flight.
Earliest memory myth and
Chinese poetry. Unfulfilled
ambition to design an ice hotel.
Most important thing in business
is courage and precision,
favourite architect, God.

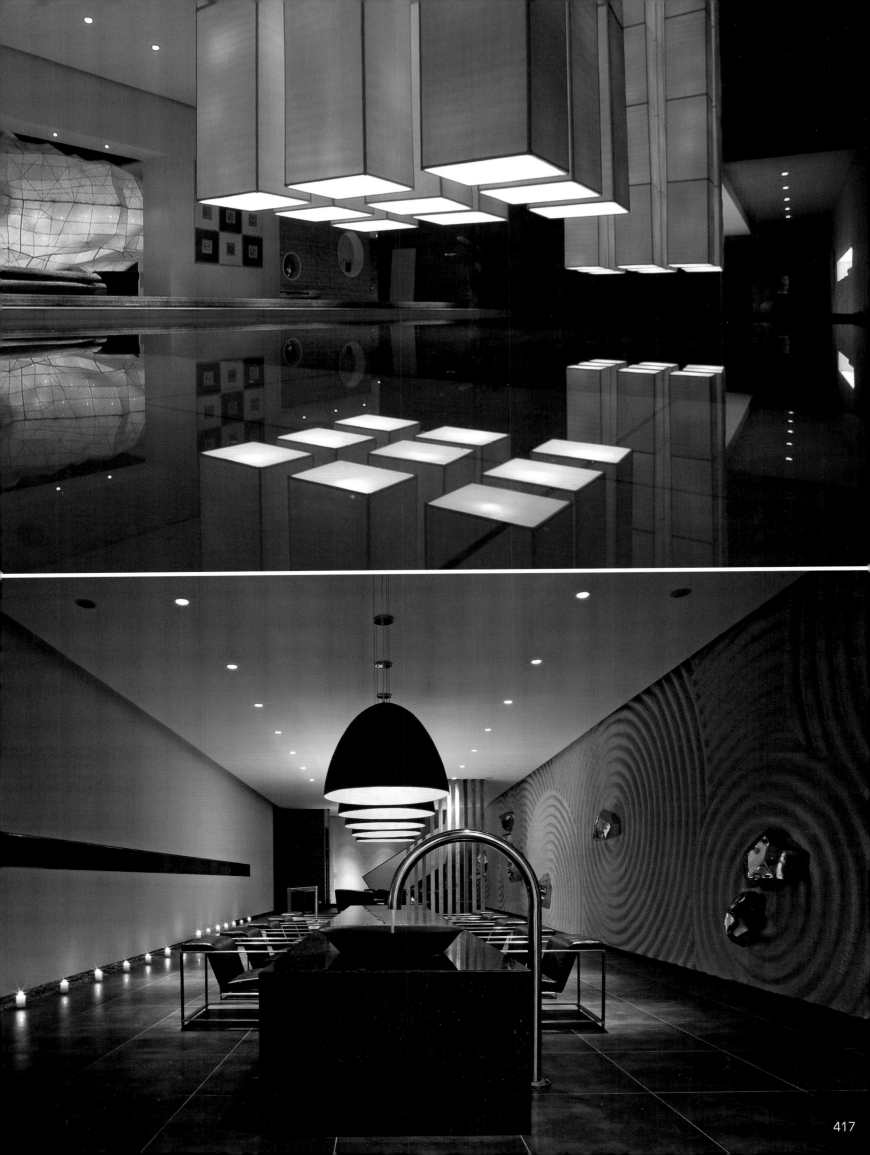

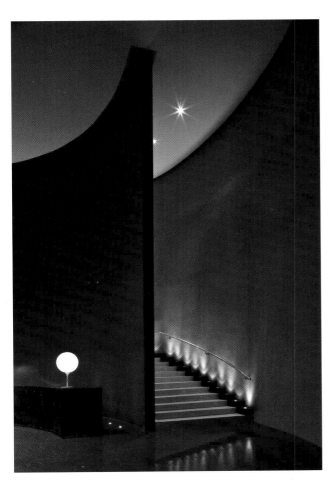

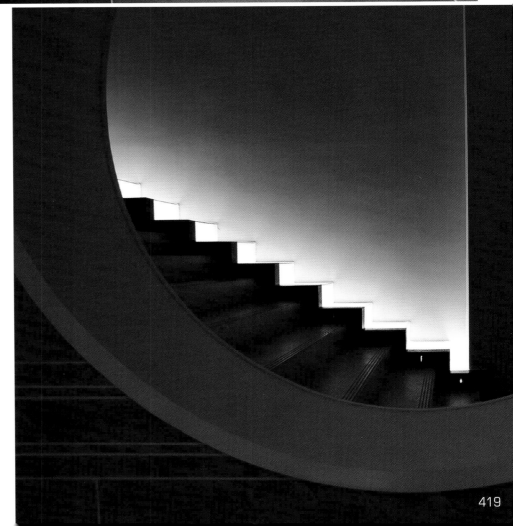

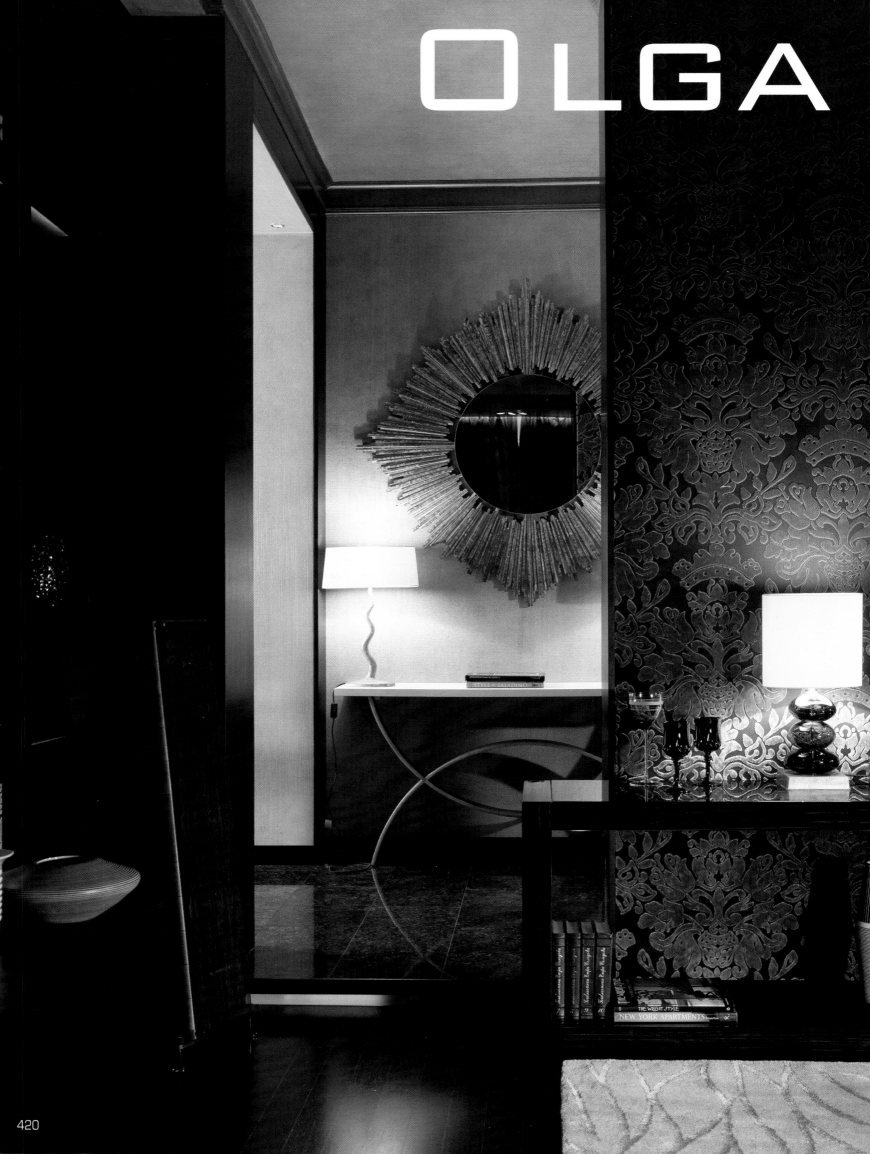

STUPENKO

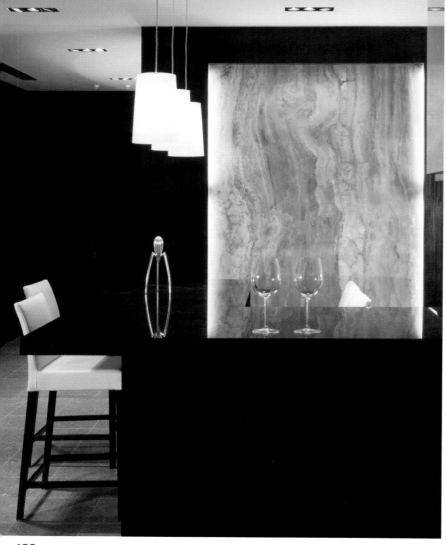

Designer: Olga Stupenko.
Company: Olga Stupenko Interior Design, Moscow, Russia.
Profile: Private and commercial high end interior design including apartments, houses, cafes, restaurants and offices predominantly in Moscow.

Wannabe surf instructor whose earliest memory is seagulls. Greatest extravagance, high speed, everyday outfit high heels. Self belief and Christmas make her happy, most memorable meal, jam. Olga believes in angels not politicians and wishes she could get more sleep. Favourite shopping, Via Condotti, Rome, best car Ferrari, fashion Anna Molinari, fancy dress, frilly.

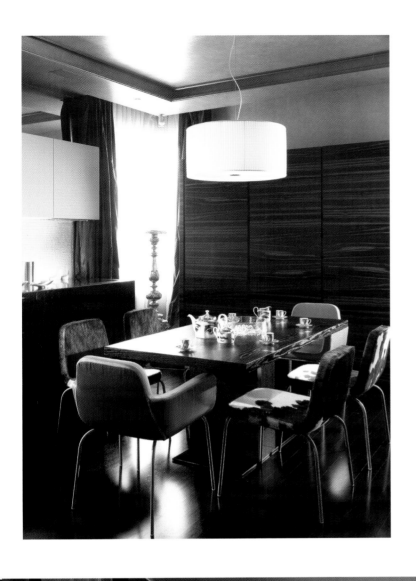

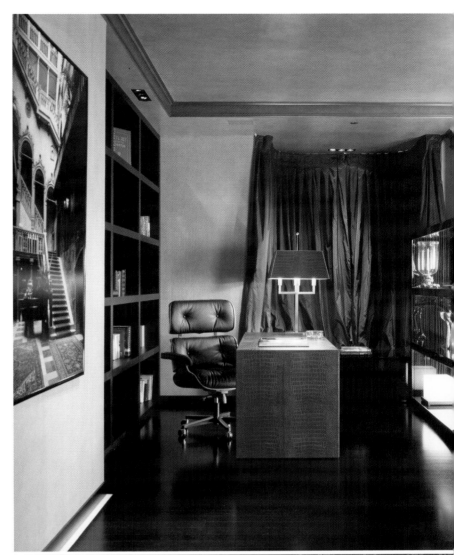

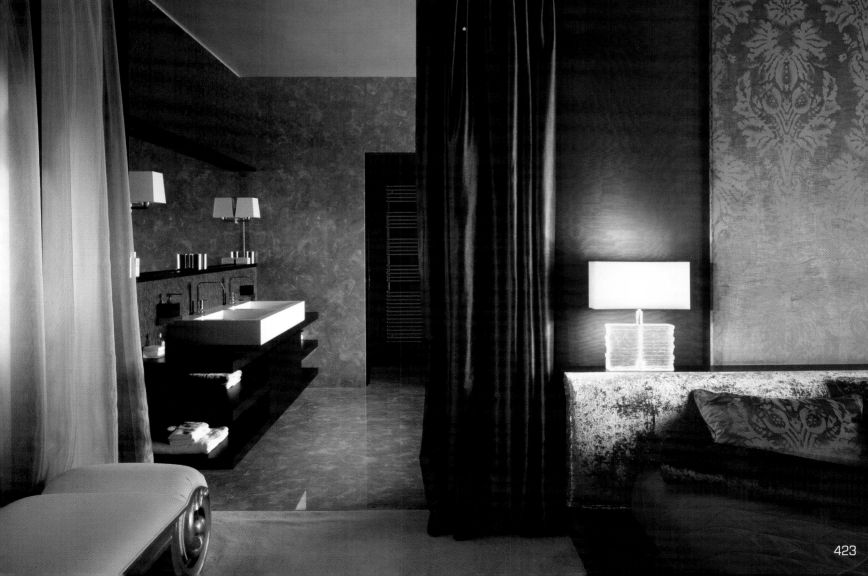

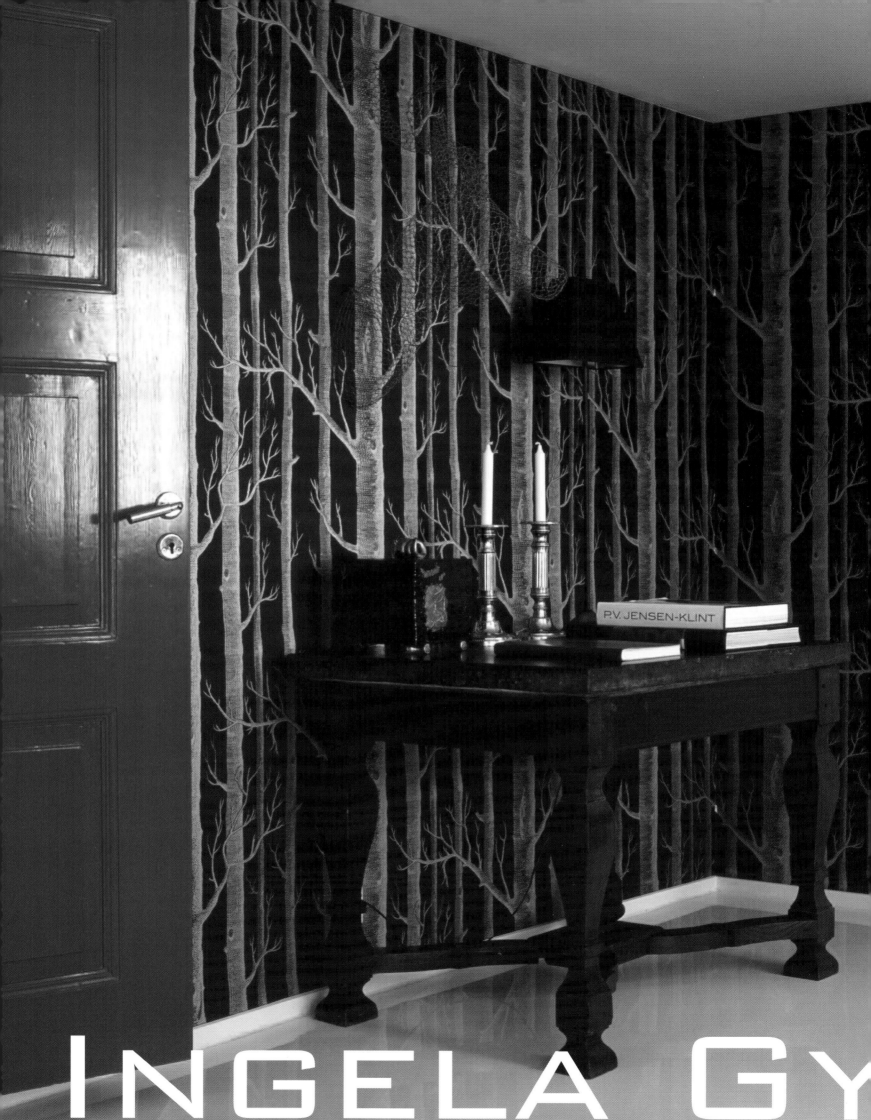

INGELA GY

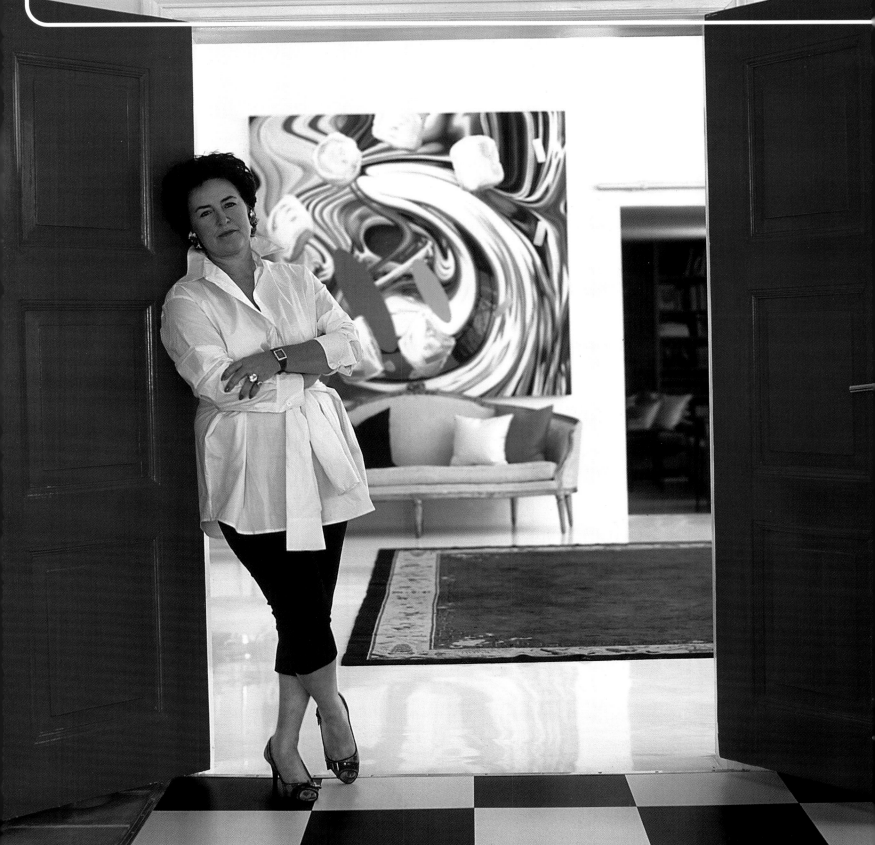

Designer: Ingela Gyllenkrok. Company: Ingela Gyllenkrok Design, Sweden. Profile: Specialising in private work predominantly in Sweden and the Ukraine. Recent projects include a large new build by the sea, a penthouse flat in Kiev and the restoration of a Swedish castle into a modern home. Current work includes the full renovation of an old stable.

LLENKROK

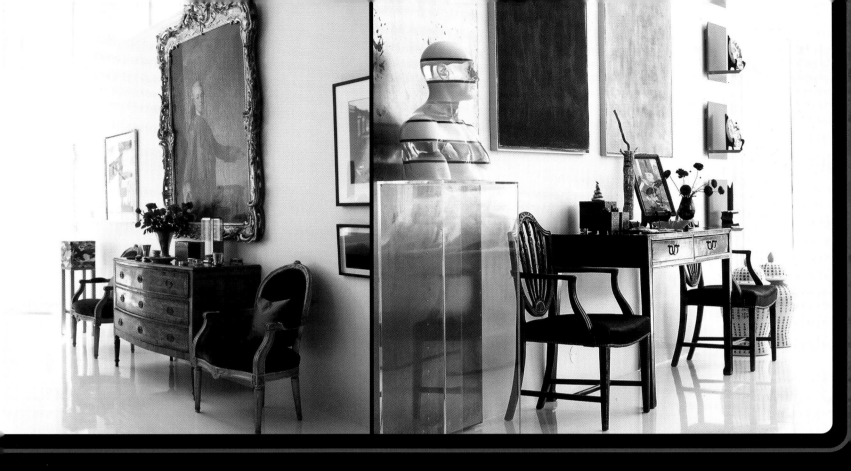

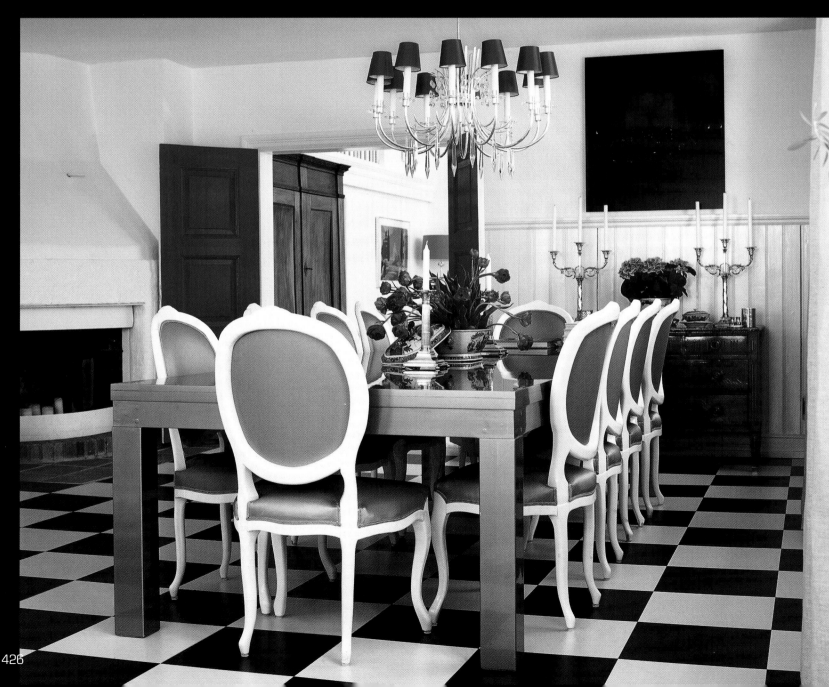

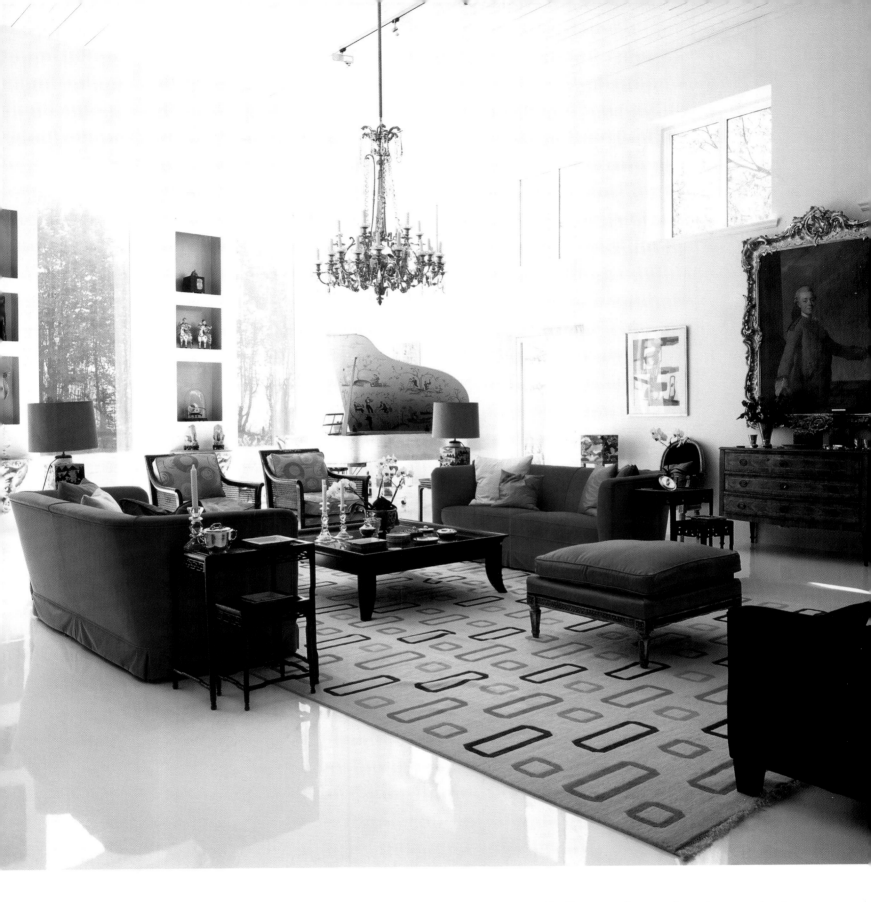

A cold, salty swim on the west coast of Sweden is Ingela's earliest memory. Most memorable meal, lobster salad on her mother's birthday. Happiest with her daughters and friends on a summer's day beside the sea. Favourite home comfort, breakfast in bed; favourite scent, Fracas by Robert Piguet, she's worn it since '68. Political heroes, Margaret Thatcher and Ronald Reagan; best group The Rolling Stones.

At 5 years old Ingela made hous
balsawood for her model farm ar
ambition to become an architect,
envisaging the completion of a pr
begun. Ideal weekend is in a fres
in the countryside surrounded by

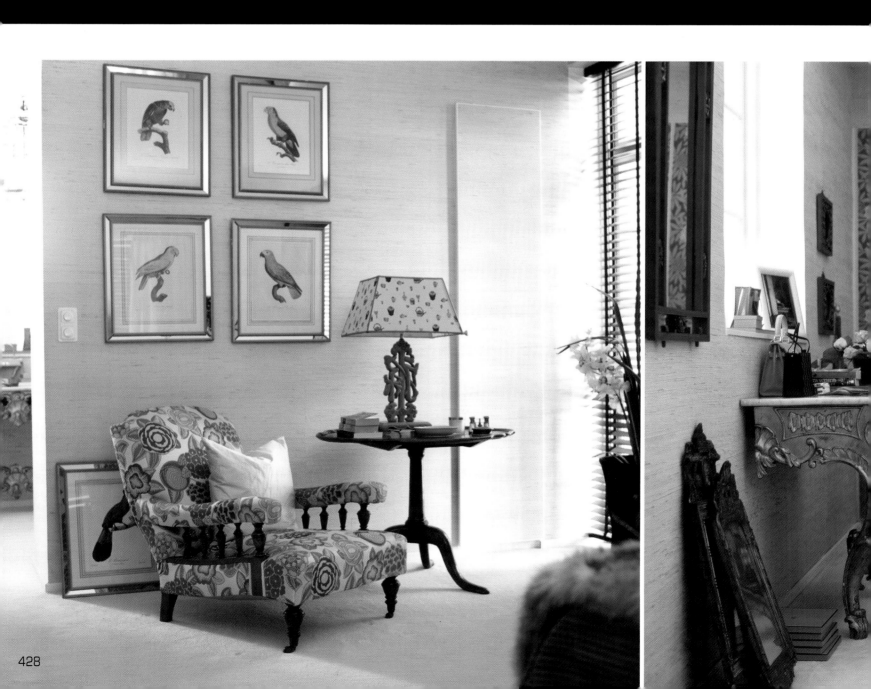

es from
mals. Childhood
best skill,
oject before it's
n green pasture
Arabian horses.

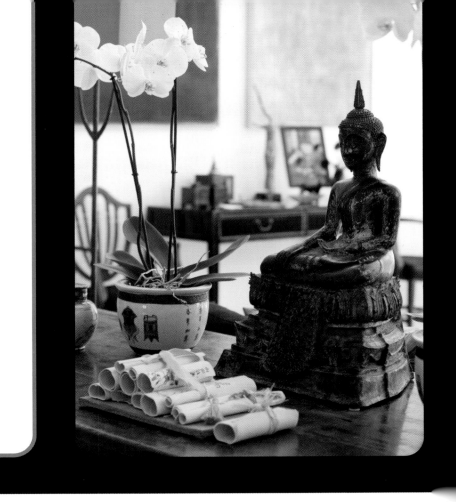

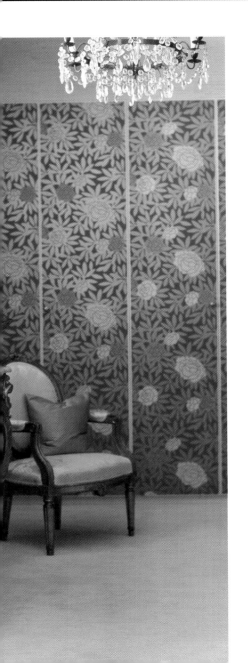

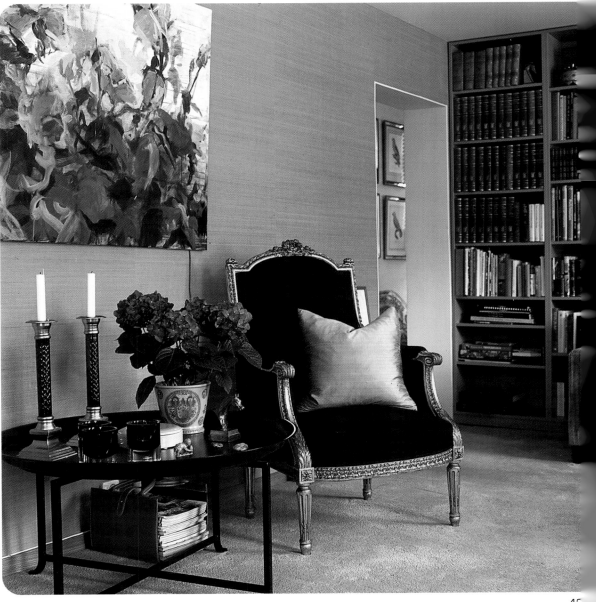

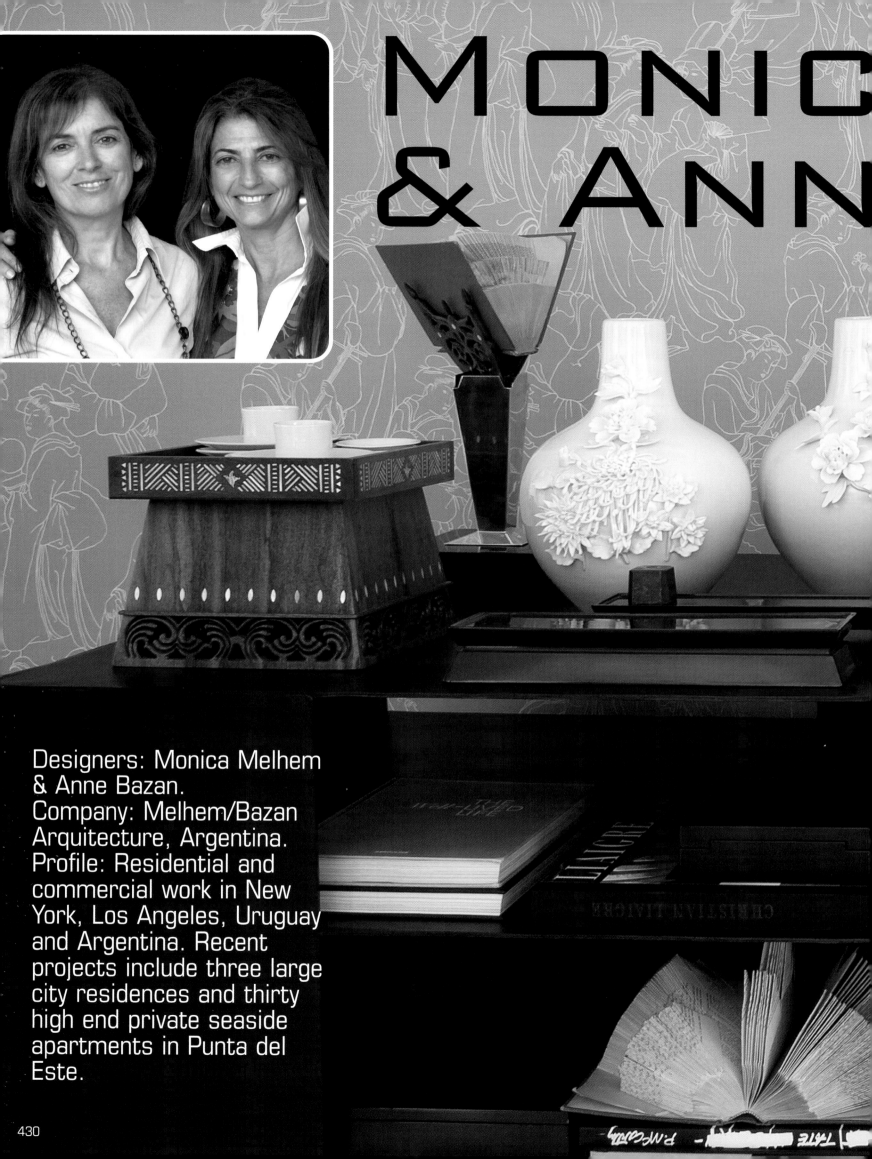

MONIC
& ANN

Designers: Monica Melhem & Anne Bazan.
Company: Melhem/Bazan Arquitecture, Argentina.
Profile: Residential and commercial work in New York, Los Angeles, Uruguay and Argentina. Recent projects include three large city residences and thirty high end private seaside apartments in Punta del Este.

A Melhem e Bazan

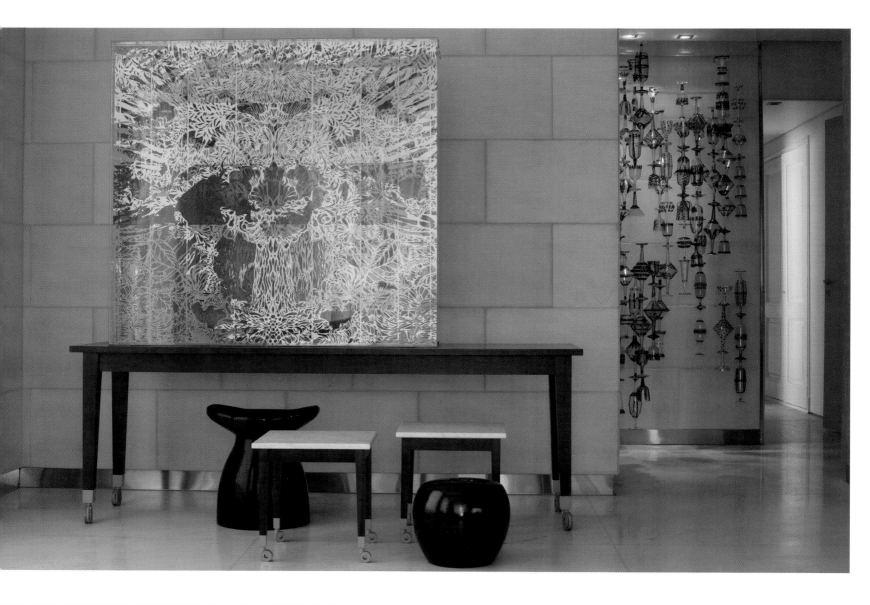

Monica likes to wake up to the smell of coffee and toast, but she thinks chocolate and ice cream are the secret of long life. Favourites: Mies van der Rohe, Pucci and Barry White, because he loves her just the way she is. Her childhood ambition was class dismissal.

THE *Well*-LIVED LIFE ASSOULINE

The Artist Observed

IRIN

Designer: Irina Dymova.
Company: Irina Dymova
Design Studio, Moscow.
Profile: Recently
completed a spa and
two apartments in
central Moscow.

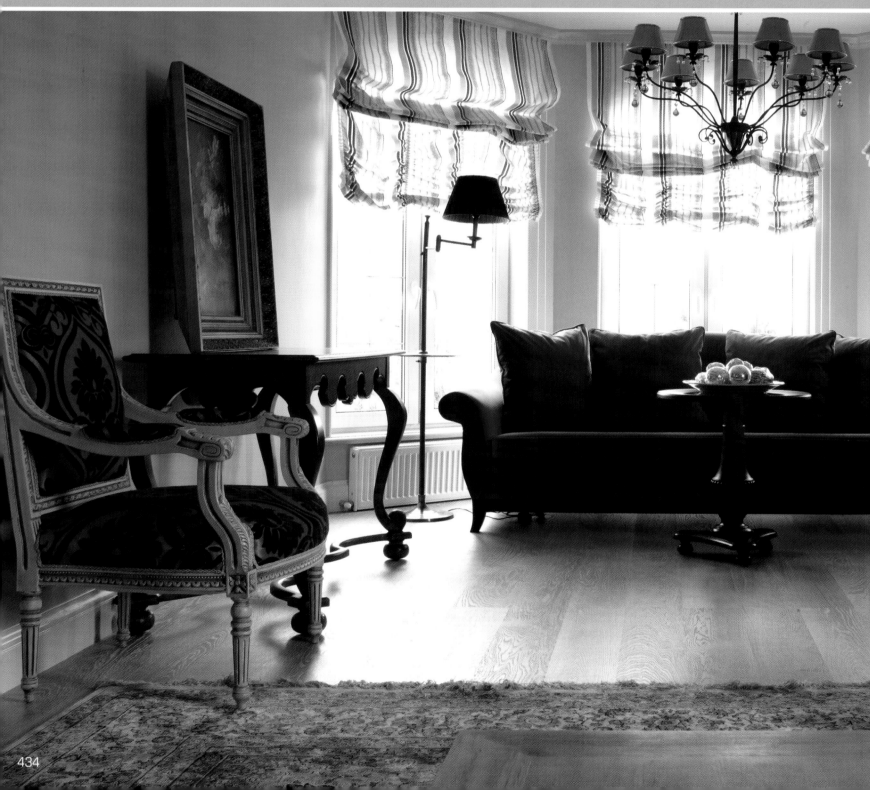

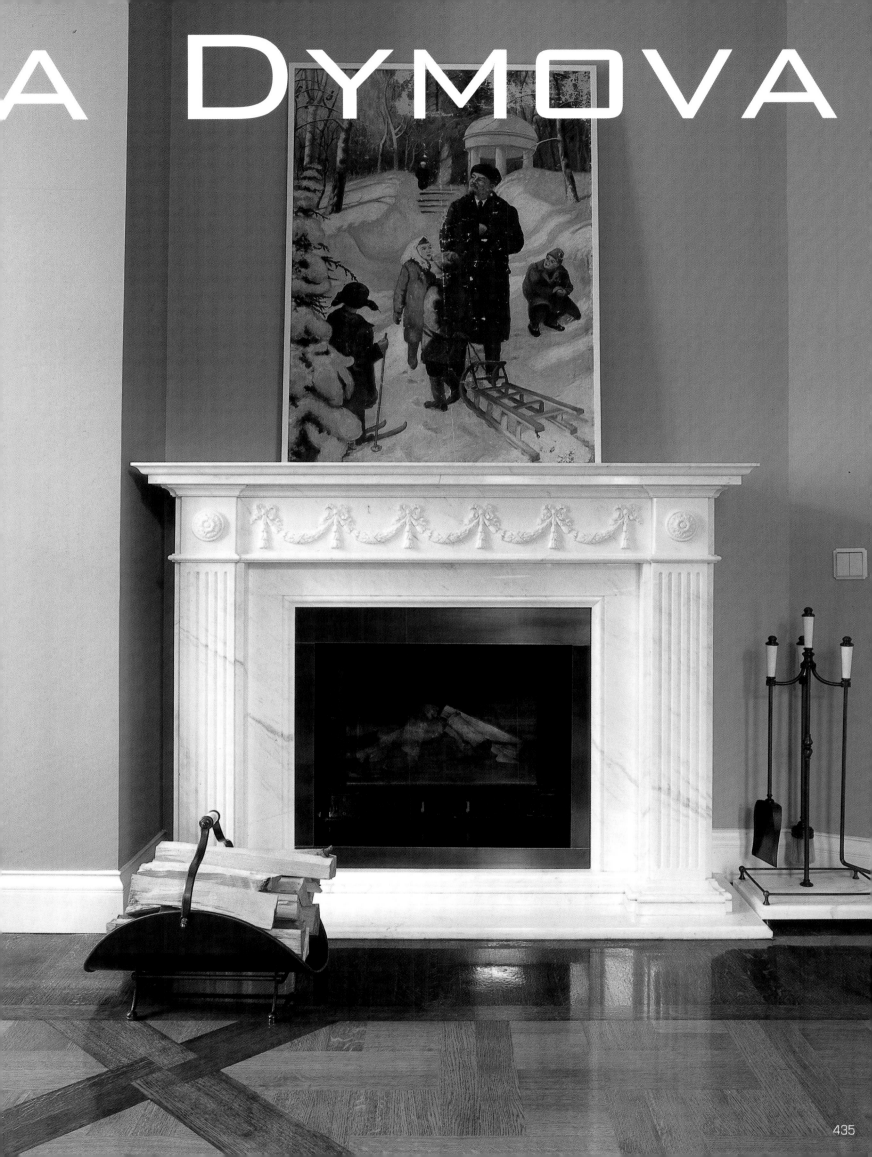

Irina likes Naval uniforms but blames Men for the financial crisis. Her life is made easier by being surrounded by people with a sense of humour. Her favourite saying 'start your day with a Martini Bianco and it will become a day off'.

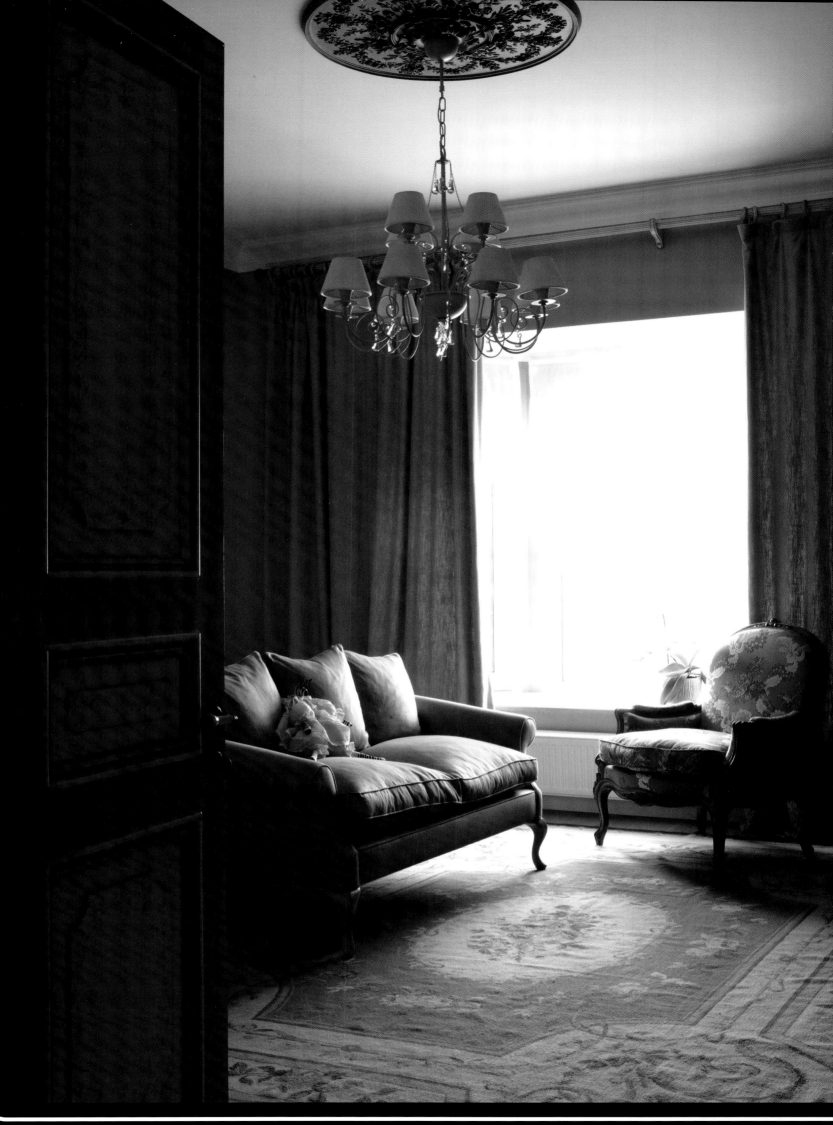

Designers: Ajax Law Ling Kit & Virginia Lung.
Company: One Plus Partnership, Hong Kong.
Profile: Young award winning firm specialising in cutting edge commercial projects in Hong Kong and China. Recent work includes retail stores, penthouses, clubhouses, public spaces and offices both locally and internationally. Current projects include a large scale office in Hong Kong and a movie theatre in China.

One Plus P

ARTNERSHIP

Too cool for school and proud of their career, they'd represent China in an international competition for interior design and relax after winning on their 3m long sofa. Favourite holiday New York, best meal the first sandwich made by Ajax. He rates architect Zaha Hadid and loves to collect books. They believe in ghosts, but there are no skeletons in the cupboard, just shoes. Ajax's favourite saying 'there's no such thing as a free lunch'.

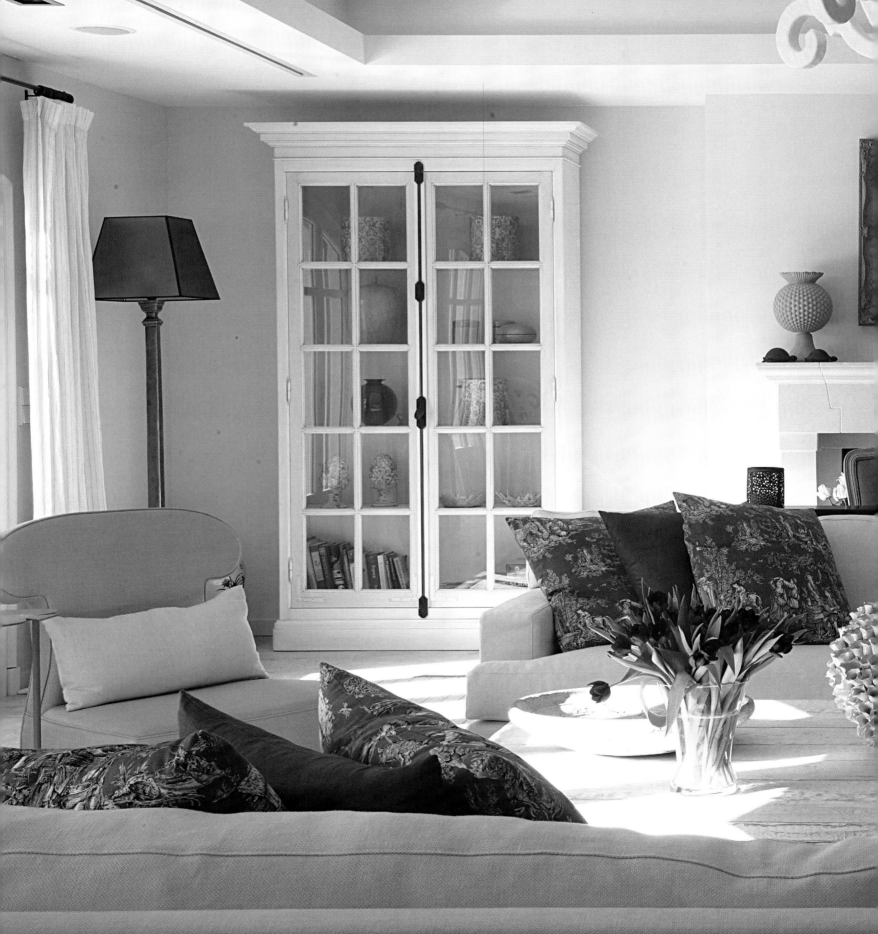

CarterTy

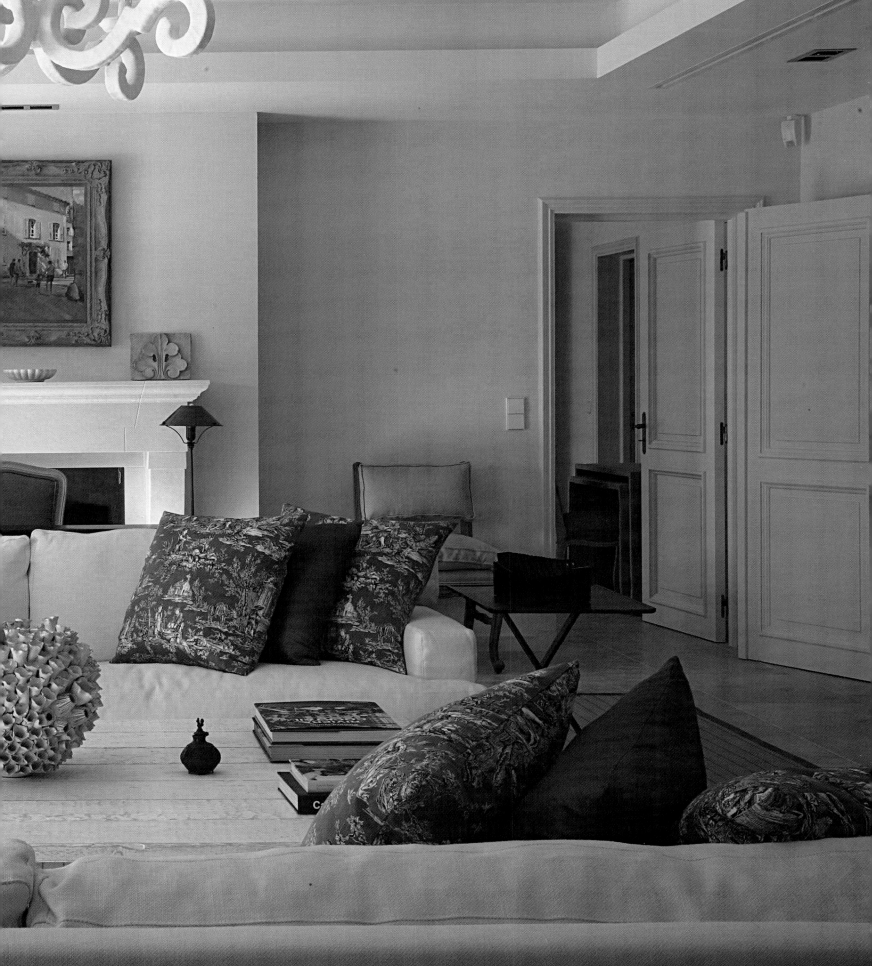

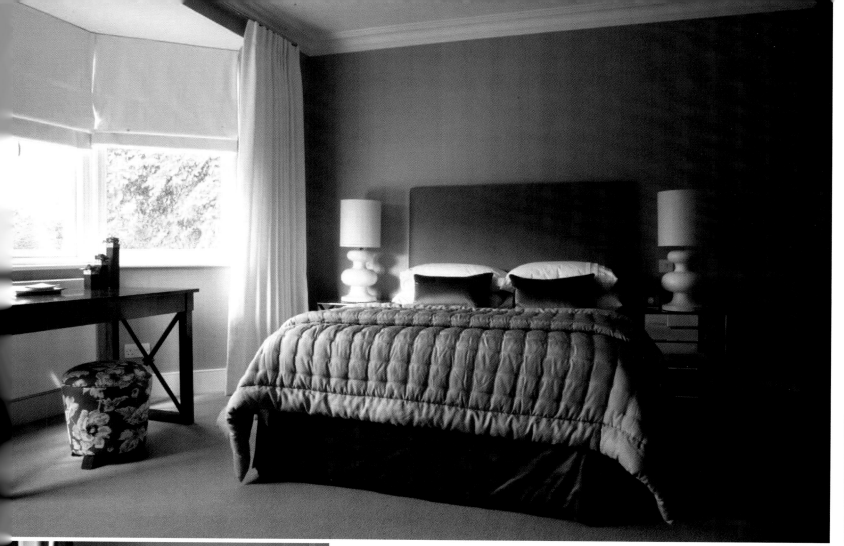

Favourite saying 'we are not human beings on a spiritual journey but spiritual beings on a human journey'. Laura's epitaph will be 'if only I had!' Patrick 'I shouldn't have but I did'.

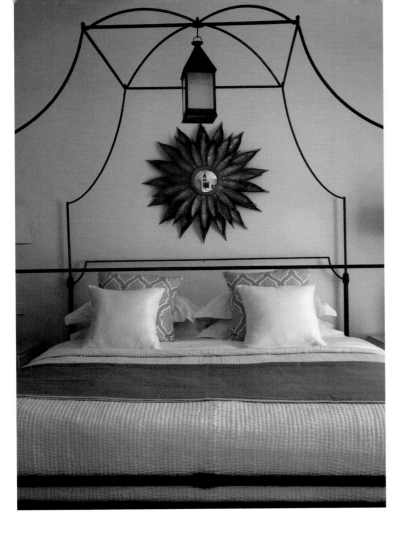

Designers: Laura Carter
& Patrick Tyberghein. Company:
CarterTyberghein, London
Profile: Specialising in high end
residential projects. Recent work
includes a private residence in
New Delhi, a villa in Cap d'Antibes
and a boutique hotel in
Montgenevre, France.

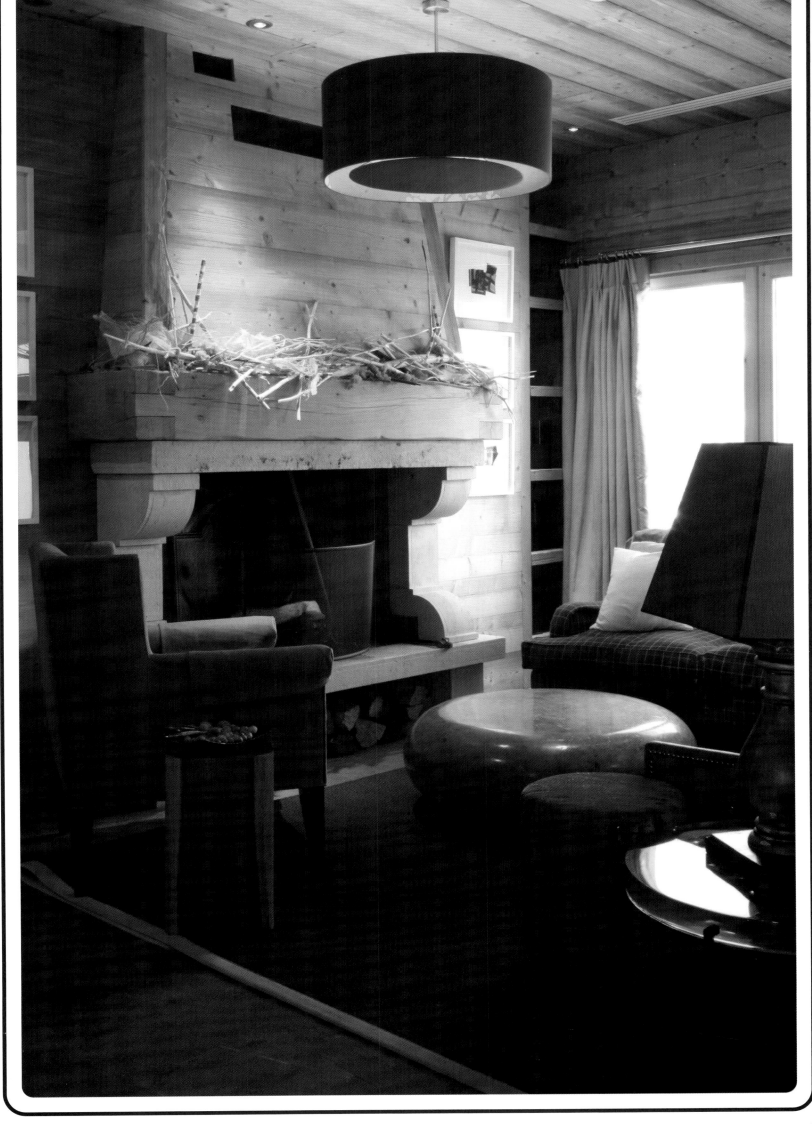

Designer: Cameron Woo.
Company: Cameron Woo Design, Sydney & Singapore.
Profile: Undertaking large scale interior design internationally. Recent projects include sales galleries and showflats in Singapore. Current work includes a development of Mediterranean style villas in China and high end condominium towers in Sentosa Cove.

Fantasy job, to reinvent a Moghul Palace for the modern age. Cameron's hometown Rabaul, Papua New Guinea, his inspiration island glamour. Favourite book Tropical Architecture by Tan Hock Beng, for its perfect explanation of the essential elements of tropical design. His hero, Martin Luther King, best car, anything Bond drives. Favourite saying 'dream big because dreams are free'.

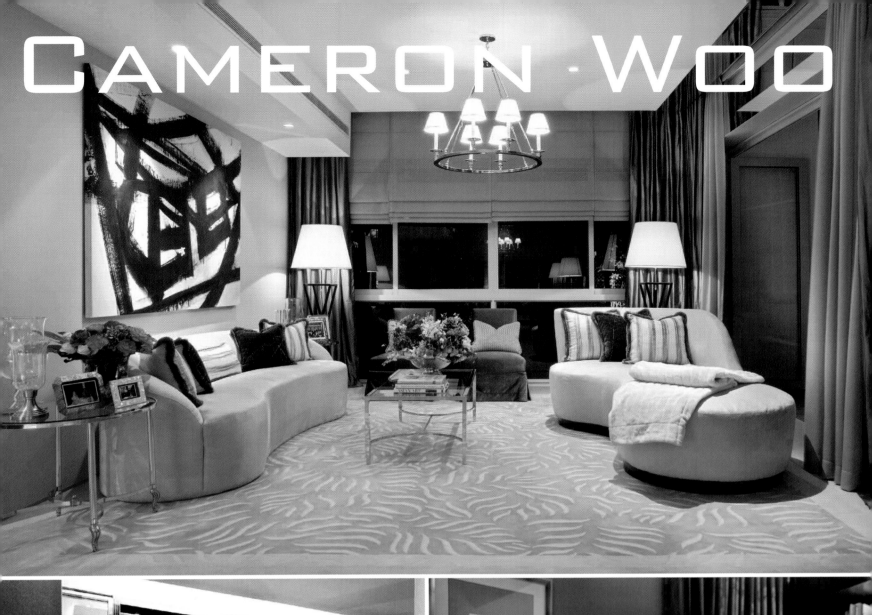

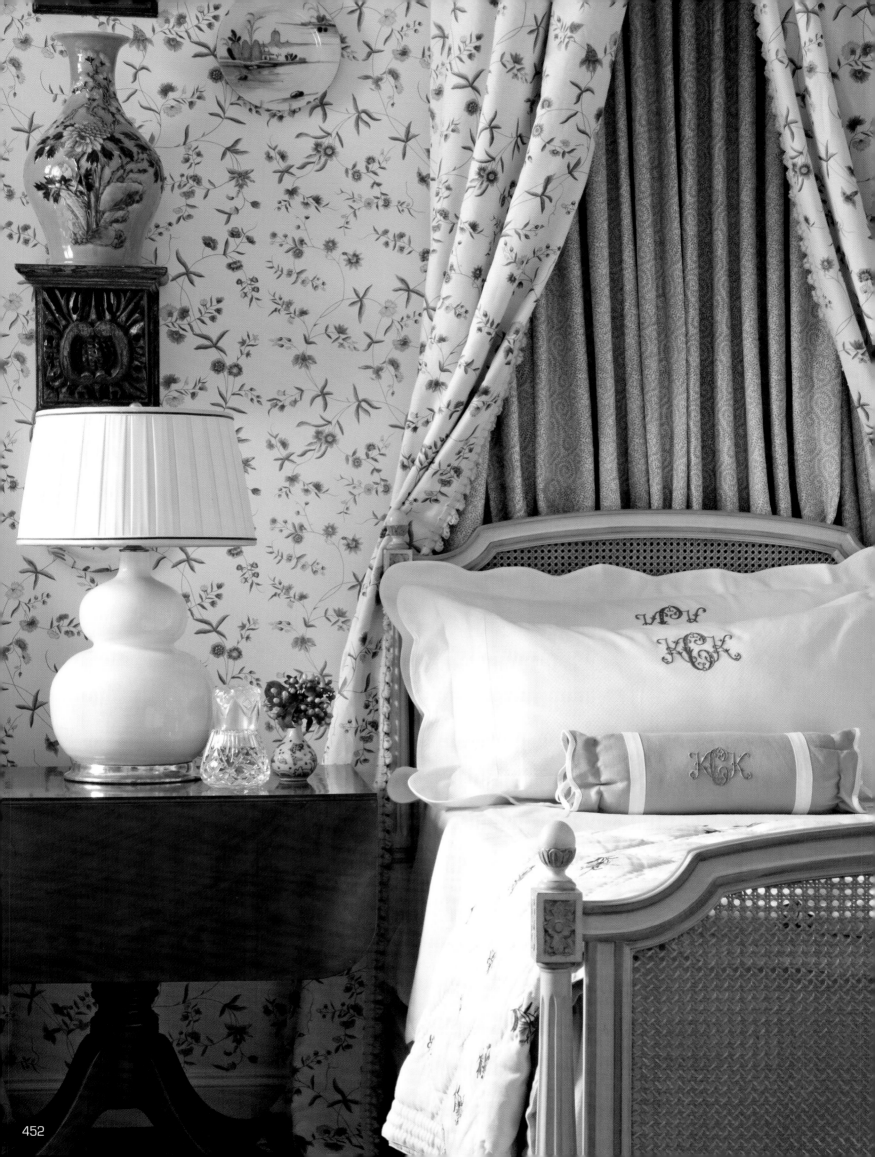

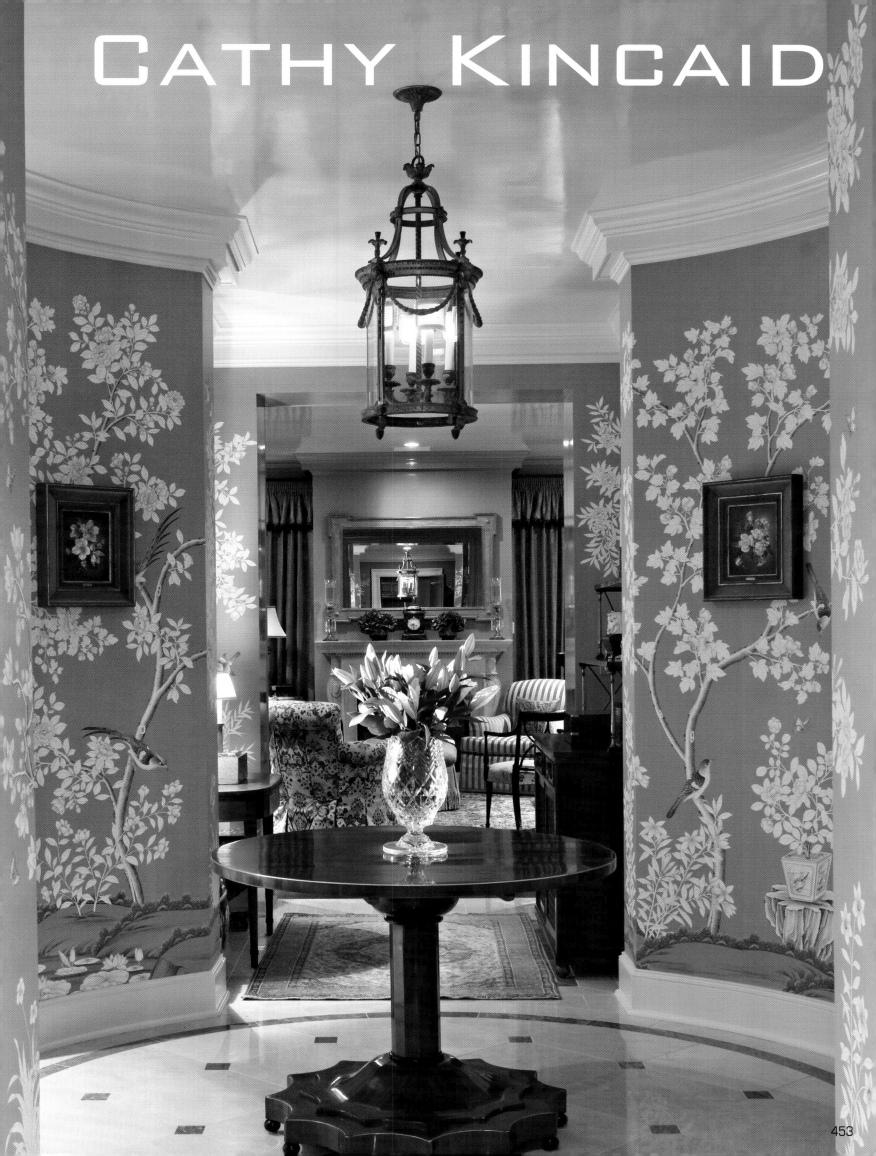

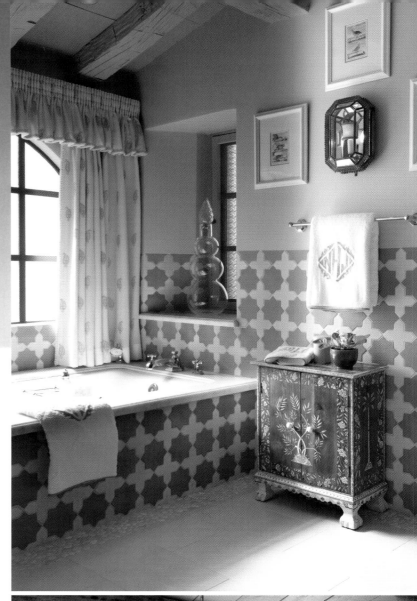

Designer: Cathy Kincaid. Company: Cathy Kincaid Interiors, Texas, U.S.A. Profile: Predominantly private work in the U.S.A. Recent projects include a 1920's style penthouse in Dallas, a Spanish style house in California and a new build Tuscan farmhouse in Arizona. Current projects include Lexus dealerships and a private apartment in Dallas plus a second home in Connecticut.

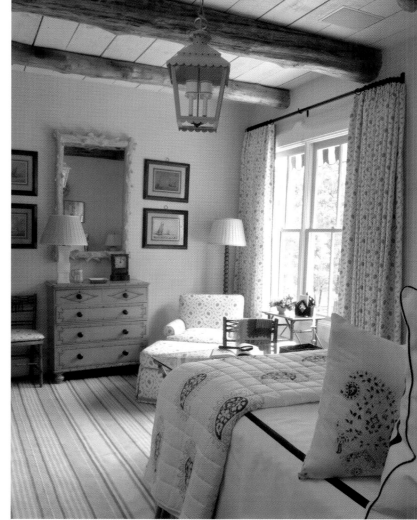

Apron collecting Texan who loves to cook and shop. She can't resist a market or Sean Connery. Best skill an eye for colour. Fantasy job naming paints. Earliest memory Saturdays with her father. Favourite holiday Mexico, music Joni Mitchell, meal pasta with white truffles in Rome. Best advice 'if you are only going to have perfect friends you won't have any.' Her epitaph will be 'always brush on the last coat of paint'.

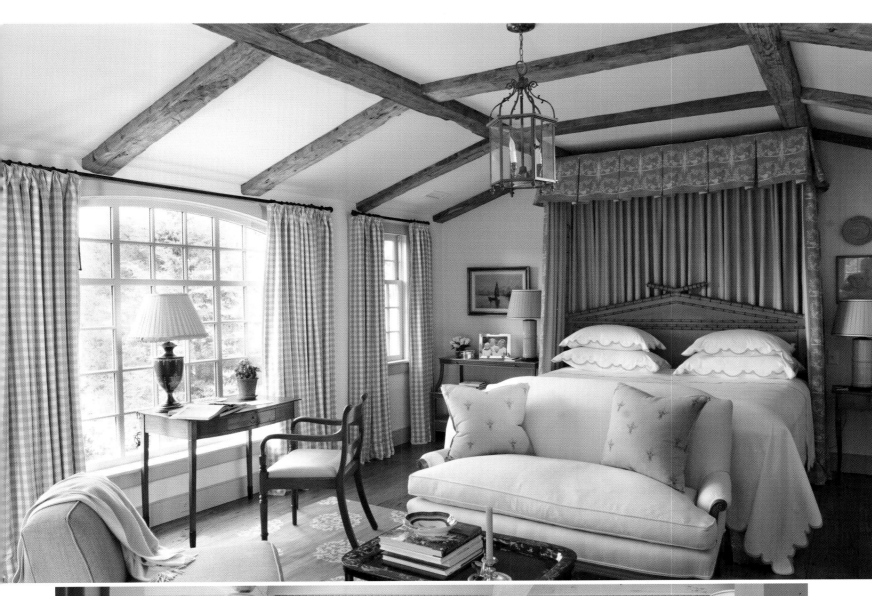

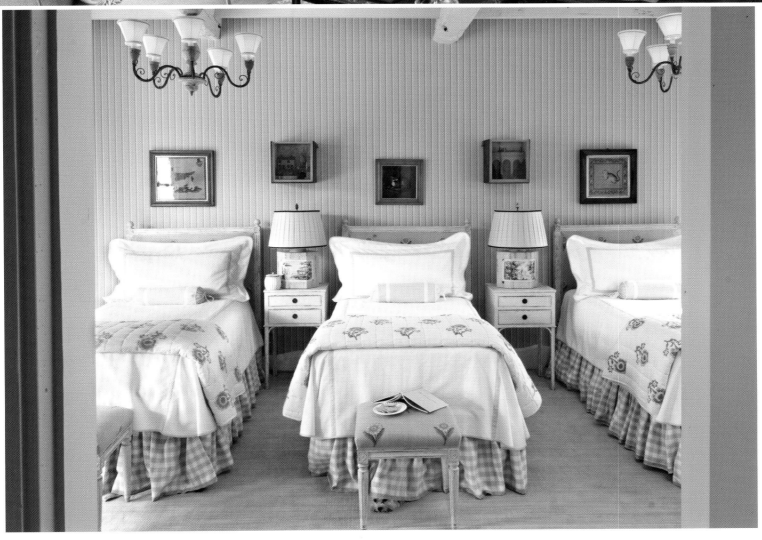

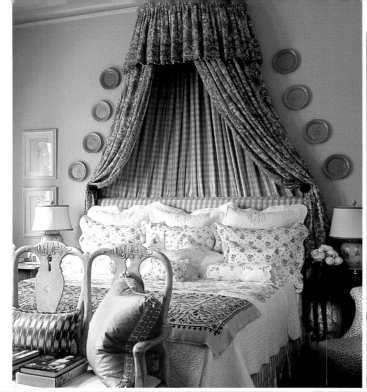

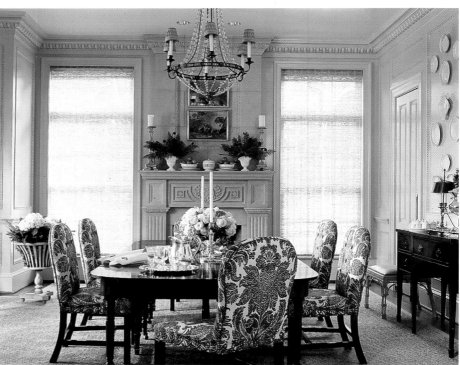

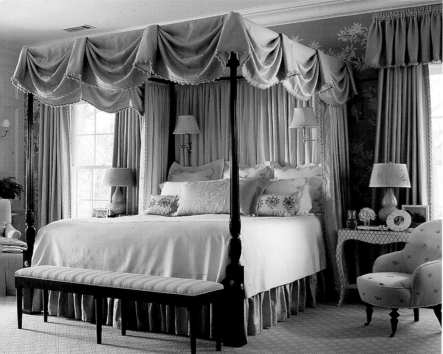

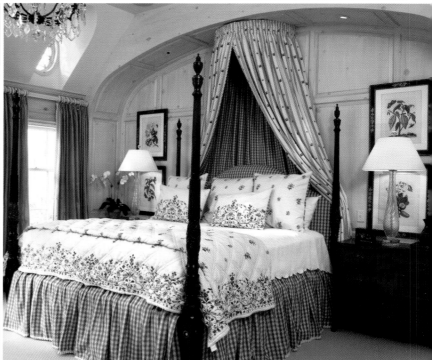

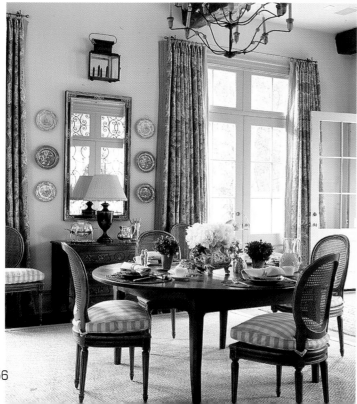

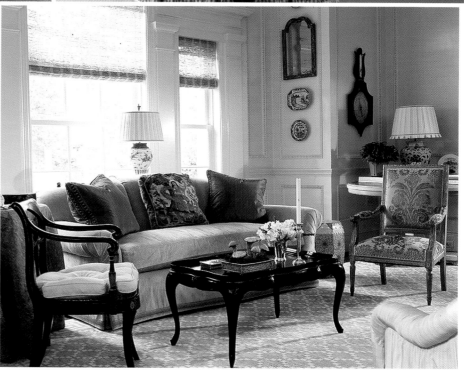

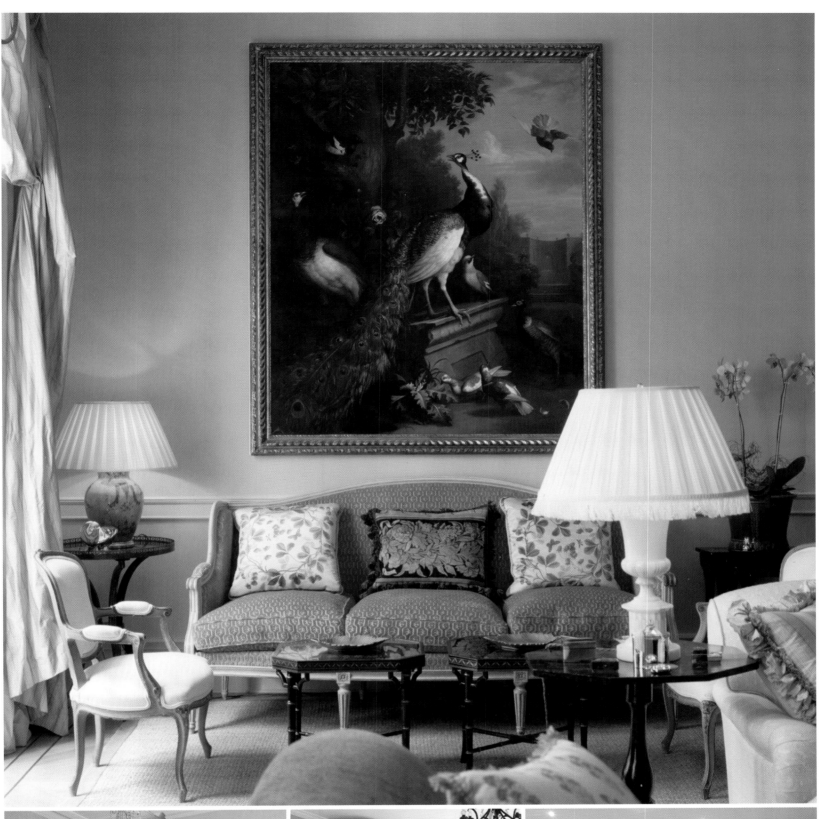

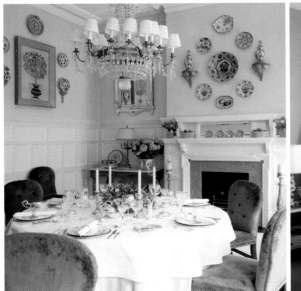

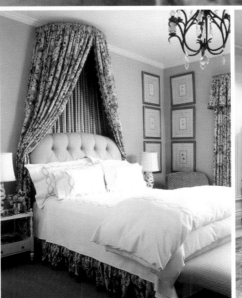

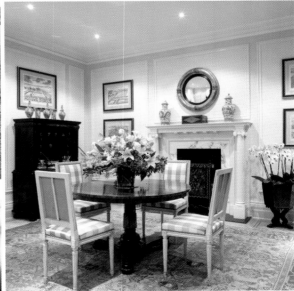

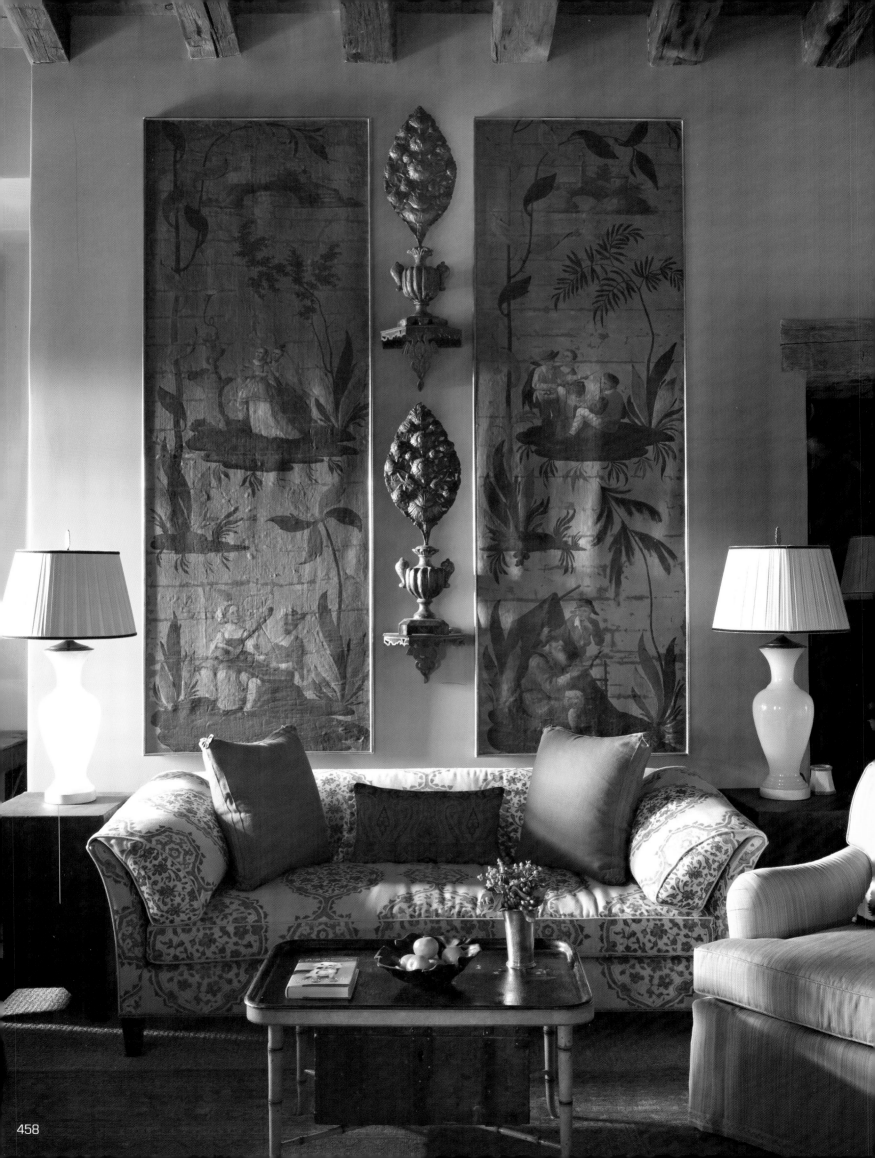

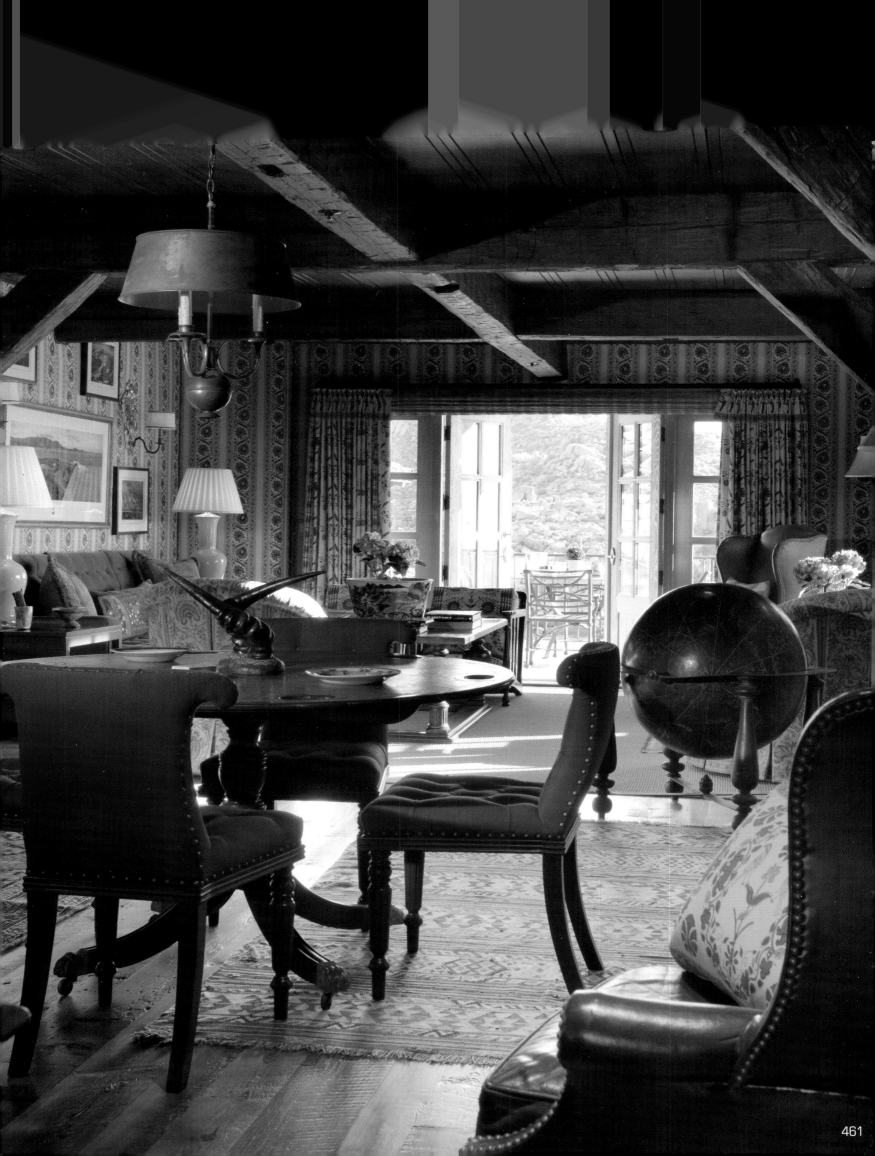

Editor: Martin Waller
Project Executive: Annika Bowman
Product Design: Graphicom Design

First Published in 2009 by Andrew Martin International

ISBN 978-0-9558938-1-0

Reproduction by F1 Colour Ltd.
Printed in Great Britain by Clifford Press.

Acknowledgments

The author and publisher wish to thank all the owners and designers of the projects featured in this book.

They also thank the following photographers:

Christian Sarramon, Pedro Ferreira, Marcus Peel, Joseph Sy, Jorge Cruz, Mark Williams, Louise Wiker, Bruce Thomas, Vangelis Paterakis, Christopher Kolk, Benno Thoma, Francisco Almeida Dias, Gonzalo Muinelo, Nacasa & Partners, Andrea Illan, Vangelis Paterakis, Marco Blessano, Daniela Olivieri, Serge Macia, Francois Schaer, Ted Yarwood, Tela Rood, Arash Moallemi, Steve Leung, Ulso Tsang, Virgilie Simon Bertrand, Thierry Cardineau, Evgenie Kazarnovkaja, Kirill Ovchinnikov, Seiryo Studio Giorgio Baroni, Irfan Naqi, Dennis Krukowski, Justin Ratcliffe, Fabrice Demoulin/Sabado Magazine, Casa Claudia Magazine, Simon Frederick, Attitude Magazine, Villas & Golfe Magazine, Christina Sullivan, Susan Bednar Long, Lisa Kereszi, Dominic Albo, Mark La Rosa, Mr Bao Shi Wang, Andreas von Einsiedel, Mariusz Bykowski, Dobre Wnetrze, Mirka McNeill Farmer, Bridget Jones, Carlos Cezanne, Miguel Perestrelo, Henrique Seruca, John Armich, Maggie Barber, Candy & Candy, Magnus Anesund, Trevor Mein, Shannon McGrath, Earl Carter, Sharyn Cairns, Marcus Peel, Michael Meier, Xiaochun Ma, Thierry Malty, Michail Stepanov, Alexey Knyazev, Giogio Baroni, Hans Zeegers, James Rudland, Caroline True, David Withycombe, Mona Gundersen, Daniel Clements, Bruno Van Loocke/Club Med, Delphine Coutant/Club Med, Studio Hertrich/Adnet, Stefan Kraus, Fabrice Rambert Pour Sofitel, Myriam Ramel/www.lumieredujour.ch, Phil Boorman Photography Ltd, Manuel Gomes da Costa, Mick Hales, Barry Halkin, Tom Crane, Beto Riginik, Dmitry Livshitz, Elsa Young, Philip Schedler, Pieter de Ras, Jens Bruchhaus, Carolin Knabbe, Studio Dreyer Hensley, Lars Petter Pettersen, Mona Gundersen, Umberto Favretto, Zhou Yao Dong, Michail Stepanov, Conor Horgan, Sean O'Neill, Thong Lei, Tim Street-Porter, Eric Tai, Dai Yong, Jamie McGregor Smith, Tiziana Arici, Christoph Koester, Olaf Lummer, Leo Ying Li, Sun Xiangyu, Todd Watson, Barry Murphy, Casey Moore of Alexander-Moore Photog'y, Moreno Maggi, Ali Bekman, Y.S. Chou, Steven Lin, Anli, Steven Lin. CZ Zai, SW Bao, Warren Smith, Chris Tubbs, Gilles Trillard, Philip Vile, Morten Andenaes, Giuseppe Pascale, Francisco Almeida Dias, Tom Sullam, Nick Smith, Sean Myers & Millie Pilkington, Vincent Cheung, Toby Seato, Kirill Ovchinnikov, Helene Toresdotter, Virginia del Giudice, Michail Stepanov, Virginia Lung, Ulso Tsang, Ajax Law, Mae Tyberghein, Patrick Tyberghein, Rory Daniel, Albert Lim K S, Edward Addeo.

222 Sera Hersham Loftus
Sera of London
Tel 07977 534 115
sera@seraoflondon.com
www.seraoflondon.com

226 Susan Salisbury & Jessica Earle
Classic Country Pub Design
Holly House, Spencers Lane
Berkswell, Warwickshire CV7 7BZ
Tel 01676 533 169 Fax 01676 535 012
pssalisbury1@hotmail.com

232 Linda Steen
AS Scenario. Interiorarkitekter
Fridtjof Nansens vei 12
0369 Oslo, Norway
Tel 0047 22 93 12 50
Fax 0047 23 36 81 01
info@scenario.no
www.scenario.no

236 Marc Hertrich & Nicolas Adnet
Studio Marc Hertrich & Nicolas Adnet
Designer - Decorator
14 rue Crespin du Gast
75011 Paris, France
Tel 0033 143 140 000
Fax 0033 143 388 601
contact@studiomhna.com
www.studiomhna.com

242 Yvonne Jones & Andrew Burch
Chameleon Interiors
62 Cathays Terrace, Cardiff CF24 4HY
Tel 029 2037 1277 Fax 029 2023 1497
info@chameleoninteriors.com
www.chameleoninteriors.co.uk

246 Ligia Casanova
Atelier Ligia Casanova
LX Factory, Rua Rodrigues Faria, 103
1350-501 Lisbon, Portugal
Tel 00351 919 704 583
ligia.casanova@sapo.pt
www.ligiacasanova.com

250 Barbara Eberlein
Eberlein Design Consultants Ltd
1809 Delancey Place, Cypress Entrance
Philadelphia PA 19103 U.S.A.
Tel 001 215 790 0300
Fax 001 215 790 0301
info@eberlein.com
www.eberlein.com

254 Joao Mansur
Joao Mansur – arquitetura & design
1922 B Rua Groenlandia, Jardim America
Sao Paulo SP Brasil 01434-100
Tel 0055 11 3083 1500
Fax 0055 11 3081 7732
joaomansur@joaomansur.com
www.joaomansur.com

262 Nadia & Georgy Ananiev
Architecture and Design Bureau
Novopeschanaya Str.
26-1 Moscow 125252 Russia
Tel 007 499 198 9008
Mobile 007 910 484 5290
angivi@yandex.ru
www.ngananiev.ru

266 Adèle van der Merwe
Adèle van der Merwe Interiors
22 Herbert Baker St, Groenkloof, Pretoria
Tel 0027 12 460 9712
Fax 0027 12 346 9040
adele@adelevdminteriors.co.za

272 Tessa Proudfoot
Tessa Proudfoot & Associates
4 Christopherson Road, Dunkeld
2196 Johannesburg, South Africa
Tel 0027 11 788 7374
Fax 0027 11 788 7376
tessa@tessaproudfoot.co.za

276 Kiki Schroeder
KSD – Kiki Schroeder Design
Rauchstr 1, 81679 Munchen, Germany
Tel 0049 89 90 109 494
Fax 0049 89 90 109 495
info@kikischroeder-design.de
www.kikischroeder-design.de

282 Anemone Wille Vage
Anemone Wille Vage Interiordesign
Dronning Astridsgte. 7
0355 Oslo, Norway.
Tel 0047 22 60 27 33
Fax 0047 22 60 56 32
anemone@anemone.no
www.anemone.no

288 Ana Maria G. de Vieira Santos
Ana Maria Guimaraes de Vieira Santos
de Escritorio de arquitetura e decoracao
Av. de Lineu de Paula Manchado
1330 Sao Paulo – SP 05601-001 Brazil
Tel 0055 11 3813 5800
Fax 0055 11 3813 5657
esdecor@anamariavieirasantos.com.br
www.anamariavieirasantos.com.br

294 Enrica Fiorentini Delpani
Studio Giardino
Via Caselle 6 – 25100 Brescia
Italy
Tel 0039 030 353 2548
Fax 0039 030 353 2548
studiogiardino55@libero.it

300 Kris Lin
K.L.I.D. Kris Lin Interior Design
301 Room, The Fourth Building No 1163
Hong Qiao Road, Chang Ning District
Shanghai, China
Tel 0086 21 6283 9605
Fax 0086 21 6209 9918
Mobile 0086 137 0185 6255
kl_iad@vip.163.com
www.krislin.com.cn

304 Irina Markidonova
& Ilona Menshakova
Sisters' Design, Moscow
Arkhitektora Vlasova, 18-100
117393 Russia
sisters-design@mail.ru
www.sisters-design.ru

308 Garry Cohn
Garry Cohn, Design
54 Bachelors Walk, Dublin 1, Ireland
garry@garrycohn.com
www.garrycohn.com

312 Thong Lei & Anne Noordam
Decoration Empire
Meridiaan 55-59, Postbus 455
DA 2801 Gouda, The Netherlands
Tel 0031 182 583341
Fax 0031 182 583351
thonglei@decorationempire.nl
www.decorationempire.nl

318 Martyn Lawrence-Bullard
Martyn Lawrence-Bullard Design
8101 Melrose Avenue
Los Angeles CA, 90046 U.S.A.
Tel 001 323 655 5080
Fax 001 323 655 5090
info@martynlawrencebullard.com
www.martynlawrencebullard.com

324 Eric Tai
Eric Tai Design Company
Tower 21A & B, HaiYing Building
CaiTian Road, FuTian District
ShenZhen, China
Tel 0086 755 829 13509
Fax 0086 755 829 24630
szyisi@126.com
www.easespace.com

328 Christopher Prain
Christopher Chanond
Studio 13, 92 Lots Road
London SW10 0QD
Tel 0207 351 5868 Fax 0207 352 6557
hw@christopherchanond.com
www.christopherchanond.com

332 Lucia Valzelli
Dimore di Lucia Valzelli
Corsia del Gambero 6, 25121 Brescia, Italy
Tel 0039 030 280 274
& 0039 339 490 2482
Fax 0039 030 280 274
info@dimorestudio.com
www.dimorestudio.com

336 Michael Bedner & Inge Moore
Hirsch Bedner Associates
3216 Nebraska Avenue, Santa Monica
California 90404 U.S.A.
Tel 001 310 829 9087
Fax 001 310 453 1182
lemorm@hbadesign.com
ingem@hbadesign.com
www.HBAdesign.com

344 Suzanne Garuda
Garuda Design
Maxol Building 261-263 Ormeau Road
Belfast BT7 3GG
info@garudadesign.com
www.garudadesign.co.uk

348 Paul Broadley & Gerda Caner
Gush Design
14 Charles St, Mayfair W1J 5DR
Mobile: 07890 656 849
info@gushdesign.com
www.gushdesign.com

354 Astrid Schiller Wirth
Via Flaminia Vecchia 497
00186 Rome, Italy
Tel 0039 335 812 2313
Fax 0039 63 321 9527
astrid@schillerwirth.com
www.schillerwirth.com

360 Seyhan Ozdemir & Sefer Caglar
Autoban, Tatarbey s. no. 1
Galata 34425, Istanbul, Turkey
Tel 0090 212 243 8642
Fax 0090 212 243 8640
info@autoban212.com
www.autoban212.com

364 T.K. Chu
TK Chu Design Group
8F No. 76, Zhouzi St, Neihu District Taipei,
114 Taiwan R.O.C.
Tel 00886 287 977 890
Fax 00886 287 977 898
scenictk@ms41.hinet.net
www.tkchu.com.tw

370 Jan des Bouvrie
Ontwerpstudio Jan des Bouvrie
Kooltjesbuurt 1, 1411 RZ Naarden, Holland
Tel 0031 35 699 62 19
Fax 0031 35 632 15 74
info@hetarsenaal.nl
www.hetarsenaal.nl

374 Christopher Dezille BIDA
Honky Interior Architecture & Design
Unit 1 Pavement Studios, 40-48 Bromells Rd
London, England SW4 0BG
Tel 0207 622 7144 Fax 0207 622 7155
info@honky.co.uk
www.honky.co.uk

380 Federica Palacios
Federica Palacios Design
3 Cour de Saint-Pierre
1204 Geneva, Switzerland
Tel 0041 223 102 276
Fax 0041 223 102 286
federica@federicapalaciosdesign.com
www.federicapalaciosdesign.com

386 Nicky Dobree
Nicky Dobree Interior Design Ltd
25 Lansdowne Gardens, London SW8 2EQ
Tel 0207 627 0469 Fax 0207 627 0469
info@nickydobree.com
www.nickydobree.com

390 Helene Forbes Hennie
Christian's & Hennie AS
Skovvn 6, 0257 Oslo, Norway
Tel 0047 22 121 350
Fax 0047 22 121 351
info@christiansoghennie.no
www.christiansoghennie.no

396 Louis Pepin & Jean Turcotte
Atelier de l'Opera, 1165 Avenue Greene
Westmount (Quebec) H3Z 2A2
Tel 001 514 935 6245
Fax 001 514 931 4316
atelierdelopera@bellnet.ca
www.atelierdelopera.com

400 Catarina Rosas, Claudia & Catarina
Soares Pereira, Casa do Passadico, Largo de
S.Joao do Souto, 4700-326 Braga, Portugal
Tel 00351 253 6199 88
Fax 00351 213 110
mail@casadopassadico.com
www.casadopassadico.com

404 Gail Taylor & Karen Howes
Taylor Howes Designs Ltd
29 Fernshaw Road, London SW10 0TG
Tel 0207 349 9017 Fax 0207 349 9018
admin@thdesigns.co.uk
www.thdesigns.co.uk

410 Bunny Turner & Emma Pocock
Turner Pocock
8 Hansard Mews, London W14 8BJ
Tel 0207 603 3440 Fax 0207 371 2001
info@turnerpocock.co.uk
www.turnerpocock.co.uk

414 Vincent Cheung & Ann Yu
Domani Group Ltd
2nd Floor of 409,South of Jiangnan St
Haizhu District, Guangzhou City
Guangdong Province 510260 China
Tel 0086 400 8822 600
Fax 008620 890 99110
Mobile: 0086 134 163 533 69
info@domanihk.net
www.domanihk.net

420 Olga Stupenko
Olga Stupenko Interior Design
48/90 Frunzenskaya Emb.
Moscow 119270 Russia
Tel 007 499 246 6706
Mobile 007 985 773 6440
olga_stupenko@mail.ru
www.olgastupenko.com

424 Ingela Gyllenkrok
Ingela Gyllenkrok Design
Palestra S-240 13, Genarp, Sweden
Tel/Fax 0046 40 480 048
Mobile 0046 70 587 1769
ingela.gyllenkrok@home.se
ingela@igdesign.se

430 Monica Melhem & Anne Bazan
Melhem/Bazan AV., Libertador 2902
Piso 12, Buenos Aires, Argentina 1425
Tel/Fax: 0054 11 480 25 762
monica@melhemarq.com

434 Irina Dymova
Irina Dymova Design Studio
30/12 Shabolovka Str, Apartment 114
Moscow 115419, Russia
Tel 007 495 236 4190
Fax 007 495 953 9863
Mobile 007 903 729 0730
& 007 495 729 0730
dymovadecor@yandex.ru

438 Ajax Law Ling Kit & Virginia Lung
One Plus Partnership Limited
9F New Wing, 101 King's Road
North Point, Hong Kong
Tel 00852 259 19308 Fax 00852 259 19362
admin@onepluspartnership.com
www.onepluspartnership.com

442 Laura Carter & Patrick Tyberghein
CarterTyberghein Ltd
Hyde Park House, Manfred Road
London SW15 2RS
Tel 0208 871 4800 Fax 0208 871 4900
info@cartertyberghein.com
www.cartertyberghein.com

448 Cameron Woo
Cameron Woo Design
36 Greenleaf Road, Singapore 279336
Tel 0065 6465 0550 Fax 0065 6465 2380
info@cwd.com.au
www.cameronwoodesign.com

452 Cathy Kincaid Hudson
Cathy Kincaid Interiors
4504 Mockingbird Lane, Dallas
Texas 75205 U.S.A.
Tel 00214 522 0856 Fax 00214 528 3527
ckincaidint@aol.com
www.cathykincaid.com